Shapeshifting

Changing

Voicing

Knowing

Locating

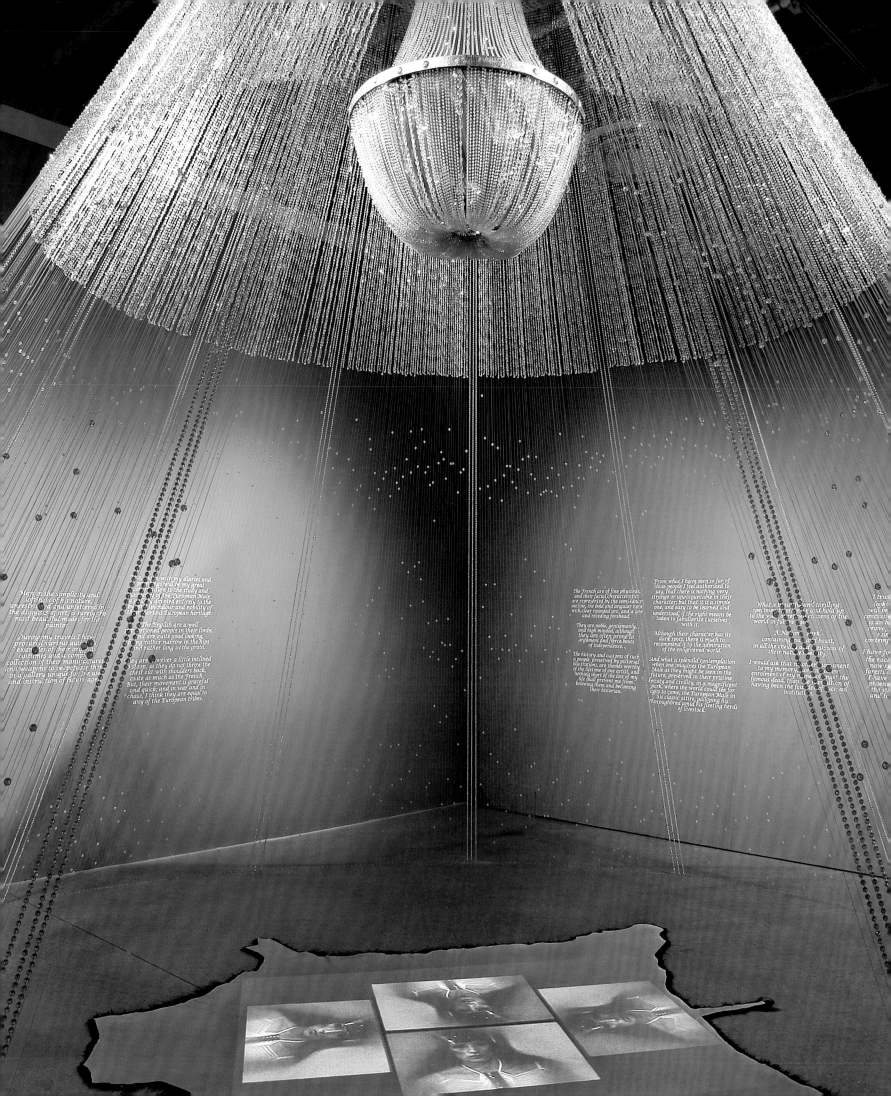

Shapeshifting
Transformations in Native American Art

Karen Kramer Russell with Janet Catherine Berlo, Bruce Bernstein, Joe D. Horse Capture, Jessica L. Horton, and Paul Chaat Smith and contributions by Kathleen Ash-Milby, Karah English, Aldona Jonaitis, Madeleine M. Kropa, Kate Morris, and Ryan Rice

Peabody Essex Museum in association with Yale University Press, New Haven and London

Shapeshifting: Transformations in Native American Art accompanies the exhibition of the same name organized by the Peabody Essex Museum, Salem, Massachusetts, on view from January 14 through April 29, 2012.

Peabody Essex Museum
East India Square
Salem, Massachusetts 01970
www.pem.org

Published in association with Yale University Press, New Haven and London.

Yale University Press
302 Temple Street
P. O. Box 209040
New Haven, Connecticut 06520-9040
www.yalebooks.com/art

Library of Congress Control Number: 2011928735

ISBN: 978-0-87577-223-3 (Peabody Essex Museum, pbk)
ISBN: 978-0-300-17732-9 (Yale University Press, cloth)

The exhibition has been supported in part by the Terra Foundation for American Art, the Bay and Paul Foundations, Consulate General of Canada, Peck Stacpoole Foundation, Ellen and Steve Hoffman, ECHO (Education through Cultural and Historical Organizations), and East India Marine Associates (EIMA) of the Peabody Essex Museum.

Front Cover: Marie Watt (born 1967), Seneca. *Column (Blanket Stories)*, 2003 (plate 61, detail). Back Cover: Tsimshian artist. House frontal totem pole, 1800s (plate 44, detail). Pages 2–4: Kent Monkman (born 1965), Cree. *Théâtre de Cristal*, 2007 (plate 1, details). Pages 28–29: Ramona Sakiestewa (born 1948), Hopi. *Nebula 22 and Nebula 23* (from "Nebula" series), 2009 (plate 12, detail). Pages 74–75: Chaticks-si-Chaticks (Pawnee) artist. Double-sided drum, ca. 1890 (plate 25, detail). Pages 114–15: Michael Belmore (born 1971), Ojibway. *Placid*, 2011 (plate 40, detail). Pages 162–63: Rebecca Belmore (born 1960), Anishinaabe. *Fringe*, 2008 (plate 74, detail). Pages 245–47: Brian Jungen (born 1970), Dunne-Za Nation. *Cetology*, 2002 (plate 2, details).

Printed in Canada

Table of Contents

Foreword

"To exist is to change, to change is to mature, to mature is to go on creating oneself endlessly."
– Henri Bergson (1859–1941)

The word "shapeshifting" encompasses many connotations from the physical to the magical, whether in Native American or popular culture. At its heart, however, are change and transformation, concepts that imply intent, movement, action, difference, and, inevitably, inquisitiveness. An outcome occurs, whatever the agent or reason for change. *Shapeshifting: Transformations in Native American Art* – in its totality as an exhibition, book, and public programming – has a clear and audacious goal: to invite and incite changes in the perception and appreciation of Native American art.

Historically, the Peabody Essex Museum has distinguished itself from most museums by taking an inclusive approach that addresses the art and cultures of indigenous people in North, Central, and South America and also embraces the dialogue between historic and contemporary expression. The museum continues to emphasize new perspectives on the diversity, particularity, and ongoing vitality of Native American art. We also seek to create interpretive bridges across multiple collecting arenas as well as across two disciplines – Native American and American art – that have traditionally and widely been considered separate.

Commencing with the museum's founding in 1799 and now numbering some fifteen thousand artworks and fifty thousand archaeological works, PEM's Native American collection is the oldest ongoing collection in the Western hemisphere. The museum has collected and exhibited Native American art throughout every phase of its history – a level of continuity that few other institutions in the world can claim. The collection encompasses an extraordinary range: some ten thousand years of indigenous visual expression in the Americas, up to and including the present day, and from northern Canada to the southernmost tip of South America. While many museums focus on their particular region or specific types of works, we have consistently collected nationally and internationally as well as across a wide spectrum of media and object types. Gathered initially by explorers, missionaries, and the military, many of our historic examples enjoy unprecedented documentation and provenance. In sum, this superlative collection offers vital testament to hundreds of Native cultures, and powerfully demonstrates the dynamic, adaptive, and evolving creativity inherent in Native American artistic expression.

Efforts to enhance the visibility, interpretation, and installation of Native American objects as art rather than anthropology in museums began in earnest at the Brooklyn Museum in the twentieth century's first quarter. A period in which this country first successfully asserted itself as a force in the international art world, the 1920s and 1930s saw a host of wealthy patrons interested in collecting, promoting, and exhibiting modern Native painting, particularly watercolors by Southwestern Pueblo painters. The 1931 Exposition of Indian Tribal Arts at the Grand Central Galleries in New York received popular and critical acclaim as it toured America and Europe, including the Venice Biennale, in its infancy as a forum for key developments in modern art. This period of aestheticizing and discovering Native American art and artists coincided with a post-World War I nation hungry for the quintessential "Americanness" this material offered. The most widely cited landmark exhibition from this period is undoubtedly *Indian Art of the United States*, organized by New York's Museum of Modern Art in 1941. Seen by thousands including avant-garde artists such as Jackson Pollock and Adolph Gottlieb, the exhibition was wholly successful in demonstrating Native artistic mastery over thousands of

years to the present and asserted Native art's place in American art.

The last quarter of the twentieth century saw many exhibitions of Native American art and culture, usually focusing on a region, tribe, or collection, and within that framework, grouping works chronologically, geographically, or by medium. The most ambitious was *Sacred Circles: 2000 Years of North American Indian Art*, organized in 1976 by the Nelson-Atkins Museum of Art, Kansas City, Missouri, with the Hayward Gallery, London. This extravaganza of 850 works framed Native objects as art, vital and continuing. Few of these exhibitions, however, mingled historical and contemporary expression to any appreciable degree, instead perpetuating a dichotomy and disconnect between then and now rather than exploring cross-cultural connections and continuities.

Since 1976, Native scholars, artists, and community representatives have assumed a much larger role in advancing the field of Native American art. Emerging from the civil rights activism of the 1960s, Native people are no longer satisfied with being represented in museums from primarily anthropological perspectives or a focus on the past. Moreover, the 1990 federal Native American Graves Protection and Repatriation Act (NAGPRA) – a human rights statute at its heart – has fostered dialogue and cultural exchange between Native people and museums housing their objects. The 1990s also ushered in several changes in Native art exhibitions, including more collaborative work with Native communities, reflecting the acceptance of ethics surrounding heritage and a commitment to working with Native Americans in equitable, meaningful ways. More exhibitions incorporate Native voice and perspective, encouraging visitors to see Native art and culture as multivalent. Native museums and cultural centers, which have tripled in number over the past three decades, have raised cultural awareness and celebrate artistic expression through self-representation. And, growing numbers of non-Native art historians and anthropologists have contributed to the expanding scholarship in Native art history and criticism.

Yet, for all of these advances, the general public too often remains comfortable with predictable approaches to Native American art and culture in a museum setting, and frequently perceives Native art and culture as lodged in the past and in the realms of craft, function, and souvenir, or as a distinct and separate category: "contemporary Native American art." And, until very recently, thematic approaches and the integration of historic and contemporary works in Native American exhibitions and public and private collections have remained rare. Building on its longstanding leadership in these avenues of inquiry, the Peabody Essex Museum is pleased to present *Shapeshifting*. Like artist Kent Monkman's alter ego, "Miss Chief," our intent is to engender thoughtful and constructive "mischief" through the selection and interpretation offered by this exhibition. The idea of a "noble savage" living in a "vast wilderness" runs counter to the historical reality of many Native communities that largely controlled and shaped the natural landscape, built major cities, and sustained complex trade networks in Mesoamerica, the Andes, and throughout North America, east to west, north to south. In this context, the power and significance of their art reflect how integral the connection between cultural values and art was and remains to everyday life and religion in most Native American cultures. The concepts of "traditional" Native American art and a Native American "style" are also, in many respects, fictions. While Native artists honor and respect "traditional" cultural values, they have routinely and proactively adopted new forms of expression and

materials in response to changing conditions, and uniformity of style is virtually impossible, given the existence of hundreds of Native American cultures and artists too numerous to count. In this sense, Native American art aligns with, expands upon, and even plays with the art world's definition of modern and contemporary art as new, of the moment, and – increasingly – global.

The intent of *Shapeshifting* is to provide a fresh way of seeing and understanding Native American artistic expression by eschewing many standard interpretive premises. In spite of overwhelming challenges to their artistic and cultural development and survival over the past five hundred years, Native American artists have created complex and beautiful objects that establish a continuum of extraordinary achievement.

This ambitious project is the brainchild of Karen Kramer Russell, PEM's Curator of Native American Art and Culture, and we applaud her rigor, originality, and passion that have informed its conceptualization and implementation. We add our deep appreciation to her acknowledgment of the talent and dedication underlying the contributions of the museum's staff and those of our esteemed advisors, authors, and publishing team. Similarly, we recognize the generosity of the many private and public lenders from the United States, Canada, and Europe, who have made available this extraordinary array of objects, some being shown in this country for the very first time or the first time in decades. To Yale University Press, we extend our warm thanks for partnering with us once again as co-publishers.

In this period of economic uncertainty, which has forced many museums to curtail their exhibition programs, we hasten to recognize the timely and enlightened support of the Terra Foundation for American Art, the Peck Stacpoole Foundation, the Bay and Paul Foundations,

Ellen and Steve Hoffman, the Consulate General of Canada, ECHO (Education through Cultural and Historical Organizations), and the East India Marine Associates (EIMA) of the Peabody Essex Museum.

Above all, we offer our admiration and gratitude to the artists featured in *Shapeshifting* – for their individual and collective power in calling out creativity as an agent and outcome of change and for calling us closer to that realization.

Dan L. Monroe, Executive Director and CEO
Lynda Roscoe Hartigan, The James B. and Mary Lou Hawkes Chief Curator

Acknowledgments

This project reflects many connections and exchanges I've been privileged to have with scholars, artists, consultants, mentors, and friends. My profound gratitude, first and foremost, goes to all the brilliant artists whose work inspired *Shapeshifting: Transformations in Native American Art*. I am deeply grateful to the ones who communicated with me about their work, and to the institutions, private collectors, art galleries, and artists who generously lent works to the exhibition.

Shapeshifting benefited tremendously from a distinguished group of advisors. The concepts presented here were strengthened by Janet Catherine Berlo, Bob Haozous, Joe D. Horse Capture, Brian Jungen, Gerald McMaster, Ryan Rice, W. Jackson Rushing III, and Ramona Sakiestewa. Nanibaa Beck, Martin Earring, Karah English, Taloa Gibson, Dylan Iron Shirt, Jennifer Himmelreich, Teresa Montoya, Elayne Silversmith, and Bridget Skenadore, Native American Fellows in 2010–11, also provided timely and insightful input and ideas.

Immense appreciation is due to a remarkable team that made this publication possible. Janet Catherine Berlo, Bruce Bernstein, Joe D. Horse Capture, Jessica L. Horton, and Paul Chaat Smith contributed their valuable expertise, fresh insights, and original essays. Object entries by Berlo, Bernstein, Horton, and Kathleen Ash-Milby, Karah English, Aldona Jonaitis, Madeleine M. Kropa, Kate Morris, and Ryan Rice have also enriched the publication. Terry Ann R. Neff, our expert editor and publication manager, spurred my intellectual growth and heroically engineered the complex realization of this book. The design and production team at Studio Blue, including Lauren Boegen and Claire Williams, led by Kathy Fredrickson, created this imaginative and graceful design. In addition, I am grateful to Patricia Fidler of Yale University Press, our co-publisher, for her belief in the book.

At the Peabody Essex Museum, Executive Director Dan L. Monroe and Deputy Director Josh Basseches provided critical guidance and leadership that made this project possible. I am indebted to Lynda Roscoe Hartigan, The James B. and Mary Lou Hawkes Chief Curator, who has been an extraordinary mentor to me and an unwavering champion of this enterprise. Jay Finney, Chief Marketing Officer, has been an additional wellspring of support. Exhibition assistant Madeleine M. Kropa took on numerous roles at critical junctures and held the center of this project together with remarkable grace and good humor. Thank you for being my sounding board and partner-in-crime. Paula Richter, Curator of Exhibitions and Research, offered significant insights and research assistance throughout. Priscilla Danforth, Director of Exhibition Planning, provided outstanding assistance and encouragement each step of the way. Head Registrar Claudine Scoville skillfully oversaw every aspect of the complex loans. Dave Seibert of Museum Design Associates crafted a fresh and inspiring installation.

Other PEM staff who contributed to the project include Mary Beth Bainbridge, Stephanie Baker, Chris Bertoni, Anne Butterfield, Karen Moreau Ceballos, Allison Crosscup, Rebecca Ehrhardt, Dan Finamore, Juliette Fritsch, Barbara Kampas, Steve Klomps, Susan Lawrence, Mimi Leveque, Toni Macdonald-Fein, Michelle Moon, Jim Olson, Will Phippen, Phillip Prodger, Anna Siedzik, Walter Silver, Gwendolyn Smith, Trevor Smith, April Swieconek, Chip Van Dyke, and Eric Wolin. Thank you to PEM Trustees Susan Leavitt, Frank Sayre, and Rob Shapiro. I offer my appreciation to former PEM staff Martha Almy, Peggy Fogelman, and Merry Glosband.

The following colleagues and friends offered infinite wisdom and unconditional support: Gavin Andrews, Sarah Chasse, Karina Corrigan, Dan Elias, Trevor Fairbrother, Truman Lowe, Native American Art Studies Association

board members, Marli Porth, Laura Rosenberger, Dr. Robert Shuman, and Nancy Vickery. I am grateful to volunteers Lise Breen and Anna Frej who gave countless hours to this project. Heartfelt thanks to Judy, Andrew, and Tricia Kramer who offered continuous support. To many more not named here, I offer my sincere gratitude.

Staff at many of the lending institutions were helpful in gathering images for the publication, but several went to exceptional lengths on our behalf: Sam Chatterton Dickson at Haunch of Venison Gallery; David Rettig at Allan Houser Inc.; Heidi S. Raatz at the Minneapolis Institute of Arts; Cynthia Frankenburg, Jennifer O'Neal, and the late Lou Stancari at the National Museum of the American Indian; Megan Dubois at the San Diego Museum of Man; Jennifer Day at the School for Advanced Research; Darcy Marlow at the Philbrook Museum of Art; and Danielle Currie at the Vancouver Art Gallery. In addition, I greatly appreciate the professional and personal courtesies offered by the following individuals: Nancy Blomberg, Trish Capone, Christian Feest, Susan Haskell, White Wolf James, Darian LaTocha, Mary Jane Lenz, Travis Lutley, Ann McMullen, Pat Nietfeld, Janet Pasiuk, Felicia Pickering, Rajshree Solanki, Ian Taylor, Rebecca Trautmann, Gerard van Bussel, Walter Van Horn, Michael Volmar, and Monica Zavatarro.

Many thanks to the generous resources provided by this project's many funders, the Bay and Paul Foundations; Consulate General of Canada; Peck Stacpoole Foundation; Ellen and Steve Hoffman; ECHO (Education through Cultural and Historical Organizations); East India Marine Associates (EIMA) of the Peabody Essex Museum; and the Terra Foundation for American Art.

I dedicate this book to Pete and Mason, my heart and home – may you stay forever young.

Karen Kramer Russell

Note to the Reader

Naming

Throughout this publication, every effort has been made to indicate tribal affiliations according to current terms preferred by tribes, followed by former and common names in parenthesis, many of which are now known to be incorrect and/or sometimes offensive. There are, however, some inconsistencies with this approach, reflecting individual preference, the historical record, or subtle distinctions in language and orthography. For example, current and former tribal names are sometimes used interchangeably. The Unangan culture (people commonly called Aleut) underscores the complexity and nuances of naming: "Unangan" is a plural noun or adjective describing the tribal community, while "Unangax^" refers to either one person or the language. Similarly, Algonquin and Algonkian are two different indigenous tribes, and Algonquian refers to the broad language group. Another example is the current orthography used by Odawa (Ottawa) and Mi'kmaq (Micmac). A slash is used to indicate if an individual has more than one tribal affiliation. Despite our attempts at consistency and clarity, we apologize for any confusion or inadvertent oversights or omissions.

Authors

Paul Chaat Smith (Comanche), Associate Curator, National Museum of the American Indian, Smithsonian Insitution, Washington, DC

Joe D. Horse Capture (A'aninin), Associate Curator, Arts of Africa and the Americas, Minneapolis Institute of Arts

KA-M Kathleen Ash-Milby (Diné [Navajo]), Associate Curator, National Museum of the American Indian, Smithsonian Institution, New York

JCB Janet Catherine Berlo, PhD, Professor of Art History/Visual and Cultural Studies, University of Rochester, New York

BB Bruce Bernstein, PhD, Executive Director, Southwestern Association for Indian Arts (SWAIA), Santa Fe

KE Karah English (Concow Maidu), independent scholar, Sacramento, California

JLH Jessica L. Horton, PhD candidate, University of Rochester, New York

AJ Aldona Jonaitis, PhD, Director Emerita, University of Alaska Museum of the North, Fairbanks

MMK Madeleine M. Kropa, Exhibition Assistant, Exhibitions and Research, Peabody Essex Museum, Salem, Massachusetts

KM Kate Morris, PhD, Assistant Professor of Non-Western and Contemporary Art, Santa Clara University, Santa Clara, California

RR Ryan Rice (Kahnawake Mohawk), Chief Curator, Museum of Contemporary Native Arts, Santa Fe

KKR Karen Kramer Russell, Curator, Native American Art and Culture, Peabody Essex Museum, Salem, Massachusetts

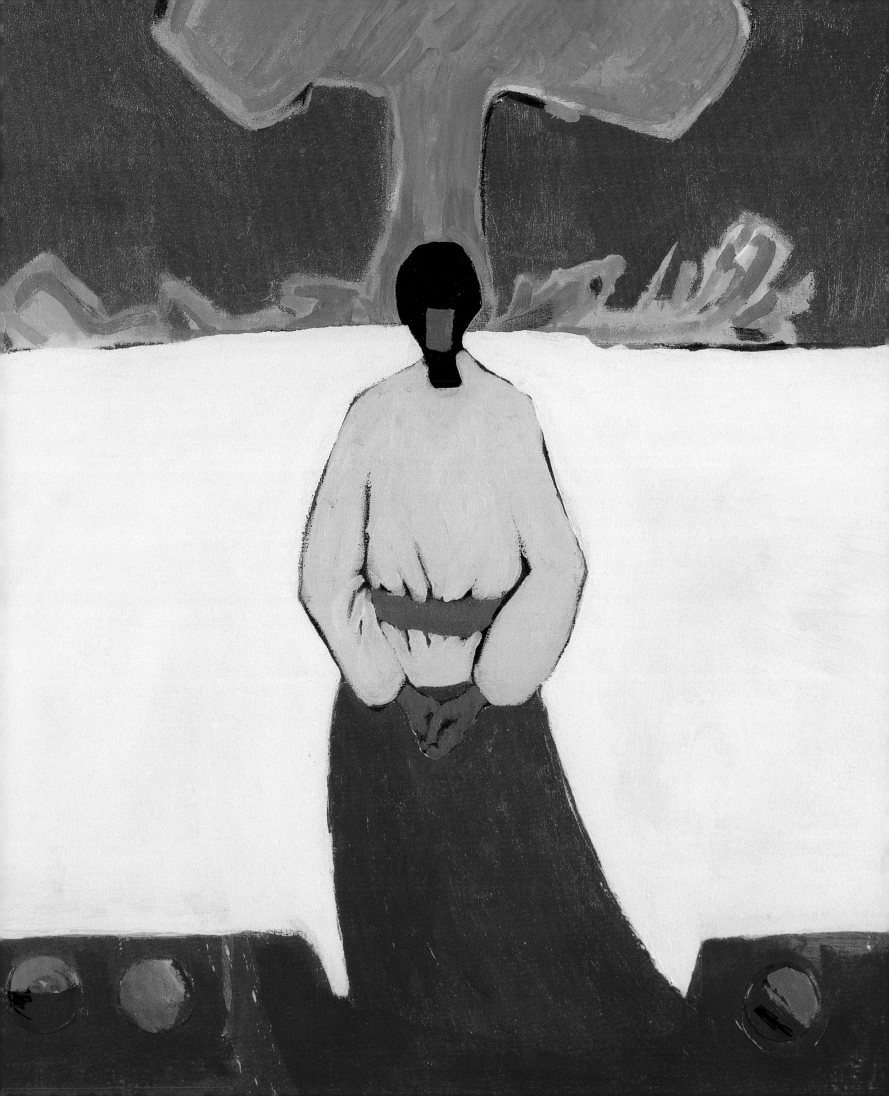

Raising the Bar

Karen Kramer Russell

Native American art is art of its time. Whether made today or five hundred years ago, it expresses the personal and cultural life experiences of the individual maker. As a contemporary expression rooted within a particular place and time, Native American art has always taken cultural knowledge and metaphors and refreshed them with new ideas and forms. Many museums and their audiences, however, have not approached Native American art in this way, particularly Native art of the historical era.

Typically arranged chronologically, geographically, or by medium, museum exhibitions have focused largely on either historical or contemporary Native American art, with very little mixing of the two. This approach perpetuates a disconnect between then and now, rather than exploring links and continuities. Further contributing to a sense of homogeneity in the public mindset rather than the art's extraordinary diversity is the flattening and conflation of the Native world by the media and in popular culture (figure 1). Persistent misperceptions view Native

Detail of plate 49

art as ethnographic specimens of the past or as curios and crafts made predominantly for the tourist market.

The United States and Canada are home to more than one thousand indigenous Native communities, each with its own history, language, and artistic expression. Grounded in ancient and varied traditions, as in any culture, their evolutions are ongoing. European colonization of the Americas and the associated displacement and marginalization of Native people have undervalued and oversimplified the significance, range, and meaning of much of Native culture, including the dynamic nature of their arts.

Shapeshifting: Transformations in Native American Art offers an exciting new orientation for understanding Native creativity and art-making as an all-encompassing product of its time, grounded in an artist's community, philosophy, language, and environment. Presenting nearly eighty objects spanning vast cultural, historical, intellectual, and aesthetic terrain, *Shapeshifting* celebrates ideas that cross time and space and thus integrate historical and contemporary artworks.

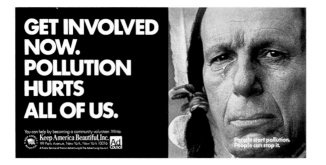

Figure 1. Keep America Beautiful's Ad Campaign, "People Start Pollution, People Can Stop It," featuring non-Native actor Iron Eyes Cody, the "Crying Indian," 1971. Courtesy of Keep America Beautiful.

The concept of transformation, sometimes referred to as "shapeshifting," is pervasive in Native cultures. Humans have the ability to change into animals and supernatural beings, and vice-versa (plates 21 and 38). While for some Native cultures shapeshifters are evil characters involved in the dark arts, other concepts of transformation have positive connotations harkening back to a time when shapeshifting occurred at will. The title itself underscores Native art's dynamism: it is always actively developing, always becoming. In recognition of that sweeping vitality, the project's title embodies its goal: to reveal the complicated, nuanced character of Native art and shift public perceptions beyond the view of anthropological specimens frozen in time. Thus, the title embraces change as a concept in Native art, and signals that the exhibition intends to transform audience perception as well.

The field of Native American art and culture is complex and fraught with political minefields. Emerging from the civil rights activism of the 1960s and in response to the dominant ethnographic approaches in museums, Native people have become more deeply involved with exhibitions and scholarship. The 1980s and 1990s ushered in focused collaborative exhibitions between Native people and museums housing their objects, in part due to the 1990 federal Native American Graves Protection and Repatriation Act (NAGPRA). Indeed, the representation of Native people and their art in non-Native museums by non-Native curators is a very careful dance. The success of museum projects such as this one relies on the insights of Native and non-Native artists, scholars, and curators alike; fruitful approaches include formal analysis, cultural specificity, artist biography, and use of Native voice.

Shapeshifting acknowledges that even the term "Native American art" can be construed as essentializing, given the geographical, linguistic, cultural, historical, and aesthetic differences that separate hundreds of individual tribes. Furthermore, using a Western museological framework for interpreting Native art is sometimes perceived as colonial by Native people, because the production of and motivation for art-making from a Native viewpoint is often very different from that in the dominant culture. Some Native artists and curators argue that placing contemporary Native American artists together in an exclusive group exhibition solely on the basis of tribal affiliation "perpetuates an otherness that is ultimately counterproductive to our careers,"[1] while others caution that ending the segregation of Native art by enfolding it seamlessly into the mainstream world will provide equity but will not create a history based on Native perspectives.[2]

In order to maintain specificity while speaking collectively, tribal designations are included throughout this publication. "Native American" and "Native" are used broadly to refer to any person of indigenous descent from the United States and/or Canada; the terms encompass the following designations: Native American, Indian, American Indian, First People(s), Alaska Native, First Nations, the People, North American indigenous, Native, aboriginal, and/or indigenous.

Shapeshifting harnesses cultural meaning and aesthetic virtues from seemingly disparate artworks. Patterns of ideas, visual imagery, and form emerge as useful frameworks for thinking about and looking at Native art in new ways. Organized according to four thematic touchstones that have consistently operated within Native art, the works demonstrate the many ways in which art-making has been and remains integral to the lives of Native people. *Changing* explores how Native artists continuously seize artistic innovations in terms of subject, materials, and process. *Knowing* celebrates diverse ideologies among tribal communities, as expressed through art. *Locating* examines how artists visually orient themselves according to family, community, land, and place, revealing some of the complex layers that comprise Native identity. *Voicing* recognizes the artist and explores individuality and expressions of self in relationship to the surrounding world. By focusing on themes as wide as they are deep, *Shapeshifting* reveals the multivalent aesthetic and cultural impetus of Native creative expression.

Two monumental installations, *Théâtre de Cristal* (2007) by Kent Monkman (Cree), and *Cetology* (2002) by Brian Jungen (Dunne-Za Nation), encompass all four themes and offer unexpected explorations in familiar icons and materials respectively (plates 1 and 2). *Théâtre de Cristal*, a fourteen-foot-tall, crystal-beaded tipi, challenges common stereotypes about Native culture. *Cetology*, a fifty-foot-long whale skeleton made from everyday, everywhere, plastic chairs, investigates universal concepts of commodification. Monkman and Jungen, through deconstructive strategies using physicality and humor, have each produced a flexible, open-ended dialogue on Native art and culture.

Opening the Dialogue

Théâtre de Cristal (plate 1), in one aspect of its title, refers to the mirrored palace in which a Native Iowa dance troupe performed in 1845 for King Louis Philippe of France. The troupe was brought there by George Catlin, the American painter and promoter of All Things Indian (figure 2). Catlin was foremost among many nineteenth-century artists who tirelessly recorded and romanticized the "noble savages," helping to establish a long legacy of distorted representations.[3] Monkman's work evokes the full-size tipi that toured with Catlin's traveling *Indian Gallery* exhibition.[4] *Théâtre de Cristal* is as much Monkman's response to Catlin's prolific comments in his journals about the Iowa dancers' myriad reflections in the hall's mirrors as it is a scrutiny of Catlin's lifework.[5]

Monkman's tipi sets the stage as the Old West for his silent black-and-white film *Group of Seven Inches* (2005), which is projected from the opulent chandelier suspended from the tipi's apex onto the simulated buffalo-hide rug below. The film recalls early twentieth-century Hollywood Westerns that embedded Native stereotypes deeper into popular imagination. Monkman's protagonist and alter ego is Miss Chief Eagle Testickle (a pun on the words mischief, egotistical, and testicle), whose "two-spirit" persona appears in his paintings, films, photographs, and performance pieces.

Physically one sex (Miss Chief is male), two-spirits dress and take on the cultural gender role of the opposite sex.[6] The term "two-spirit" goes beyond the binary of male/female to encompass a third gender long revered in Native cultures and understood to possess sacred powers. Catlin, however, thought two-spirits were a "disgraceful degradation."[7] By imbuing Miss Chief's character with a trickster sensibility, Monkman examined sexuality and power dynamics between the colonized and colonizers through an alternative, Native, lens. Scantily clad and sporting seven-inch platform shoes, Miss Chief lures two European males in loincloths back to her cabin. In this deft role-reversal, she gets them

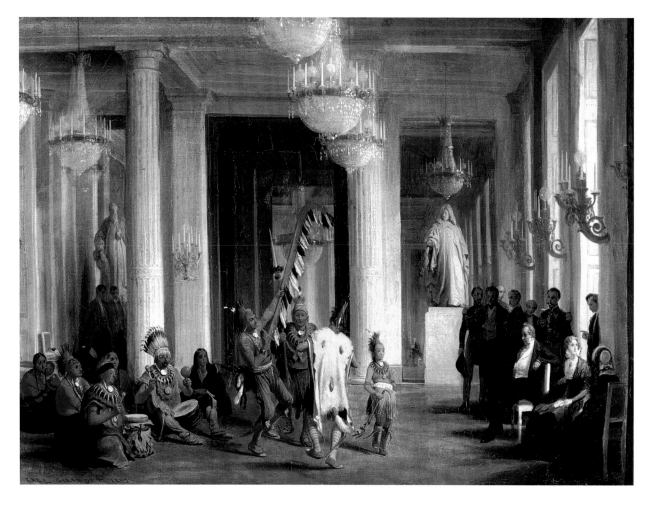

Figure 2. Karl Girardet (1813–1871). *King Louis Philippe, Queen Marie-Amélie and the duchess of Orleans attending a dance by Iowa natives in the Salon de la Paix at the Tuileries, presented by the painter George Catlin on 21 April, 1845....,* 1845. Oil on canvas. Châteaux de Versailles et de Trianon, Versailles, France, MV6138. Image © Réunion des Musées Nationaux/Art Resource, New York.

drunk and employs them as figure models (figure 3). Then, inspired by Catlin's journals, she dresses them up as more "authentic" versions of the European male.[8]

Monkman's use of new materials and a fresh approach to a traditional Native form and aesthetic calls out the theme of *Changing*. His articulation of the experience and perspective of a two-spirited person addresses *Knowing*. Monkman has challenged viewers to broaden

their understanding of the West and of Native sexual variance as a way of *Locating*, while his subversion of the colonial narrative invokes the theme of *Voicing*. Monkman's mirrors refract and reframe what we think we know about Native America; they challenge us to rethink what we think we see.

Changing – Expanding the Imagination

Native American tribal communities have faced profound and often devastating challenges over the last five centuries brought about by contact: epidemics, wars, eradication, oppression, assimilation, relocation, and marginalization. Many tribes were completely decimated, while hundreds of others survived and flourished. Paul Chaat Smith (Comanche) has written: "All Indians alive

today are here because our ancestors used intelligence, skill, planning, strategy and sacrifice. They didn't fear change; they embraced it. They survived because they fought for change on our terms."[9] In other words, change is not new to Native Americans.

The health and longevity of any culture, in fact, relies on change. Despite a longstanding presence on the continent and the myriad changes hundreds of generations have navigated, Native Americans and their art continue to be concealed within the past. Art-making and creative expression have been in part tools of survival, providing an avenue to make meaningful realities they face in the world around them, as well as connecting and upholding their own cultural heritage.[10] While changes in materials, techniques, and imagery are usually considered a break from tradition, Tuscarora educator Richard W. Hill Sr. suggested that "a tradition of … creativity has always allowed [Native] art to change, even before contact with other art traditions."[11]

Works selected to reflect the concept of *Changing* – expanding the imagination – demonstrate artists' responses and adaptations to social, personal, and cultural changes. A wide-ranging representation of historical and contemporary works celebrates how Native Americans have incorporated new ideas, materials, styles, and techniques into their life and art. *Changing* examines the impact of embracing innovation and imagination; several works signal a convergence of cultures, namely Native and non-Native, a demonstration of transculturation (figure 4).[12] While Native artists embrace new designs or materials and fold them into existing aesthetic vocabularies, the politics of an era can also heavily shape and influence visual expression (plate 3). Works in *Changing* illustrate the means by which artists and their communities have succeeded in enduring and transcending a changing world, countering the notion of a flattened, oversimplified, and static view of Native art and culture.

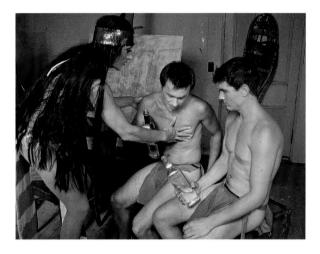

Figure 3. Kent Monkman (born 1965), Cree. Film still from *Group of Seven Inches*, 2005. Super-8 film (7:34 minutes). The Glenbow Museum, Alberta, Canada, purchased with funds from Historic Resource Fund, 2008, 2008.099.011. Courtesy of Kent Monkman and Bruce Bailey Art Projects.

Knowing – Expressing Worldview

Each tribal community has a distinct way of understanding the world: how people came to be, how to behave in the community, how to sustain ancestral connections. *Knowing* – expressing worldview – examines how Native artists as individuals and, concurrently, as members of larger communities, see and experience the world. The art in this section expresses diverse ideologies, contradicting the perception that all Native Americans have the same worldview. By including objects created for use in ceremony and storytelling, this theme explores how ways of knowing the world are shared yet distinct within separate communities.

Worldviews can be understood as mental lenses – holistic cognitive and emotional maps – used to make sense of social landscapes.[13] Artist and curator Truman Lowe (Ho-Chunk) has posited that ideology is a vital part of Native visual expression, shaped by the cultural memory of how tribes became who they are (through Creation and Origin stories), as well as how tribes understand and voice cultural knowledge.[14]

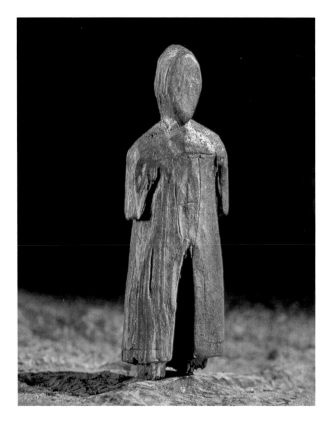

Figure 4. Inuit artist. Figure (Norse man, possibly a bishop), 1200s. Wood. Canadian Museum of Civilization, Ottawa, KeDq-7:325. Image © Canadian Museum of Civilization, KeDq-7:325, S94-6299.

Several objects in *Knowing* make visual a specific individual's internalized worldview. Whether they were created for personal or collective use, they are adorned with symbols that reflect a communal view as well as the artist's experience of being Native in the world, often conveyed through a narrative or metaphorical visual language. By illuminating different worldviews and the layers of meaning that surround and imbue art objects, we can make interconnections between art and culture, and better understand how Native art functions within its own systems of artistic and cultural values. Many Native artists express their understanding and experience through cultural stories and histories. They are visual storytellers, recalling tribal knowledge and conveying important events. More than just entertainment,

storytelling in Native culture is a means of educating and of upholding values.

Artworks in *Knowing* also embody concepts of honor, protection, and transformation. Some functional objects are created to honor a person or animal. Symbols perform as protective devices, for example, when used in ritual and prayer. Artists also make manifest longstanding ancestral connections among humans, animals, and supernatural beings, who share the ability to transform, or shapeshift (plates 36 and 38).

It is more productive to look closely at artworks that elucidate a specific artist's worldview than to talk about Native worldviews in general terms. The permutations of worldview and religion are legion, as a result of partial, selective, or complete conversion to Christianity, among many other formal religious institutions, including Native religions. As writer Sherman Alexie (Spokane/Coeur d'Alene) so aptly articulated: "There are 2.5 million Indians … that means there are 2.5 million ways of being Indian."[15]

Locating – Exploring Identity and Place

Often, Native American art is defined demographically by tribal or group affiliation, or geographically by region. This approach grew out of nineteenth-century anthropological concerns, as scholars sought to understand tribes, regions, and language groups. While these approaches help to classify diverse information, they limit our understanding of the many ways Native individuals position themselves with regard to community and/or place. *Locating* – exploring identity and place – moves beyond geography to examine how Native artists, whether living within tribal communities or in urban settings, orient themselves in relation to the lives of their ancestors. W. Richard West Jr. (Cheyenne), former director of the Smithsonian Institution's National Museum of the

American Indian, identified place as one of the most defining elements of Indian life. He posited that place "determines who we are in that it establishes our relationship to everything around us. Our cultures, including our aesthetic productions, grow out of that relationship to place."[16]

Locating underscores the cultural fluidity between identity and place. In 1983, George Longfish (Tuscarora/Seneca) and Joan Randall coined the term "landbase" in an attempt to express the interwoven dynamics of "place, history, culture, philosophy, a people and their sense of themselves and their spirituality, and how the characteristics of the place are all part of a fabric."[17] *Locating* looks at the ways in which Native people have used artistic expression to examine their identity and/or their place – within their communities, the broader world, or both. *Locating* explores questions: What is family? What is home? What does it mean to belong? Can "home" transcend borders and bloodlines? Cumulatively, this thematic section presents a range of specific, personal expressions of home, however defined, that reveal many of the multifaceted layers that comprise Native identity.

Several works represent an artist's response to family, whether in terms of significant persons or events in the artist's life or lineage (plate 44). The artists explore the many circumstances that bring families together, reflecting the personal and social dimensions of their lives. Native communities can have a profound impact on self-identity. Marianne Nicolson (Kwakwaka'wakw) is "defined by my family, by my standing, by my rank, and by my nation.… I know who my mother and my uncles are because they all define who I am. It is how I relate to other people and community members."[18]

Place likewise nurtures culture, but Native artists separated from their community relate to identity and place

through a very different lens. Kathleen Ash-Milby (Diné [Navajo]) has discussed how land has also been a "site and source" of conflict, given the ruptures, dislocations, and disempowerment many tribes have undergone for more than five hundred years. As such, land also represents disconnections, dispossession, violence, and loss that have shaped identity and place in Native visual expression (plates 49 and 50).[19] While Native Americans have traditionally and stereotypically been associated with "the land" in a general sense, Native artists have voiced their connections through abstract expressions rather than realistic ones (plates 40–43). Material and design can embody concepts of home – land, place, or family. The works demonstrate the individuality of the relationships and break down the notion that all Native people are inherently connected to identity and place in the same way.

Voicing – Engaging the Individual

This theme recognizes the artist and explores the idea of individuality and expressions of self in relation to the surrounding world. *Voicing* – engaging the individual – addresses again the misconception that Native Americans have a monolithic voice that is conveyed through functional and decorative objects. The objects in this section emphasize how Native artists assert themselves in reflecting on the world around them.

Very few named artists have been identified for Native American works made before 1900. From a tribal point of view, signatures were unnecessary for works created within communities, though certainly the finest artists were recognized for their talents (plates 19 and 58).[20] Initially, anthropologists, museum curators, and collectors considered this artwork to be ethnological specimens that helped document a way of life. No attention was paid to individual makers; linking the object to a general tribal origin was sufficient to place it within an explanatory and contextual framework.[21] Within this

paradigm, objects became detached from their personal histories and the maker's individuality was lost.

The works in *Voicing* celebrate the artist, named or not. Thought-provoking personal statements demonstrate how Native artists portray themselves and reflect their experiences and outlooks (plate 72). While every work of art is grounded, to some degree, in the values and views of an artist's community and culture, at its very core, each remains an individual expression. Many contemporary Native artists reinforce this by insisting that they speak as individuals and not as representatives of their tribal community. James Luna related: "I am responsible for my own ideas. Certainly people want me to speak for the community…. I do not speak for the community, I speak for myself, I speak for my vision and my interpretation of it."[22]

Like artists anywhere, Native artists voice personal histories and ideas, their joys and successes, in addition to their questions, struggles, and political agendas. Native art is bound, in part, by the history and politics of its time, and the artworks in *Voicing* underscore this point. Many works in this section are political, created in response to colonization, marginalization, and assimilation. The past few decades have seen increasing involvement by Native Americans in self-determination and sovereignty movements. Contemporary Native art is used as a direct means for asserting and exploring autonomy, resistance, and, ultimately, Native voice, confirming that, indeed, "Indian art is not neutral" (plate 74).[23]

Advancing the Dialogue

Similar to Monkman's *Théâtre de Cristal*, Brian Jungen's *Cetology* is a reimagining of the oddly familiar. Jungen deconstructed and then reconstructed mass-produced plastic patio chairs to create a stark evocation of a whale skeleton nearly fifty feet long. More than just visually

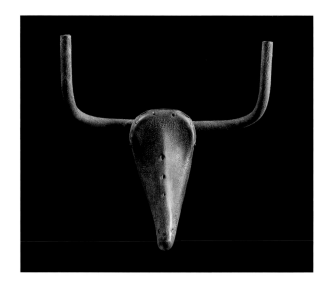

Figure 5. Pablo Picasso (1881–1973). *Bull's Head (Seat and handles of a bicycle)*, 1942. Leather and metal. Musée Picasso, Paris, MP330. Image © Réunion des Musées Nationaux/Art Resource, New York, photograph by Thierry Le Mage © 2012 Estate of Pablo Picasso/Artist Rights Society (ARS), New York.

appealing, the whole of *Cetology* is greater than the sum of its parts. This generic, reductive giant is neither scientifically exact nor based on an actual mythical creature, yet it evokes the fossils and skeletons hanging from the rafters in natural history museums. Twentieth-century modernist artists transformed found commodities into animal forms as early as 1942, for example, in Picasso's *Bull's Head (Seat and handles of a bicycle)* (figure 5). Jungen has continued this tradition by monumentalizing it with a nimble one-two punch.[24]

These "bones" can be considered on many levels. Through its materiality, *Cetology* explores how consumerism of oil and petroleum byproducts like plastic affects the planet. Jungen has said: "I attempt to transform these objects into a new hybrid object, which both affirms and negates its mass-produced origin, and charts an alternative destination to that of a land-fill."[25] The plastic is not biodegradable or disposable. Ironically, it comprises the skeleton of an endangered animal. Whales are often

threatened by natural resources mismanagement, which has rendered them seemingly disposable. Jungen also tackled the legacy of natural history museum display by unpacking the act of owning, making precious, and selling the natural world.

Cetology synthesizes all four exhibition themes: The artist's recontextualization and repurposing of consumer products points to the theme of *Changing*. The expression of his personal, environmental, and political viewpoints as a contemporary Native person demonstrates *Knowing*. By showing himself as an active participant in the contemporary world, Jungen has addressed *Locating*. And, finally, raising questions about museum presentation, mass production, and natural resources reflects the theme of *Voicing*.

Cetology levels the idea that art has to look the same and say the same things in order to be Native American art. *Cetology* does not obviously announce its ethnicity or geographical roots. While Jungen's art explores the experiences of being of Native ancestry in contemporary society, he rejects the label "artist," whether Native or not, preferring instead the simple assertion: "I make art."[26] By placing himself and his work within the global economy, he contradicts the public perception of an idealized, indistinct Native persona. *Cetology* orients the viewer to issues of cultural relevancy on a worldwide scale. By raising universal and timely human questions about consumerism, our place in the natural world, and relationships with nature, Jungen opens the conversation to everyone.

Objects exist in many realms – personal, cultural, ceremonial, commercial, academic, and more. Once they are freed from the constraints of specific regions, media, and even definitions of functional versus fine art, grouping Native art according to ideas encourages meaningful dialogue with artists' personal expressions and their world at large. Whether the objects are old or new, their interpretation and representation removed from their cultural context demands respectful engagement with cultural values and insights.

Native American art is neither stagnant nor immutable. Like all art, it evolves as culture evolves. New ways of knowing the world and articulating these experiences emerge every day.[27] All of the works in *Shapeshifting* demonstrate that Native American art is the culmination and crystallization of current trends of thought, rooted to the personal and cultural life experiences of the individual.

Notes
1. Fragnito 2002, p. 232.
2. Young Man 2006, pp. 79–82.
3. McIntosh 2007, p. 31.
4. Others include Paul Kane, Albert Bierstadt, and Eugène Delacroix.
5. Several hundred painted portraits and landscapes as well as thousands of North American indigenous objects went on tour with the troupe of Iowa Natives.
6. The term "two-spirit" goes beyond the binary of male/female to encompass a third gender widely accepted in Native cultures over time.
7. Catlin 1841, p. 215.
8. Madill 2007, p. 25.
9. Chaat Smith 2009A, p. 110.
10. Longfish 1995, p. 62; Touchette 2003, p. 11.
11. R. Hill 1994, p. 76.
12. Transculturation is a term coined by Fernando Ortiz in the 1940s that describes the merging and converging of cultures. Ortiz 1947, pp. 97–98.
13. Hart 2010, p. 2.
14. Lowe, in discussion with author, 2009; Bernstein and Lowe 2006, p. 22.
15. Alexie 2010. Thank you to Mr. Alexie for his permission to include this quotation in this publication.
16. West 1998, p. 11.
17. Lippard 1985, n.p.
18. Nicolson 1998, p. 100.
19. Ash-Milby 2007B, p.17.
20. Berlo 2010, p. 17.
21. See Karp and Levine 1991; Clifford 1988.
22. Luna, as cited in Sweet and Berry 2001, p. 75.
23. Chaat Smith 2009B.
24. B. Brown 2010, p. 197.
25. T. Smith 2005, p. 87.
26. Jungen, in conversation with the author, June 25, 2009.
27. The idea that people have always created new objects and ideas in conjunction with culture, and that these activities were "modern," was articulated in 1867 by cultural historian Jakob Burckhardt. See *DesignTAXI.com*.

1 **Kent Monkman (born 1965), Cree.** *Théâtre de Cristal*, **2007.** Chandelier, plastic beads, acrylic string, cabouchons, simulated buffalo hide, and Super-8 films: *Group of Seven Inches*, 2005 (7:34 minutes), and *Robin's Hood*, 2007 (6:00 minutes), edition 1/3. 168 × 240 inches (diam. approx.) (426.7 × 609.6 cm). The Glenbow Museum, Alberta, Canada, purchased with funds from Historic Resource Fund, 2008, 2008.099.001. Courtesy of Kent Monkman and Bruce Bailey Art Projects.

In the video installation *Théâtre de Cristal*, Kent Monkman built an elaborate structure out of crystal beads strung in the shape of a tipi for his drag queen alter ego persona Miss Chief Eagle Testickle to project her/his films. The glitzy structure is a simple yet elaborate mash-up of modern theatricality, contemporary architecture, and Great Plains innovation. Inside Monkman's alluring venue, a crystal chandelier projects the films *Group of Seven Inches* (2005) and *Robin's Hood* (2007) onto a stretched simulated buffalo hide lying in the center of the floor. The hide acts as a screen, reflecting and emulating the visual experiences of testimony and history conveyed through traditional Plains buffalo robes for all to behold.

The histories Kent Monkman articulated critique and challenge the dominant Euro-American ethnocentric construction of Native North America embedded in a global consciousness. The silent film *Group of Seven Inches* and the Super-8 movie *Robin's Hood* subvert codifying narratives frozen in time by passing them through a satirical lens. They appropriate and reverse one-dimensional histories to present a "what if?" scenario to deliberate in the twenty-first century. By restaging the invented and imagined Indian, Monkman inserts his flamboyant and sexually charged guise Miss Chief into encounters with influential and colonial representations of grandeur documented and depicted in the nineteenth century by artists such as George Catlin and Paul Kane, photographers such as Edward S. Curtis, novelists such as Henry Wadsworth Longfellow, and ethnographers/anthropologists like Franz Boas, who were determined to tame the North American wilderness and capture the "vanishing race." – RR

References
UrbanNation.com.

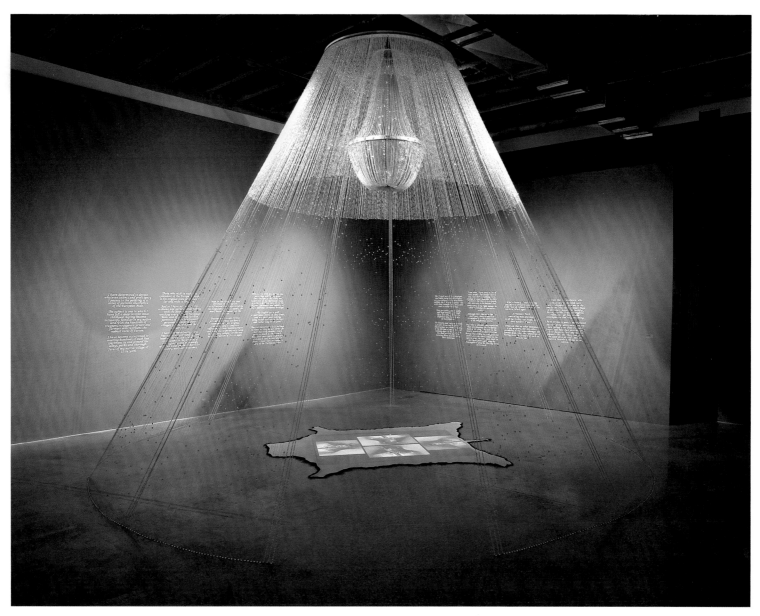

Plate 1

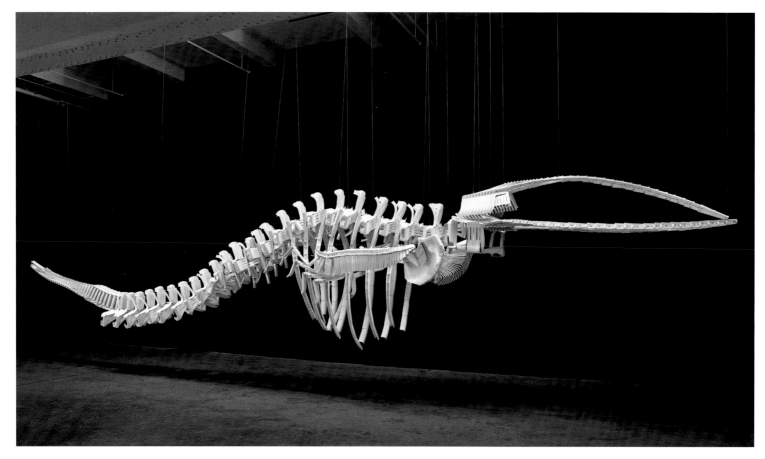

Plate 2

2 **Brian Jungen (born 1970), Dunne-Za Nation.** *Cetology*, **2002.** Plastic chairs. 63 × 496 × 66 inches (160 × 1260 × 168 cm). Vancouver Art Gallery, British Columbia, Vancouver Art Gallery Acquisition Fund, purchased with the support of the Canada Council for the Arts Acquisition Assistance Program, VAG2003.8a-z.

Raised in the northeastern corner of British Columbia in Fort St. John, the conceptual artist Brian Jungen frequently reassembles and recontextualizes familiar, mass-manufactured goods. In so doing, he transforms the use and meaning as well as the physicality of the original object into an unexpected, handcrafted, highly symbolic work of art. His installations provide a visually and intellectually immersive experience.

In *Cetology*, Jungen dismantled, strung together, and suspended hundreds of pieces of white plastic patio chairs to create a fifty-foot-long whale skeleton. Jungen was inspired, in part, to make *Cetology* (named for the science devoted to the study of whales) after spending considerable time visiting Bjossa, Vancouver Aquarium's captive orca whale, and thinking about the interaction of whales and humans, and the historically overzealous whaling industry in British Columbia.[1] He was also struck by the process in which natural history museums take

ownership of, make precious and scientific, and fundamentally "sell" nature.

At the same time, through the materiality of *Cetology*, Jungen addressed how the demand for oil and petroleum byproducts such as plastic impacts the planet. By enshrining cheap, disposable chairs that are, in fact, completely undisposable, and creating a colossal whale skeleton, Jungen played with tensions between real and fake, precious and mundane, old and new, natural and manufactured, and sacred and profane.[2] *Cetology* ultimately engenders a challenging examination of mass production, museum display, and the destruction of the environment. – KKR

Notes
1. Jungen's series of whale installations also includes *Shapeshifter*, 2000, and *Vienna*, 2003. Gopnik 2010; Jungen, conversation with the author, June 25, 2009.
2. AbsoluteArts.com 2009.

References
Jungen and Augaitis 2005; AbsoluteArts.com 2009, B. Brown 2010; Gopnik 2009.

Changing

Voicing

Knowing
Locating

Expected Evolution The Changing Continuum

Bruce Bernstein

For Native Americans, as for other peoples and groups, the visual arts are living documents of historical changes such as material innovation, new concepts, location and relocation, neighboring cultures – even barter in a trade/ gift economy. For Native people, their objects are not simply artifacts, or pieces of abstraction, but the embodiment of ancestral origins and often theological markers of action, phenomenon, and explicit record. They can serve as catalysts for reconnection with the ancient and with a specific community as much as they serve as identity and narrative of the mundane and extraordinary. In their work, Native artists use humor, irony, autobiography, and nuance to voice their thoughts about history, politics, and art. Native art is a form of communication, functioning within and between societies, both Native and non-Native.

Native art plays a central role in health and endurance. The fact that Native people have survived to this day and continue to produce their art is itself phenomenal and a tribute to the power of creative human will and internal strength. Native art is not limited to a focus on the past occupation of lands, social upheaval, and loss, but it serves as a catalyst for human activity and cultural continuity. The arts are an intellectual synthesis of contemporary and immediate experience. Art is why tribes persist, as it strengthens Native American aspects of life, from performance, word, prayer, and material construction or deconstruction. It holds the message of the past, and proposes and situates the continuity of the individual and Native communities for the future.

As a form of communication, art must and does change. This is as true for Native art as for other arts, despite the fact that an overemphasis on ethnographic purity with its corollary that therefore the art itself is immutable has generated restrictions both internally and externally. Tradition and traditional art can be seen as restrictive and stultifying concepts, but this is to misunderstand the service they can render to creativity. For Native people and their art, tradition is not a stagnant set of rules and practices but rather a set of principles and values that provide a foundation for change – a wonderful and vital part of art-making, a strength of Native communities.

Change is synonymous with art; it engenders creativity that crosses generations and movements. But, Native

people are not always afforded this vibrancy in their arts and cultures. The past is revered and sentimentalized to the detriment of the present. Evolution, however, exists in Native art; history passes through a family every day as it is lived. Native artists do not bother with distinctions between contemporary and traditional because they are unnecessary. Such distinctions represent an imposed notion of time more reliant on a non-Indian sense of longing and sentimentality than an accurate way to describe Native art. Grace Medicine Flower (Santa Clara Pueblo) expressed it succinctly: "What we call contemporary today will be considered traditional tomorrow. I think our ancestors did the same things years ago, and now we are rediscovering them."[1]

Native art is nothing less than life itself; and Native life is everything and anything that people want and desire to experience – in whatever century lived. New materials and new technologies have impacted and continue to affect art in critical ways. Many artists who insist on the word "evolution" rather than "change" also believe that non-Indians continue to view and ask the wrong type of questions: "Is that a raincloud?" rather than the essential question: "What makes a raincloud?" This is not an existential exercise but rather one of understanding motivation and the artistic process on the artists' own terms.

Tradition and Changing

Artistic evolution is an organic, unending process that involves creating art that adds meaning, relevancy, and vibrancy to a culture's values and principles. Objects become charged with significance without losing their gritty materiality. True to the particularity of things, each piece, each style, is a node around which meanings accrete thickly. But not just any meanings: what these things are made of and how they are made shape what they can mean. Neither the pure texts of semiotics nor the brute objects of positivism, these things are saturated with cultural significance. The objects become talkative when they fuse matter and meaning; they lapse into speechlessness when their matter and meanings no longer mesh. Pueblo people tell us that while language is prayer, art is lifeline.

It falls upon scholars and viewers alike to locate these meanings within whose very substance social order

and explication are made and maintained. It is clear that the non-Indian world and the academic disciplines continue to transpose the meanings and values of Native art. Nicholas Galanin (Tlingit/Aleut) observed: "I now embrace my position as a contemporary indigenous artist with belief that some forms of resistance often carry equal amounts of persistence."[2] He elaborated further: "I often like to irritate the Indian in me, putting them [sic] back on the shelf with new meaning, clarity or focus. As an artist that contributes to my culture, I feel immense gratitude knowing that I am able to give to something greater, this feeling of belonging is the Indian art world."[3]

Some within his community have disparaged Galanin's work, suggesting it is wrong or disrespectful. He has replied that his work is a natural and logical continuation and that it has the freedom to be something that it was not a generation ago (plate 5). Like many others, this artist bridles at a conservative view of tradition that ignores its necessary functionality and is instead used solely as a descriptive terminology. The sentimentality and visions of ethnographic purity imposed from the outside and from within are the principal mis-users or abusers of the word "tradition" and have created the distorted lens through which many people, unfortunately, view Native art.

Tradition does hold an important and distinguishing place in Native art. It represents community and common history as well as an ethical set of circumstances that must be followed. Consider that Charles Loloma (Hopi), after twenty years of living and working away from the Hopi mesas, achieved his greatest creative period after he returned to the nurturing world of traditional Hopi life (plate 16). Similarly, Allan Houser (Chiricahua Apache) and Fritz Scholder (Luiseño) worked in relative obscurity until they came to Santa Fe and nestled within Native communities and among students where they honed their vision (plate 52 and figure 1).

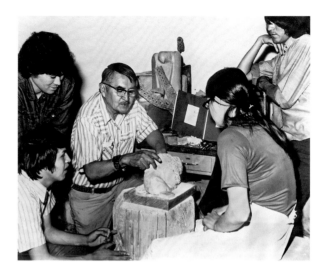

Figure 1. Allan Houser teaching sculpture to Institute of American Indian Arts students, Santa Fe, ca. 1969. Allan Houser Foundation Archives, Santa Fe. Image courtesy of IAIA photo archives.

The misunderstood role of tradition and the notion that change is bad for Native art have also resulted from issues of blood quantum and the complex concerns regarding purity and authenticity. Hybridity, in this context, denotes change and artificiality. Both of these concepts were imposed but they have gained a great deal of currency within the Native community as well. Neither is a particularly fruitful avenue to understanding Native art-making. The idea of blood comes from the movies – the scout is always the half-breed who crosses cultural boundaries to help the cavalry. However, the ability to cross boundaries is not genetic or hereditary but rather a result of observation and perception. Although many may lament changes in designs, tools, materials, and forms brought from the non-Indian world, the infusion of new ideas has always kept Native people and their traditions vital. Native artists situate their work made for home use or for sale, or with indigenous or introduced materials, with the vast reservoirs of Native stories, knowledge and circumstances. Their arts encompass a range of indigenous motivations: to be, to survive, to endure, to thrive, and to create (figures 2–4).

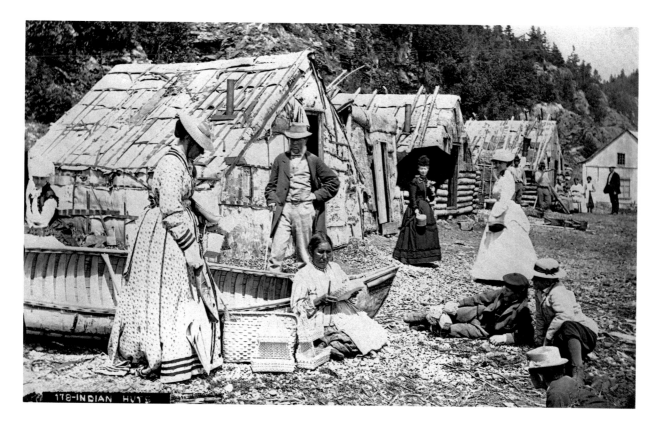

Figure 2. Tourists visiting a Wolastoqiyik (Maliseet) village, New Brunswick, Canada, ca. 1880. University of Pennsylvania Museum of Archaeology and Anthropology, Philadelphia, image 139042.

Even works linked to a specific sense of place have successfully embraced change. An extraordinary Unangan cape made of seal intestines takes an entirely new and "foreign" form, yet it is still undeniably Unangan (plate 20). Truman Lowe (Ho-Chunk) makes work that is not historic yet evokes what he calls "hereditary memory" (plate 8).[4] His pieces emphasize the water and wood so pervasive in the Great Lakes area he comes from. By focusing on elements indigenous to the landscape, Lowe emulates his heritage and ancestors and their ability to survive and prosper within their natural environment.

If Lowe's work is made of the materials of his tribe's First World, Fritz Scholder, by contrast, used new materials but chose First World subject matter (figure 5). Scholder painted Indians doing things that Indians do today (plate 3). In so doing, he disturbed those who thought they knew the Indian world. He infuriated, intrigued, and even amused people because his Indians were not romantic. Scholder wanted change and struggled against being pigeonholed within an ethnic trap. "He was not so much interested in rendering the beautiful as he was in expressing powerfully the powerful, the ambivalent and disturbing. He did not lift the spirits, he awoke them, sometimes he assaulted them."[5] Scholder said of himself:

I am a paradox in that I influenced a great many young Indian painters because for five years I taught at the Institute of American Indian Arts in Santa Fe. I am part Native American – I'm one quarter Luiseño.... I'm very proud of it, but you can't really be anything for your quarter. According to the government, that's what one needs to be on the rolls, and I'm on the rolls of my tribe. But I grew up a non-Indian. I never thought about it, and I really

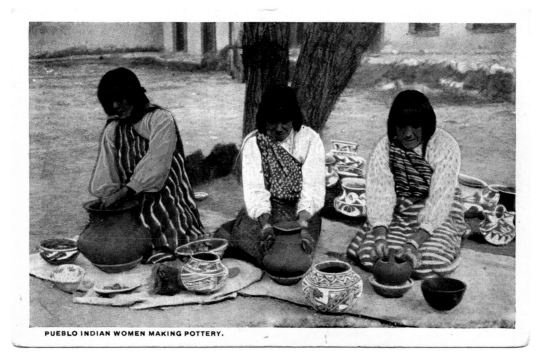

Figures 3 and 4. "Pueblo Indian Women Making Pottery" (Maria Martinez [left]
next to her sister-in-law and sister Maximiliana working at the Palace of Governors,
Santa Fe), 1910–15. Postcard. Courtesy of Bruce Bernstein.

Figure 5. Fritz Scholder in Taos, New Mexico, 1977. Photograph by Meridel Rubenstein.

don't think the way most Indian people think, which in a way puts me in a very unique position because I can understand what they're going through, and yet I'm in very much the dominant society. I was mislabeled an Indian artist early on, because Santa Fe is probably hypersensitive to whether one is an Indian or not. I have a very German name and I'm also English and French. It's always interesting because in this country … people love to label someone. If I'm to be labeled, I'm simply an American expressionist. An expressionist means I celebrate paint. Paint drips. It smears. It does all kinds of things."[6]

Changing means evolution in the larger art world as well. There is an assumption that a Euro-American form or material in a Native-made piece represents change. While on some level this is true, it does not necessarily indicate any change of rules or principles. Rather, new ideas, forms, and materials can serve as innovative tools that may help artists expand a repertoire with which to tell their stories and produce their narrative. New tools and materials are also necessary for Native artists to tell modern, contemporaneous, and ongoing stories rather than rigid representations of an idealized past. No matter when it was made, every piece once was new: a pair of women's embroidered hide moccasins (Locating, figure 6), a painting, or clay figures that still clearly state the artist's world of origin (plate 11). Virgil Ortiz (Cochiti Pueblo) is a fashion designer as well as a potter. He uses clay to tell his own story as well as explore his own sexuality and the world that he lives in; recent new work is about the entwined lives of man and animal.

Nicholas Galanin considered traditional art and the culture and origins it brings to mind as appropriate: "It's a language, and it's a tool, and it's beautifully powerful." But, he added: "The line between traditional and contemporary is blurred. Any culture that is living or breathing is going to move forward, and change is undeniable. It's important to understand the history and to ground myself in that foundation before trying to expand too much. On the other hand, as an artist, I hope to offer something different and new. It's a fine line to walk. People have preconceptions about what traditional artwork is or what Tlingit art should look like" (plate 5 and figure 6).[7]

Galanin's work brings to the surface a debate about the meaning and value of change. The very pace of changing or evolution is also a consideration. In the face of mounting pressure from electronic media, language loss, and urban living, tradition in the Native world has become in some quarters increasingly conservative and narrow. Memory is complicated and elusive. It can be very difficult to distinguish the knowledge of an event from the memory of an event, especially if it is repeatedly

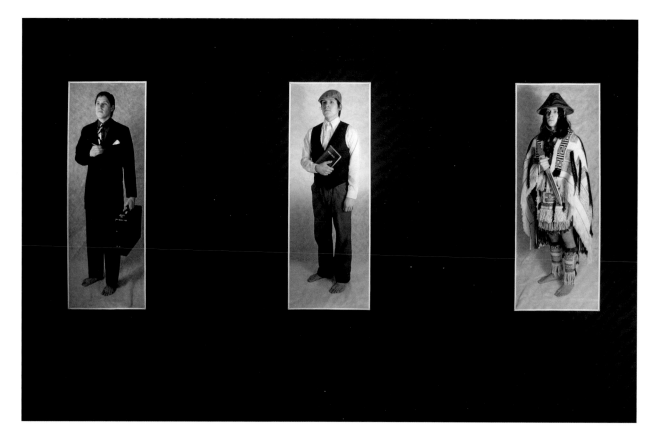

Figure 6. Nicholas Galanin (born 1979), Tlingit/Aleut. *Progression*, 2006. Photographs on canvas. Courtesy of the artist.

retold. The truth is that Natives and non-Natives alike oversimplify the true nature of art and Indian-ness. Too often today, tradition is used as a preservation device, an adherence to a literal recording of Native ideas and values. In art-making, that attitude may give birth to sentimental and replica-based work, whether in whole form or through the copying of symbols and patterns.

In the same breath, one cannot view Native art and ignore Native history. The art is a record of survival and celebration as much as a record of subjugation and oppression. As it continues to evolve, historic moorings will continue to loosen, helping to broaden the references used by artists such as Jeffrey Gibson (Choctaw), Charlie Willeto (Diné [Navajo]), Ramona Sakiestewa (Hopi), and Virgil

Ortiz (plates 43, 9, 12, and 11, respectively). At a recent ceremonial day at a Native village near Santa Fe, a friend participating in the men's song chorus wore a Hawaiian shirt instead of the traditional ribbon shirt. He seemed assured that others would join him in this updated fashion statement. The songs continue, the deportment and position of the men's chorus continue – they are the immutability of culture. A half-dozen or so men now wear Hawaiian shirts – and they are seen in the other villages as well. Clearly, a shirt does not stop or even filter the songs and prayers for fertility and rain.

Thus, it follows that an homage to Native women and mothers by Allan Houser is no less powerful – or Native – because he created it in bronze (plate 52). A Chumash weaver likewise created new context and form, but the power of the work and the affirmation of a cultural worldview is not diminished (plate 19). Indeed, the use

of others' forms, materials, and ideas is empowering: it amplifies the vitality of an artist's vision and society.

Consider that the messianic movement initiated by William Faw Faw (Oto) was intended to return the world to one devoid of non-Indians, yet a symbol of the movement relied on non-Native beads and wool in a coat cut in a fashionable Euro-American style (plate 17 and figure 7). The coat's materials were all manufactured in factories by white industrialists – the very progress that helped to destroy Native cultures and which Faw Faw prophesized against. The power of the coat with its rendering of potent Native symbols like the uprooting and replanting of the cedar tree was perhaps heightened by the use of these materials. Perhaps as appropriated, but perhaps more as incorporated, the use of wool and beads demonstrates the authority of a culture to integrate new ideas and influences. If there is affirmative power in appropriating materials and ideas and making them one's own, perhaps it increases exponentially when all the materials used are non-Indian.

Charlie Willeto's wooden figures function in a similar way. Made of commercial paint and milled lumber, there is little Navajo about them, although they are loosely based on representations of Navajo deities (plate 9). But, Willeto was a deeply traditional Navajo man[8] and the figures are a byproduct of his creative process. For him, it was the act of making that was important: beauty reposed not in things but in the relationships among things – between the maker and his creativity and the act of creating. Beyond appreciating the figures, one must understand them as the transformation of experience.

Traditional arts are the basics, like a grammar and syntax. Native artists might innovate and evolve these forms or use the narrative ideas in their work. Native artists work within a universe that necessitates an ethical position

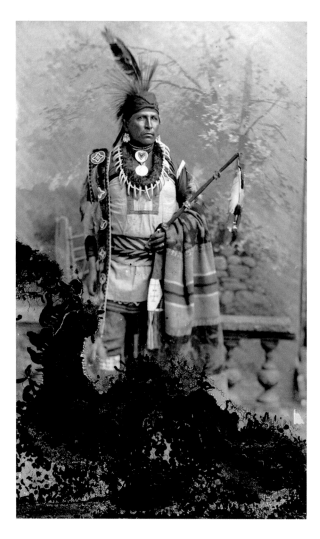

Figure 7. Charles Milton Bell (1848–1893). William Faw Faw or Wawasi in Native dress with peace medal, headdress, bear claw necklace and ornaments and holding pipe and bag, n.d. Black and white gelatin glass negative. National Anthropological Archives, Smithsonian Institution, Washington, DC, BAE GN 0053/Bell Collection 06636300.

with respect to their families and communities. Today's artists may be different because of their focus on storytelling and resolving centuries of forced change and assimilation, or, inversely, celebrating and affirming their survival and continuance. Artists are true to their own vision and serve as visual documentarians. Traditions by their very definition are malleable, bending and conforming to the ever-changing needs of people. Traditions continue but they are not the same as in 1700, 1850, or even

2000. Each of these periods was distinct and a reflection of particular events and sequences of history.

While tradition may appear unchanged, it is not. Rather, tradition is the embodiment of changing because it works and is necessary for cultural maintenance; tradition is connective tissue as well and replete with meanings and connotations. It constantly re-creates what is known through a continuous dialogue with contemporaneous experience. Tradition is changing because it contains the vitality of artistic impulse, the embodiment of the tension between persistence and evolution.

Changing and the Named Artist

Unfortunately, most often the notion of change in Native art is considered to be part of contact, conquest, and colonization with the European world. For example, when an artist's name is known, it suggests something different from pre-contact art or art made for Native people. This is a slippery issue. Artistic mastery was appreciated even when the name was not part of that appreciation. Nonetheless, relative to the longevity and size of the Native art world, few artists' names are known. Native artists have been thought to be interchangeable – mere craftspeople who blindly follow tradition. Viewed as craft, Native art has erroneously been relegated to being seen as replication of existing forms rather than as a celebration of creativity, change, and continuity.

Although scholarship is now beginning to identify artistic individuality (particularly on the Pacific North Coast), much remains to be done, particularly in understanding the temporal arch of artistic production. Consider an Algonkian/Mi'kmaq chair (plate 14) and the small number of chair makers that might have been present in the Canadian Maritime Provinces and Northeastern Maine in the middle to late nineteenth century. There were probably a select few quill artists who worked with the

non-Native furniture makers or sellers but their names are still unknown. The problem is often solved by calling the object simply Mi'kmaq, which recognizes tribal style but dissolves the role of the artist or maker.

However, being bundled under the inadequate label "Indian art" or even a tribal name is a mass ethnic label that ignores the nuance and complexity of art made by Native people over the millennia in their societies. The rise of the named artist signals the transition to accepting change, the integration of new materials, technologies, and ideas. It is a way to acknowledge the individuality of Native-made art instead of using an ethnic moniker or even the term "traditional." Unfortunately, the Indian art market is filled with expressions of "pure," "authentic," and "unchanged," and it exerts a strong influence:

With this increase in appreciation has come a new level of concern related to the identification of genuine Indian art. Old pieces that obviously can be traced to traditional tribal origins give no trouble; but the work of contemporary Indian artists, incorporating new materials and technology or expressions of ideology not befitting the stereotype of what "real" Indian art should be, has become a source of worry to collectors and others.[9]

One example of the "new" Indian art that challenges the old definitions is the coffee service by Roger John Tsabetsaye (A:shiwi [Zuni]), which expands the idea of functional form to encompass broader American craft traditions (plate 15). It might be instructive to take this a step further to help unpack and understand the embedded and often debilitating notions imposed on Native art and artists. As a reference, Tsabetsaye's use of silver is hermetic because silver is synonymous with

Detail of plate 7

the Southwest and Indian people; however, in this case, saying something is silver and from the Southwest suggests incorrect assumptions about its origins, originality, and correctness or authenticity. If we take the time to explore the work, we immediately comprehend the intertextuality of the coffee service with its smooth planished surface and walnut handle and finial as a nod to American craft traditions and Tsabetsaye's attendance at the School for American Craftsman program at the Rochester Institute of Technology.

Even when the name of the artist is unknown, a work may exhibit a distinct individual identity. The mask likely representing jilaa quns (Djilakons) at the Peabody Essex Museum is one such example (plate 13). This mask and its companions have been identified by scholars as representing the fabled jilaa quns, a mythological being of the Haida.[10] However, the depiction of women in masks and other wood carving[11] is relatively rare; furthermore, the absence of a bite-plate for a wearer of this mask indicates its unused or nonfunctional basis. The Peabody Essex Museum's 1827 catalogue documentation reads: "Indian mask, representing the features of an aged female of the Casern [sic] tribe on the N.W. Coast of America." The 1831 catalogue reads: "Wooden mask…, said to represent exactly the manner in which she painted her face." So, rather than a mythological being, why not identify the mask as depicting a living woman, a trading partner, and serving as a symbol of kinship? Perhaps the mask was made as a gift of remembrance; as calling card, it would arrive in Salem to be used by subsequent traders to locate this shrewd trader. Such a token of her esteem would also distinguish her from other Haida women. One hundred and eighty-five years later, she is still remembered.

Time and Changing

Perhaps the most significant difference between Native work produced for their own communities versus work produced for tourists, including anthropologists, relates to time. A primary example is the work of Charles Edenshaw (Haida) (plate 18). His work for home use was for the present: a cane, bracelets with family crests, a headstone commemorating a deceased relative. His work made for sale tended to relate to the past: drawings of crest tattoos, miniatures of objects that once existed, souvenir replicas referring to exotic myths. These functional differences were often tied to structural differences like an emphasis on narrative and material differences such as foreign, nontraditional items. However, aesthetic excellence exists in both genres.[12] Museum and private collectors, however, often suggest a differentiation in the value of something made for home use compared to a piece made for sale.

The emphasis on the past has stressed authentic or pure cultural products and privileged the scholar's knowledge over that of the Native person. The San Ildefonso Pueblo potters Maria and Julian Martinez were indeed handed a potsherd by anthropologist Edgar Hewett, but the issue is what they did with that. When the Martinezes tried to please Hewett and reconstruct the past, they made uninspired and often awkward replicas. Once freed from his art direction, they began in 1915 a period of artistic innovation that continues today. First and foremost, they created a wholly new style of pottery that combines fresh ideas with ancient ones (plate 6). The pottery blends contemporary designs with Julian's reinterpretation of thousand-year-old Mimbres pottery and that of contemporary neighboring villages of Acoma and Hopi. The black-on-black is a new idea that the artists created and nothing like the pottery with runny black designs painted on a soft creamy slip that Hewett was excavating from their ancestors' villages. The husband-and-wife team began experimenting with the new style in 1916–17; four years later, they had achieved a successful but still nascent form of highly polished blackware with matte

designs. They experimented throughout the 1920s, finally creating a unique iconography because, quite simply, the old ideas did not work on the new pottery style.

Hewett's intention was to have the Martinezes make work that manifested the purity of their aboriginal style before European influences. This task was impossible because the premise is absurd. Suggesting that anything pre-1500 is purer and less subject to change and evolution is a stultifying artistic concept. Throughout its two thousand–year history, Pueblo pottery changed and incorporated new ideas in design, form, and clay. With the arrival of European settlement, coupled with population loss, pottery did become more conservative and less varied. Nonetheless, its evolution continued through the nineteenth century with the introduction of new forms to help with storage and preparation of new foodstuffs, such as wheat, and objects for the tourist market.

During his lifetime, Charles Edenshaw (ca. 1839–1920) was considered one of the most accomplished Haida carvers; today he remains the most revered and widely known Haida artist. He was born during a period when his people's culture was experiencing an economic and artistic fluorescence spurred by the increased wealth resulting from the Euro-American fur trade at mid-century; he survived the devastating smallpox epidemic of 1862 and the later period of missionizing and colonizing by Euro-Canadians.[13] His work is remarkable for its delicacy and balance. For his elegant and functional wooden settee, he borrowed a European furniture form but embellished it in a distinctly Haida way (plate 18). In the Edenshaw house, it represented wealth and worldliness.

Non-Native Influences and Changing

Native jewelry in the Southwest is distinguished by its use of "found" materials for tools and reliance on blacksmithing techniques. Following centuries of stone,

Figure 8. Pat Pruitt in his studio, Paguate, New Mexico, 2010. Image courtesy of Pat Pruitt.

bone, and shell jewelry-making, the arrival of the railroad in 1881 brought the new tools and steel used in the locomotive and repair shops. In an adaptive use of technology, "Native" found materials now included metals from rail yards and machine shops.

Such adaptation is part of evolution. Pat Pruitt (Laguna Pueblo) identifies himself as a metalsmith rather than a silversmith or jeweler, because he draws his inspiration from body piercing, cars, and his work and training as a machinist (plate 10 and figure 8). In place of silver and a wooden anvil, he uses stainless steel and computer-driven machinery along with his files and hammers. Silver is malleable while steel – and now titanium – is unforgiving and cracks and breaks with mistakes, which can prove costly. Southwest jewelers' roots include blacksmithing,

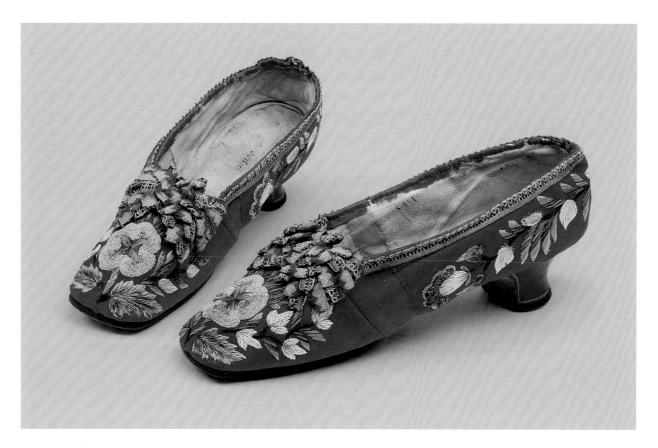

Figure 9. Huron-Wendat artist. Lady's evening slippers, 1850–75. Moosehair and kid leather. Victoria and Albert Museum, London, T.10-1929. Image © V&A Images/Victoria and Albert Museum, London.

so there are a variety of places and ways that tools are found and made. Pruitt claims his hands as his favorite tools: "Without them I couldn't sketch or do anything; my hands allow me to do many things and not be dependent on any one thing … despite and beyond the tools two hands gives [sic] you the capacity to make things."[14]

Even when a European form has been made or embellished by a Native artist, it was not necessarily made for sale to a tourist as a souvenir or curiosity. A pair of nineteenth-century Huron-Wendat embroidered evening slippers possibly were functional items meant for Native use rather than as curios (figure 9). The tendency in contemporary texts is to sentimentalize Indians

themselves as objects of curiosity. But, the core issue was and is functionality: how useful and essential new forms may be. Women artists have played a considerable role in the development of quality goods that were fashionable and thus were also sound economic strategies.[15]

James Schoppert (Tlingit) was especially concerned with the fact that the art market places immense pressure on Native artists to maintain the stylistic directions of their ancestors. He opposed this restrictive trend in favor of propounding a vision of possibilities still unexplored by his culture and a commitment to shift indigenous tradition toward a contemporary framework. His constant question was: "What would Alaska art have become if allowed to progress uninterrupted?"[16] Schoppert, like other Northwest Coast artists, was motivated by the perpetuation of tradition through the acknowledgment of evolution. As carvers, their work is instantly identifiable

as coming from this region. But, Northwest Coast art is a highly developed style that should take its place within the broad canons of American or world art. Artists who choose to work within the style should not be classified as making "Indian" art. Of his piece *Blueberries* (1986) (plate 4), Schoppert wrote:

This piece deals with traditions – the art traditions – of the Tlingit people and other Native peoples of the Pacific Northwest. To take what's known as Northwest Coast into more modern context I did a number of things. One, I removed the cultural relevancy of it. Two, I got rid of the traditional use of black and red colors. Third, I got rid of the focused specific image. Then I started adding to it. I fragmented the work. I began abstracting some of it. I began minimalizing others [sic]. I started using non-traditional colors.[17]

History and Changing

Art is not history or aesthetics, but rather the indelible transposition and use of the world that surrounds us, which we hear and experience as "voice." Voice can also be understood as culture; however, unlike the shared meanings of culture, voice is about an individual's relation to and understanding of that culture. This voice is made manifest in what we see and experience in an object. When Native-produced art leaves the maker's hands, his or her voice goes global; the objects move quickly, and with more ease than mere history. Artistic production has been used since the beginning of time to signify, reify, and present identities. All art is interactive and becomes ours, unlike history which requires experts, books, and storytellers.

Art is not always an exercise in ethnicity; it is an exercise in freedom, the freedom to make work devoid of systemic institutional or academic filters. Each artist has worked hard to self-define his or her work "and

to allow it to stand alone as art and not as 'artifact.' Their art states some very simple facts about the world around them. The world we inhabit is continuously complex, multi-layered, diverse, eclectic and chaotic."[18]

We visit an Indian reservation and we learn about history; we might experience history, but we leave it there, where it belongs, embedded in the landscape. Objects work in powerful ways. Perhaps subversive, perhaps not, these pieces come home with us, permeating our consciousness, reminding us of a broader and bigger Native place. In their work, artists tell stories about themselves, what their world looks like, and, importantly, imbue it with their deep philosophical and metaphysical comprehension of their world. Their production places into circulation their community's and their own consciousness.

Notes
1. Flower 2005.
2. Galanin 2010A.
3. Galanin 2010B.
4. Bernstein and Lowe 2006.
5. Momaday 2005, p. 34.
6. Scholder 2008, p. 34.
7. Galanin 2004, p. 102.
8. LaChappelle 2002, p. 8.
9. New 1975, p. ix.
10. Holm 1982, p. 92; Macnair and Stewart 2002B, p. 150; Macnair 1998, pp. 66–67.
11. Wright 1986, p. 38.
12. Ryan 1999.
13. Wright 2000.
14. Pruitt, as quoted in Bernstein and Gomez, 2010, p. 27.
15. R. B. Phillips 1991.
16. Everett in Everett and Zorn 2008, p. 188.
17. Breunig and Younger 1986, p. 65.
18. Apache Skateboards 2011.

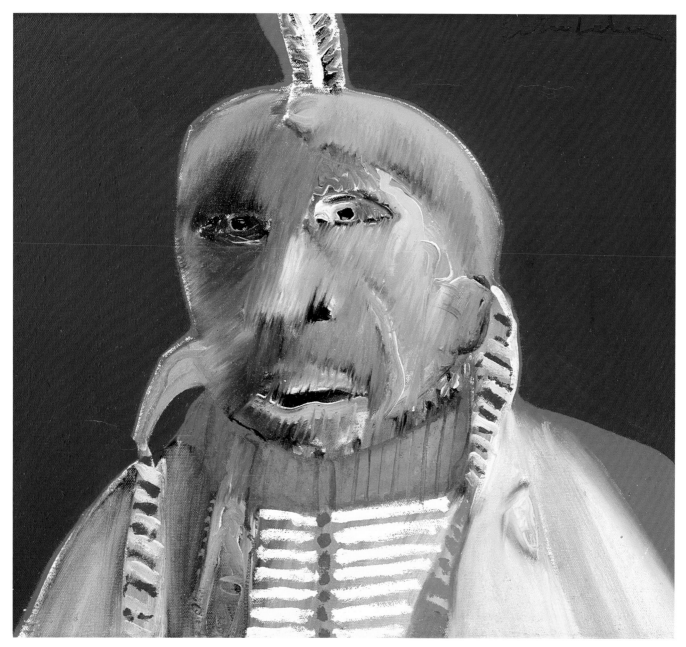

Plate 3

3 Fritz Scholder (1937–2005), Luiseño. *Monster Indian* (from "Super Indians" series), 1968. Oil on canvas. 18 × 20 inches (45.7 × 50.8 cm). Collection of Anne and Loren Kieve.

Fritz Scholder was the most influential, prolific, and controversial figure in the history of Native art.
– Opening statement, *Fritz Scholder: Indian/Not Indian* [1]

Fritz Scholder's "Super Indians" series, which he began in 1967, made him both hugely successful and hugely controversial. One critic remarked that Scholder had "single-handedly destroyed Indian painting."[2] He intended to do exactly that. As an instructor in 1964–69 at the Institute of American Indian Arts in Santa Fe, Scholder grew increasingly frustrated with the romanticized images of Indians popular in Santa Fe: his young Native students seemed unable to break away from what he considered clichés. He decided that "somebody should take this subject and transcend it in paint."[3]

Drawing on his own training with the modernist Oscar Howe (Yanktonais Sioux) and Pop artist Wayne Thiebaud, Scholder created in *Monster Indian* an image that tapped into the radical politics and Pop art sensibilities of the 1960s. His portrait is reminiscent of a romanticized, turn-of-the-twentieth-century Edward S. Curtis

photograph, depicting a man in traditional dress wearing a symbolic eagle feather but rendered in the candy colors of Pop art – lime green, lemon yellow, bubblegum pink. This unexpectedly distorted but hardly "monstrous" figure is pushed so close to the picture plane that the edge crops the eagle feather a couple scant inches up the shaft. A vibrant red contour line isolates the figure against the saturated blue background and heightens the immediacy and potency of the "monster." Ultimately, it is the face that differentiates Scholder's Indian from the usual romantic counterparts: the features are blurred, the eyes do not align, the mouth is frozen open in a grimace. *Monster Indian* may not be a "pretty" picture, but it did exactly what it was meant to do – it forever changed Indian painting. – KM

Notes
1. National Museum of the American Indian, Smithsonian Institution, 2009.
2. Scholder 2011.
3. Scholder, quoted in Highwater 1976, p. 183.

References
Two American Painters: Fritz Scholder and T. C. Cannon 1972; Adams 1975; Highwater 1976; Rushing 1991; Sims 2008; Scholder 2011; National Museum of the American Indian, Smithsonian Institution, 2009.

4 **James Schoppert (1947–1992), Tlingit.** *Blueberries,* **1986.** Alder and paint. 72 × 72 × 2 inches (182.9 × 182.9 × 5.1 cm). Anchorage Museum, Alaska, 1986.36.1.

James Schoppert was an innovative Tlingit artist who consciously sought to bring northern Northwest Coast art (predominantly that of the Tlingit, Haida, and Tsimshian) into the contemporary age. Over several centuries, his ancestors had developed an elegant two-dimensional art based on the "formline," a narrowing and swelling band that outlines the elements of the composition and depicts interior details, such as in the Chilkat blanket (plate 47). That refined and "classic" northern Northwest Coast art, made around 1820–80, is characterized by the adherence to a formal canon, which by the turn of the twentieth century had been largely abandoned. Following its revival after 1960, hundreds of artists have made art in the style of their nineteenth-century predecessors.

Well versed in the formline tradition, Schoppert often used its elements. However, he dismissed as reaction-ary works too closely based on nineteenth-century prototypes, challenging their makers to bring Northwest Coast art into the late twentieth century. Unlike his contemporaries who replicated the earlier symmetrical, balanced, and smoothly flowing components, he chose to break up and rearrange the elements in a striking and vibrant manner.

In this panel, nine squares, each illustrating a segment of a larger formline image, are placed together like mismatched pieces of a jigsaw puzzle. For Schoppert, the dynamic abstract composition referred to Northwest Coast artistic traditions in a decisively late twentieth-century manner. The artist viewed the breakdown of the conventions as a result of an attempted destruction of his culture. Rearrangement of these disparate elements into a unified, albeit unconventional, whole, conveys the revitalization and strength of contemporary Tlingit culture. – AJ

References
Schoppert 1987; S. Brown 1997; Nichols 1997; Ostrowitz 1999; Fair 2006.

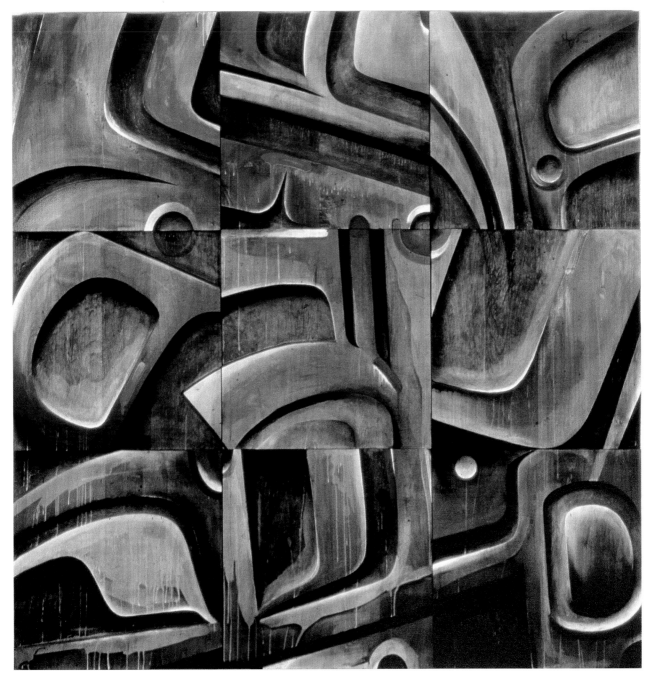

Plate 4

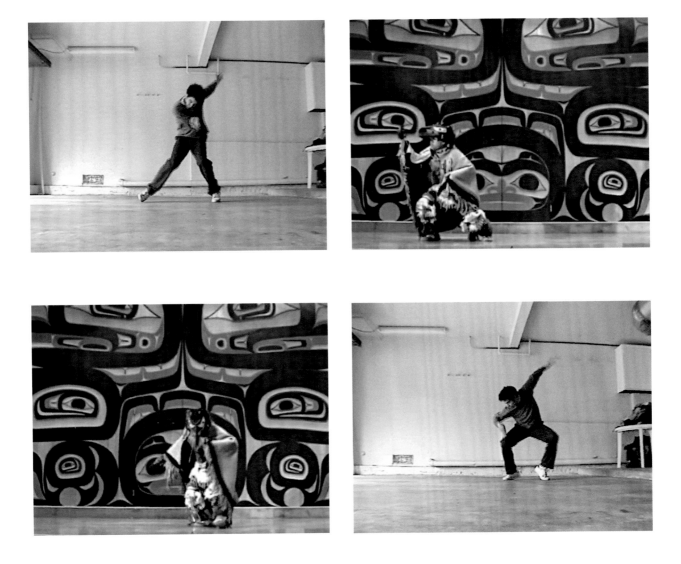

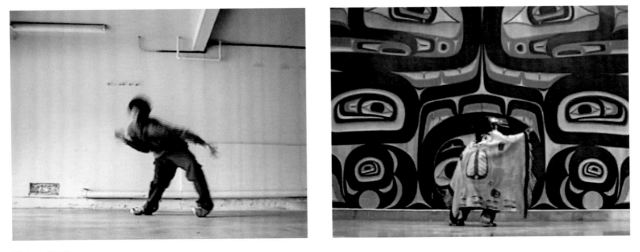

Plate 5, details

5 Nicholas Galanin (born 1979), Tlingit/Aleut. *Tsu Heidei Shugaxtutaan (We Will Again Open This Container of Wisdom That Has Been Left in Our Care)*, parts I and II, 2006. Digital video: 10 minute loop, performance by David Elsewhere; 5 minute loop, performance by Dan Littlefield. Dimensions variable. Courtesy of the artist.

Since 1492, Native Americans have challenged colonization by resisting forms of Western assimilation in the form of imposed legislation. The transitions, adaptations, displacements, and acculturation driven by colonization have impacted essential elements of indigenous culture, economy, and politics. Native response to change has created a unique intersection for traditional societal values and contemporary culture to converge rather than collide.

Tlingit/Aleut artist Nicholas Galanin keeps one eye on the past and a clear view to the future. In his two-part video *Tsu Heidei Shugaxtutaan*, he used dance and music to merge his traditional culture with contemporary hip-hop culture. In the first video, a "break dancer pop-locks with rhythmic virtuosity to a traditional tribal song. In the second, a Tlingit dancer in traditional garb moves effortlessly to a soundtrack of electro-bass rap."[1] With regard to the video's Tlingit-language title and its corresponding English translation, Galanin explained that the piece signifies "an opportunity to take this container (the culture) and open it creatively with a new conceptual voice that is not limited by boundaries, only when our culture is able to grow unrestrained and organically will we be able to pull from a highly reactive state of being."[2] The container of wisdom Galanin referred to is indicative of a fundamental responsibility placed upon Native generations to maintain a balance for their culture and tradition to remain intact as well as in motion. The videos strike an exceptional equilibrium between old and new, traditional and contemporary, Native and non-Native, and attest to the persistence of cultural continuity. – RR

Notes
1. Sanchez 2010, pp. 26–27.
2. Galanin 2010A.

References
Beat Nation 2010B; Galanin 2010A; Sanchez 2010.

6 **Maria Martinez (1881–1980) and Julian Martinez (1879–1943), San Ildefonso Pueblo. Black-on-black jar, ca. 1938.** Ceramic. 18 3/4 × 22 1/2 inches (diam.) (47.6 × 57.2 cm). Museum of Indian Arts and Culture/Laboratory of Anthropology, Department of Cultural Affairs, Santa Fe, www.miaclab.org., 31959/12.

Maria Montoya and Julian Martinez were both from the small Tewa village of San Ildefonso Pueblo, just north of Santa Fe. These exceptionally skilled and aesthetically astute artists singlehandedly transformed a two thousand-year-old pottery production from that of household and village use to world-renowned ceramic art. A testament to their genius is the continued presence today of Pueblo pottery.

Maria Martinez possessed dazzling ceramic skills, gathering and mixing her clay, shaping, smoothing, and polishing to absolute perfection, and controlling with precision

the outdoor firing process. Evident from the building of the vessels to their unrivaled stone polished surfaces is the new design language Julian Martinez developed, borrowing from rock art and ancestral pottery styles.

This large storage jar, made in the winter of 1939, earned first prize at the 1942 Indian Market in Santa Fe. Maria said of the sales price: "[the buyer] gave me forty. I nearly fall down. Forty dollars and three shawls.… And I and my sister [Anna] we polished it, one on one side and the other on the other side."[1] The price was truly remarkable at a time when most pots sold for about a dollar and Maria's best work sold for twelve dollars. – BB

Notes
1. Spivey 2003, p. 40.

References
Marriott 1948; Bernstein 1994; Bernstein 1998; Spivey 2003.

7 **Awa Tsireh (1898–1955), San Ildefonso Pueblo. Koshare *on Rainbow*, ca. 1925–30.** Watercolor on paper. 15 1/2 × 20 inches (39.5 × 50.8 cm). School for Advanced Research, Santa Fe, SAR.1978-1-318.

One of the most celebrated Native painters of the early twentieth century, Awa Tsireh was featured in a *New York Times* article in 1925, in which Alice Corbin Henderson (an early collector of Pueblo painting) pronounced his drawings "as precise and sophisticated as a Persian miniature."[1] A prolific and innovative artist, he was particularly adept at melding diverse pictorial influences into a coherent style.

Born in San Ildefonso Pueblo in 1898 and baptized as Alfonso Roybal, he later signed his work with his Indian name, Awa Tsireh (Cattail Bird). In 1917, Henderson and

her husband (a painter) befriended Awa Tsireh and began to buy his works. In their home, he examined books on Japanese prints, modern art, Persian miniature painting, and Egyptian art. His own work began to reflect his familiarity with these exotic forms. Here, he depicted the distinctive Pueblo striped clowns who climb poles and engage in buffoonery (see plate 35). They straddle a rainbow that emerges from stepped Pueblo cloud forms. Below, two horned serpents create a groundline; out of their tails grows a complex abstract design derived from Pueblo pottery-painting imagery (see plates 23 and 33). The colors are the black, white, and rust-red of Pueblo pottery and ancient mural painting.

Pueblo watercolor paintings were exhibited for the first time in fine arts contexts in Santa Fe, New York, and Chicago in 1919 and 1920. In 1931, The Exposition of

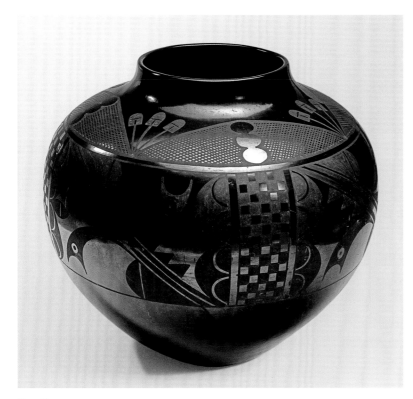

Plate 6

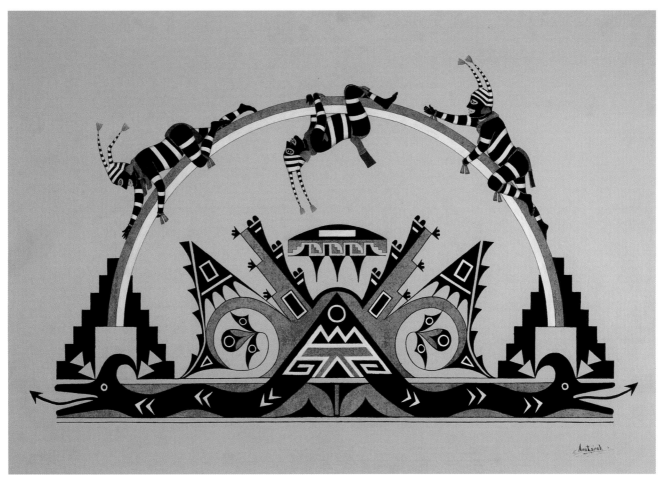

Plate 7

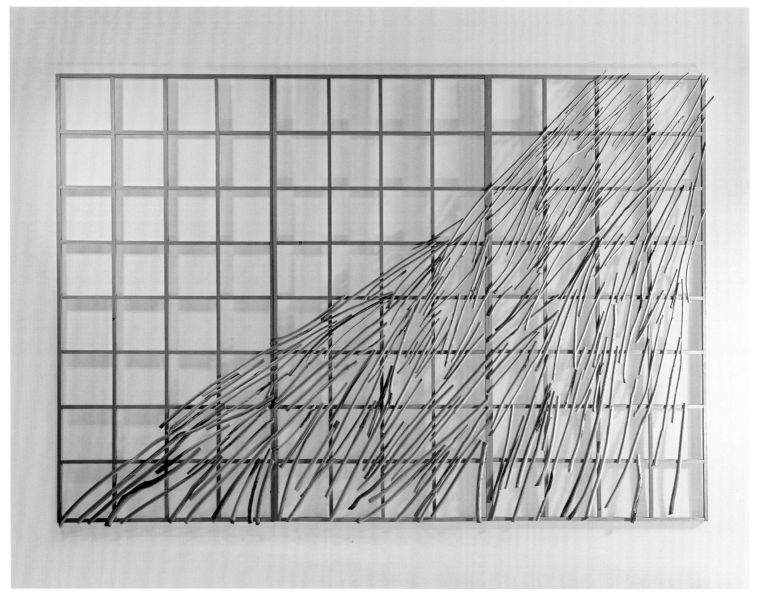

Plate 8

7

Indian Tribal Art premiered at the Grand Central Galleries in New York. It subsequently toured America and Europe, including the Venice Biennale.[2] Critics called the exhibition "American art, and of the most important kind." One observed: "probably never before has an exhibition been given so much space in the newspapers and periodicals."[3] Capturing, as it does, Art Deco's love of eclectic design sources, stepped and zigzagged geometries, and lush curvilinear forms, it is no surprise that this work by Awa

Tsireh graced the cover of a catalogue that sought to show the modernity of Indian art. – JCB

Notes
1. Henderson 1925, p. SM18.
2. Dunn 1968, p. 240.
3. Schrader 1983, p. 50; Rushing 1995, pp. 97–103.

References
Henderson 1925; LaFarge and Sloan 1931; Dunn 1968; Schrader 1983; Rushing 1995; Brody 1997, esp. ch. 4.

8

Truman Lowe (born 1944), Ho-Chunk (Winnebago). *Waterfall*, 1999. Wood. 96 × 144 × 4 inches (243.8 × 365.8 × 10.5 cm). Eiteljorg Museum of American Indians and Western Art, Indianapolis, 1999.6.4.

Truman Lowe's *Waterfall* performs the perfect marriage of traditional and modernist forms. On the one hand, the artist presents us with the essential form of high modernism – the grid, which art critic Rosalind Krauss famously described as "what art looks like when it turns its back on nature."[1] On the other hand, Lowe has enchanted us with the twisting and turning natural forms of raw sticks that cascade from the upper corner across the surface of the work. For Lowe, there is no contradiction between these components – grid and nature, water and wood, surface and depth, order and organic flow – all are united in his experience and his vision.

Lowe was born and raised in the Ho-Chunk community at Black River Falls, Wisconsin, and like many other local families, the Lowes supplemented their income by making traditional wooden baskets. By the time he began his formal training in sculpture at the University of Wisconsin at Madison in the early 1970s, the pervading movements in art were Minimalism and Conceptualism. Lowe felt

an instant affinity with sculptors Robert Morris and Donald Judd, whose Minimalist works explored the properties of raw materials such as wood, plastic, and felt. But, Lowe transformed the static structures of the Minimalists into exquisite evocations of place, movement, and time.

Since the 1980s, Lowe's sculptures have centered on themes and forms drawn from woodland and river environments, where the artist says he feels most at home. During a short interlude living in Kansas, Lowe wrote: "I discovered I was really a Woodland Indian. I was so familiar with trees and water and bluffs that it was important for me to come [home]."[2] – KM

Notes
1. Krauss 1984, p. 9, also cited in Ortel 2003, p. 110.
2. Lowe, cited in Ortel 2003, p. 42.

References
Krauss 1984; Nemiroff 1992; *Haga (Third Son): Truman Lowe* 1994; Ortel 2003.

9 **Charlie Willeto (1897–1964), Diné (Navajo). Pair of figures, 1960–64.** Wood and paint. 40 × 13 × 12 inches each (101.6 × 33 × 30.5 cm). Collection of Stephanie K. Smither.

Timeless and deceptively simple, Charlie Willeto's oeuvre of several hundred carved figures created over just a few years has been variously classified as folk art, outsider art, American art, and Navajo art.[1] The work defies easy categorization because it is so original, firmly rooted in Willeto's worldview and imagination.

Willeto was born of Tódich'ii'ni (Bitter Water, his maternal clan) and born for Hashtłishnii (Mud People, his paternal clan). With both parents medicine practitioners, he grew up well versed in Navajo healing arts. He became a *hataałii* (ceremonial singer and medicine man) of the Windway and Blessingway, extensive curing and protective ceremonies, respectively, and married Elizabeth Ignacio, of similarly traditional foundations. Willeto facilitated healing by calling upon Holy People to restore *hózho* – an all-encompassing Navajo concept involving balance, well-being, and beauty. A self-taught artist, he made human, animal, and spirit carvings that were likely inspired by figurines he used in curing rites. For supplementary income, he sold carvings that lacked the ritual details and context through the local trading post. This was a bold move, as carving nonritual figures was forbidden in Navajo society until the late 1970s. Furthermore, there was no precedent in the tourist market for Navajo carvings.

This stylized couple is the second largest figural pair extant.[2] Willeto's confident carving and bold paint application captured the essential details. The twentieth-century everyday dress and jewelry – his buckled belt of silver concha disks and their large silver beaded necklaces – reflect Navajo concepts of beauty and wealth. The

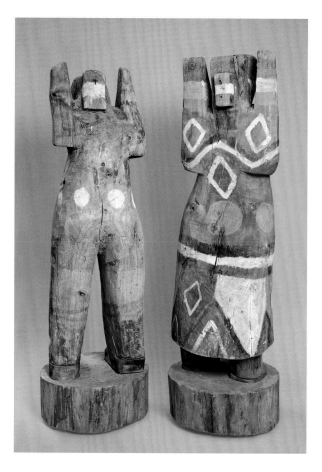

Plate 9, back.

diamond designs on her back strongly resemble Navajo textile patterns. Willeto sensitively used the most basic tools to shape their cheeks, chins, and lips, and painted large eyes to balance their chiseled, elongated noses. Their upraised, foreshortened arms possibly suggest a call to the spirits in prayer or blessing. – KKR

Notes
1. Willeto's widow has said that his earliest carvings may date to 1955 but it remains unclear if these were made for sale or used in healing ceremonies. See McGreevy 2010, p. 65.
2. The largest is the almost life-size couple in the Smithsonian American Art Museum.

References
C. Rosenak and J. Rosenak 1994; Begay et al. 2002; McGreevy 2010.

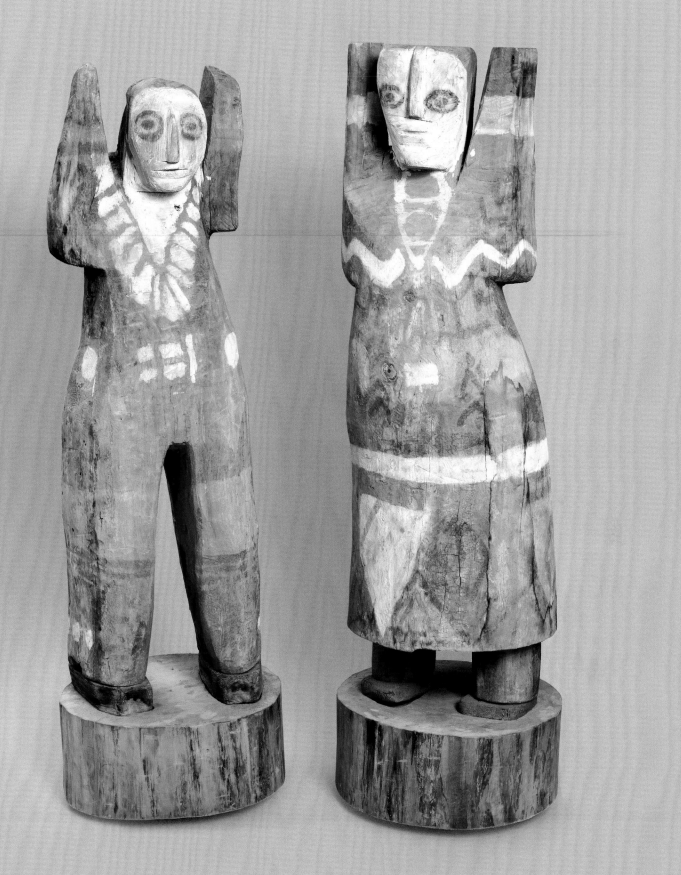

Plate 9

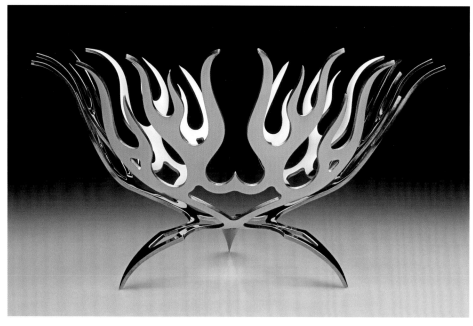

Plate 10

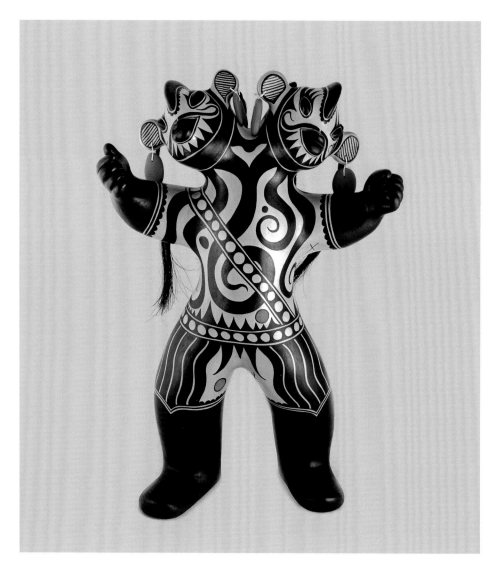

Plate 11

10 **Pat Pruitt (born 1973), Laguna Pueblo. *Hot Rod Fruit Bowl*, 2009.** Stainless steel. 9 × 12 inches (diam.) (22.9 × 30.5 cm). Collection of Margit Biedermann.

An experienced jeweler, Pat Pruitt transforms customarily elegant and lithe ornaments such as rings, bracelets, and belt buckles into audacious, aggressive forms. Combining a plethora of traditional techniques and contemporary technology, his work pushes the boundaries of Native art. In this instance, Pruitt's creation is a threatening take on a domestic vessel, the humble fruit bowl. The flame motif, like the flames painted on a tricked-out car, ignite the form, the swirling, sharp edges lapping upward. The powerful design – an equal balance of dramatic positive and negative forms – also calls to mind the painted designs favored by ancient and contemporary Pueblo artists, as well as the graphic qualities found in street art.

The idea of a domestic fruit bowl contrasts with the work's extreme appearance. Although it may initially seem that actually using this beautiful object as a fruit bowl would only result in shredded fruit and fingers, Pruitt always strives to make objects that are fully functional: "A lot of my work is extreme in form, but it is also empowering in ways that I find very intriguing."[1] – KA-M

Notes
1. Pruitt, interview with the author, January 2011.

References
PatPruitt.com; Ringlero 2008.

11 **Virgil Ortiz (born 1969), Cochiti Pueblo. *Untitled*, 2005.** Ceramic, paint, and hair. 21 1/2 × 15 × 7 inches (54.6 × 38.1 × 17.8 cm). King Galleries of Scottsdale, Arizona.

Tradition is not static. The artist Virgil Ortiz seized the process of traditional pottery distinct to Cochiti Pueblo (New Mexico) and his family as an extension of his art practice that includes painting, pottery, fashion, and film. *Untitled* is one of Ortiz's clay pieces inspired by traditional coil-built clay shapes and figures, Cochiti Pueblo's storyteller sculptures, and the imaginative aesthetic supplied by nineteenth-century clay caricatures called *manos*. *Manos* were initiated by Cochiti potters who began to depict the absurdities and temperament of strangers – circus performers, immigrants, travelers – in curios for trade. "The figurative style was a form of social commentary…. They captured in clay the images of all the crazy, nonnative people who were passing through the area at that time," Ortiz attested.[1]

Ortiz picked up on the accentuated features and mocking spirit of the *manos* to expand on difference as a form of diversity. He infuses his sculptures with a fashion sensibility, an essence of sexual ambiguity, and a "rock 'n' roll" style. *Untitled* bridges traditional principles and tribal motifs with contemporary elements culled from popular culture and today's ongoing globalization of experience. – RR

Notes
1. Morgan 2010.

References
Mint Museum 2010; Morgan 2010.

12 **Ramona Sakiestewa (born 1948), Hopi. *Nebula 22 and Nebula 23* (from "Nebula" series), 2009.** Wool and dye. 20 × 20 inches each (50.8 × 50.8 cm). Collection of Carl and Marilynn Thoma.

Ramona Sakiestewa's "Nebula" series embodies her painterly aesthetic and knowledge and mastery of wools, dyeing, and weaving. Her ability to blur the warp and weft of the horizontal loom helps her achieve an illusion of broad brushstrokes that effortlessly combine color and imply shadow. In fact, many of Sakiestewa's weavings are based on watercolors she has painted. She explained the connection of nebulas to her work: "In the same way the layers of cosmic dust make themselves known [in nebulas] by red or blue wavelengths, I continue to explore the layering of color in my work. My challenge in tapestry weaving is to layer the color, as if it were watercolor, in each combination of weft strands to achieve a specific relative color value."[1]

A self-taught artist, she spent her early career working with historic collections, Southwest textile scholars, and studying Pueblo weaving traditions through replication and interpretation. Sakiestewa blends ancient techniques with abstraction to express her own experience of the Southwest and its millennia of textile traditions. Made expressly for decorative purposes, with their brilliant colors and modernist design, these works are a radical departure from traditionally functional Hopi weaving. After thirty-five years of weaving, the "Nebulas" are her final woven series. – BB and KKR

Notes
1. LewAllen Galleries 2007.

References
LewAllen Galleries 2007; Baizerman 1989; Zorn in Everett and Zorn 2008, pp. 184–87.

Plate 12

13 **Kaigani Haida artist. Mask, ca. 1827.** Wood and paint. 10 1/4 × 7 1/2 × 5 inches (26 × 19.1 × 12.7 cm). Peabody Essex Museum, Salem, Massachusetts, Gift of Captain Daniel Cross, 1827, E3483.

Many human face masks from the Northwest Coast carved in the nineteenth century depict women wearing labrets, pierced lower lip ornaments – a practice that involved permanent facial modification. An unmistakable marker of individual, family, and cultural identity and status, and a symbol of female fertility, the labret indicated the wearer's position within the restricted elite class. The largest and most elaborate labrets were worn by elder noblewomen. Although early travelers and missionaries found the tradition ghastly, they nevertheless obtained souvenir items featuring labrets.

This exquisitely carved female face mask may represent jilaa quns (or Djilakons, Djilaqons, Qiilaa Kuns), the Haida ancestress who gave birth to the Eagle moiety. She is distinguished by her prominent labret, the red design on the right side of her nose and cheek, the blue design adorning her forehead, and the red edging on her face. Her features are naturalistic and sensitively rendered, from her wonderfully sculpted cheeks and chin to her flaring nostrils. This is one of several related masks and figurines collected over a twenty-year-period by European and American mariners and missionaries. Attributed to a single master carver, they are among the earliest examples of tourist art – there is no antecedent for them in Haida ceremonials, and the masks lack evidence of having been worn in dance. This exceptional example is the product of the intersection of cultural identity, cultural politics, and intercultural trade.

Pressure from nineteenth-century missionaries resulted in the abolishment of wearing labrets, but their recent revival and depictions in art continue today, in part as a visual acknowledgment of the contributions Haida women make in carrying on their clan lineage within their matrilineal society.[1] – KKR

Notes
1. Trish Collison, e-mails to the author, February 10 and April 19, 2011.

References
Vaughan and Holm 1982; Swanton and Enrico 1995; Macnair, Joseph, and Grenville 1998; Malloy 2000; La Salle 2008.

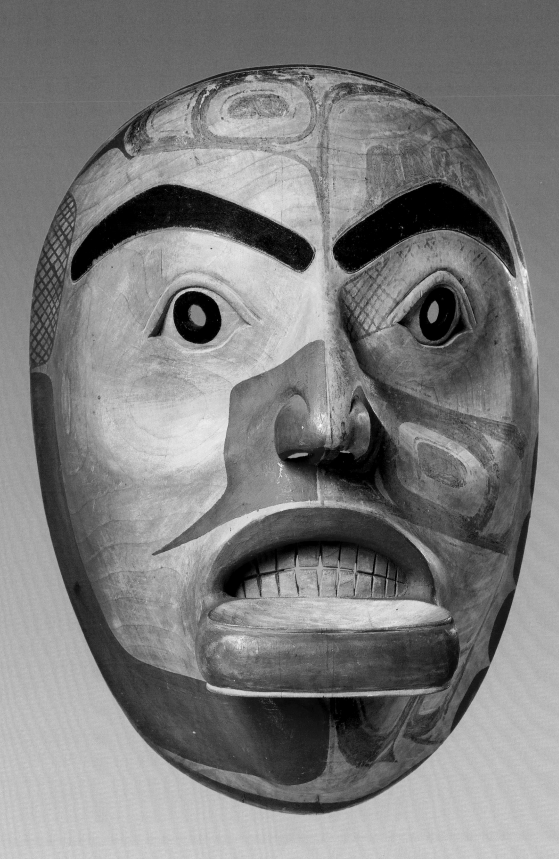

Plate 13

14 Algonkian/Mi'kmaq artist. Side chair, 1860–80.

Ebonized mahogany, porcupine quills, plant dye, birchbark, and porcelain. 43 × 18 1/2 × 18 3/4 inches (109.2 × 47 × 47.6 cm). Museum of Fine Arts, Boston, Museum Purchase with funds by exchange from a Gift of the Estate of Jeannette Calvin Hewett in memory of her husband Roger Sherman Hewett, Bequest of Greenville Howland Norcross, Bequest of George Nixon Black, and Bequest of Mrs. Stephen S. FitzGerald, 1992.521.

This stunning chair is a harmonious mix of wooden turned legs and a distinctive frame with a dyed porcupine quill back and seat. In the 1860s, the side chair concept itself and the quillwork were new and innovative contemporary expressions. Moreover, the chair is a functional and elegant item on its own terms, without self-conscious analysis of what is or is not Indian. It represents a rich cultural and historical negotiation. In addition to demonstrating the maker's skill and industriousness, the quillwork features melodious designs that reflect a knowledge of modern taste.

Quillwork represents women's artistry. This quilled panel's quadripartite composition is arranged along a strict axis of bilateral symmetry, characteristic of Northeastern Native art. The central double-curve designs on the back and seat echo the elegant scrollwork on the chair crest, while the additional quilled stepped and cross motifs balance the chair's incised gilt decoration in rectangles. This side chair is a true hybrid: the quilled panels were attached to the seat by a non-Native furniture maker. – BB and KKR

References
Ewing 1982; R. B. Phillips 1998; R. B. Phillips and Steiner 1999; R. B. Phillips 2001.

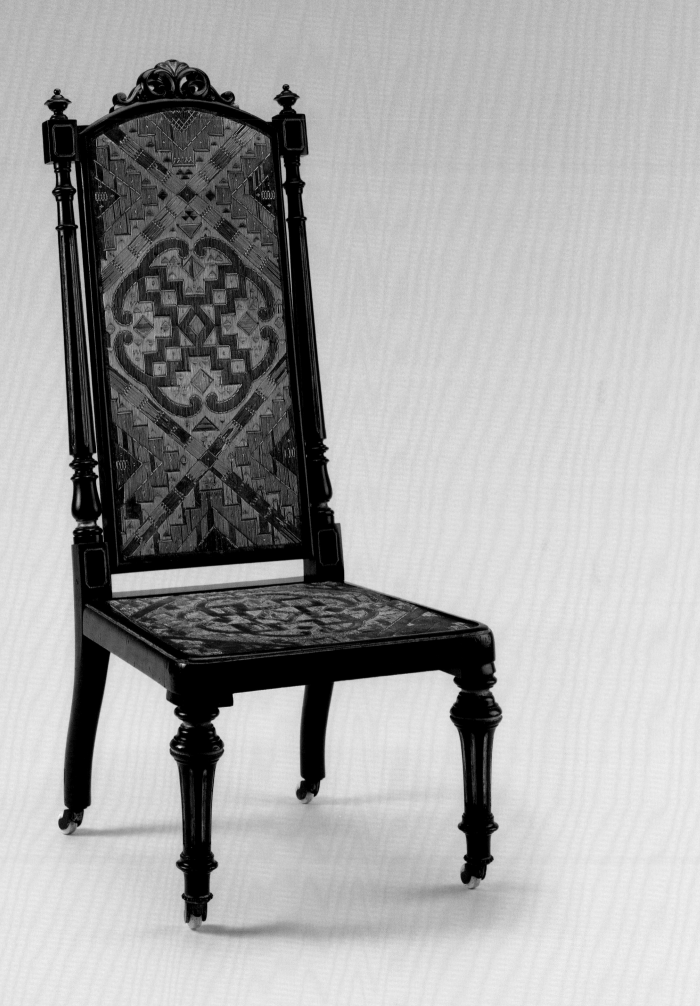

Plate 14

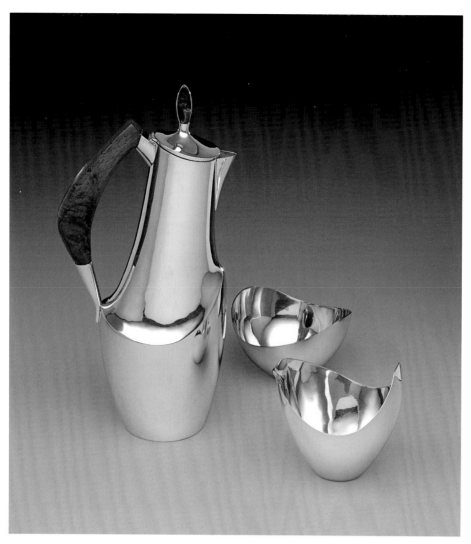

Plate 15

Plate 16

15 **Roger John Tsabetsaye (born 1941), A:shiwi (Zuni). Coffee service, 1965.** Silver, rosewood, and petrified wood. Coffee pot: 12 × 6 1/4 × 4 5/8 inches (30.2 × 15.7 × 11.6 cm); creamer bowl: 4 × 4 × 4 1/2 inches (10.2 × 10.2 × 11.4 cm); sugar bowl: 3 × 4 3/4 × 4 1/2 inches (7.6 × 12.1 × 11.4 cm). National Museum of the American Indian, Smithsonian Institution, Washington, DC, 25/8219.

Roger John Tsabetsaye is an innovative artist whose work and life reflect the artistic and social changes of the 1960s. He attended the University of Arizona Southwest Indian Art Project, which led to the formation of the Institute of American Indian Arts (IAIA) in Santa Fe, where he was one of the school's first students. He also studied at the Santa Fe Indian School Studio program under Geronima Montoya, and at the School for American Craftsman program at the Rochester Institute of Technology in Rochester, New York. The Southwest Indian Art Project was designed to increase young people's awareness of their own artistic heritage and world art traditions while providing new tools, technologies, and materials. The purpose of the Rochester program was to develop and raise the standards of handcrafts in the United States by expanding ideas of functional forms.

Tsabetsaye's broad artistic training and his incorporation of new ideas into Native metalwork along with an expanded idea of functional form are reflected in this coffee service. The elegant service demonstrates tools and materials beyond the usual Native jeweler's bench at mid-century. Its sleek surfaces and curving forms were achieved through hundreds of planishing hammer hits. The choice of a rosewood handle and petrified wood finial are further tribute to broader American craft traditions. – BB

References
Adair 1944; Bahti 2008; Tsabetsaye 2011.

16 **Charles Loloma (1921–1991), Hopi. Cuff bracelet, 1982.** Gold, jet, ironwood, turquoise, lapis lazuli, ivory, and coral. 2 ½ × 3 1/8 × 1 inches (6.4 × 8 × 2.4 cm). National Museum of the American Indian, Smithsonian Institution, Washington, DC, 25/6307.

Charles Loloma was the dominant force in Native jewelry-making in the second half of the twentieth century. He is recognized for many innovations, but most important is his use of what then was decidedly "un-Indianlike" materials and techniques. At a time when Indian jewelry was defined by silver and turquoise, he explored a breadth of materials such as gold, ivory, and exotic woods, and techniques such as lost-wax casting. Embracing the notion of chance, he rejected the emphasis on flawless technique that was beginning to dominate definitions of Native art and increasingly restrictive notions of authenticity. Instead of being bound by non-Indian notions of balance and perfect technique as measurements of quality and value, Loloma created asymmetrical pieces that connote a deep, nuanced understanding of humanity (frailty and balance) and reflected his extraordinary imagination. He used texture as a design element; unusual combinations of materials, sometimes stacked; and allowed mistakes to remain as part of a finished piece. His pieces were built to accentuate the human body rather than function as simple adornments; the act of wearing the work is a theatrical restoration of its balance.

16 For this cuff bracelet, Loloma (Hopi for "Many Beautiful Colors") drew inspiration from the colorful, stepped Hopi mesas and local rock formations he returned to live near in 1964. He inlaid vertical slabs and produced a vivid stone mosaic: its three-dimensionality resembles a miniature sculpture and goes far beyond traditional Southwestern jewelry heavy in turquoise, silver, and stampwork. – BB

Notes
1. Struever 2005, p. 12.

References
Adair 1944; Cirillo 1992; Dubin 2004; Struever 2005; Pardue 2007; Burke 2009.

17 **Oto artist. Faw Faw coat, ca. 1900–20.** Wool cloth, glass beads, metal, and sequins. 28 × 25 × 10 inches (71.1 × 63.5 × 25.4 cm). Philbrook Museum of Art, Tulsa, Oklahoma, Museum Purchase, 1991.23.

Some objects have a historical significance beyond their aesthetic virtues. This black cloth coat with beaded decorations is associated with a short-lived messianic religion that originated with William Faw Faw (Oto). He taught his followers to reject European influences and return to their traditional roots. Such movements were common among tribes at the end of the nineteenth century, when their ways of life were coming to a tragic end. Faw Faw's vision of everlasting life included instructions to uproot and replant a cedar tree, the central design element on this coat. Other elements from his vision and the ceremony he created from it – human and equine figures, stars, and bison heads – are also depicted.

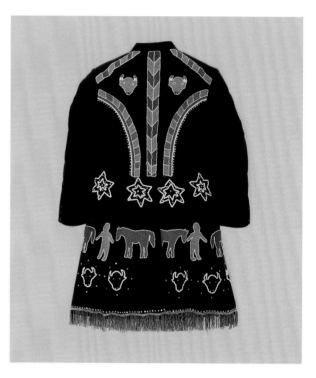

Plate 17, back.

This coat is notable for its ability to unbalance the familiar and unfamiliar and thus underscores the complexity of Native art. The few surviving coats attributed to Faw Faw's followers are all front-opening, single-breasted, and knee-length, emulating a stylish Euro-American man's coat of the day. Their ornamentation, however, demonstrates their maker's ability to transform the style to conform to Native tastes. The beadwork shows the influence of the Great Lakes groups in its floral patterns that are treated as geometric shapes with strict bilateral symmetry. The cedar tree was used as symbol by many different Plains tribes. No doubt, some of its power derived from its ability to remain green and thus alive while most trees shed their leaves. – BB

References
Wooley and Waters 1988; Bailey and Swan 2004; G. P. Horse Capture and Her Many Horses 2006.

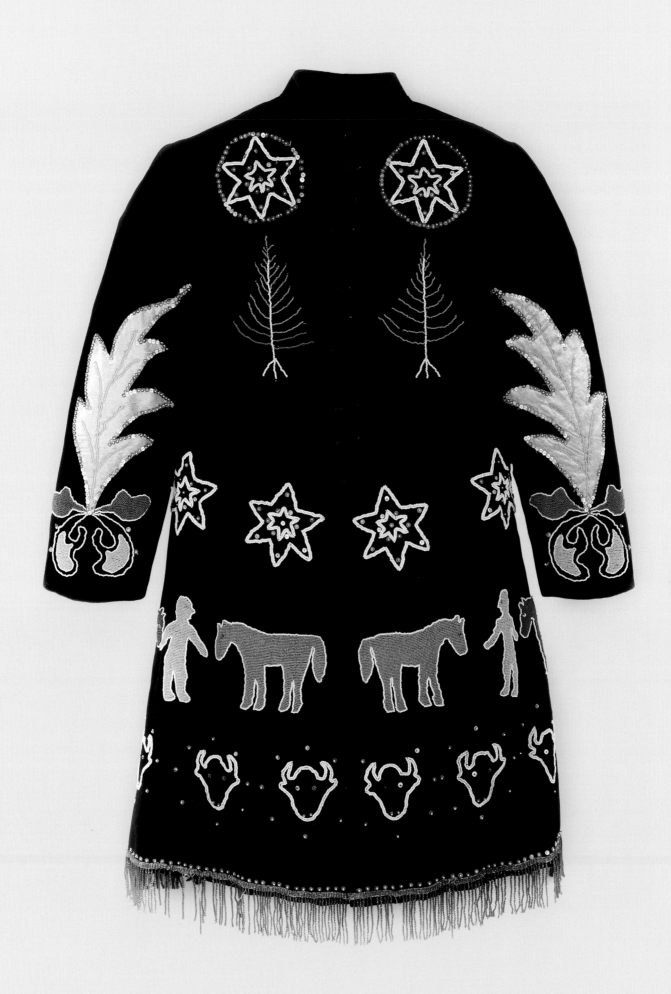

Plate 17

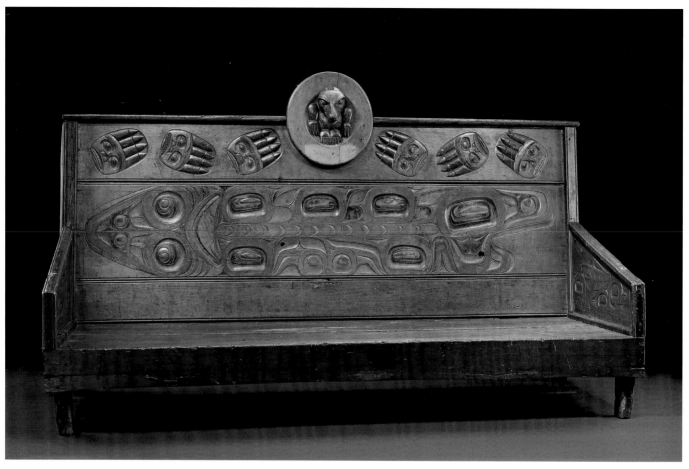

Plate 18

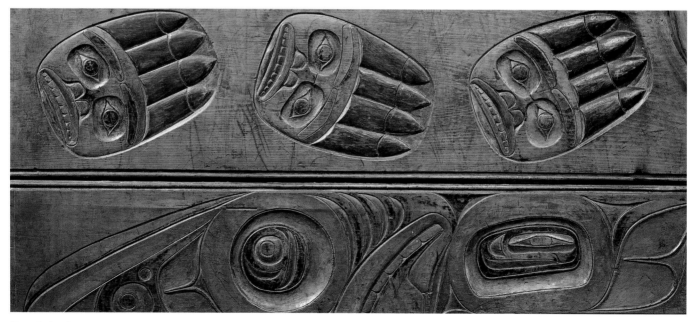

Plate 18, detail

18 **Charles Edenshaw (ca. 1839–1920), Haida. Settee, ca. 1890.** Wood and paint. 44 7/8 × 74 1/8 × 28 3/8 inches (114 × 188.3 × 72.1 cm). National Museum of the American Indian, Smithsonian Institution, Washington, DC, 18/2098. Not in exhibition.

Charles Edenshaw (also known as da.a xiigang and Tahayghen) is perhaps the most accomplished, renowned, and influential artist from the Pacific Northwest Coast. Born into nobility, he succeeded his uncle Albert Edward Edenshaw (7idansuu) as one of the highest chiefs of the Saangga.ahi Stastas Eagle clan. A painter and master carver firmly rooted in his culture, over the course of his life he navigated profound changes on Haida Gwaii, including surviving colonization, missionary conversion, and the 1862 smallpox epidemic that nearly annihilated the Haida. His work is celebrated for its quality, range, imaginative forms, and his superior command of the formline so central to Northwest Coast art. Edenshaw carved wood, argillite, silver, and gold. He produced the bulk of his artwork between 1880 and 1910 for Haida and non-Haida clients, making his living as an artist – an accomplishment remarkable even today. Jewelry, masks, chests, tombstones, and full-size totem poles were among the objects Edenshaw produced for Haida clients and family. He journeyed frequently to Victoria to sell elaborate miniatures, replicas, and souvenirs to tourists, anthropologists, and museum collectors.[1] Edenshaw never signed his work; attribution is determined by his distinctive style of very bold formlines and/or through documentation.

Edenshaw made two settees for his family. One, bearing his own frog crest, was in an older style of chief's seats.[2] The other, seen here, with his wife's *q'ad* (dogfish) and *xudj* (grizzly bear) crests, has wooden legs inspired by Euro-American furniture; its multipaneled back rest has an attached circular carved crest-rail ornament. Edenshaw represented the bear's power with just two essential elements: its head and tracks. According to his daughter, Florence Edenshaw Davidson, her parents kept very little of his work, and this was used in their family home as a chesterfield with a feather mattress on it. It was transferred to a relative, Alec Yeltatzie, when he inherited Charles Edenshaw's name and title, and later sold it to buy a casket for his son who died.[3] – KKR

Notes
1. Most notably anthropologists and museum collectors Franz Boas, George T. Emmons, C. F. Newcombe, and John Swanton.
2. Carved from three panels, it sat on the wooden platform in the cedar-plank house. Wright 2001, p. 240.
3. Hoover 1995, p. 47; Wright 2001, p. 242.

References
Duff 1967; Macnair, Hoover, and Neary 1984; Hoover 1995; Wright 2000; Wright 2001; J. Hart 2004.

19 **Juana Basilia Sitmelelene (ca. 1782–1838), Barbareño Chumash (Santa Barbara). Basket tray, ca. 1820.** Juncus rush and dye. 3 1/8 × 22 5/8 × 18 1/2 inches (7.8 × 57.5 × 46.8 cm). National Museum of the American Indian, Smithsonian Institution, Washington, DC, 25/0001. Not in exhibition.

Woven into this basket are the words "*Soi de Catarina Ortega*" [I belong to Catarina Ortega] by Juana Basilia Sitmelelene, an exceptionally talented Chumash weaver working in the first two decades of the nineteenth century. Equally unusual is the nonindigenous oval shape, which suggests the tray was modeled after a porcelain European or Chinese serving tray or platter.[1] Despite the innovative inscription and non-Native form, the inner features of materials, designs, and weaving technique are loyal to Chumash weaving traditions.

The tray is made in a three-rod sewing technique utilizing split natural and dyed juncus stems (*juncus textilis*) sewn over a foundation of three juncus stems. The highly formalized composition has bands at the base and rim delineating the area to include design. The motifs themselves are a balanced, geometrical network pattern typical of Chumash iconography. The rim also includes characteristic rim ticking, small blocks of alternating dark and light stitches that often provided the finishing touch on the last row. Here, tradition has served Sitmelelene not as a list of rules but a set of values, which allowed her the flexibility to create a masterpiece distinct from every other basket. – BB

Notes
1. European and Chinese porcelain was traded on the California coast in the 1820s.

References
Dawson and Deetz 1965; Weber 1978; L. Smith 1982; Hudson and Blackburn 1983; Bernstein 2003; Timbrook 2010.

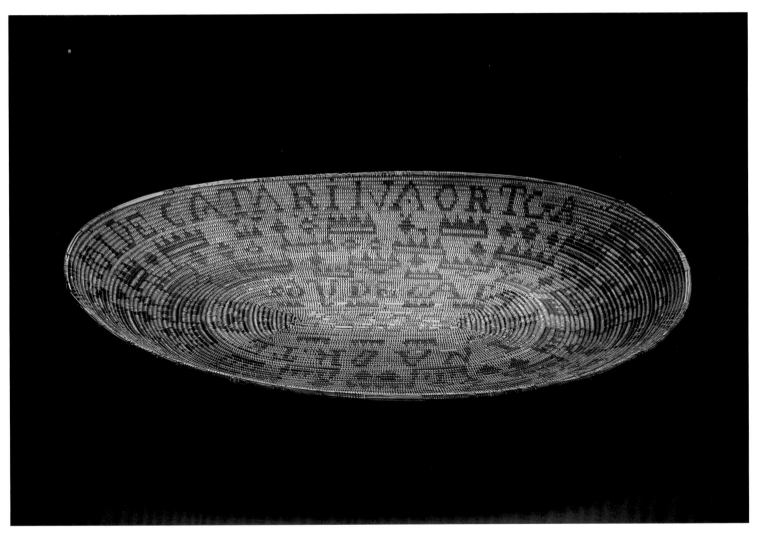

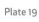

Plate 19

20	**Unangax^ (Aleut) artist. Cape, ca. 1824–27.** Mammal intestine, esophagus, and dye. 58 × 36 1/2 × 12 inches (147.3 × 91.4 × 30.5 cm). Peabody Essex Museum, Salem, Massachusetts, Gift of Seth Barker, 1835, E7344.

For hundreds of years, Unangan people from the Pribilof and Aleutian Islands, Alaska, wore lightweight hooded raincoats made from seal, sea lion, walrus, whale, or bear intestines. These windproof, watertight jackets were essential for hunting on sea or land. They were also worn in ceremonies and community festivals. No part of an animal went unused, and intestine, or gut, was no exception. Women cleaned, inflated, dried, sliced, and sewed the intestine together with seams of native grasses or sinew. The result was a flexible and completely waterproof shell to be worn over warm furs or sweaters.

In the early nineteenth century, when this coat was made, the Russian American Company, which had explored coastal Alaska for nearly a century, had full control of the region's seal and sea otter fur trade. The company subjugated hundreds of Unangan and other Native Alaskans, removing them from their homes into forced labor in hunting settlements on the isolated Pribilof Islands in the Bering Sea. The harshly exploited people adapted from a subsistence-based economy to the wage-based fur industry. The women transformed their traditional anoraks into novelty items made for sale to Russian military and sailors and visiting Europeans and Americans. Based on examples of European-style military jackets and overcoats, these long gut garments feature a continuous opening and a high-collared shoulder cape. In this example, the borders are lavishly decorated with appliquéd geometric motifs of dyed esophagus. These coats were likely commissioned as souvenirs, gifts, or for trade. High-ranking visitors and dignitaries dressed in such richly ornamented capes during celebrations and ceremonies. Unangan culture persists on the Pribilof Islands, despite the influence and colonization of Russia and then the United States, following the 1867 purchase of Alaska. Gut garments are still made and worn today. – KKR

References
Hickman 1987; Black and Liapunova 1988; Varjola 1990; Grimes 2002C; Fair 2006.

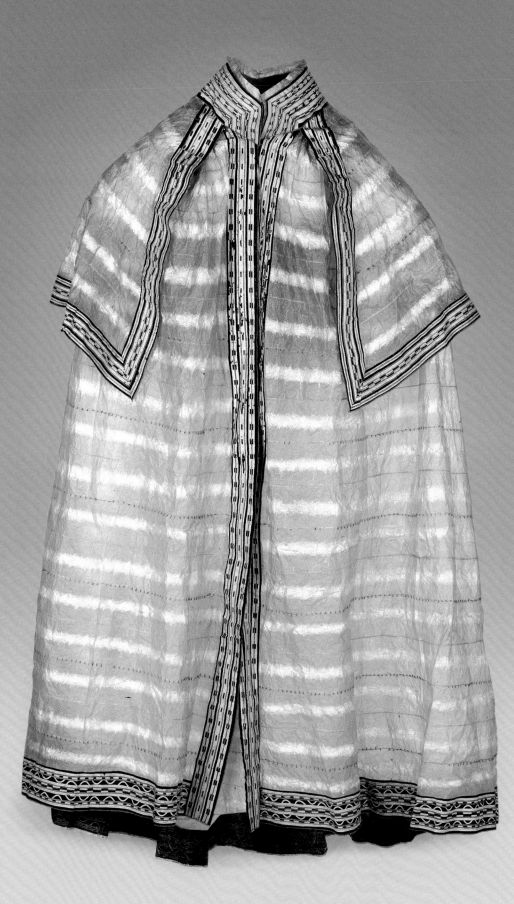

Plate 20

Changing
Voicing

Knowing

Locating

Time-Honored Expression The Knowing of Native Objects

Joe D. Horse Capture (A'aninin)

Whether they emerged from cracks in the earth's crust, were formed by small pieces of clay, or came from the animals, Native people have respected and relied on the stories and their meanings passed down from their ancestors. For some tribal groups, the sacred pathway of knowledge, a path that had been established for generations, veered into the deep, dark woods following Euro-American contact when Christianity was forced upon them. Pushing past the poison ivy, the thorny thickets, and into the open field, many Native people have rediscovered their traditional stories and philosophies. Their tools of understanding, of *knowing*, are universal, although the specifics vary wildly.

Telling a story is a powerful method of transferring knowledge and experience. Sharing stories is the life blood of any Native community; the practice is vital to preservation and continuance. Whether engaging within a small group or giving a formal presentation in a ceremony, storytelling is the instrument most widely used for the dissemination of knowledge. Social interaction much more than written language is critical for tribal well-being. Communal sharing and exchange – learning from one another – is valued among traditional people over isolation and private study. To learn together is to keep the People together.

Keeping cultural knowledge alive also means to participate in the requisite ceremonies. Each tribe has its own series of ritual celebrations that mark renewal and regeneration. They honor the Creator and the associated spirits, their world, and animals. The physical tools and paraphernalia used in ceremonial life have often emerged as objects of beauty. Whether their power and aesthetic quality derive from their physical properties or from their spiritual energy, such objects are imbued with their own stories. They are works of art, born from traditional life, that express the life-ways, philosophies, and worldviews of Native people. For example, a Tlingit Chilkat blanket declares the dancer's family heritage and links to clan ancestors through its crest imagery, dynamic representations of ancestral animals, heavenly bodies, heroes, and supernatural beings (plate 47 and Locating, pages 118–21). Worn in a community ceremony called a potlatch, such blankets serve a social and religious function by confirming a person's inalienable connection to

his or her clan or lineage through the visual embodiment of the spirit depicted – in this example, the killer whale.[1]

Reliance on the spirit world and those spirits embodied in animals is an essential element in the belief system of the Plains Indians. Since their arrival on the Great Plains, Native people had a nomadic existence, moving from one area to the next to ensure their food supply through the seasons of the year. Such an existence is inherently competitive because of limited and shifting resources. When the horse was introduced into North America and specifically to Native people of the Plains during the eighteenth century, it had a tremendous impact on their lifestyle. No longer solely dependent on the dog to transport belongings, they found every aspect of their lives improved. They could traverse greater distances, thus increasing the size of accessible territories. Hunting buffalo and other game became significantly easier. Possessions could increase because more could be transported. Warfare also increased because tribes became possessive of their expanded territory and more competitive. With the encroachment of Euro-American settlements, available areas shrank and conflict became

even more inevitable. Competing for territory, Plains Indians participated in small skirmishes with rival groups. Although this period was brief when considered within their history, such battles have become the stereotypical image of Plains Indians.

Essential for this new lifestyle, horses became a commodity, a means and an indication of wealth; they were trained for battle or for hunting. Men stole horses from their enemies. Those horses that distinguished themselves in battle by unflinchingly ignoring gunfire or running down the enemy were recognized and revered by their owners. Owners decorated and paraded them, celebrating their battle prowess. Horses killed in battle were honored, too. Some warriors sculpted wooden horse memorials or "horse sticks" representing their fallen comrades. Few object types created by Plains Indian warrior-artists symbolize the importance of honor and respect more than these memorials that bring together ideas of sacrifice and protection of the community. The memorials fall into two basic types: a full-bodied miniature horse or a head and long torso terminating in a hoof, with the stick forming the leg of

the animal. Few of the former have survived; the "stick" type is more common.

The Lakota people made two kinds of "stick" horse memorials. The first type features circular, sometimes brass-tack, eyes, a rounded hoof, and a streamlined jaw. The better-known second type, such as those made by No Two Horns (1852–1942)(also known as Joseph No Two Horns and He Nupa Wanica), are often painted blue and feature almond-shaped carved eyes, a series of small straight lines demarcating the jaw line, and an articulated hoof (figure 1). Here, the Plains artistic convention of red paint applied around the mouth symbolizes mortal injuries and the inverted V shapes across the body indicate bullet wounds.[2] No Two Horns was Hunkpapa Lakota and a member of Sitting Bull's band. He participated in the Battle of Little Bighorn, where General Custer was defeated and where, according to researchers who interviewed the artist, No Two Horns's horse was killed in battle (figure 2).[3]

With the confinement of the Hunkpapa Lakota on Standing Rock Reservation in the late nineteenth century, many Native artists modified their creations to appeal to a new, non-Native audience. Instead of waiting for this market to come to them, they went to the market. Mandan, North Dakota, was a little over fifty miles north of Standing Rock, and several Native artists made the trek. The Great Northern Railway stopped in Mandan on its way to the West Coast. Tourists from Chicago and farther east got off the train to take a break from the long hours of sitting. Alfred B. Welch, Mandan's postmaster, had arranged to have people from Standing Rock stage performances for tourists on the station platform (figure 3).[4] Wearing traditional dress, Native men and women would sing and dance for the crowd; beadwork and other items were available for purchase as souvenirs. No Two Horns's horse memorials may have been sold through this

market. Their production fulfilled his desire to honor his fallen horse but also served an economic purpose. The new market helped some of the Lakota survive during a time that was difficult for many Native Americans.

Although the physical presence of No Two Horns's horse was important, the soulful connection between horse and rider was equally essential. The relationship between human and animal in general has both physical and spiritual dimensions in many cultural regions in Native America. A number of tribal groups on the Plains associated animals with specific spiritual powers, which could be shared through dreams or visions. Chief among the animals was the bear, the largest carnivore on the Plains. It commanded particular respect because certain of its characteristics seemed anthropomorphic and thus made it partly human. For example, although it walks on four legs like other animals, it can also walk on two. In fact, the bear was the only animal on which a warrior could count coup. This practice of touching the enemy with a hand or stick and escaping, rather than killing him, took great skill and courage.

Plains Indians formed cultural and military societies, which were associated with different levels of status. Warrior societies trained warriors on what to do in battle and how. There were also dreamer societies that were associated with specific animals. A vision or dream of the animal was required for membership. One could be a member of only one society at a time. Many such societies existed in historical times, each with its own sacred powers. The most well known was the Elk Dreamer's Society, whose members claimed, among other powers, the ability to generate passion and control love – a powerful belief based on the bull elk's prowess (figure 4). For men on the Northern Plains, Bear societies were a large part of tribal life. Bear power was usually used for two purposes: healing or medicine for war.

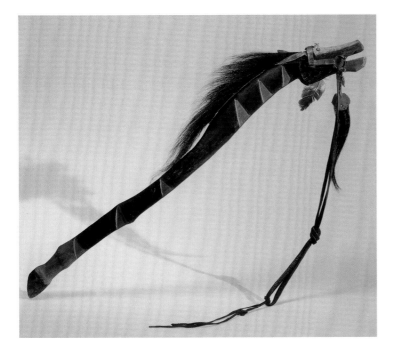

Figure 1. No Two Horns (also known as Joseph No Two Horns and He Nupa Wanica) (1852–1942), Hunkpapa Lakota. Horse memorial, ca. 1890. Wood, wool cloth, horsehair, leather, metal, hide thong, eagle feathers, iron nails, paint, and sinew. National Museum of the American Indian, Smithsonian Institution, Washington, DC, 14/1566. Photograph by David Herald.

Figure 2. No Two Horns (also known as Joseph No Two Horns and He Nupa Wanica) (1852–1942), Hunkpapa Lakota. Tipi cover (detail), ca. 1915. Pigment on canvas. Minneapolis Institute of Arts, The Christina N. and Swan J. Turnblad Memorial Fund, 94.47.4.

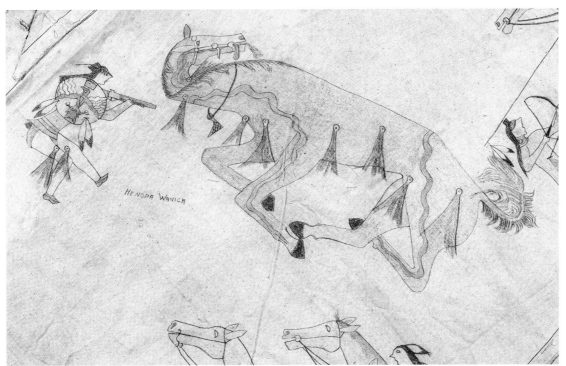

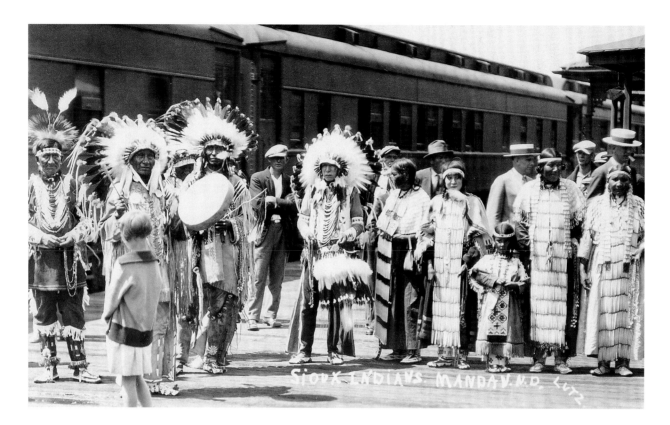

Figure 3. Hunkpapa Lakota at Mandan, North Dakota, train station, 1909–22. Postcard. Photograph © Rolland Ray Lutz, courtesy of Joe D. Horse Capture.

Among the Blackfeet and Gros Ventre (A'aninin), these societies were highly regulated. Strict rules governed membership, what to wear during ceremonies, and how to conduct oneself during battle. Among tribes such as the Blackfeet, Gros Ventre, and Assiniboine, the men went into battle with only one weapon, the bear knife. Its handle was made from the lower jawbone of a bear, the sheath from sweetgrass, and the blade was double-edged. The knife had both spiritual and physical properties. Because Bear Society members carried into combat the knife and a shield, hand-to-hand struggle was intense.[5] The shields were often decorated with bear-related imagery, invoking the warriors' relationship with the animal and demonstrating their power. An Upper Missouri River shield cover with a large bear paw painted in red in the center is a testament to the power of the bear (plate 37). The painted broken lines, which may symbolize bullets or hail, appear to be moving from right to left, stopping at the paw that dominates the field. The dashes seem aimed toward five smaller paws on the left side of the shield but are stopped by the large paw: the large bear is protecting the smaller ones from injury. Like a mother bear guarding her cubs, this Bear Society member protects other society members and/or their community. The sacred bear powers enable society members to not only honor their relationship with the animal but also protect their way of life.

Traditional stories telling of the reliance on animals is a commonality that is shared across cultural regions and tribal groups throughout Native America. Among Hopituh Shi-nu-mu (Hopi) who reside in the Southwest, the bird played an important role in their Creation story by leading the People from the caverns through an opening in the

Figure 4. Lakota artist. Elk Dreamer's Society pouch, 1890–1910. Porcupine quills, hide, beads, tin, and feathers. Minneapolis Institute of Arts, The Ethel Morrison Van Derlip Fund, 96.115.

Figure 5. Dan V. Lomahaftewa (1951–2005), Hopi/Choctaw. *Dream of Ancient Life*, 1995. Acrylic on canvas. Peabody Essex Museum, Salem, Massachusetts, Museum Purchase, 1997, E300221. Courtesy of the Lomahaftewa Estate.

earth's crust. As a consequence, its image figures prominently in many different forms of their art. The 1995 painting *Dream of Ancient Life* by Dan V. Lomahaftewa (Hopi/Choctaw) pays homage to the bird and other symbols that reflect Hopi traditions (figure 5). In addition to the main motif of the large abstracted spiral-shaped bird, Lomahaftewa showed Spider Woman, the female life force, who gives much needed rain. Lomahaftewa's bird design has clearly been influenced by earlier Hopi ceramics. Such imagery and stories exist throughout the Southwest. They can be seen in ceramics by Nampeyo and have stylistic roots further back in protohistoric (ca. 1275–1600) Sikyatki villages on the east side of the First Mesa.

Probably the most famous Hopi potter, Nampeyo, was a major leader in the Sikyatki Revival movement in the early twentieth century. Her designs were influenced by ancient Sikyatki pottery shards that she found.[6] A single one of her pots can embody an entire belief system (plate 23). Here, a coiled central figure of an abstracted bird, probably a reference to the Origin story, is flanked by abstracted Kachina designs that refer to Hopi spirituality and traditional stories.

On the other side of the continent, some Yup'ik masks illustrate the connection between the human and animal worlds. According to Yup'ik thinking, humans are animated by several elements, including breath and warmth, which are essential to life. When a body runs out of heat or breath, it ceases to live. Although these elements work together to sustain life, they can be separated in the spirit world. Breath that has left a body waits until it is passed on to the next generation. When a person is given the name of someone from the previous generation, the "breath" from that ancestor can be reborn in the younger individual. This transference of spiritual energy (breath) from one generation to the next ensures continuity and regeneration of the People.

In the Yup'ik world, spiritual transference applies not only to humans but to animals as well, especially seals. Although life breath could not be directly transferred from humans to animals, it could be preserved for the next generation. Like other traditional Native groups, the Yup'ik feel that hunted animals consent to give their life to the People. It is believed that the hunters' breath puts the seals to sleep and their life force moves to their bladder. After the hunt, the bladders are preserved, to be used in a ceremony held in the spring. The bladders of all the seals killed during the year are inflated (filled with air or breath) and hung during the ceremony. The lives and sacrifice of the seals are honored and celebrated. On the fifth day of the ceremony, the breath-filled bladders are taken to the sea and pushed through a hole in the ice, to be reborn into the next generation of seals.

No objects reflect this philosophy of transference and rebirth better than *walaunuk* masks. In this wonderfully abstract example (plate 32), the lower portion is painted black with white dots while the upper portion is unpainted. These two areas may represent the upper world and the lower world, where humans reside. The long appendage with three disks protruding from the top of the mask represents *walaunuk* (bubbles). The curved stick not only holds the bubble disks, but also shows the trail of the bubbles – pockets of air and life. The air bubbles are the life force that comes from the humans and is blown into the seal bladders, where the animals' life force resides. It is activated when the air-filled bladder is submerged in the sea and the bubbles escape.[7] Here, the life and breath of humans and animals merge into one. From the ancestors to their descendants, to the seals, and back to the ancestors, the breath of life continues to energize and enliven the animal, human, and spirit worlds.

Detail of plate 31

Coyote is a character common to many Native American people, both today and in the past, who often appears in stories. Coyote is a trickster, a mischievous rule-breaker who challenges the authority of the natural and supernatural worlds. Coyote's acts of deception, thievery, clownishness, and cunning shape the world, often creating a positive outcome. The difficult lessons he learns help teach the value of keeping a sense of humor while persevering through the hardships that life presents. A shapeshifter, Coyote has the ability to transform into different guises; he appears in his many forms in contemporary Native American art and literature. For example, in *When Coyote Leaves the Reservation (a portrait of the artist as a young Coyote)* (plate 34), Nisenan Maidu/Hawaiian/Portuguese artist Harry Fonseca depicted the infamous trickster in a stylized self-portrait. By portraying Coyote in contemporary clothing and a contemporary setting, Fonseca honored Coyote's extensive cultural roots while showing this time-honored figure as relevant today.

Rick Bartow (Wiyot) demonstrated Coyote's resourcefulness and adaptability in *From Nothing Coyote Creates Himself* (plate 24). Bartow's work is his medicine for processing life's challenges. In this piece, Coyote is in the process of transforming – and creating – himself. Bartow's work acknowledges Coyote's ongoing importance in his culture and simultaneously serves as a means through which the artist explores personal identity. Bartow said of this work: "I suppose the literal truth here is that we all create ourselves with the aide of our talents, or situations of adversity or benefit."[8]

Children brought into this world are considered gifts from the Creator and are accompanied by hopes for their health and happiness. Parents, grandparents, and extended family often express their love in items they make for them. In traditional Plains culture, highly decorated children's clothing produced around the turn of the twentieth

Figure 6. Todd Yellow Cloud Augusta (dates unknown), Oglala Lakota. Baby bonnet, 1991. Cotton and glass beads. Minneapolis Institute of Arts, The Christina N. and Swan J. Turnblad Memorial Fund, 91.93.

century was not only intended to look good, but also reinforced ideas and philosophies that had been embedded for generations. With the changing of traditional life-ways and beliefs during this period, reminders of who the Plains Indians are as a people assisted in cultural preservation. In an earlier, pre-1840, time, drastic cultural change was not a dominant concern. The highly decorated items created for children during this period served as a template for later works (figure 6).

The Dakota in the Eastern Plains and Western Great Lakes regions were responsible for some of the finest examples of cradleboards made in the first half of the nineteenth century. A wooden board served as the foundation of the cradleboard; straps attached to the sides prevented the infant from getting free. The vast majority of these objects had a thin piece of wood that protrudes out of the sides and around the front and over the head area of the cradleboard. This piece served as a bumper, protecting the child's face if the carrier overturned. A mother would carry the cradleboard on her back, mount it on the side of a horse,

or lean it against a tree, thus having multiple ways of tending to a young child while keeping it safe. Cradleboards were often created by the child's relatives and presented as gifts at birth. A prestigious family could receive over a dozen embellished cradleboards for their offspring.[9]

An elaborate early cradleboard (plate 22) has straps and bands lavishly ornamented with porcupine quills. Using a basic palette of black, red/orange, and the natural white of the quills, the woman who created this prized possession embellished it with embroidered symbols that reflect the cosmos while simultaneously protecting the child. There are zoomorphic figures on the decorative band that hangs from the bumper, on the carrying strap, and on the lower portion of the strap that holds the child inside the cradleboard. These beings look like abstracted birds that are standing on their tail feathers with wings on each side of their upright bodies (plates 25 and 29).

For many tribes throughout Native America, this symbol represents Thunderbird, a spirit-being that controls the Upper World. For many generations, all the way back to ancient times, the cosmos was seen as basically divided into Upper and Lower worlds. The Underwater Panther (or "Underwater Monster") controls the Lower World (figure 7). These two spirit-beings are in constant competition with one another. When lightning flashes, it is said to come out of the eyes and talons of Thunderbird, who also creates the thunder. Although considered extremely powerful and often dangerous, Thunderbird also brings the rain and weather to the People. His image appears on many ceremonial objects created in the Plains and Great Lakes regions, either to summon his power to the object or honor his presence.

The multiple presence of Thunderbird's image on this cradleboard is significant. On the strap used by the mother to carry the child, it signifies that the bond

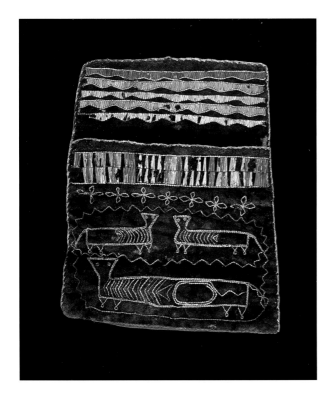

Figure 7. Chippewa-Ojibwa (Anishinaabe) artist. Pouch, before 1840. Leather, porcupine quills, and dye. Peabody Essex Museum, Salem, Massachusetts, Ex A.B.C.F.M. Collection 1976, E53449. Image © 2012 Peabody Essex Museum, photograph by Mark Sexton and Jeffrey R. Dykes.

between mother and child is a sacred one. It also appears on the decorative strip that hangs on the bumper and on the tab above the cradleboard, so it is first and foremost in front of the child. Lastly, a row of red Thunderbirds appears on the lower decorated strap between two rows of anthropomorphic figures. Although their specific symbolism is not known, the combination of the rows of anthropomorphic and Thunderbird figures on a strap that is wrapped around the child can be interpreted to mean that the community (anthropomorphic) and the spirit world (Thunderbird) are protecting the child, ensuring its safety and empowering its success.

With such tools of transferring knowledge from one generation to the next, Native people continue to make tradition part of their lifeways. Their objects are frequently imbued with clues that can be used to reacquaint them with information that may have been lost. These ideas from the past can be used today to enliven and reenergize today's People. From traditional objects to contemporary works, Native people continue to rely on knowledge that their ancestors used and preserved for the future.

Notes

1. De Laguna 1990, p. 213.
2. Maurer 1992, p. 144.
3. Wooley and J. D. Horse Capture 1993, pp. 32–33.
4. Unpublished manuscript, Mandan Indian Shriners, Mandan, North Dakota.
5. Ewers 1968, pp. 131–45.
6. Morand, K. Smith, Swan, and Erwin 2003, p. 136.
7. Fienup-Riordan 1996, pp. 171–75.
8. Bartow 1989.
9. Lessard 1990, pp. 44–53, 105.

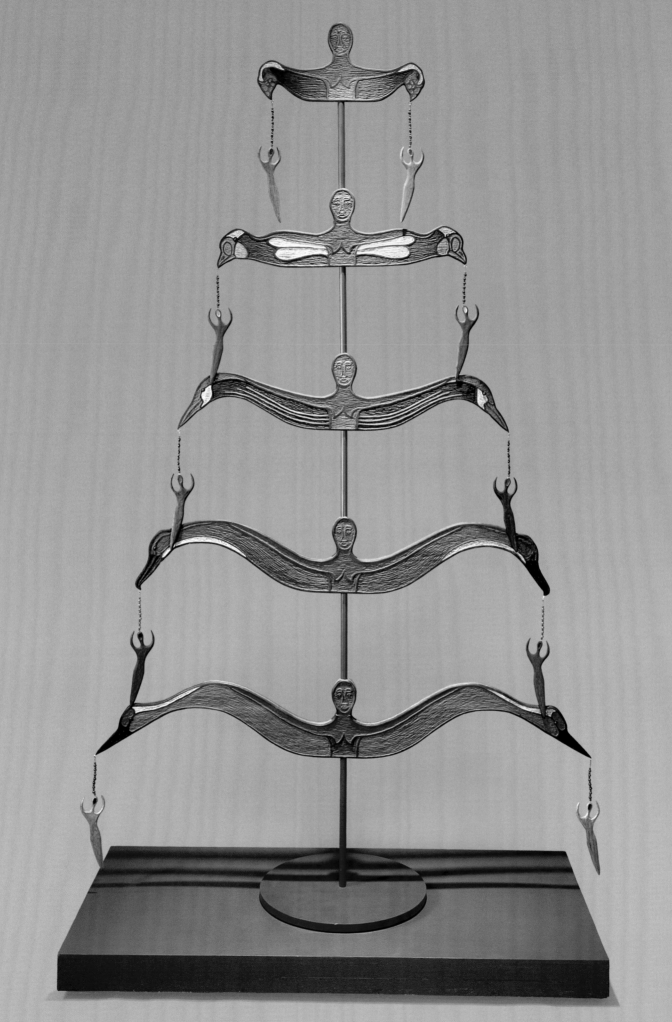

Plate 21

21

John Hoover (born 1919), Aleut. *Shaman's Tree of Life*, 1985. Cedar, paint, glass beads, and metal. 121 × 71 × 3 1/2 inches (307.3 × 180.3 × 8.9 cm). Anchorage Museum, Alaska, 1985.50.1.

John Hoover was born in 1919, the son of an Aleut mother and Dutch father. He was brought up in Cordova, Alaska, and in 1953 moved to Washington state. Despite not growing up in a Native community, Hoover is intimately connected to the spirituality of his ancestral Aleuts. For decades, he has been inspired by shamanism of northern people. One characteristic of a shaman's supernatural experience is shapeshifting, the ability to transform into another being, often a bird. A central aspect of shamanic cosmology is the Tree of Life, the wellspring that stands at the center of the cosmos. The shaman can climb the tree to the Upper World or descend along its roots to the Lower World.

In this carving, Hoover interpreted the tree of life as a five-branched object with sinuous women hanging from its boughs. For Hoover, the female, who possesses immense creative powers, represents the origin of life.

These suspended figures thus enhance the generative and sustaining essence of the tree itself. The importance of woman is reinforced on the center of each branch by a female head and torso. Their outstretched arms merge with the heads of five different species of sea birds, suggesting transformation from human to avian form. On the middle branch is the loon, which, as a guardian spirit for Aleut shamans, has special significance for Hoover.

This is a highly dynamic sculpture. Each branch rotates on the central tree trunk, and each suspended woman moves like an element of a mobile. The movement of the elements suggests that the tree has within itself an inner force – that of life. – AJ

References
Decker 1999; Decker 2002; Fair 2006.

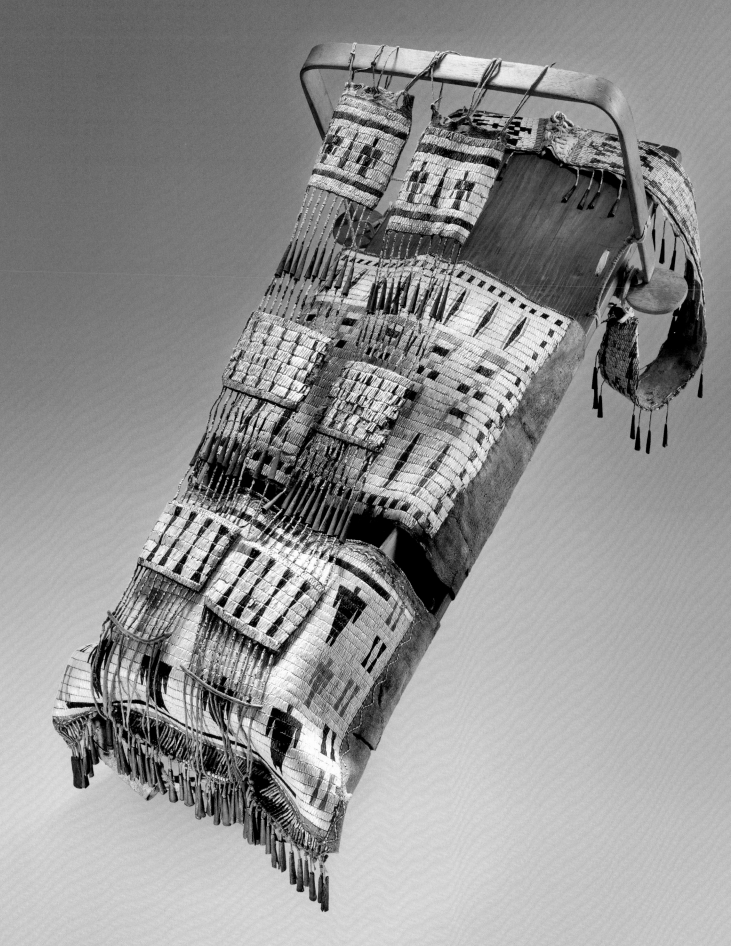

Plate 22

22 **Dakota (Eastern Sioux) artist. Cradleboard, ca. 1840.** Wood, leather, porcupine quills, metal, and dye. 33 × 15 1/2 × 17 inches (83.8 × 39.4 × 43.2 cm). Peabody Essex Museum, Salem, Massachusetts, Museum Purchase, 2002, E27984.

Newly made or heirloom cradleboards, also called baby carriers, were gifted to an expectant mother from a female family member related through blood or marriage. The carrier secured, protected, and transported the baby, and freed up the mother's arms for her chores. The infant spent its first year strapped to the mother's back, thus placing the baby at adult eye level and facilitating important formative socialization.

The orange, white, and dark brown color scheme used here is very distinctive in Dakota quillwork from the first half of the nineteenth century. The main wrapping consists of large fields of white quillwork boldly decorated with hourglass shapes, elongated diamonds, and anthropomorphic figures. The carrying strap and strips hanging from the bumper rail feature motifs thought to represent Thunderbird, the omnipotent spirit-being who keeps dangerous Lower World creatures at bay and also bestows blessings on humans. The hourglass designs on the main wrapping and the solid truncated triangles on the straps may be stylized abstractions of Thunderbird and thus understood as an appeal to its protective powers. The figures may represent *manitos*, nonhuman beings who bless humans with power.

The prestigious trade materials used on this carrier include dozens of pendant metal cones formerly filled with dyed deer hair, and precious blue pony beads strung along the base. Furthermore, the tremendous feat of processing thousands of porcupine quills and weaving such an elaborate and meaningful design suggests this cradleboard was made for a family member of very high rank. Comparative examples of Dakota full-size and model cradleboards from this time frame comprise a spectacular group of quillwork production. The design elements are similar enough to suggest they were produced by the same artist or family of artists.[1] – KKR

Notes

1. The only other known full-scale example from this early period (Smithsonian National Museum of Natural History, cat. no. 73311) was collected by George Catlin between 1832 and 1839. Other comparative works include the quilled remnants from a model cradleboard (Brooklyn Museum, cat. no. 50.67.44), and model cradleboard (Wisconsin Historical Society, cat. no. 1952.449). For additional examples, see Feest and Kasprycki 1999, pp. 283–84.

References

R. B. Phillips 1984; Feest and Kasprycki 1999; Catlin, Heyman, Gurney, and Dippie 2002; Grimes 2002A; K. Kramer 2007.

23 **Nampeyo (ca. 1860–1942), Hopi. Polychrome jar, ca. 1925.** Ceramic and paint. 8 1/2 × 14 1/4 inches (diam.) (21.7 × 36.3 cm). Gilcrease Museum, Tulsa, Oklahoma, 54.4396.

Nampeyo, born in the Hopi village of Hano, is widely recognized as one of the greatest Native American potters. By the early nineteenth century, drought and epidemic illnesses nearly caused the disappearance of Hopi ceramics. In the late years of the century, Nampeyo was critical in helping to revive Hopi pottery traditions. In her early work, she used imitative designs inspired by pottery shards found in the nearby ruins of Sikyatki, an abandoned village on the Hopi mesa. Notably, she rediscovered Sikyatki clay sources long abandoned by her ancestors. Her style evolved into highly innovative forms with distinctive fine-line abstract designs that influenced future generations of family and other Hopi artists. Nampeyo commented: "When I first began to paint, I used to go to the ancient village and pick up pieces of pottery and copy the designs. That is how I learned to paint. But now I just close my eyes and see designs and I paint them."[1]

Nampeyo was particularly drawn to bird designs found on shards of prehistoric polychrome vessels. On this polychrome jar of her making, she painted a swirling stylized bird, its long beak tucked under fluid, sweeping wings and feather "fans." Kachinas, benevolent Hopi ancestral spirit beings who act as intermediaries between humans and the spirit world, flank the bird. Integral to Hopi life, these design motifs embody important cultural concepts. Nampeyo's work remains highly sought after by collectors around the world. – KKR

Notes
1. Nampeyo, quoted in Bunzel 1972, p. 56.

References
Bunzel 1972; B. Kramer 1996; Blair and Blair 1999; Morand, K. Smith, Swan, and Erwin 2003; McChesney 2007.

24 **Rick Bartow (born 1946), Wiyot/Yurok. *From Nothing Coyote Creates Himself*, 2004.** Wood. 41 × 84 × 16 inches (104.1 × 213.4 × 40.6 cm). Courtesy of the artist and Froelick Gallery.

From the elegant curve of *From Nothing Coyote Creates Himself* to the detailed construction of the face and languid tongue, Rick Bartow's expressionist sculpture portrays the human condition, transformation, and the process of healing. In part self-portraiture, Bartow's art is his therapeutic outlet for coping with life's challenges, in particular his experience serving in the Vietnam War.[1] Using animals to represent people and vice versa, he speaks to the interconnections of all living creatures. Employing found materials from within or around his home in Oregon near Yaquina Bay, he pushes viewers to see their own reflection in the imagery.

Bartow carries forward the traditional belief in following "the voice of the wood."[2] Although he may have an idea in mind, the wood often dictates the direction his forms will take. Bartow finds personal healing through making art that is process-oriented instead of outcome-specific. For him, "Drawing is an attempt to exorcise the demons that have made me strange to myself. My work has never stopped being therapy. I have drawn myself sane."[3] In *From Nothing Coyote Creates Himself*, for example, the extended arm is a metaphor for having regained the strength to shake the world's hand.

Plate 23

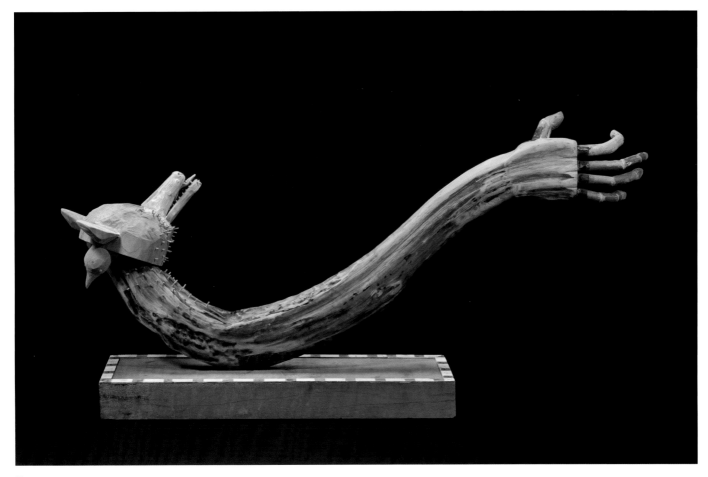

Plate 24

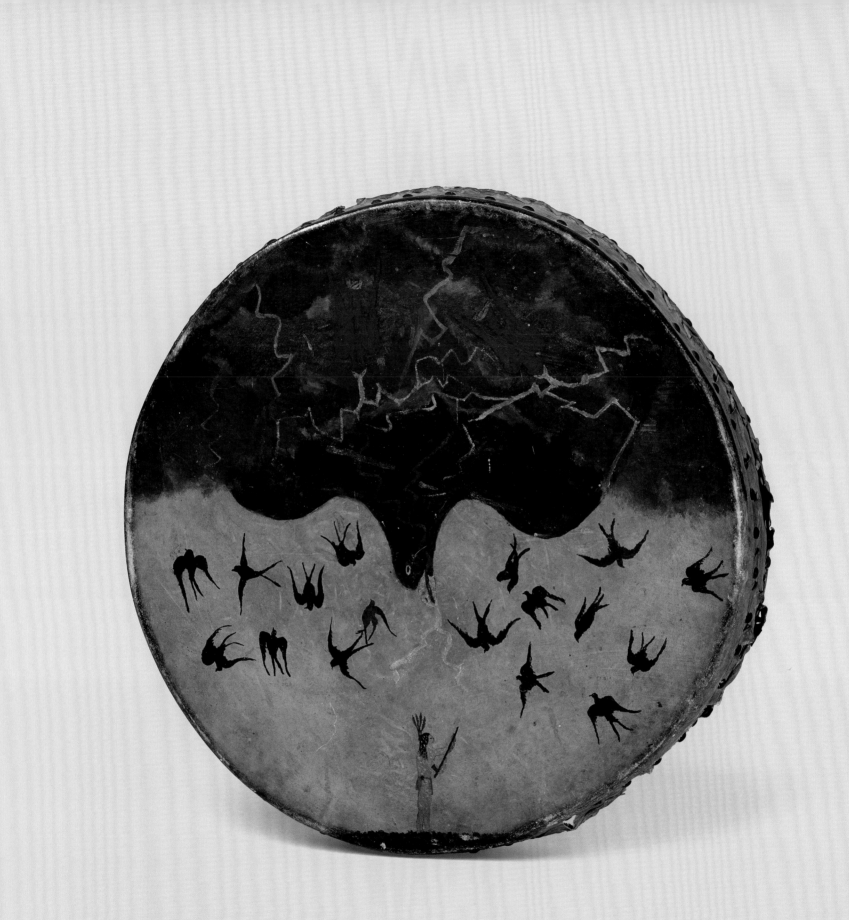

Plate 25, day side

24

Bartow intends his work to be mythic and universal, but it is also deeply informed by his Wiyot heritage and his preoccupation with Coyote likenesses and Eastern Woodlands–style crooked knives and adzes. An iconic figure in the oral histories of many Native American cultures, Coyote stars in humorous tales that teach morality through the negative consequences of his misbehavior. In Bartow's sculpture, however, Coyote is a cathartic vehicle. Bartow desires all people to know that through grief and agony, recovery can be attained, bringing with it hope, inspiration, and joy. – KE

Notes
1. During the Vietnam War, Bartow was a teletype operator and a member of a military band that performed in hospitals for American soldiers and for Vietnamese amputees and victims of napalm.
2. Bartow 1989.
3. Bartow 1996.

References
Bartow 1989; Bartow 1996; Bartow 1998; Dobkins 2002; Everett in Everett and Zorn 2008, pp. 7–10; Bartow 2010.

25

Chaticks-si-Chaticks (Pawnee) artist. Double-sided drum, ca. 1890. Rawhide, wood, iron, and pigment. 3 1/2 × 18 inches (diam.) (8.8 × 45.7 cm). Fenimore Art Museum, Thaw Collection, Cooperstown, New York, T0086.

Wovoka, a Paiute prophet acclaimed for organizing the Ghost Dance religion, which inspired people to revive cultural traditions such as hand-games, renewed Native faith and hope during a dark era of Native American history. Native people were being forced into reservation life and were suffering from hunger and disease. Wovoka encouraged good behavior and cultural revitalization, claiming that colonial expansion would soon cease and a traditional way of Native life would be restored. Emerging just before 1890, Ghost Dance ceremonies quickly spread throughout the North American plains but were extinguished by the devastation of the Wounded Knee Massacre that ended the "Indian Wars."

This double-sided drum is similar to two drums attributed to George Beaver and may have been part of his hand-game bundle.[1] A renowned medicine man, Beaver was also a core member of the first Seven Crow Brothers, of

Plate 25, night side.

the Skiri band of Chaticks-si-Chaticks (Pawnee), formed as an alternate group to assist the Seven Eagle Brothers in leading the Ghost Dances.[2] While the dance was usually performed without instruments, hand-games used them to accompany songs believed to enhance the guessing team's ability to win.[3] Thus, this striking drum carries

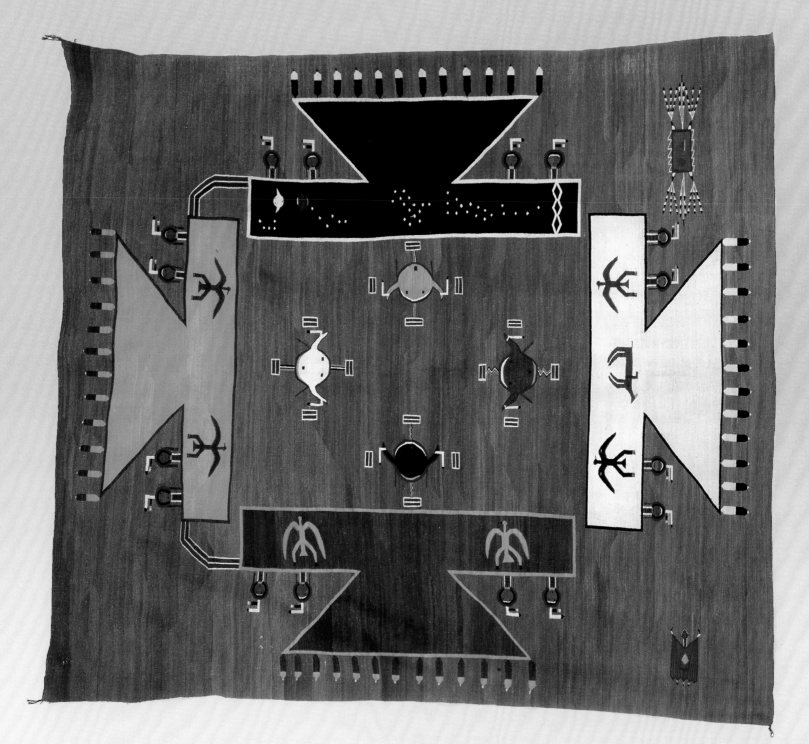

Plate 26

25

the knowledge of Ghost Dance history and hopes ignited by the music of the hand-games. The speckled hail pattern surrounding the five-pointed star, on the side of the drum intended for night games, relates to the vision that instructed Beaver to carry out the game in a dark blue tent dotted with a hail design.[4] The day-use design vividly reveals Pawnee credo concerning Thunderbird, the omnipotent spirit being, associated with birds in general and especially eagles, believed to bring storms and lightning. Black, blue, and green symbolize the North and yellow signifies the South. The pipe offering is directed at Thunderbird, a literal depiction of the prayer before each game. – KE

Notes
1. The two drums are in the American Museum of Natural History, New York, and the Field Museum, Chicago.
2. Lesser 1996, pp. 97–100. Beaver is also credited with reviving The Society of the Crows (*raris kaka*), a lance society.
3. Unlike all other hand-games, Ghost Dance hand-games did not involve betting.
4. Maurer 1992, pp. 134–35. This star and hail design was intended for night games.

References
Howard 1951; Wissler 1975; Vennun 1982; Maurer 1992; Lesser 1996.

26

Hosteen Klah (1867–1937), Diné (Navajo). *The Skies (from the Shootingway Chant)*, 1937. Wool. 110 × 123 inches (280 × 312.4 cm). Kennedy Museum of Art, Ohio University, Athens, KMA 91.023.172.

A Navajo sandpainting diagrams the constant motion of an animate and dynamically symmetrical universe that, in the words of scholar Trudy Griffin-Pierce, exists in "the mythopoetic context of layered time, space and meaning."[1] The maker of this sandpainting textile, Hosteen Klah, was a powerful, widely respected religious practitioner born into a family of weavers. Nearly a century ago, he was among the first to translate sandpaintings into textiles, and wove many such works during his long life.

This was his last weaving. It depicts an episode from the Shootingway Chant called *The Skies*, imagery that Klah and subsequent weavers used repeatedly.[2] The four large keystone-shaped forms represent the clouds of the four directions as well as four types of light. East is the white light of dawn, South the blue sky of noon, West the yellow light of sunset, and North the black of night revealing the Milky Way. These shapes also call to mind the four sacred mountains that surround the Navajo landscape, which in English are called Mount Blanca, Mount Taylor, the San Francisco Peaks, and Mount Hesperus. The four round semi-abstract heads in the center of the textile evoke what the Navajo call the "inner forms" of these mountains, from which all light emanates.

The prototypes for sandpaintings were the ephemeral diagrams that the Navajo Holy People or Supernaturals composed out of rainbows, clouds, and lightning bolts. Navajo religious practitioners make sandpaintings out of pollens and minerals to heal and restore *hózho* (harmony, beauty) to those who are unwell; after use, the pictures are destroyed. For nearly a century, such ritual diagrams have been recorded in fiber by a small number of talented weavers. – JCB

Notes
1. Griffin-Pierce 1992, p. 7; see also Newcomb 1964.
2. Klah wove one in the 1920s. See McGreevy 1982, Object #44/8. His niece, Gladys Manuelito, wove a similar one also in the collection of the Kennedy Museum of Art, #91.023.417. See also Campbell 2005, figure 1; Winter 2002, p. 44.

References
Newcomb 1964; McGreevy 1982; Griffin-Pierce 1992; Winter 2002; Campbell 2005; Berlo 2011.

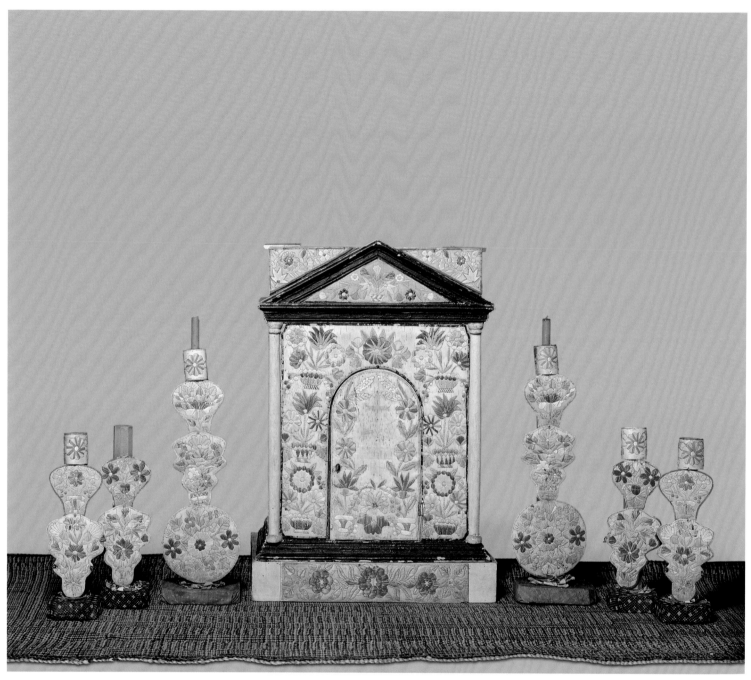

Plate 27

27 **Odawa (Ottawa) artist. Tabernacle, candlesticks, and antependium, 1840.** Wood, birchbark, porcupine quills, and fiber. Tabernacle: 27 1/4 × 13 1/4 × 19 3/4 inches (69 × 33.5 × 50 cm); candlesticks: 13 3/4 and 19 3/4 inches each (length) (35 and 50 cm) ; antependium: 41 3/8 × 89 3/4 inches (105 × 228 cm). Museum für Völkerkunde, Vienna, 131684-131690, 131693.

By the time the Austrian painter Martin Pitzer collected these magnificent works at Cross Village (La Croix) on the northeastern shores of Lake Michigan in 1846, the Odawa community had been interacting with European fur-traders, explorers, and missionaries for nearly two centuries. Singular in Great Lakes Indian art and made around 1840 for the Catholic mission chapel established at Cross Village a decade earlier, these pieces held a place of honor on an altar in the center of the congregation.[1] They reflect a confluence of Odawa and Western aesthetics and religious ideologies.

The tradition of porcupine quill-decorated birchbark is longstanding in Odawa art. Floral and plant iconography was introduced to Great Lakes Native artists from European sources as early as the eighteenth century. Considered to be a "civilized" decoration, it replaced earlier "pagan" geometric and stylized figural motifs. In this ensemble, the flowers and plants, including the flowering potted plants, were possibly inspired by patterns seen in mission schools or from the ubiquitous calico textiles.[2] The designs also bear an affinity to early nineteenth-century American women's painted furniture and needlework and American Fancy, a decorative arts movement reflecting cultural enlightenment.[3]

This resourceful artist used turned dowels for columns and picture frame remnants form the pediment and base; combined, they reflect Neoclassical architecture common to this time period. White feathers once joined the silk and cloth ribbons at the calico-wrapped candlestick bases. These items would have fluttered, a kinetic quality fundamental in pre-contact Odawa worldview indicating airborne, ascending prayer. That these items were included in an altar suggests the artist's religious ambivalence.[4]

Pitzer, who was attached to Cross Village from 1850 to 1853, painted a new altarpiece in 1851 to replace this set, which he acquired and toured in Austria with other Odawa objects in order for the Leopoldine Society to raise money for the mission schools established among the Odawa. – KKR

Notes
1. The tabernacle is one of the most important religious objects, for it houses the Eucharist, or Holy Communion, which is consecrated and consumed in remembrance of Jesus's death.
2. The flowering potted plants may also reflect flowers in urns that possibly were painted on the walls of the church, as in the case of Red River Métis women, who embroidered this same imagery onto clothing and were inspired by the paintings on their cathedral walls. Penney 1991, p. 71.
3. See Priddy 2004; Salm 2010.
4. R. B. Phillips 1998, pp. 180–81.

References
Penney 1991; Harp 1998; R. B. Phillips 1998; Van Bussel 2001; Priddy 2004; Salm 2010.

28 **Hopewell artist. Hand, 100 BC–AD 400.** Sheet mica. 10 × 5 1/4 inches (25.4 × 13.4 cm). Ohio Historical Society, Columbus, A283/294.

This mica hand emits a strong presence, beckoning the viewer toward an entrance, a view into the soul, or, alternatively, issuing a warning to come no closer. Beautiful and ethereal, it elicits a deep emotional response, a sense of humanity, vulnerability, and intimacy.

The mysterious object was excavated in Ross County, Ohio, at the Hopewell site, from mound 25; the mica is thought to have come from what is now North Carolina. It may have been a gift between people representing the importance of spiritual beings as a dimension of Hopewell life. Many of the materials appropriated for such exchanges – copper, marine shell, mica, red ocher –

held value for a thousand years or more and continue to be used for such purposes. This brittle, ancient hand suggests the fragility of being human.

Historic records indicate that severed hands were sometimes taken as war trophies, evoking the spirit and strength of an enemy out of respect and the potential value of sympathetic and contagious magic. Hopewell ceramics incorporating severed hand motifs are thought to have been used in purification rituals before and after warfare. Depictions of these and human bones on pottery are believed to be representations of war trophies as a means to maintain and increase status. – BB

References
Douglas and D'Harnoncourt 1941; Coe 1977; Dubin 2004; Seeman 2004; Dye 2007.

29 **Algonquin artist. Pendant, 1500–1700.** Copper. 9 1/2 × 4 7/8 × 1/8 inches (24 × 12.2 × .1 cm). Peabody Museum of Archaeology and Ethnology, Harvard University, Cambridge, Massachusetts, 33-54-10/1536.

Long a traditional material for Native artists, copper was produced for decorative arts and regalia prior to trade with Euro-Americans. In the eastern half of North America, for example, pure nuggets from locales such as the southern Appalachian Mountains and the Great Lakes were gathered and then hammered into thin sheets and fashioned into desirable items.

This copper Thunderbird pendant was found at Amoskeag Falls, New Hampshire, the original home of the Amoskeag, an Algonquian language–based culture that like many Native cultures hold Thunderbirds in high regard. Typically depicted as bird-man figures, these powerful guardians watch over humans, transport their prayers to the Creator when they fly south for the winter, and have the power

to bring back the spring growing season. The migration pattern of birds in North America – arriving in spring, present during the summer season of thunderstorms, and departing to southern warmth in the fall – helps to explain why many Native American oral histories view Thunderbirds as the creators of thunder and lightning.

Although it is difficult to say with certainty what this adornment represented to its wearer, some scholars believe it was intended to imbue its owner with a long and healthy life and ensure many generations of descendants. The two small holes in this pendant, which serve as the bird's eyes, are a practical detail that allowed the pendant to be suspended as a necklace. Yet, it is clearly a personal item, and beyond its common iconography, its deep and specific meaning would have been known only to its owner. – KE

References
Bragdon 1996; Diaz-Granados 2004; Steponaitis and Knight 2004.

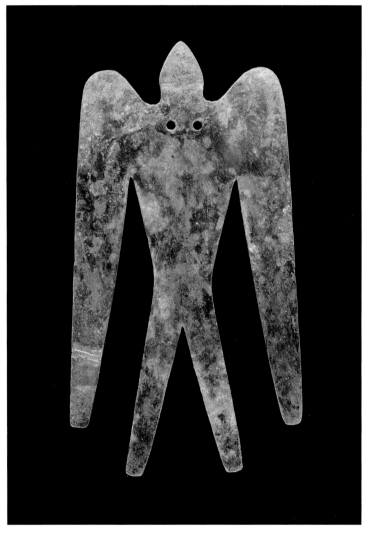

Plate 28

Plate 29

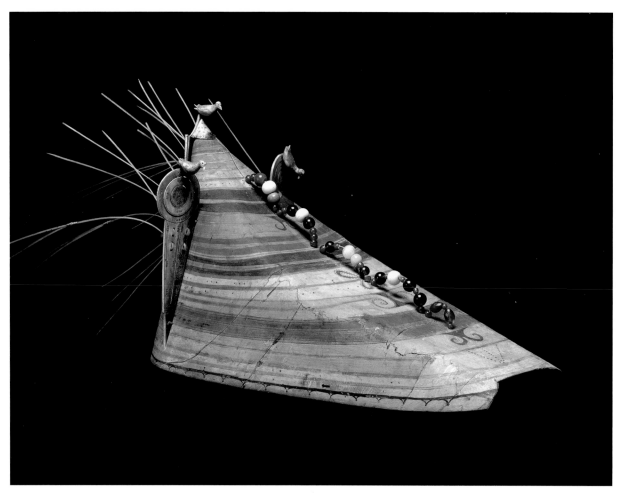

Plate 30

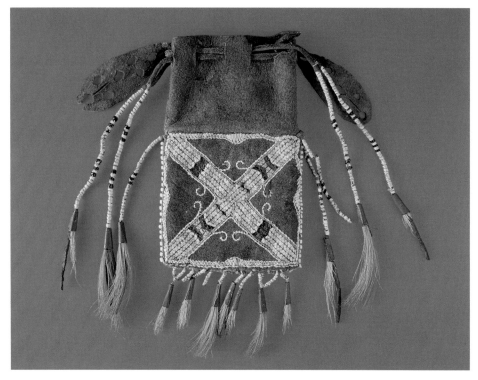

Plate 31

30 **Unangax^ (Aleut) artist. Hunting hat, ca. 1820s.** Wood, glass beads, ivory, sea lion whiskers, and paint. 14 3/4 × 42 × 14 1/2 inches (37.5 × 106.7 × 36.8 cm). Peabody Essex Museum, Salem, Massachusetts, Gift of Thomas Meek via William Osgood 1829, E3486.

In the spring months, Unangan hunters of Alaska's Aleutian Islands took to their kayaks to pursue sea mammals, including the seals, walruses, and sea lions that would ensure the survival of their community. Extremely dangerous, hunting was surrounded by elaborate symbolism and ritual. On the water, the hunter – also a skilled artisan in woodworking, carving, and painting – wore an ornately decorated bentwood hat that shielded the sun's glare but also bore a mix of individual and cultural aesthetics that embodied Unangan worldview and thereby protected the hunter and connected him to his home. The hat's cultural meaning – embodied in material and design – spanned the unknown between water and land, creating comfort, confidence, and power where there was often uncertainty and danger.

The materials used to make these hats had symbolic value. The driftwood body of the hat acted as a physical prayer and an expression of hope for a safe return to land. It was often adorned with feathers, baleen, walrus ivory, and sea lion whiskers (thought to attract prey). Imbuing the hat with the qualities of these animals ensured the success of the hunt and the ritual act of wearing the hat transformed the hunter into the animal with which he was often associated – the powerful predatory sea bird.[1] The tapered design – painted with strategically placed spirals to resemble eyes – gives the appearance of a bird floating along the water; carved ivory volutes attached perpendicularly along the sides of the hat resemble diving birds. These characteristic motifs and their complex associated meanings express the ambivalent nature of the sea bird that, like the hunter, moves between land and sea as both a benevolent life-force (or provider) and dangerous predator, whose presence heralds home's harbor. – MMK

Notes
1. Black 1991, pp. 11–80.

References
Black 1991; Grimes and K. Kramer 2002; Fienup-Riordan 2007; British Museum 2010.

31 **Northeastern artist. Pouch, late 1600s–mid-1700s.** Deerskin, porcupine quills, porcelain beads, animal hair, metal, and sinew. 7 1/2 × 6 1/2 × 1/2 inches (19 × 16.5 × 1.3 cm). Peabody Essex Museum, Salem, Massachusetts, Donated by Edward S. Moseley, 1950, E28561.

This elegant draw-string pouch is a magnificent example of the elaborately decorated buckskin pouches made in the geographic region from the Western Great Lakes to the Eastern Seaboard during the seventeenth and eighteenth centuries. This utilitarian object – likely worn in the belt of the artist's husband for carrying tobacco – was

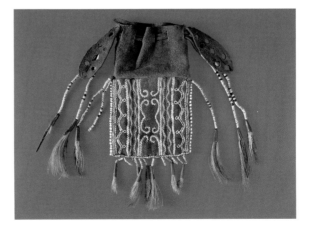

Plate 31, obverse.

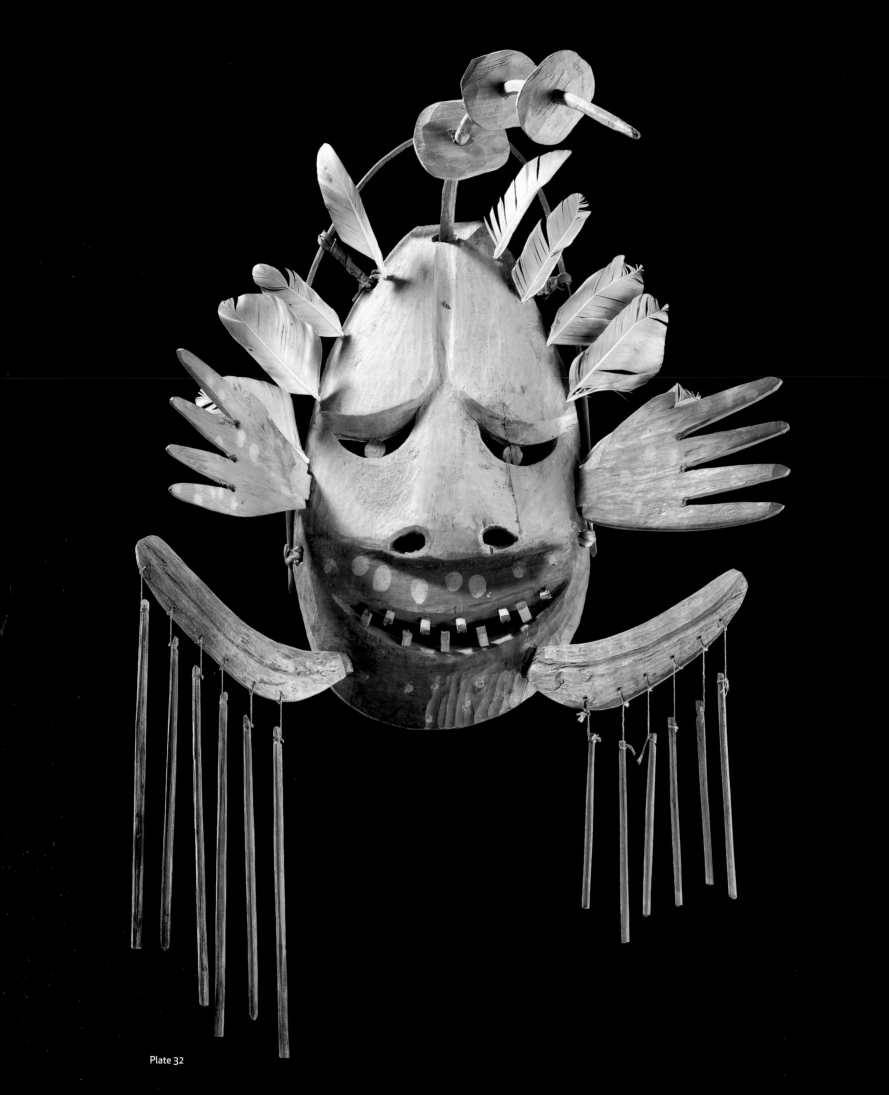

Plate 32

31

transformed into a portable work of art, and a profound container of her worldview.

Among Native cultures of the Northeast Woodlands, the earthly cosmos is inhabited by humans, animals, and supernatural beings. Here, benevolent and malevolent forces are in a constant state of flux, humans and animals are kindred spirits, and animals are respected for their spiritual powers. Thus, only with its consent and in times of need can a hunter take the life of a creature; he then appeases its spirit with a prayer offering of tobacco.

Related to this hunting ritual, this pouch can be understood as a reverent symbol of the hunted: the pull-ties possibly becoming legs and decorative perforated leather tabs suggesting ears or beaver tails.[1] On the deerskin body are finely woven and embroidered dynamic patterns of dyed porcupine quills and moosehair. While early records indicate a Pennacook provenance,[2] the quillwork on one side of the pouch resembles the equal-armed cross common to Great Lakes artistry. Symbolizing the earthly axis through which humans and spirits could communicate,[3] the cross finds visual and ideological affinity with the cascading delicate double-curved motifs of the Northeast Woodlands on the

pouch's obverse. Among their many symbolic functions, these double-curves manifest the desire and necessity for balance in one's life – a concept further articulated in the double-sided nature of the pouch itself. Profoundly emblematic of a vital confluence of all human and animal life, this personal object ensured the survival of the artist's family and community through the maintenance of cosmological equilibrium. – MMK

Notes
1. Dodge 1949, p. 9; see Speck 1935, pp. 227–30.
2. Issues of provenance stem from two handmade labels that accompanied the pouch when it was given in 1979 to the Peabody Museum of Salem by Edward S. Moseley. These labels indicate the pouch was made at the Poore family's ancestral house at Indian Hill, Newbury, Massachusetts (which passed through marriage to the Moseley family in 1883), but contain conflicting information as to which family member collected the item and when. Consequently, it has been difficult to finalize the Pennacook attribution. Based on stylistic conventions, Kasprycki believed the pouch was likely made by an individual from a politically associated group, the Abenaki. See Dodge 1949, pp. 3–6 and Kasprycki 1997, pp. 71, 74. It is important to note that the pouch was part of a group of items belonging to the Moseley family, several of which were likely collected by the Reverend Ebenezer Moseley, who served as a missionary among the Onaquaga in New York in 1765 –73. Given the extensive histories of the Poore and Moseley families in the Northeast, future research is called for.
3. Phillips 1984, p. 27.

References
Speck 1935; Dodge 1949; R. B. Phillips 1984; Wilbur 1995; Kasprycki 1997; Grimes 2002D, p. 96; Longtoe 2006.

32

Yup'ik artist. Mask representing _walaunuk_, early 1900s. Wood, feathers, paint, and cordage. 34 × 21 1/2 × 17 inches (86.4 × 54.6 × 43.2 cm). National Museum of the American Indian, Smithsonian Institution, Washington, DC, 9/3432.

The arched strand of circular disks at the top of this mask represents _walaunuk_, or bubbles as they rise to the surface of water. Among the Yup'ik people of Alaska,

bubbles are visible manifestations of breath. This spiritually potent substance is integral to systems of reciprocity between Yup'iks and the animals they depend on for survival. Animals have an extraordinary capacity to see, smell, hear, and know, and must be willing to give themselves up to hunters. When a seal is killed, its _yua_, or soul, retreats to its bladder, awaiting release by human hands. During the five-day midwinter Bladder Festival, young men inflate each bladder with their breath and the

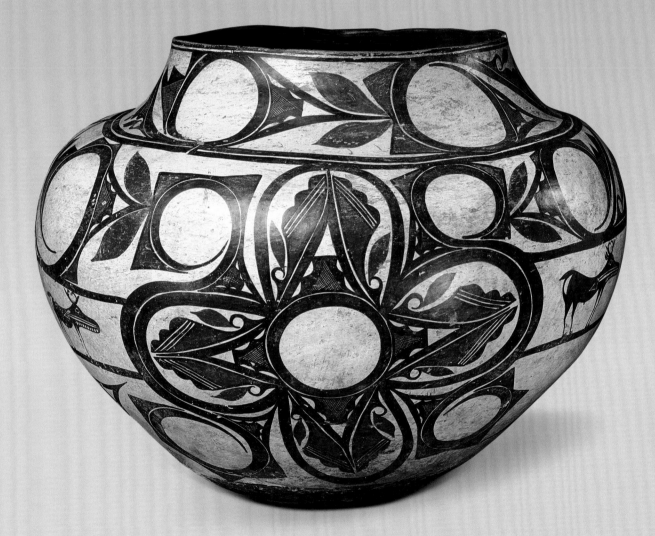

Plate 33

32

community honors the *yua*. At the close of the festival, the bladders are deflated under the ice. The satisfied *yua* escapes like bubbles, only to return, embodied, during next year's hunt.

Yup'ik people expelled their breath through songs and stories to accompany masked dances during long winter ceremonial months. Masks such as this one gained meaning only when enlivened by song, dance, and stories, conjuring an imperceptible world of spirits. By the early twentieth century, Euro-American contact had displaced masked dancing from the center of Yup'ik spiritual life.

Today, we can only imperfectly grasp this mask's symbolism. Feathers, spots, and zones of light and dark may correspond to the complementary worlds of sky and water; the hoop suggests the circularity of the Yup'ik universe; the appendages at the bottom evoke seal flippers. A hand with stunted thumbs signifies the supernatural power emanating from the activity of human hands as well as breath. – JLH

References
Fienup-Riordan 1996; Wallen 1990.

33

Attributed to Arroh-a-och (ca. 1830s–1900), Laguna Pueblo. Jar, 1870–80. Ceramic and paint. 19 × 25 inches (diam.) (48.2 × 63.5 cm). School for Advanced Research, Santa Fe, IAF.1026.

This unusually large storage jar was made at Laguna Pueblo, New Mexico. When archaeologist Kenneth Chapman purchased the vessel in 1928, he noted in his collecting journal that it was made by "Arroh-a-och, a famous Laguna hermaphrodite." Less is known today about Arroh-a-och than about his "two-spirit" contemporaries We'wha (Zuni, ca. 1849–1896) and Hosteen Klah (Diné [Navajo], 1867–1937), but it is clear that like these other men who assumed women's gender roles, Arroh-a-och excelled at an art form traditionally reserved to women.

As on many Pueblo pots, the designs here are painted in red and black over a background of white slip; they include two large floral rosettes, a frieze of antelope, and a series of spiraling forms called "rainbird" motifs. All these design elements were common to Zuni Pueblo pottery in the late nineteenth century, but

here they were modified to align with Laguna aesthetic traditions, which favor flowing, organic forms. For example, the rosettes are unique in that Arroh-a-och has removed the round framing elements of the Zuni prototype, allowing the "petals" to mingle with surrounding motifs. The center of each rosette is a perfect empty circle, which resonates visually with the large rhythmic spirals around the neck and the body of the vessel, unifying the two design fields.

"Two-spirits" were honored as intermediaries in Pueblo societies and it is tempting to suggest that the hybrid designs on this jar – part Zuni and part Laguna – reflect the life of its maker. Arroh-a-och's adaptation of Zuni motifs became a signature style and a number of other pots have been attributed to him on the basis of this unique aesthetic. – KM

References
Batkin 1987; Harlow 1990; Roscoe 1991; Dillingham 1992; Anderson 1999; Lanmon 2005.

34 Harry Fonseca (1946–2006), Nisenan/Maidu/Hawaiian/Portuguese. *When Coyote Leaves the Reservation (a portrait of the artist as a young Coyote)*, 1980. Acrylic on canvas. 48 × 36 inches (122 × 91.5 cm). Heard Museum, Phoenix, IAC 1412.

In the early 1970s, Harry Fonseca was deeply immersed in his Maidu heritage: he was learning traditional dances and painting vast canvases illustrating Maidu Creation stories as told to him by his elders. Coyote featured prominently in these early works – as Creator and trickster, and as a central figure in Maidu ceremony. In 1976, however, Fonseca's Coyote took a huge conceptual leap – in *Coyote Leaves the Res No. 1*, he stepped out of tradition and into popular culture. Now clad in leather jacket and blue jeans, he was something of a rebel, and as Fonseca's alter ego, he provided the artist with "a chance to confront the world."[1] Over the next thirty years, Fonseca's Coyote traveled through multiple realms and appeared in multiple guises: as Pueblo clown, skateboarder, opera star, and, of course, artist. Embodying characteristics immediately recognizable to both Native and "mainstream" audiences, Coyote became a nearly universal symbol. In 1993, Fonseca even beatified him, in *St. Coyote*.

During a brief period in the late 1980s, Coyote took a leave. Fonseca had turned his attention first to a series of works that were again based on tradition and spirituality, and later, to a series addressing the darkest moments in California Native history.[2] His friend the scholar Aleta Ringlero believes that Fonseca was concerned that the more serious associations of Coyote in Native culture had become compromised by the popular and commercial success of the Coyote series.[3] Nevertheless, he eventually returned to his favorite character, perhaps recognizing that Coyote's greatest contribution lay in demonstrating how a traditional figure such as the trickster could still be relevant in the modern world. – KM

Notes
1. Fonseca, quoted in Antoine and Bates 1991, p. 10.
2. *Stone Poems* (1989–90) are based on ancient rock art symbols; *The Discovery of Gold and Souls in California* (1991–92) confronts the history of genocide during the California Mission Period and the Gold Rush.
3. Ringlero 2005, p. 62.

References
Wasserman 1987; Antoine and Bates 1991; Ringlero 2005; Fonseca 2010.

35 Roxanne Swentzell (born 1962), Santa Clara Pueblo. *Emergence of the Clowns*, 1988. Ceramic and paint. 23 × 13 × 15; 17 × 23 × 18; 17 × 14 × 14; 7 × 19 × 11 inches (58.4 × 33 × 38.1; 43.2 × 58.4 × 45.7; 43.2 × 35.6 × 35.6; 17.8 × 48.3 × 27.9 cm). Heard Museum, Phoenix, IAC2344A, IAC2344B, IAC2344C, IAC2344D.

The potter Roxanne Swentzell depicted four *koshares* or sacred clowns as they emerge from the earth. In the Euro-American tradition, the words "sacred" and "clown" do not belong in the same sentence; in the Pueblo imagination, they are inseparable. These striped tricksters have been part of the cosmological tool kit of Puebloan peoples of the American Southwest for more than a thousand years, and they appear frequently in contemporary Native art. Clowns defy normative behavior. They alone can satirize both the sacred and the foreign. In so doing, they hold up a mirror to the social order. Ritual clowning as part of public performance extends back at least a millennium in the Native American Southwest; such figures are painted on bowls from the eleventh century.[1] They are also ubiquitous in Pueblo watercolors created during the early

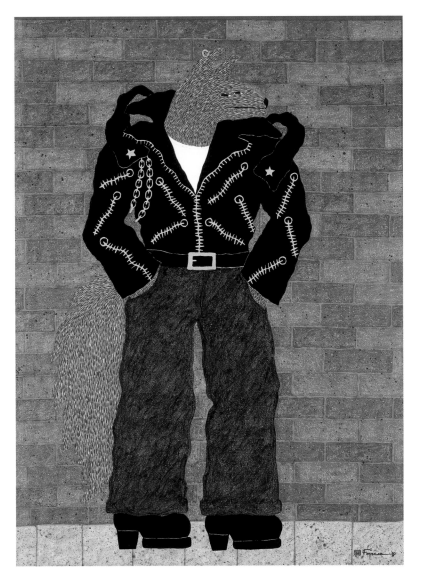

Plate 34

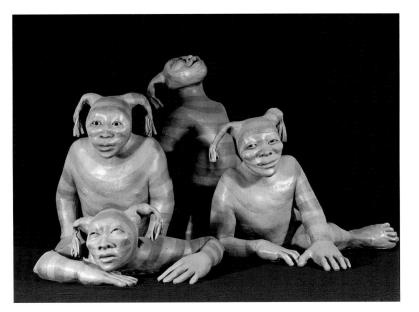

Plate 35

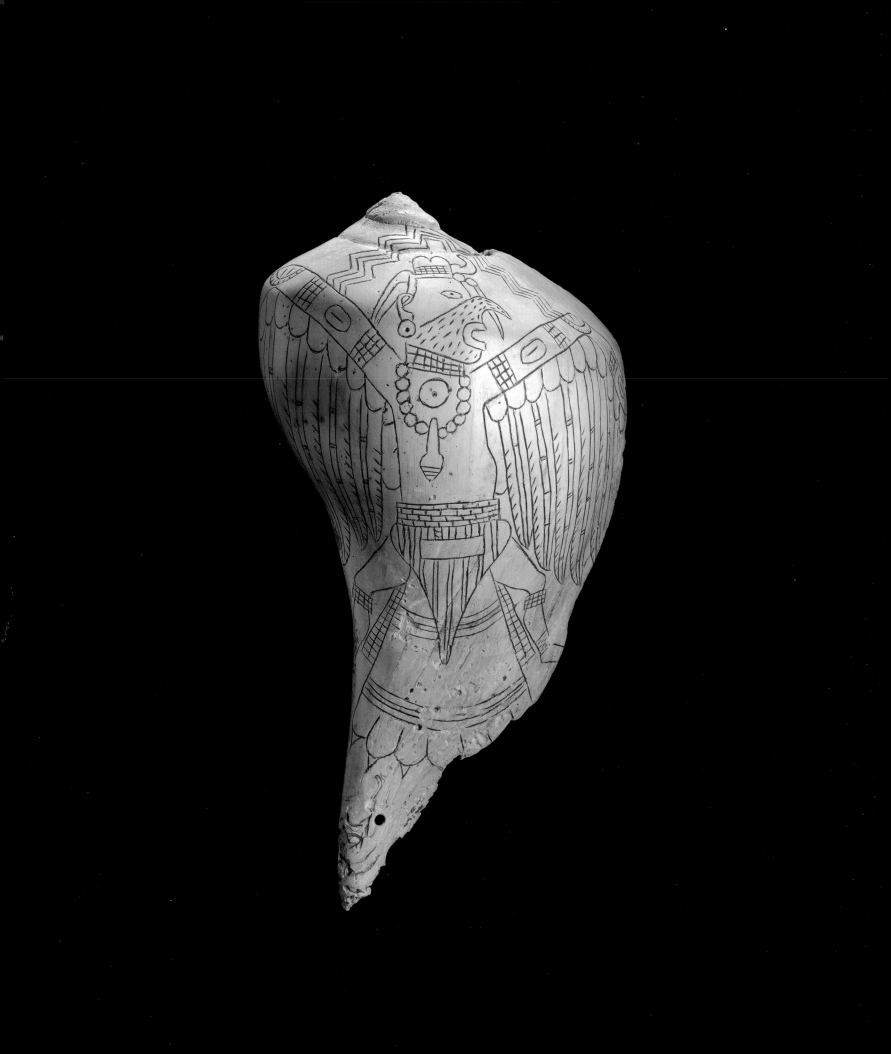

Plate 36

35

twentieth century, when Native painters first embraced the modern genre of easel painting (plate 7).

Swentzell has been making "clay people," as she calls them, since childhood. She comes from a distinguished family of potters, including her uncle Michael Naranjo, her mother, Rina Naranjo Swentzell, her aunt Nora Naranjo-Morse (plate 56), and her daughter Rose B. Simpson. In addition to her artistic apprenticeships within Santa Clara Pueblo, she studied at the Institute of American Indian Arts in Santa Fe and at the Portland Museum Art School in Oregon. Her work is in numerous museum collections, including the Smithsonian Institution, the Denver Art Museum, and the Wheelwright Museum of the American Indian in Santa Fe. – JCB

Notes

1. See Brody 1977, fig. 18, which depicts a masked striped figure painted on a Mimbres bowl.

References

Brody 1977; Babcock 1984; Peterson 1997; Batkin 1999.

36

Spiro Mound, Cahokian artist. Drinking cup, 1200–1400. Lightning whelk. 13 1/4 × 7 1/8 × 5 1/8 inches (34 × 18 × 13 cm). National Museum of the American Indian, Smithsonian Institution, Washington, DC, 18/9121.

Across the vast Mississippi River floodplain, Mississippian culture flourished from approximately 800 to 1600. From the ancient Midwest to the South, people participated in an intricate network of trade, religious, and artistic connections, centered on a newly developed maize-based agriculture and a politically stratified chiefdom. Cultural, aesthetic, and ideological similarities among Mississippians are known as the Southeastern Ceremonial Complex (SECC). At the epicenter of this expanse was Cahokia, at its peak (1050–1250) one of the world's largest cities and a cultural model for many of the outlying regional centers, including Spiro, Oklahoma, where this cup was found.[1] Spiro's nobles and elite leaders were buried in a massive eighty-acre mound, with hundreds of thousands of personal and ritual objects that reflected their rank, exclusive knowledge, and power.[2]

A chief would have used this ceremonial drinking cup in a ritual performance for communicating with the supernatural realm for victorious outcome in warfare.

Engraved on the cup is a human figure impersonating Birdman, a prominent entity in the religion of the SECC. This mythic culture hero – the falcon warrior – constantly fights for life against death.[3] He embodies the virtues of warfare and competition. Here, he stands in a highly engaged pose, wings upraised, under a stepped platform associated with the Upper World. Barred ovals and hatch marks on his arms symbolize the Serpent, ruler of the Lower World. The hatching also represents beaded arm, leg, and head bands worn as markers of wealth. This shell, most likely traded from the Gulf of Mexico and embellished with powerful imagery, would have further elevated the status of its owner with whom it was buried. – KKR

Notes

1. Townsend 2004B, p. 18. Ancient Cahokia is located just east of present-day St. Louis.
2. This mound, called Craig Mound, and other areas of Spiro were looted by artifact hunters in 1933–35 in one of the greatest archaeological tragedies in North America. Such large architectural mounds served as platforms for buildings, religious and/or political stages, and cemeteries.
3. J. A. Brown 2007, p. 71. One of Birdman's guises is the Morning Star, whose light prevails against darkness.

References

P. Phillips and J. A. Brown 1978; King 2002; Dye 2004; Townsend 2004B; J. A. Brown 2007.

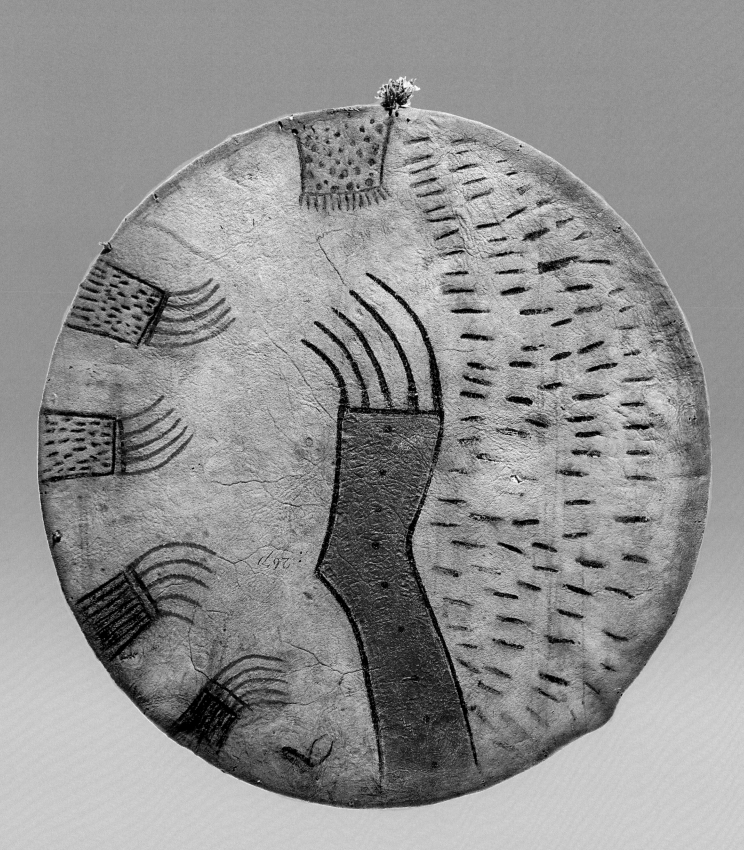

Plate 37

37 **Upper Missouri River artist. Shield cover, ca. 1820.**
Hide, pigment, and dewclaws. 23 1/2 inches (diam.)
(59.7 cm). National Museum of Natural History,
Smithsonian Institution, Department of Anthropology,
Washington, DC, E2671.

Prior to Westward Expansion in the nineteenth cen-
tury, the formidable grizzly bear roamed western North
America from the Great Plains to Alaska. Respected
and feared for their great strength and ferocity and ever-
present on the landscape, these animals became
ingrained in the ideologies of many Plains tribes (see
Knowing, pages 78–80). The bear's power was thought
to be protective, and warriors sought to acquire it
through visions and dreams. Such visions were often
painted on tipi covers and drums, as well as on rawhide
shields and their hide covers, as in this magnificent
example. The designs were believed to contain such strong
medicine that they, rather than the shields, protected
the owner. Despite the very public display of the shield
cover's design, the vision itself and its associated
meaning remained private to its owner.

A red bear paw with its five distinctive long, sharp, curl-
ing claws reaches upward from the foreground, dividing
the cover into two lateral fields. On the right, a fairly
uniform pattern of horizontal short black lines, possibly
representing a hail of bullets, stops short at the center,
as if deflected by the paw. Two pairs of smaller bear's
claws, each with their own designs facing different direc-
tions, are on the other side. A small animal with long,
thin, upturned horns is tucked adjacent to the large paw.
A dotted, fringed square extends from the top of the
cover, with a string of deer dewclaws.

This shield cover was probably collected by the U.S. War
Department, the agency responsible for managing
trade, treaties, and delegations with Native people in the
1820s, administered by Colonel Thomas L. McKenney,
the Commissioner of Indian Affairs.[1] Stylistically, it has
been attributed to an artist in the Upper Missouri
River region, which includes the Arikara, Hidatsa, Mandan,
Assiniboine, Blackfeet, and Crow tribes. – KKR

Notes
1. Greene, Richard, and Thompson 2007, pp. 66, 75.

References
Grinnell 1923; Ewers 1968; Ewers 1982; Greene, Richard, and Thompson
2007; Hansen 2007.

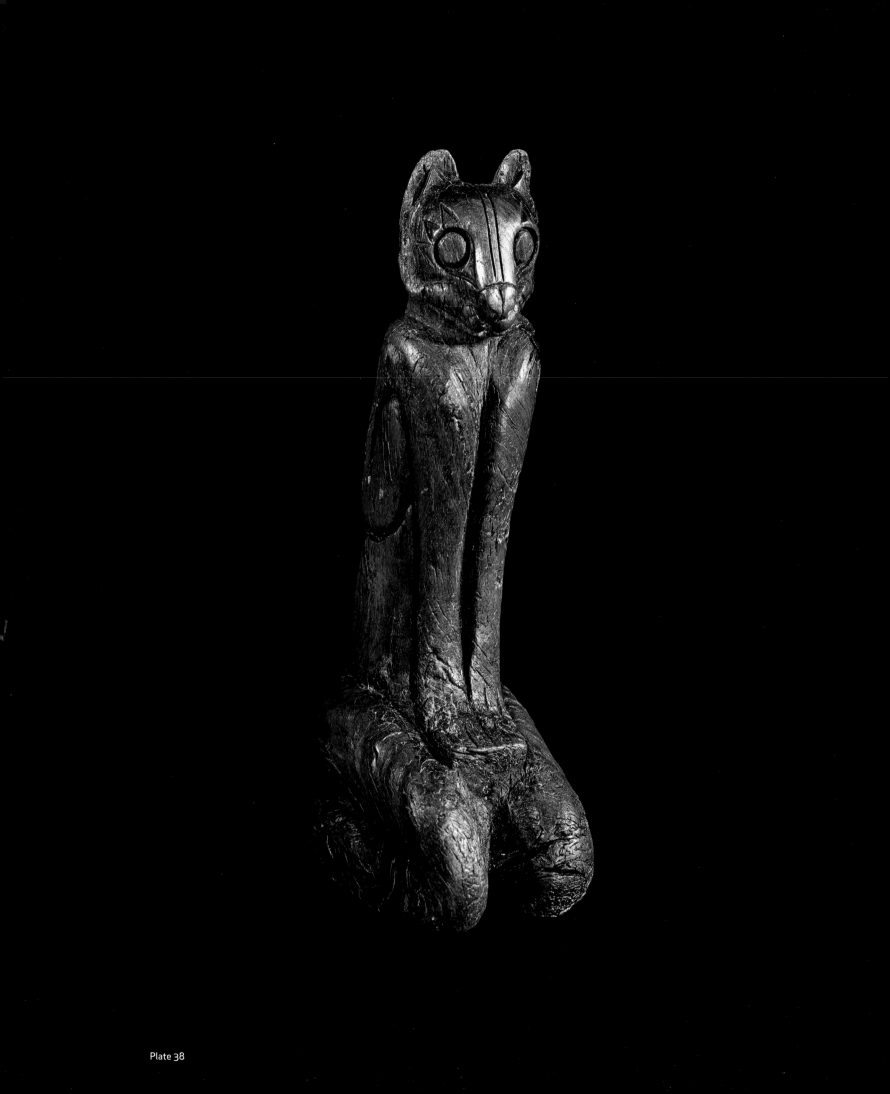

Plate 38

38 **Southeastern artist. Human-feline effigy, 700–1500.** Wood. 6 × 1 3/4 × 2 3/4 inches (approx.) (15.2 × 4.4 × 7 cm). National Museum of Natural History, Smithsonian Institution, Department of Anthropology, Washington, DC, A240915-0.

This human-feline effigy, found at Key Marco in Florida in 1895 by noted anthropologist Frank H. Cushing, was carved using shell scrapers and a shark's tooth (apparent from the smooth sweeping lines and clean edges), and rubbed with a protective layer of animal fat. Panthers, indigenous to what is now Florida, would likely have inspired Native artists to create their likeness. Additionally, Native people of Southeastern North America, among others, have in their oral histories the concept of a world order kept in balance by Underwater Panthers who rule the watery Lower World and Thunderbirds who rule the Upper World. These human-animal beings are continually at war, not only to maintain the balance between the worlds but also between the elements of fire and water.

Archaeologists consider this figure to be stylistically distinct from all other regions.[1] Stories and images of Underwater Panthers in North America, similar to those of jaguars from Central and South America, portray these animals as cross-breeds, with mountain lion or lynx tails, deer antlers, snake scales, and/or bird feathers. In contrast to some of these deliberately terrifying characteristics, the face is typically described as benign. It is unknown who the inhabitants of Key Marco were in 700. Some scholars suggest this effigy may have been carved by someone associated with the Southeastern Ceremonial Complex. By historic contact times, however, this region was part of the greater Calusa domain and, as such, the carving was possibly made by a Calusa artist. – KE

Notes
1. Gilliland 1989, p. 71.

References
Howard 1960; Waldman 1985; Wilson 1985; Gilliland 1989; Bolgiano 1995; Deloria 1995.

Changing

Voicing

Knowing

Locating

A Shore without a Horizon Locating by Looking Anew

Jessica L. Horton

A watery diptych (plate 39). Above, mist smudges ripples late or early in the day. Streaks of reflected light emanating from a terrestrial world cropped from view give way to purplish-black depth. Below, the gaze is washed to shore. Infinite water arriving from beyond the frame meets a beach of sand and pebbles – or perhaps they are boulders. White foam marks the agitation of encounter.

The intensive detail and saturation of the large-scale photographs of Thomas Joshua Cooper (Cherokee) effectively create a world: the viewer lingers in their visual borderlands, looking back, looking forward, suspended in the uncertainty of departure and arrival.[1] The long, descriptive titles *A Premonitional Work. Plymouth Sound - Looking S., S. W. – Hopefully, Towards the New World …* and *A Premonitional Work. Plymouth Bay - Looking N., N. E. – Back, Towards the Old World …* (1998–2001) explain that the visual vibration the diptych sets up between locales echoes a concrete historical connection; our gaze moves between two Plymouths, one in Devon, England, where the Pilgrims set sail on the Mayflower in 1620, and the other in the indigenous Nauset territory of the Americas that would eventually become the state

of Massachusetts, where the sea-battered vessel landed sixty-six days later. Like all journeys, that one did not end with the dropping of an anchor. The Mayflower's arrival was one segment in the multiple geographies of contact, sending ripples through landscapes that are continuously and presently felt.

In his photographs, Cooper poetically restages historical ambitions to circumnavigate the globe. This diptych is part of his vast project to document the Atlantic Basin with his 1889 field camera, in each instance taking a single painstakingly composed photograph at unpeopled sites where the shores of the five continents meet the ocean. The horizon is omitted and the scale of things rendered indeterminate. Exposures as long as several minutes reveal spaces out of time, all traces of past human encounters reduced, like the jagged peaks of waves, to silky surface.[2] Yet, the titles of individual works call into question the fiction, dear to European forebears, that the intrepid explorer to North America dwells in the "emptiness and extremity" of lands where no other has dared to go.[3] They name shores long traversed by the ships and canoes of Native and non-Native ancestors

and strangers. In the meditative photographic map that emerges, history will not stay in place any more than Plymouth stayed in England.

Cooper's photographs dispense with any notion that *locating* is a straightforward task – one with a discrete beginning and end. Behind the *ing* of the gerund lie worldly constants of movement and change. The agency implied in *locating* shifts attention toward human actors involved in mapping, connecting, and making sense of the various forces shaping their environments. Such a project of identifying spatial and temporal coordinates is always unfolding, guiding the urge of Cooper and other artists to chart, and therefore see, anew.

This sense of a perceptual landscape continuously sculpted by human and nonhuman forces was present in the imaginative cartographic practices of Native Americans prior to European contact.

Maps were not created as permanent documents in Native North America. The features of geography were part of a much larger interconnected mental map that existed in the oral traditions. The world was perceived and experienced through one's history, traditions, and kin, in relationships with the animal and natural resources that one depended upon, and in union with the spirits, ancestors, and religious force with whom one shared existence.[4]

Euro-American explorers, less than discovering unknown territories, relied heavily upon Native peoples' sophisticated knowledge of the land. In 1801, Ac ko mok ki, a Blackfeet leader, sketched a hasty but accurate map in the snow outside a Hudson Bay Company trading post near present-day Alberta. Its complex of lines and symbols denoted the salient features of two hundred thousand square miles of North America, with circles marking the locations of important Native settlements. Peter Fidler, the English surveyor who befriended Ac ko mok ki, copied the sketch and sent it to London; three years later, Meriwether Lewis and William Clark retraced the hand-drawn waterways, charting a northwest passage for a rapidly expanding United States (figure 1).[5]

The qualities of relationality and adaptability evident in early indigenous conceptions of space help to account

for their antecedent resilience in the wake of continuous colonial upheavals. Diverse works by Native artists that span the seventeenth century to the present, demonstrate a will to locate by looking anew, orienting human subjects within shifting kinship networks, animate landscapes, spiritual geographies, and global economies. Some offer partial views into alternative systems for organizing space and time, while others create novel worlds, on the surface of a canvas or in the relationships between objects. As in Cooper's photographs, the viewer is often asked to look in multiple directions at once; the forms and coordinates of these "mental maps" are myriad.[6]

Serving a function like the circles in Ac ko mok ki's sketch, the concentric rows of shell beads sewn onto four deerskin panels of "Powhatan's Mantle" are thought to correspond to thirty-four political districts under the leadership of the Algonquian Wahunsenacawh in the early seventeenth century (figure 2). In this work, the circles bear no relationship to physical geography; instead, the artist has placed them at regular intervals surrounding three central motifs: a human flanked by two animals resembling a cougar and a white-tailed deer. Wahunsenacawh, known as "Chief Powhatan" by the nearby Jamestown colonists, may have displayed this work in a storehouse devoted to the treasures he amassed through continental trade. According to the accounts of the English colonist John Smith, who was captured and then adopted by Wahunsenacawh in 1607, four enormous creatures stood like sentinels at the corners of the building, possibly denoting the great chief's spiritual connection to beings either real or mythological.[7] These beaded images on deerskin likewise communicate an individual's command of an ideological terrain. Power is centralized in the human figure, bolstered by his zoomorphic attendants, and expanded to include outlying villages in a singular image of sociopolitical cohesion.

In reality, such symmetry could be achieved only in representation; Wahunsenacawh's political domain was continuously in flux, contested by neighboring indigenous groups and by the colonists who settled nearby.[8]

The earliest known example of a Chilkat blanket, made before 1832, likewise maps chiefly power, by denoting totemic relations between human wearers and the animals that populate the Northwest Coast (plate 47). Oral stories that accompany the object suggest that Tlingit peoples conceived of coastal waters as a contact zone long before the arrival of European explorers and fur traders in the late 1700s. In one Tlingit story, an earthly woman was rescued from an unwanted marriage by a fisherman in a canoe, who turned out to be the benevolent sea spirit Gonaqadet. She gave birth to a son in their underwater home, but eventually returned to the human world to raise him. Years later, she presented Gonaqadet with a magnificent robe – the first Chilkat blanket – into which she had woven the story of their courtship. In a related story, Raven, the progenitor of human life, met Gonaqedet while wandering the shoreline, gathering knowledge essential to the survival of his children. Gonaqadet fed Raven, taught him ceremonial dances, and gifted the blanket he wore so that Raven could teach women how to weave.[9] The textile is pivotal in these narratives, indexing cycles of reciprocity connecting humans and spiritual beings in a shared environment.

In contrast to the vertical stacked arrangement of carved totems on a splendid Tsimshian house pole (plate 44), the Chilkat blanket required the skillful transposition of key characteristics of a single animal – a killer whale – into the pentagonal frame of a wearable garment. Bordered by thick bands of black and cream, the diving whale's snout curves around the baseline of the blanket; lateral and dorsal fins follow the left and right sides, and tail flukes fill the center top. Concentric ovoids in

Figure 1. Peter Fidler (1796–1822). Ac ko mok ki's map of *The Different tribes that inhabit on the East and West Side of the Rocky Mountains*, February 7th, 1801. Pencil on paper after a map by Ac ko mok ki (Blackfeet) reduced 1/4 from the original. Hudson's Bay Company Archives, Archives of Manitoba, HBCA G.1/25.

Figure 2. Woodlands or Algonquian artist. Powhatan's Mantle, before 1656. Deerhide, *Marginella* shells, and sinew. Ashmolean Museum, University of Oxford, 1685B no. 205. Image © Ashmolean Museum, University of Oxford.

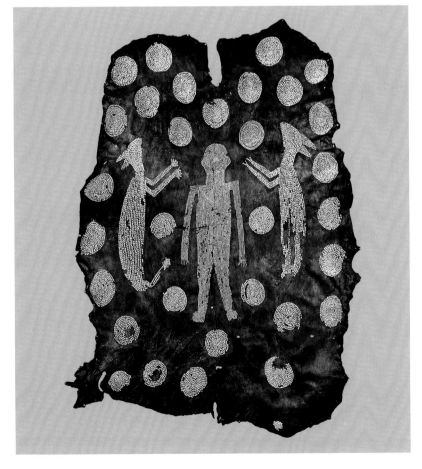

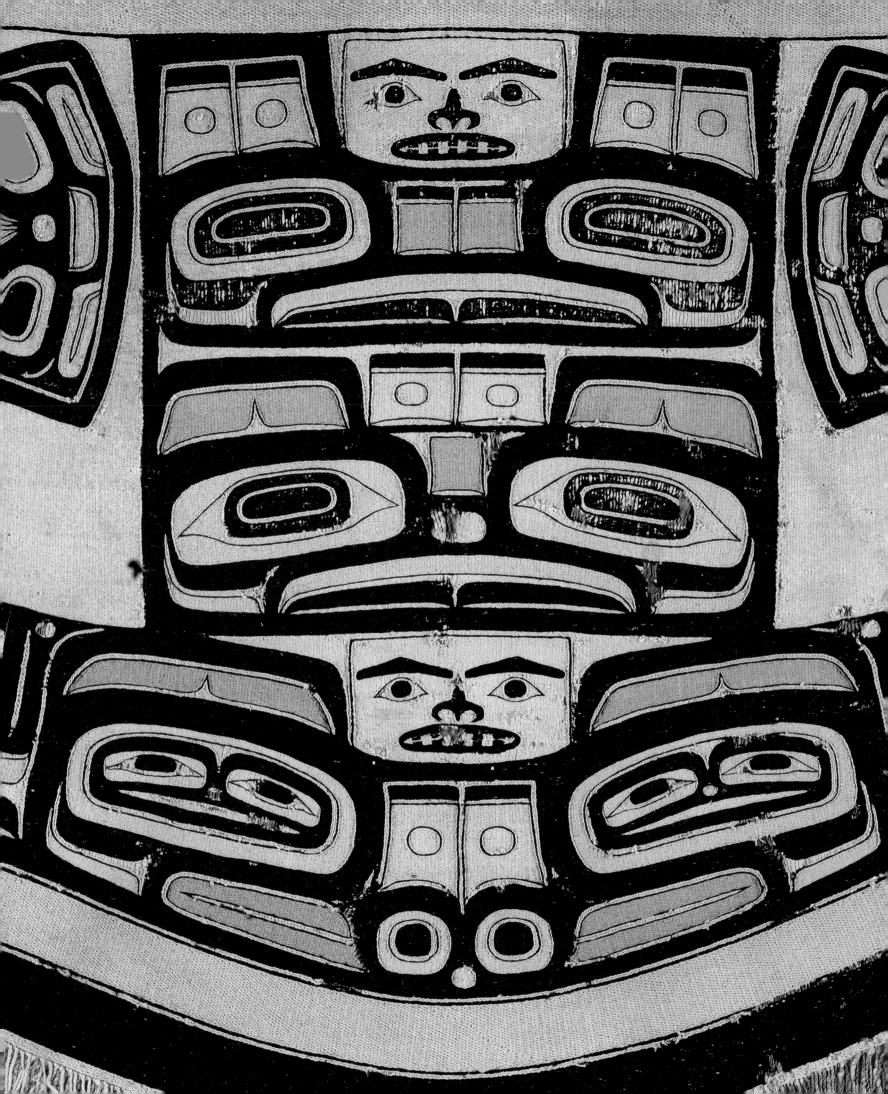

cream and pale green appear to leap out of the continuous black formline, fragmenting the body of the animal into numerous smaller human and animal faces. Peter L. Macnair and Jay Stewart see a pod of whales, calling the blanket's playful geometries a form of "visual punning … unprecedented in this medium."[10] Draped across the back of wealthy men and women from the Northwest Coast during ceremonial dances and speeches, Chilkat blankets bespoke their kinship to marine mammals and earthly obligations to redistribute gifts of food and materials (figure 3).[11]

Echoing the symmetry of the blanket, an early twentieth-century watercolor, Koshare *on Rainbow* (ca. 1925–30) by San Ildefonso Pueblo painter Awa Tsireh offers up an ordered universe in a single glance (plate 7). Three *koshares*, or sacred clowns, climb across the arch of a rainbow that defines the upper limits of the heavens. Below, the sinuous body of Avanyu, a two-headed water serpent deity, articulates the boundaries between a terrestrial realm and a watery underworld. Like the indigenous pottery and rock mural designs that inspired Tsireh, the stepped, rectangular, and curved forms in white, sepia, and black evoke ceremonial structures, clouds, and birds, contributing to an overall sense of symbolic, as well as aesthetic, unity.[12] Only the unidirectional movement of the clowns breaks with the symmetry, signaling their unorthodox behavior. It is through such transgressions, occurring in carefully conscribed ritual contexts, that Pueblo peoples tapped into sacred forces to ensure the cyclical arrival of rainfall and other celestial gifts that nurture life in the Southwest.

It may be tempting to view Tsireh's painting as evidence of an intact Tewa worldview that survived the

Detail of plate 47

Figure 3. Tlingit man with ceremonial art, Klukwan, Alaska, ca. 1900. Photograph. Alaska State Library, Juneau, Winter and Pond Photograph Collection, P87-0230.

displacements of contact alluded to in Cooper's prints, but this is only a piece of the story. Eighty years prior to the Pilgrims' landing, the Spanish trekked north from Mexico in search of gold; in 1711, they built one more in a string of mission churches, this time in Tsireh's hometown of San Ildefonso Pueblo. Pueblo people's resistance to foreign impositions is legendary, and Tsireh grew up intimately connected to Tewa language and rituals.[13] At the same time, his world was filled with tourists, anthropologists, and art pilgrims hoping that red rock mesas and Native cultures would yield up their spiritual secrets (figure 4). Tsireh's delicately rendered cosmologies tapped a deep reserve of romantic longing in non-Native elites, who were coping with the societal changes brought on by rapid industrialization in the early

Figure 4. William Penhallow Henderson (1877–1943). *Awa Tsireh*, 1917. Oil on canvas. New Mexico Museum of Art, Santa Fe, Gift of Amelia Elizabeth White, 1962, 222.23P.

twentieth century. Convinced that watercolors bespoke an authentic collective consciousness lost to Western culture, they enthusiastically patronized the new Native painting movement.[14]

Created in the midst of changes sweeping through Native and non-Native communities alike, Koshare *on Rainbow* does not reflect a prior unity, but rather organizes a self-contained world on the page. While outsiders looked to Tsireh to document Native ceremonies deemed on the brink of disappearance, his resulting images are better seen as parallel performances.[15] Could not a line of black paint drawn firmly across a sheet of paper, like the clowns' heavenly ascent, bring order to a world in flux?

The circular imagery of Powhatan's Mantle, the Chilkat blanket, and Tsireh's watercolor share an aesthetic of containment and completion. In contrast, the undulating horizontal stripes of the rectangular *Pollen Path* (2007) by D. Y. Begay (Diné [Navajo]) evoke the vegetation and sediments of a Southwest landscape whose horizon extends far beyond the borders of the textile (plate 41 and figure 5). Strips of sage green and earthy grays, tans, and reds are shot through with thin vibrant ocher lines representing sacred corn pollen; these materials are quotations of topography. Begay spins wool shorn from sheep raised on Navajo lands and prefers to work with natural dyes drawn from her intensive, ongoing experiments with the material properties of local plants. The resulting piece is both metaphor and metonym for the Navajo Nation, the largest Native-governed territory in the United States, which spans significant portions of Utah, Arizona, and New Mexico.

For Begay and other Navajos, the language of weaving expresses the significance of homeland more adequately than geopolitical descriptors.[16] Textiles, like the sacred landscapes they are derived from, are alive. They are in an intimate reciprocal relationship to human thought and action, calling forth the same love and respect one gives a relative.[17] They simultaneously embody the intergenerational transfer of environmental knowledge, and highly individualized human intervention in its aesthetic expression. In the Navajo worldview, weaving is thinking; mental and physical worlds merge in the movement of a hand across a loom.[18]

Pollen Path is both landscape fragment and global crossroad. Begay's practice integrates culturally and environmentally specific data with collaborative and archival research, participating in the transfer of knowledge among libraries, collections, and practitioners worldwide.[19] As her weavings travel beyond Navajo land,

Figure 5. Yucca, Monument Valley Navajo Tribal Park, 2010. Photograph by Jessica L. Horton.

they connect to a wider epistemological space, unbounded by loom or polity.

While the world of *Pollen Path* expands, that of *Who Shot the Arrow ...? Who Killed the Sparrow ...?* (1970) (plate 49), a painting by T. C. Cannon (Caddo/Kiowa), implodes. Here, wide red and white bands, connoting an arid landscape, are interrupted by a large mushroom-shaped splash of sage green outlined in streaks of blue and pink – a distant toxic cloud. The top third of the painting is divided into zones of red and black by a decorative horizontal strip of blue and silver paint. Blue circles floating in the black field suggest a cosmological vision in place of a naturalistic sky. A lone woman wearing a Navajo *tsiiyeel*, or hair bun, stands in the center of the canvas with her back to the viewer. Her red skirt rises as if continuous with the top of a structure that resembles the adobe buildings of the nearby Pueblo cultures, with colored circles in place of wooden beams. The woman is centered in this world, commanding the view, her black hair bisecting the base of the green. Although she appears fixated on the strange shape, her clasped hands and relaxed shoulders belie the violence she is witnessing. In 1967, on the eve of his departure to Vietnam, Cannon sketched a vision of nuclear detonations in the Southwest

that would later inspire this painting.[20] The intrusions of the United States military were most visible to the indigenous inhabitants who called these "test sites" home.[21]

Here, the environment is not merely a natural backdrop for the human drama unfolding within it. It is rather a mediated view of the land, the layers shaped at turns by culture, politics, and racism, converging on the painted surface of what Cannon has called "an appendage of my mind."[22] Kathleen Ash-Milby (Diné [Navajo]), curator of the 2007 exhibition *Off the Map: Landscapes in the Native Imagination*, defined such landscapes as "imaginary constructs," a characterization that makes way for the apparent dissonance in government officials' and a Navajo woman's understanding of the same physical space.[23] At the same time, the ominous green cloud in Cannon's painting is a stark testimony to the material effects of ideologies concerning the land. Marcus Amerman (Choctaw) offered an even greater multiplicity of views in his oversized *Postcard* (2002), made from brightly colored glass seed beads stitched on rubberized cotton (plate 51). Chunky cartoonish letters on a banner reading "Greetings from Indian Country of the Great Southwest" contain vignettes of stoic Natives, buffalo herds, atomic explosions, fighter jets, and the space program. Amerman foregrounded the widespread appropriation of Southwestern lands and cultures for touristic consumption, but traded the usual fantasies of exotic retreat for an expanded geopolitical consciousness.

A postcard is a paradoxical thing; it is inherently in motion, like the traveler whose journey it narrates, yet its effect is to enshrine, transforming people and places into frozen tableaus. As in all souvenirs, the world it imagines stays locked in place in order to activate personal stories, hastily scribbled while en route to the next destination.[24] In a related fashion, it is easy to imagine a foreign dignitary, or perhaps the wife of a French officer, passing

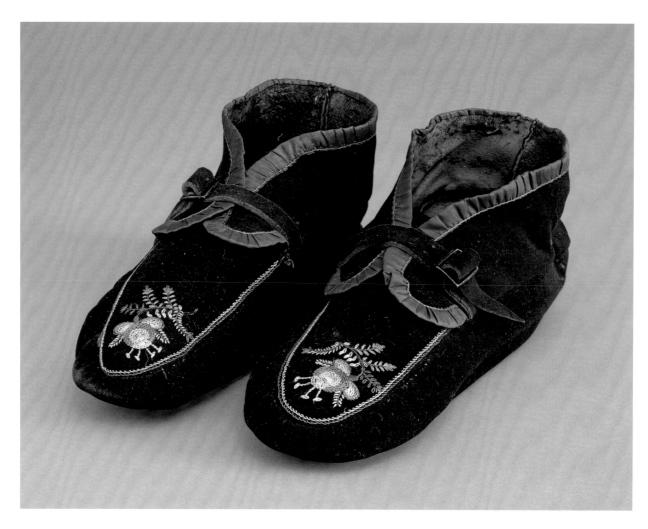

Figure 6. New York artist, possibly Huron. Mocassins, early 1800s. Deerskin, silk, and metal. Peabody Essex Museum, Salem, Massachusetts, E3712. Image © 2012 Peabody Essex Museum, photograph by Mark Sexton and Jeffrey R. Dykes.

near Niagara Falls in the early 1800s and encountering a Huron woman selling this pair of delicately embroidered leather moccasins (figure 6). Like a nineteenth-century postcard, this memento traveled far from its maker, perhaps gracing the mantle or the feet of a female aristocrat for the admiration of her visitors. Native American moccasins, baskets, and decorative textiles made their way to Europe and beyond in the trunks of travelers, prized as proof of one's intrepid journey through rugged North American wilderness and encounters with remote peoples.[25] The curling fronds and open buds that enhance the surface of this pair further connoted nature and the fragility of life in the minds of non-Native buyers; apt symbols for a culture deemed antiquated and that they imagined would soon fade away, much like the frontier lands being transformed by settlement.[26]

It is an ironic twist that for the newcomers, footwear should stand in for a people "left behind" in the march of progress. Moccasins, like other leather garments, were well suited to the long journeys Native peoples undertook in the centuries before contact with Europeans, seeking hunting grounds, political expansion, and trade opportunities. Their shapes and materials attest to their

makers' creativity and adaptability through the period of colonial expansion, apparent in the incorporation of green silk, embroidery floss, and floral motifs in this pair. Instead of an isolated frontier, these moccasins traversed a busy intersection, where cultural traders have long paused, exchanged various offerings, and continued on their ways.

Crossroads are beset by unpredictability; their potential for conflict, and also for communication, is explored in the work of Iñupiaq/Athabaskan artist Erica Lord. In her two-channel video *Binary Selves* (2007), she located such an intersection inside the self, wherein experiences culled from disparate times and places converge and struggle to cohere (plate 53). The piece begins with mirrored images of two figures facing one another at a frozen coastline. Close-ups reveal two Lords, dressed differently and singing into the camera as the screens fade rhythmically to and from black. They engage in traditional Inuit throat-singing, a highly trained performance in which two women stand close together and match their breath in song, until they eventually collapse into shared laughter. The visual unity is broken as the screens reveal slices of family videos and Lord's journey away from her Alaskan hometown, Nenana.[27] She recites an autobiographical poem and sings another song, as if struggling to bridge the spatial and temporal gap between images and pull them back into alignment. Lord insisted that the expression of a more "honest version of self" demands such an imaginary space, where conflicting elements are allowed to diverge, overlap, or run parallel.[28]

Such doubleness is also evident in a remarkable Kiowa cradleboard from 1903 (plate 48). On one side of its densely beaded canvas cover, a series of unique geometric shapes outlined in white, yellow, and pink zigzags burst like stars or lightning from a background of sapphire blue. On the opposite side, a pair of large, tuliplike

shapes sprout from white chalices at the base of the cradle, topped by circular organic forms in green, blue, and pink around the head opening. Here, the background is black, while a narrow band of striped turquoise curves around the edge of the cover's central split. The expert maker drew from a repertoire of at least four different kinds of stitches in order to create an unprecedented beadwork "sampler." The wayward designs are drawn together at the center by leather laces, which served a dual purpose as aesthetic intersection and protective binding for Dorothy Rowell, the infant who once rested inside the cradleboard's beaded embrace.[29]

Before they were forced onto reservations in the late nineteenth century, the Kiowa charged cradles with protecting infants from the vicissitudes of unknown climes. Following the introduction of Spanish horses in the early 1800s, the Kiowa and other Plains groups led a nomadic life, following the buffalo herds they depended on for food and shelter. Modest portable cradleboards could be carried on mothers' backs, hung from the saddlebags of a horse during long journeys, or propped against a nearby tree while women prepared camp.[30] Wood and tanned buffalo hide formed a protective shell to keep out wind, rain, and dust. Yet, the cradle's role was more than defensive. It additionally served as a social and cultural interface; the infant's gaze was not obstructed, but rather raised to the level of the adults' and invited to look out at the changing landscape from the center of a tight-knit community.[31]

The collective seasonal journeys of the Kiowa would soon fragment into separate paths to be recorded on highly individualized cradles. In 1867, the United States government consigned the Kiowa to reservations in Oklahoma; those who refused joined fierce resistance campaigns that ended in unmitigated violence.[32] Dorothy was the daughter of Tahote (Maud), a descendant of the last

Figure 7. Saubeodle, maternal aunt of Maud Rowell, in Ghost Dance apparel, with two of Maud's daughters: Dorothy Rowell, seated, and Mattie Kauley, n. d. Photograph. Courtesy of Everett R. Rhoades Collection.

Plains warriors and James Rowell, a wealthy East Coast doctor who collected Native American art. She and her many siblings maintained close ties to her two maternal great-aunts, Saubeodle and Hoygyohodle (figure 7). Both women were accomplished artists and leaders who actively carried forward Kiowa ways as part of a quiet cultural resistance. Inspired by the influx of new goods available from the nearby Fort Sills Trading Post, they joined other Kiowa women in ushering in a new tradition of fancy cradle-making for privileged infants. Dorothy was born into a hybrid environment where Kiowa and Victorian values co-existed, not unlike

the motifs and materials that converge on the surface of her cradleboard.[33] As in *Binary Selves*, the maker of her cradle eschewed a harmonious resolution in favor of dynamic discord.

To shelter and to navigate are two locating impulses that translate into aesthetic language not as opposites but as interactive pairs: closure and openness, stillness and dynamism, rigidity and softness. In the bronze sculpture *Dawn* (1989) by Allan Houser (Chiricahua Apache), irregular hatch marks cover a rounded organic form, as if elemental forces had battered and worn the surface over eons (plate 52). Time is stretched so far beyond human scale that it approaches eternal stillness. The edges arch and fold inward, forming a cave whose deep brown, nubbly inside appears as fresh as newly turned soil. One long arm curves to form a kind of pod, as if to embrace a life form that remains hidden from view, or has already crawled out from beneath the protective mantle. It is both mother and mountain; a point of origin and a place to return.

Houser's maternal form falls within a lineage of Earth Mothers that occupied the artist's attention in the last few decades of his life. Ranging from stylized representations to highly abstracted archetypes, their strong and nurturing bodies evoke North American topographies and resonate with indigenous beliefs that associate women with the regenerative powers of the earth. Yet, in distilling his configurations of the mother motif, Houser's own artistic process ranged globally. He searched for antecedents in Mesoamerican art, as well as European modernists such as Barbara Hepworth and Henry Moore.[34] Interestingly, his admiration for Moore's monumental female forms brings the chain of references full circle, for they were inspired in part by that artist's sketches of wooden Nuu-chah-nulth mother-and-child carvings in the British Museum, brought by Captain James Cook from the Northwest Coast in 1778 (figures 8 and 9).[35]

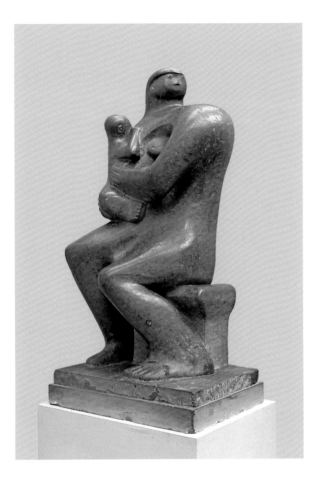

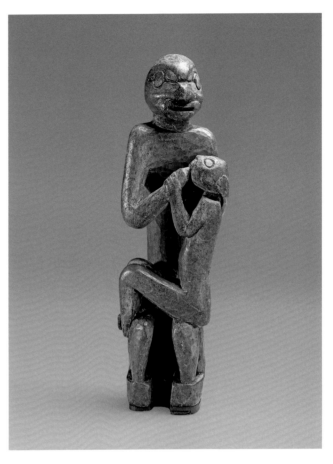

Figure 8. Henry Moore (1898–1986). *Mother and Child*, 1932. Green Hornton stone. Sainsbury Centre for Visual Arts, University of East Anglia, Norwich. Image LH 121, courtesy of The Henry Moore Foundation archive, reproduced by permission of The Henry Moore Foundation.

Figure 9. Nuu-chah-nulth artist. Woman and child, ca. 1778. Wood. The British Museum, London, Am,NWC.64. Image © The Trustees of The British Museum. All rights reserved.

Figure 10. Michael Belmore (born 1971), Ojibway. *Flux*, 2010. River stones and gold leaf. Courtesy of the artist.

Dawn joins *Pollen Path* and *Postcard* in locating a coordinate from which to plot journeys of a grand scale. Cooper's silken waves likewise bear witness to the underlying constancy of movement, contact, and change. The recognition of this shared, global condition unites the works in *Locating*, stimulating each artist to look and create anew. Where Cooper's photographs were scaled to the vastness of the sea, it is fitting to close with a related watery world, this one small and modest. *Placid* (2011), an installation by Michael Belmore (Ojibway), follows the spiraling molecular path of water receding from a shoreline, leaving behind delicate foam traces (plate 40). Belmore witnessed this momentary lull, occurring right after the ordered pattern of waves contact the earth and degenerate into chaos, while standing at the edge of Lake Superior. *Placid* thus forms an integral pair with Belmore's 2010 work *Flux* from the same series (figure 10). For both works, the artist collected pale round stones tumbled smooth by the action of water over centuries. He then meticulously carved them to interlock and lined the surfaces where they meet with vivid copper or gold leaf culled from the Great Lakes region, giving each a firm foundation within a larger, connected structure.[36] His intervention and controlled arrangement merge the contradictory notions of time found in nature: the momentary and chaotic, with the cyclical, patterned, and enduring. The protean form of *Placid* lends an airy lightness to stone, a material usually associated with heaviness and stasis. The stones seem ready to burst back into the fluid motion from which they were born: human hands can only briefly pause a world in flux.

Notes

1. Cooper makes his photographs using with black-and-white film, but his elaborate printing process yields a far richer range of hues, from purple to sepia. Everett in Everett and Zorn 2008, p. 28.

2. Macmillan 2004, p. 45.

3. Cooper's ongoing project, begun in 1990, will eventually produce about three hundred photographs, which he plans to gather under the title *An Atlas of Emptiness and Extremity.* Yau 2006, p. 51.

4. Warhus 1997, p. 3.

5. Ibid., pp. 1–2.

6. Ibid., p. 3.

7. Feest 1983, pp. 132–34.

8. Gallivan 2007, p. 97.

9. Emmons 1993, p. 330.

10. Macnair and Stewart 2002A, p. 162.

11. Chilkat blankets were not exclusively Tlingit; they continue to be made by Northwest Coast weavers from Alaska and British Columbia.

12. Brody 1997, p. 23.

13. Ibid., p. 39.

14. Rushing 1995, p. 13.

15. For example, the archaeologist Edgar L. Hewitt, an important supporter of the Native painting movement in Santa Fe, hired Tsireh to paint such scenes for the School of American Research in 1920. Brody 1997, p. 85.

16. D. Y. Begay, e-mail to Janet Berlo, December 15, 2010.

17. *Weaving is Life: Navajo Weavings from the Edwin L. and Ruth E. Kennedy Southwest Native American Collection* 2006; Berlo 2006, p. 45; see also Bonar 1996; Thomas 1996, p. 33.

18. McLerran 2006B, p. 9.

19. Ibid., p. 26.

20. Frederick 1995, p. 76.

21. From September 1945 through March 1962, scientists working in labs at Los Alamos conducted 254 implosion experiments at test locations in the southwestern United States. Radioactive fallout blew across the plains, damaging the ancestral lands and bodily integrity of indigenous inhabitants. Masco 2006, pp. 135–36. Cannon visited nearby Santa Fe for the first time in 1965 and attended the Institute of American Indian Arts beginning in 1973. Images of nuclear bombs appear in numerous of his paintings from this period. Wallo and Pickard 1990, pp. 19–20, 104.

22. Frederick 1995, p. 76.

23. Ash-Milby 2007B, pp. 23, 45.

24. Papadaki 2006, p. 55.

25. R. B. Phillips 1998, pp. 130–35, 170–71.

26. Ibid., pp. 185–88.

27. Lord 2011.

28. Ibid.

29. Hail 2000A, p. 40.

30. Hail 2000B, p. 20.

31. Ibid., pp. 30–32.

32. The treaty of 1867 confined the allied Kiowa, Comanche, and Kiowa-Apache to a piece of land in southwestern Oklahoma, until the Allotment Act of 1892 divided the land into individual homesteads. Ibid., pp. 20–22.

33. Rhoades 2000, pp. 41 –51; Rushing 2004, pp. 133–43.

34. J. C. H. King 1999, pp. 143–44.

35. Holubizky 2009, pp. 73–74.

36. Belmore 2011.

Plate 39, parts 1 and 2

39

Thomas Joshua Cooper (born 1946), Cherokee.
A Premonitional Work
Plymouth Sound – Looking S., S. W. – Hopefully, Towards the New World
The Mayflower Steps, Plymouth
Devon, England 1998–2001
(The Pilgrim Settlers left England forever, for the hope of new lives in the New World, on the Mayflower from this site)
(Part 1, the top part of a 2-part vertical work)
A Premonitional Work
Plymouth Bay – Looking N., N. E. – Back, Towards the Old World
Just Below Plymouth Rock, Plymouth
Plymouth County, Massachusetts
USA 2000–2001
(The Pilgrim Settlers, finally, landed the Mayflower around this spot – and, at last, "arrived" and began to settle in the New World)
(Part 2, the bottom part of a 2-part vertical work),
1998–2001.
Selenium-toned silver-gelatin prints, edition of 3 (#2/3). 28 × 35 7/8 inches each (41.2 × 57.8 cm). Courtesy of the artist and Haunch of Venison Gallery, London.

There has probably never been a more widely traveled artist than Thomas Joshua Cooper. A Cherokee born in California, Cooper studied in New Mexico, taught in Tasmania, and now lives in Scotland; his art has been exhibited around the world. What makes Cooper truly global is his work: photographs of the Arctic and Antarctic, Greenland and Tierra del Fuego, Africa and Nova Scotia, and scores of other places make up the ever-evolving "Atlantic Basin Project – The World's Edge." Cooper is fascinated with geographers and explorers, and his quest to photograph the Atlantic Ocean from the vantage point of all five landmasses that border it has made him one, too. Lugging an 1898 field camera, he endures enormous physical hardship to reach rocky promontories, each time coming away with but a single photograph (meeting a challenge he set himself years ago). Land elements rarely appear in Cooper's photographs; he keeps his back to the continent and his lens trained out to sea because it is really the ocean that captivates him.

Though no humans appear in his photographs, it is nevertheless human culture that is evoked in *A Premonitional Work*. Cooper explained: "What I set out to do … was to try and measure the space that culture came through from the old world to the new world."[1] In this diptych, it is the Pilgrims' perspective that interests Cooper. From England, he imagined them looking "Hopefully, Towards the New World" as they set sail on the Mayflower. When they reach their destination, however, he pictured them "Looking Back, Towards the Old World." Curiously, just as they are embarking on their new lives, they look back. Perhaps Cooper's own travels have generated a longing for home; or perhaps this melancholy clings to photography itself, as moments captured in the present are forever fading into the past. – KM

Notes
1. Cooper 2006.

References
Cooper 2006; Everett in Everett and Zorn 2008, pp. 27–30; John Simon Guggenheim Memorial Foundation 2009; Kouwenhoven 2010.

40 **Michael Belmore (born 1971), Ojibway. *Placid*, 2011.** Crystalline limestone and copper leaf. 4 3/4 × 84 × 80 inches (12 × 213 × 203 cm). Courtesy of the artist.

Placid is one of a series of meditative, sculptural rock installations by Michael Belmore. For several years, water has been a focus of the artist's work, for both its ability to define geography and its ephemeral and sculptural qualities. *Placid* is a reflection on the fleeting calm that exists between waves as they hit a shoreline. Composed of river rocks, first shaped and smoothed by the water's erosion and then carved and nested together by the artist, these rudimentary objects seem far-removed from today's high-tech culture. But, rocks were man's first tools, and represent the hidden resources that still support our culture. To this end, Belmore coated the carved inner surfaces of these stones with a thin layer of copper; the reflections of the stones against one another create a subtle, warming glow. This small but sophisticated detail quietly celebrates the resources that are hidden within the land. – KA-M

References
Deadman 2007; Wlasenko 2009; Holubizky 2010.

Plate 40

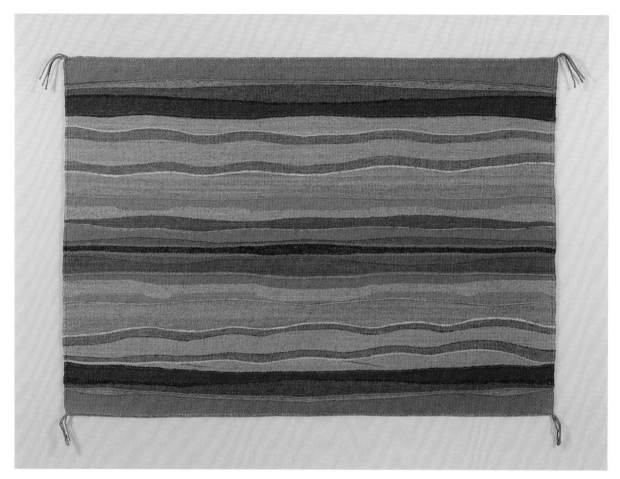

Plate 41

Plate 42

41

D. Y. Begay (born 1953), Diné (Navajo). *Pollen Path*, **2007.** Wool and plant dye. 26 × 36 1/2 inches (66 × 92.7 cm). Collection of Rowland and Diane Hill.

D. Y. Begay is an accomplished weaver, writer, and scholar of Navajo textiles. Her art in recent years has focused on semi-abstract landscape designs such as this one. These painterly textiles recall the terrain of her youth on the reservation in Tselani, near Chinle, Arizona. The artist recalls watching her mother weaving and gathering plant materials for her dyes, and she carries on these traditions. The colors in *Pollen Path* derive from goldenrod, purple onion skins, coreopsis, and madder roots – each dye the result of years of practice and experimentation. The title of the work refers to the sacred corn pollen used in Navajo ceremony to restore beauty and harmony to the life of an individual.

The artist attended boarding school off the reservation, then college at Arizona State University. She carried her love of weaving with her. When Begay sold her first rug at age twelve, she learned that weaving could be a source of independence, while connecting her with the traditions of her ancestors. Today, she lives in both Phoenix and Tselani, and makes her living as an artist and museum consultant. She has traveled to Canada, Guatemala, and Peru to study other indigenous weaving traditions. Begay has won many prizes for her work, including, most recently, "Best of Show" in the textiles division at the Heard Museum 2010 Indian Fair and Market. – JCB

References
D. Y. Begay 1996; McLerran 2006A.

42

George Morrison (1919–2000), Grand Portage Band of Chippewas. *Structural Landscape*, **1952.** Oil on canvas. 22 1/2 × 50 inches (57.2 × 127 cm). Joslyn Art Museum, Omaha, Nebraska, Museum Purchase, JAM1955.187.

The life of Ojibwe artist George Morrison involved patterns of displacement and return…. His art, while abstract, is imbued with the significance of place. – Bill Anthes[1]

For viewers familiar with George Morrison's abstract wood collages, totem sculptures, and "horizon paintings" of the 1970s and 1980s, *Structural Landscape* may come as something of a surprise. Combining the flattened spaces of Cubism with the enigmatic lines of Surrealist automatism, the work is nevertheless in part representational. Amid forms reminiscent of Joan Miró's is a horizon line punctuated by soaring mesas; in the middle ground, a domed dwelling with an open door beckons. The palette of earthy greens is more subdued and naturalistic than in the artist's later landscape paintings, though it hardly seems appropriate for a high desert scene. For Morrison, the contradictions come naturally; a landscape does not have to be "real" to be evocative. He wrote: "I always imagine, in a certain Surrealist way, that I am there. I like to imagine it is real…."[2]

Morrison painted *Structural Landscape* in 1952, a year that he spent in Paris and in Aix-en-Provence studying on a Fulbright scholarship. He had already worked for a

Plate 43

42

decade in New York developing a new pictorial language of abstraction – alongside his friends Jackson Pollock, Willem de Kooning, and Franz Kline – at the Art Students League. *Structural Landscape* demonstrates Morrison's successful effort to link American Regionalism[3] to the avant-garde styles of the present. It also offers insight into his future – his eventual return "home" to Minnesota and the shores of Lake Superior, and the development of his "mature style" – works characterized by high, undulating horizon lines and the seamless integration of natural forms and lyrical abstraction. – KM

Notes
1. Anthes 2006, pp. 102 and 112.
2. Morrison, quoted in Touchette 2001, p. 73.
3. During the 1940s, Morrison was also a frequent visitor to Provincetown, Massachusetts, considered a bastion of modernist American landscape painting.

References
Morrison and Galt 1998; Penney 1999; Touchette 2001; Haas, Chaat Smith, and Lowe 2005; Anthes 2006.

43

Jeffrey Gibson (born 1972), Choctaw/Cherokee. *Camouflage*, 2004. Oil and pigmented silicone on wood. 31 1/8 × 30 inches (79 × 76 cm). Collection of Judy Goldis.

Jeffrey Gibson's "Fantasy Island" is a tropical paradise of lush foliage and limpid blue pools, pink flamingos, cocktail glasses, and palm-tree swizzle sticks. Reminiscent of Mardi Gras necklaces, beads of pigmented silicone hang over the top of the painting. Gibson's use of deeply saturated oil paints overlaid with brilliantly colored silicone is a distinctly contemporary technique, yet, as fellow Cherokee artist and critic Jimmie Durham has written: "it is squarely in the Native American tradition.... Our strongest tradition is the willingness to use whatever comes along."[1]

Gibson says that he finds his inspiration in a wide variety of forms ranging from the accretions of nineteenth-century Iroquois beadwork to the electric colors of pow-wow fancy dance regalia. To these Native sources, he adds a large dose of New York graffiti (he lives and works in Brooklyn) and remnants of London club culture (from

his days at the Royal Academy of Art). The resulting works are multilayered and multifaceted imaginary landscapes that are at once alluring and vaguely unsettling. In the case of this painting, *Camouflage*, the title refers to a patterned surface but also hints at something disguised or hidden within. Curator Kathleen Ash-Milby (Diné [Navajo]) suggested that what lurks beneath the surface of Gibson's landscapes is "the darkness in our collective relationship to the land, the toll of displacement, the often nomadic existence of contemporary life."[2] – KM

Notes
1. Durham 2009, p. 64.
2. Ash-Milby 2007B, p. 44.

References
Ash-Milby 2007B; Morris 2007; Durham 2009.

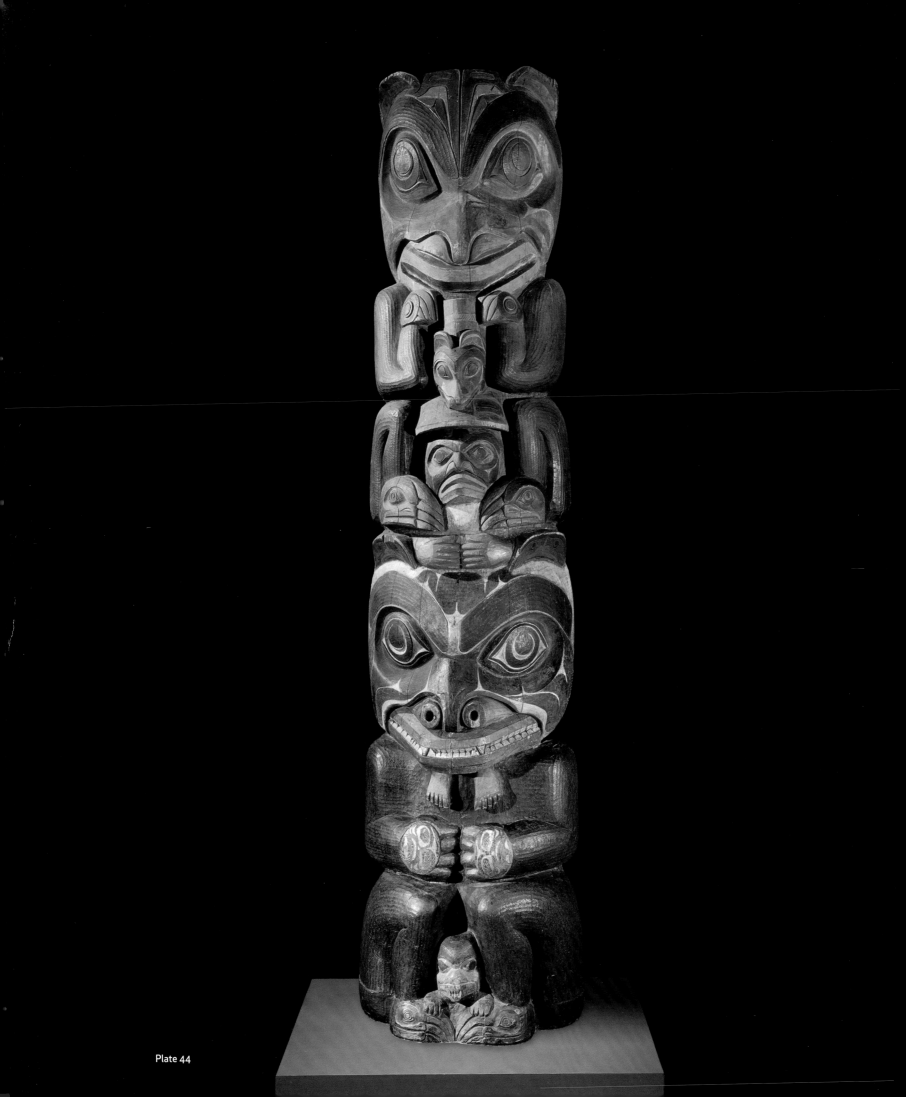

Plate 44

44 **Tsimshian artist. House frontal totem pole, 1800s.** Cedar and paint. 147 1/2 × 38 3/4 × 20 inches (374.7 × 98.4 × 50.8 cm). Peabody Museum of Archaeology and Ethnology, Harvard University, Cambridge, Massachusetts, 17-15-10/87055.

In the nineteenth century, the Tsimshian lived in large cedar plank houses lined up along the shore. Standing before the houses were totem poles owned by the kin group living within. The carved images on poles depicted beings called crests, who, in times past, interacted in some way with the family's ancestors and gave them the right to display their images and tell their story.

Certain animals have distinctive identifying features, such as the ears, flared nostrils, and sharp canines of the bottom figure on this pole, which is a bear. But, species alone tells little about which particular bear crest from which particular story owned by which particular family this carving represents. Unfortunately, these specifics are not documented. Nonetheless, the pole is formally intriguing. Dangling from the chin of the bear are two human legs that appear to be connected to a human figure whose clasped hands rest between the bear's ears

and whose face is nestled between the uppermost being's legs. Such interweaving of beings is one characteristic of Northwest Coast art.

Totem poles were indications of status. Regardless of its inherited position, a family was not considered noble unless it hosted potlatches – several-day celebrations at which hosts gave guests quantities of gifts and guests in return validated the host's claims to high rank. The raising of a totem pole is occasion for a potlatch, and thus the pole signifies not only a visual expression of a family's history but also ceremonial validation of its social status. – AJ

References
Barbeau 1929; Halpin 1981; Stewart 1993; Jensen 2004; Jonaitis and Glass 2010.

45 Marla Allison (born 1980), Laguna Pueblo. *Mother and Father*, 2008–2009. 36 × 24 inches each (91.4 × 61 cm). Mixed media and acrylic on masonite. Heard Museum, Phoenix, 4560-1, 4606-1.

Mother and Father is an unexpected mixed-media diptych from the artist Marla Allison, whose paintings are often lively abstractions of Southwestern motifs. Although she has included representational imagery in her previous work, most notably in paintings that reinterpret iconic photographs by her Laguna Pueblo neighbor and friend Lee Marmon, the markedly realistic *Mother and Father* takes a different approach to the figure.

This two-part work is an homage to her parents, Sharon Toya Allison and Ray Allison. As in the venerable artistic tradition of New Mexican devotional portraiture and specifically depictions of saints, known as retablos, the subjects are surrounded by objects – or attributes – that clarify their identity and significance to the maker. The artist's mother, Sharon, is seated casually, cross-stitching a composition of Hopi maidens with traditional hair buns, representing the creative traditions passed down through her family. Likewise, her father, Ray, seated at the same kitchen table, repairs an array of power tools, signifying his own gift of practical and creative handi-work. Each masonite panel contains a window, disguised as a framed photo, through which a small DVD screen plays a short video portrait of the subject. Sharon and Ray narrate their own videos, giving a brief overview of their lives, from childhood to the present, illustrated with old family photos, historic footage, and re-created vignettes. Allison's parents are lovingly immortalized by their daughter in *Mother and Father*. – KA-M

References
MarlaAllison.com.

Plate 45

Plate 46

46 **Kevin Pourier (born 1958), Lakota. Spoon, 2008.** Buffalo horn and stones. 10 1/2 × 3 1/4× 3 7/8 inches (26.6 × 8.3 × 9.8 cm). Private collection.

For hundreds of years, Lakota people depended on buffalo, their sacred relatives, for food, shelter, and ceremony. In the late nineteenth century, buffalo herds suffered a devastating decimation brought about by Manifest Destiny, the belief that it was America's mission – and right – to expand westward across the continent into land occupied by Native Americans. At the same time, the Lakota people were being forced onto reservations by the United States government and their spirituality and nomadic lifestyle forbidden.

Inspired by nineteenth-century Lakota utilitarian buffalo-horn drinking cups and spoons, self-taught Kevin Pourier is one of very few artists today working in this medium. His creations range from spoons and cups to belts, jewelry, and eyeglasses. Pourier painstakingly carves and buffs designs as channels for powdered mineral inlay, transforming found horns into detailed, sophisticated small sculptures. The spirit of the buffalo lives in its horn and connects Pourier to his ancestors while he takes the art form into the twenty-first century.

Using the material so personally and culturally significant to his tribe, here Pourier carved Sitting Bull, his signature monarch butterfly pinned to his hat, after the well-known 1883 photograph by an unidentified photographer. The famous Hunkpapa Lakota leader remained steadfastly opposed to tribal acquiescence until his tragic death in 1890.[1] He is an enduring legend, revered for his courageous struggles on behalf of the Lakota. Even today, Lakota people retain spiritual connections to their homelands and the memory of Sitting Bull blazes strongly. Pourier surrounded Sitting Bull with swarms of bas-relief Monarch butterflies. For Pourier, he symbolizes Lakota strength and lifeways, and butterflies represent the love of family.[2] Bringing them together in one object is a cathartic act uniting concepts of home and family. – KKR

Notes
1. Sitting Bull was murdered on December 15, 1890, by tribal policemen who feared the leader would join and further ignite the Ghost Dance movement (see page 93) that was rapidly spreading to Lakota territory. His death foreshadowed the horrific violence that was to follow at the Wounded Knee massacre on December 29, 1890.
2. Kevin Pourier, in conversation with the author, 2010.

References
Indyke 2006; Pourier 2008; Pourier 2010; KevinPourier.com.

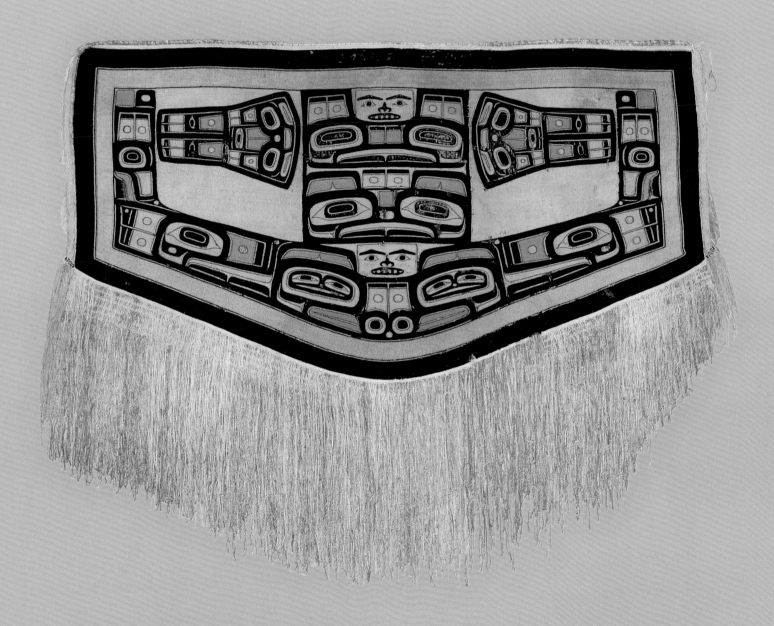

Plate 47

47 **Tlingit artist. Chilkat blanket, ca. 1832.** Wool, bark, and leather. 50 × 63 3/4 inches (127 × 161.9 cm). Peabody Essex Museum, Salem, Massachusetts, Gift of Robert Bennett Forbes, 1832, E3648.

This ceremonial dance regalia is the oldest known and perhaps the most finely woven Chilkat blanket extant. Named for the northern Tlingit group who advanced this art form, Chilkat blankets are a belonging of prestige and prerogative, declaring the owner's family heritage, social standing, and economic wealth. The blankets display a family crest animal. Such crests are deeply honored because they symbolize significant events in clan history, such as an Origin story, and thus are closely linked to a clan's group identity. Ownership of and the right to display the crest were more valuable than the physical object. Chiefs, earthly representatives of the founding clan ancestors, and others of prominent standing in the community recount and legitimize their impressive hereditary rights to the associated crests at potlatch ceremonies attended by witnessing guests. When the blanket is worn as a cape in dance, the swaying fringe transforms it into a kinetic sculpture – indeed, its Tlingit name, *na·x·en*, has been interpreted as " fringe about the body."[1]

Chilkat blankets incorporate highly complex twining and braiding techniques of characteristic flowing black outlines, called formlines, which delineate the main design, as well as perfectly woven circles and abstract geometric patterns. Here, a highly stylized killer whale dives down the center of the blanket and is split in two and flattened to each side. Its fluked tail is in the center, and attached to both sides are lateral fins extending upward. The artist cleverly incorporated several smaller whales into the design, transforming the whole into a pod of killer whales.

Representing five-sided copper ingots, two additional geometric designs called "coppers" appear in the somewhat empty side panels of the upper register. A rare design motif on Chilkat blankets, coppers are literal and metaphoric symbols of chiefly wealth and status, and a medium of exchange at potlatches.[2] – KKR

Notes
1. Samuel 1982 p. 22.
2. The physical material copper is also linked to supernatural beings. Jopling 1989, pp. 16–18.

References
Samuel 1982; Jopling 1989; Emmons 1991; Pasco 1994; Macnair and Stewart 2002A, p. 162.

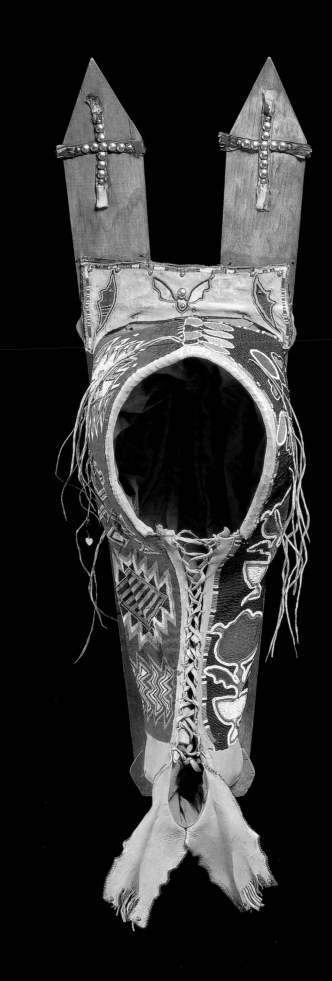

Plate 48

48 **Maud Rowell (Tahote) (1880–1927), Kiowa; or Saubeodle or Hoygyohodle. Cradleboard, 1903.** Deerskin, wood, rawhide, glass beads, and assorted fabrics and metals. 48 1/2 × 13 3/4 × 9 1/8 inches (123 × 35 × 23 cm). Haffenreffer Museum of Anthropology, Brown University, Bristol, Rhode Island, HMA 61-339.

The iconography of beaded cradles helps us to chart the transition of Kiowa people from a nomadic existence guided by seasonal buffalo hunts, to the relatively stationary life on Oklahoma reservations in the last quarter of the nineteenth century. Women used non-Native decorative materials, available at trading posts on the reservations, to articulate cradleboard covers with a dense field of geometric and figurative designs. The women associated with the Rowell family were especially talented at beadwork, integrating deerskin and rawhide, cotton cloth, silver buttons, silk ribbon, and the ubiquitous glass beads to elegant effect.

The Kiowa woman Tahote (Deep-Set Eyes), also known as Maud, was born near Fort Sills, Oklahoma. She was the niece of Chief Paitahlee (Sun Boy), a prominent leader of the final, legendary Kiowa and Comanche battles of resistance to the takeover of their lands by the United States government in the late nineteenth century. She eventually married James Rowell, a wealthy physician from a prominent East Coast business family, forming one of the first mixed-race unions on the Plains. Her aunt

Hoygyohodle, one of Paitahlee's sisters, helped raise their children to maintain strong ties to Kiowa arts and culture. A second aunt, Saubeodle, was a powerful medicine woman and esteemed maker of cradles. One of the three remarkable women was responsible for making this unusual cradle for Maud's daughter, Dorothy, in which the sides of the cover are decorated with distinct yet complementary geometric and floral patterns. – JLH

References
Hail 2000B; Rhoades 2000.

49

T. C. Cannon (1946–1978), Caddo/Kiowa. *Who Shot the Arrow…Who Killed the Sparrow…?*, 1970. Acrylic on canvas. 40 × 36 inches (101.6 × 91.4 cm). U.S. Department of the Interior, Indian Arts and Crafts Board, Southern Plains Indian Museum and Crafts Center, Anadarko, Oklahoma.

T. C. Cannon was a master of color, an innovator whose cheery palette of bright pinks, purples, and oranges often cloaked a biting critique about contemporary society, war, and violence. An early student of the newly established Institute of American Indian Arts in Santa Fe, Cannon was one of the most influential artists of his time, bringing together popular culture, historical imagery, and critical vision in his expressive work. His personal experiences as a soldier in Vietnam gave many of his later depictions a piercing edge and painful insight.

In *Who Shot the Arrow … Who Killed the Sparrow …?*, the silhouette of a young Navajo woman idly looks across an expanse of white sand as a green mushroom cloud grows on the horizon. Is this a bleak foreshadowing of a nuclear holocaust, or does she represent one of the many people exposed unknowingly to radiation during nuclear bomb testing in New Mexico in the 1940s? The horizontal band of black with light blue bubbles or clouds adds an ominous yet whimsical note to this beautiful and terrifying scene. Cannon created this painting from a sketch he made after receiving notice that he would soon depart for Vietnam in the 101st Airborne Division. He was an enlistee, but the image suggests a personal sense of helplessness and foreboding. The mushroom cloud reappeared throughout his work, often symbolically, representing death, destruction, futility, or, in this case, as he explained in a letter to a friend, "another control device that will keep the Indian quiet…"[1] Cannon continued to grapple in his art with concerns about the fragility of life and cultural violence, both contemporary and historical, throughout the decade, until his sudden and untimely death in 1978. – KA-M

Notes
1. T. C. Cannon to Sherman Chaddlestone, 1970, cited in Frederick 1995, p. 76.

References
Two American Painters: Fritz Scholder and T. C. Cannon 1972; Wallo and Pickard 1990; Frederick 1995; TCCannon.com 2009.

50

Richard Ray Whitman (born 1949), Euchee/Creek. *States of Pervasive Indifference: Earth, Air, Fire, Water*, 1993. Digital print. 40 × 30 inches (101.6 × 76.2 cm). Courtesy of the artist.

In 1992, three Spanish ships toured the ports of the United States in commemoration of the four hundredth anniversary of Christopher Columbus's "discovery" of the New World. When the replicas of the *Nina*, *Pinta*, and *Santa Maria* sailed into Corpus Christi, Texas, the last stop on their voyage in 1993, photographer Richard Ray Whitman and a host of Native American protesters were there to greet them. Like many other Native artists and activists, Whitman felt there was nothing to celebrate on the quincentennial anniversary, except the very survival of Native peoples (plate 76). Rather than turning his lens on the European ships, Whitman focused instead on a young man who was part of the protest group.

The subject stands with his back to the Gulf of Mexico, gazing confidently at the camera; his expression, posture, and the American flag he wears coalesce into a

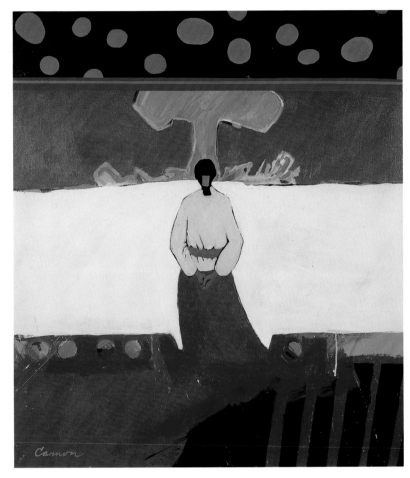

Plate 49

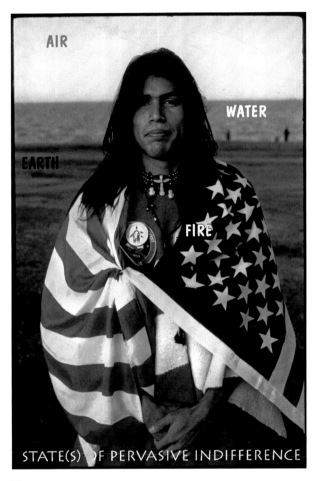

Plate 50

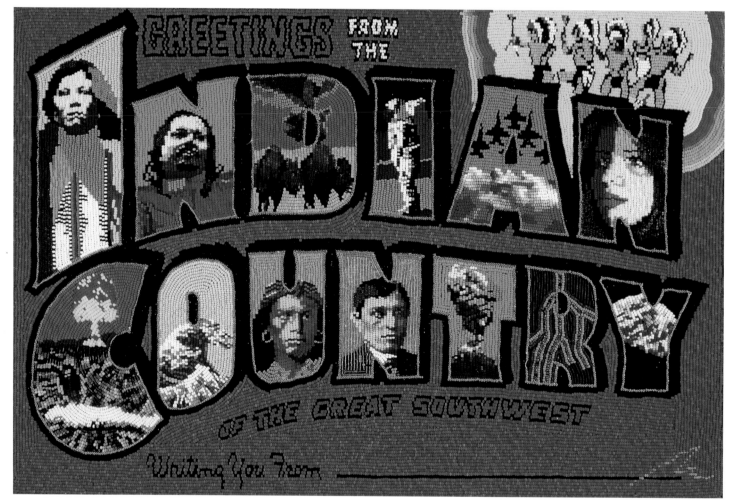

Plate 51

powerful visual statement of sovereignty. For Whitman, the message is overtly political: "This is who we are. We are still here."[1] In the final version of this work – *States of Pervasive Indifference* – language is superimposed on the image: the title appears at the bottom edge of the composition, and the words "air," "water," "earth," and "fire" hover in the upper half. The first three words are placed to correspond to the elements that are pictured; significantly, however, "fire" is placed over the man's heart. In referencing the four elements, Whitman moved the work beyond the context of a specific political action and into the realm of the universal. "It is the Indian way to be involved in defining who we are in the universe, to be concerned about our identity, and how we go into the future."[2] – KM

Notes
1. Whitman 1990, p. 78; Whitman 2001.
2. Whitman 1990, p. 78.

References
Whitman 1990; Rushing 1992; Lippard 2000; Whitman 2001.

Marcus Amerman (born 1959), Choctaw. *Postcard*, 2002. Glass beads and rubberized cotton. 11 × 17 inches (28 × 43 cm). Private collection.

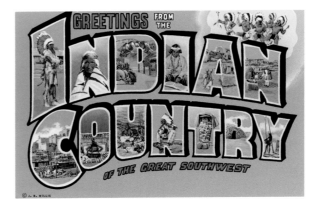

Figure 1. *Greetings from the Indian Country of the Great Southwest*, 1938. Postcard. Courtesy of Curt Teich Postcard Archives, Wauconda, Illinois.

The term "Indian Country" was part of a settler narrative that identified sovereign territory occupied and governed by Indians across North America. Formal treaties adopted the expression to identify the territory colonized, negotiated, and allotted in federal trust. The concept of Indian Country also connoted warfare (at home and abroad) and adventure and exploration. Subsequently, the term has been reclaimed by Native people and interpreted "as a place that gathers Native North Americans together, wherever – on any reservation, at any pow wow or Native conference, in any Indian bar or Native centre, at any Native ceremony, feast, or community event."[1]

Marcus Amerman's *Postcard*, a bold and vivid colored glass seed beaded rendition of the large billboard letter style postcards popular in the 1940s and 1950s, confronts, politicizes, and obscures the landscape and history of the American Southwest. Amerman's postcard, which reads "Greetings from the INDIAN COUNTRY of the Great Southwest," complicates the generic, romanticized notions of the locale by depicting images tied to the territory's true past and present. The imagery exposed within the large letters replaces the picturesque landscape and culturally derived expectations with iconic images. These recount expansion and development across the territory through art and artists (T. C. Cannon,

Plate 52

51

Amerman self-portrait), invention (the atomic bomb), warfare (Japan, Indian activist Leonard Peltier), and testing grounds (fighter jets) impacting the tourist destination. Amerman's conceptual souvenir indicates that the burden of spiritual, economic, social, and political changes is visible and trespasses upon the sovereign status of the original people and their land. – RR

Notes
1. Valiskakis 2005, p.103.

References
Valiskakis 2005; *Wikipedia* 2010A.

52

Allan Houser (1914–1994), Chiricahua Apache. *Dawn*, 1989. Bronze, edition of 10. 19 × 38 × 20 inches (48.3 × 96.5 × 50.8 cm). Allan Houser Inc., Santa Fe.

The true subject of *Dawn* is Native culture and Native women. Its undulating lines and textures blur the space between realism and abstraction. Allan Houser's work expresses his deep love, admiration, and understanding of Native cultures, the Southwest, and the landscape, and offers a moving tribute to Native femininity. His use of the female figure was innovative for a Native artist but only because of the restrictions imposed on Native people from the dominant society. His choice of the nude was the foundation of his authority as an artist able to bring together disparate traditions. Moreover, his preference for what were once defined as "non-Indian" materials such as bronze and art forms like sculpture cements his well-earned status as icon and legend.

Houser is best known as a sculptor – a legend within his lifetime for his honest and flawless vision. Blending Native subject matter with a sleek modernist aesthetic, he created elegant and highly refined figures of Native people in stone and metal. His career was marked by perseverance. There were no Native sculptors to teach or mentor Houser. He worked from his heart and learned along the way, breaking imposed sentimentalist

shackles and inspiring generations of students. He said of himself: "I use all that I know, for I feel that I must make progress, I must not stay in one place…. Being around my Indian friends makes the difference in the way I live and the way I paint. I always tell my students to be an Indian but allow for something creative too." – BB

Notes
1. Highwater 1976, p. 150.

References
Highwater 1976; Pearlman 1992; Lowe 2004; Rushing 2004; Lowe and Bernstein 2006.

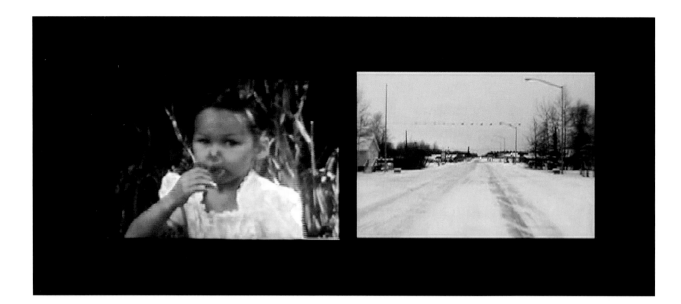

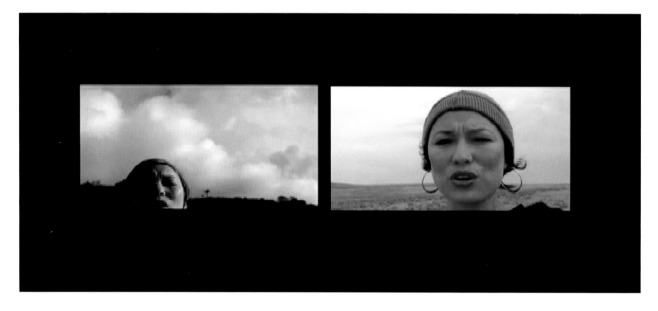

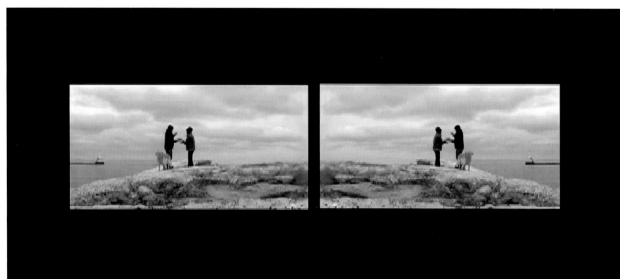

Plate 53, details

53 Erica Lord (born 1978), Iñupiaq/Athabaskan. *Binary Selves*, **2007.** Two-channel video installation. Dimensions variable. Courtesy of the artist.

In *Binary Selves*, Erica Lord presented a self-portrait, literally split in two. In this narrative video, Lord used Inuit throat-singing, traditionally sung by two women whose faces nearly touch as they produce this unusual, guttural sound. But, instead of singing with a sister or close friend, Lord created the illusion of singing with her double. This concept of a divided or fragmented self is amplified as we observe variations of these two selves singing or standing in front of a variety of retreating geographical landscapes that encapsulate her itinerant life and isolation. Even without knowing details about her personal biography, one can deduce that her life has been divided between places and cultures and she longs for stability. One journey of constant departure, captured in this video, is leaving Nenana, the small Alaskan hometown of her father: the path of Lord's camera is the only way out of the town, whether one is planning to return or being taken to the local cemetery (see Locating, page 125).

Despite its eerie sound, throat-singing is in essence a light-hearted game that demands concentration that is easily broken as the singers stare so closely at one another, clasp each other's shoulders, and literally breathe into each other's mouths. Participants compete to be the last one singing before they both break down in laughter. After what seems to be a sober and lonesome journey, Lord's incarnations also eventually lose concentration and dissolve into giggles and broad smiles. The levity makes us question whether rigid constructions of identity are a bit of a farce as well: a game well played but easily undone. – KA-M

References
EricaLord.com; Ash-Milby 2007A; Jackinsky 2008; Chavez Lamar, Racette, and Evans 2010; Lord 2011.

54

Bently Spang (born 1960), Northern Cheyenne. *War Shirt #1* (from "Modern Warrior" series), 1998. Mixed media. 36 × 56 × 10 inches (91.4 × 142.2 × 25.4 cm). Collection of Sandra Spang.

In the 1800s, Cheyenne warriors wore intricate animal-skin shirts decorated with quills and beads detailing their brave deeds in battle against neighboring groups and the encroaching United States Army (figure 1). The lines of these shirts emphasized the natural shape of the stitched buffalo hides, harnessing the power of the animal to protect the man, and in turn his community.

Inspired by his encounters with collections of historical shirts, Bently Spang's *War Shirt # 1*, from the ongoing "Modern Warrior" series, utilizes contemporary storytelling devices to communicate the artist's relationship to his Northern Cheyenne community and home in Montana. Snapshots and portraits of relatives from his mother's family form one piece of the "fabric" of this shirt, while photographs from his father's side fashion a second. Images of ancestral lands and his great-great-grandparents' homestead line sleeves fringed with strips of photographic negatives, all tied in place with imitation sinew. Working against a long, romanticizing tradition of photographing stoic Plains warriors in headdresses, Spang has invited viewers to find commonalities with the grinning faces in these snapshots.

Spang emphasizes that the "Modern Warrior" series is not meant to conjure the kind of spiritual power that older shirts channeled to a highly trained class of

Figure 1. Tsethasetas (Northern Cheyenne) artist. Shirt, ca. 1855–65. Semi-tanned hide/leather, porcupine quills, fur, hair, glass beads, copper alloy, glass, wool, and pigment. National Museum of the American Indian, Smithsonian Institution, Washington, DC, 01/3931. Photograph by Katherine Fogden/NMAI.

Cheyenne warriors. Part sculpture, part scrapbook, *War Shirt # 1* enables an encounter with a contemporary Cheyenne community, a source of strength that Spang both relies on and protects.[1] – JLH

Notes
1. Bently Spang, in conversation with the author, 2010.

References
J. D. Horse Capture and G. P. Horse Capture 2001.

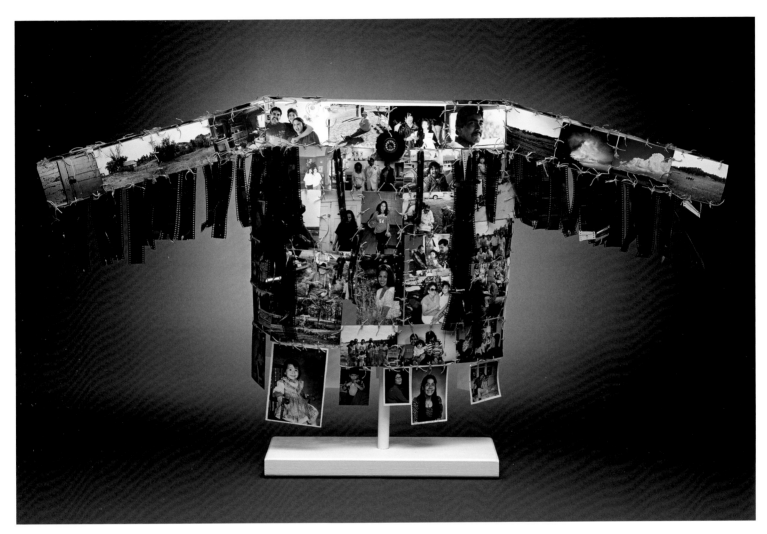

Plate 54

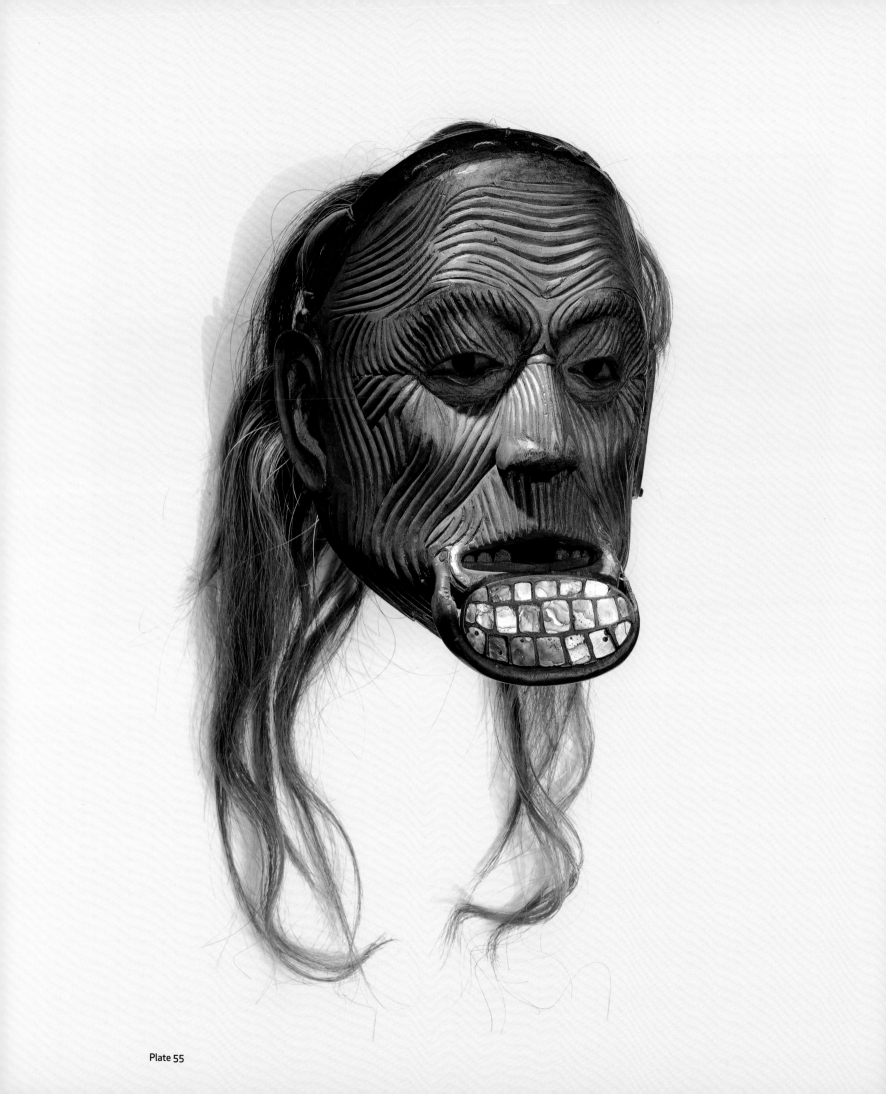

Plate 55

55 **Nisga'a artist. Mask, ca. 1850.** Wood, abalone shell, hair, hide, leather, iron alloy, and twine. 15 × 10 × 5 inches (38.1 × 25.4 × 12.7 cm). National Museum of the American Indian, Smithsonian Institution, Washington, DC, 9/8044.

Various Northwest Coast groups used masks for different purposes. Among the Tlingit, masks enabled shamans to transform into their spirit helpers. The Kwakwaka'wakw and Nuu-chah-nulth used masks as depictions of supernaturals and ancestors during dramatic performances of inherited stories. Masks of the Nisga'a as well as the related Tsimshian and Gitksan demonstrated the supernatural power of chiefs. Called *naxnox* masks, these depicted beings with whom a chief enjoyed special relationships, and their presentation demonstrated the spiritual wealth of his lineage.

Naxnox is sometimes translated as "wonders," but its meaning is more complex, encompassing a supernatural, an individual having supernatural power, and the dramatic masquerade that demonstrates that individual's power. Unlike the crest, which was communally owned by a lineage (see plate 44), the *naxnox* was the possession of its heir, who was required to validate his association with this spirit and its power by hosting a potlatch.

Naxnox masks could depict a variety of different beings, both zoomorphic and anthropomorphic. Those that represented people embraced the multiplicity of human categories: men and women, young and old, foreigners and rivals. This mask, portraitlike in its detail, represents an extremely old woman with deeply wrinkled skin and a large labret, or lip plug. When a Tsimshian, Tlingit, or Haida woman reached puberty, a small pin was inserted into her lower lip to indicate her availability for marriage; she received a larger labret after marriage. In addition to signifying sexual maturity and marital state, labrets indicated status, for only the highest-ranking women could wear so large a labret as this. Another indication of the old woman's nobility is the labret's inlay of abalone, a material restricted to use by the elite. – AJ

References
Boas 1951; Halpin 1984, pp. 281–308; Miller 1997; Macnair, Joseph, and Grenville 1998.

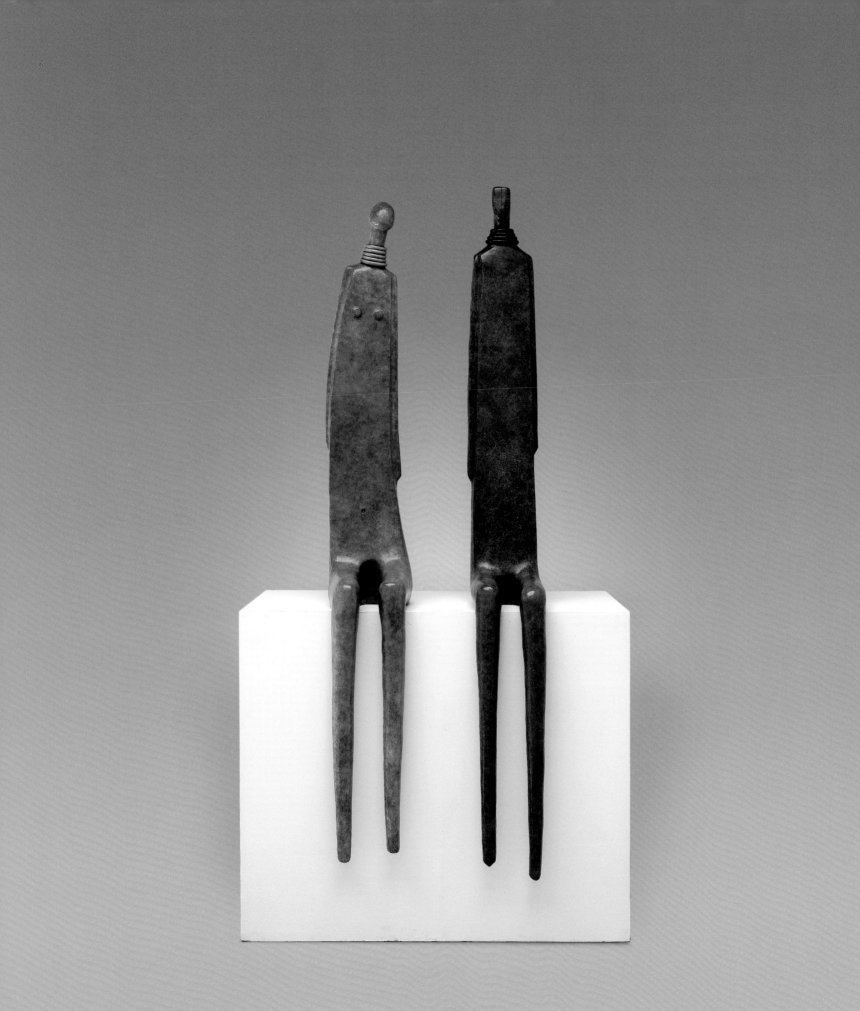

Plate 56

56 **Nora Naranjo-Morse (born 1953), Santa Clara. *The Way She Leans into Him*, 2007.** Bronze. Female figure: 64 1/2 × 9 × 14 inches (163.8 × 22.9 × 35.6 cm); male figure: 68 × 7 1/2 × 14 inches (172.7 × 19.1 × 35.6 cm). Courtesy of the artist.

In the tradition of women from Santa Clara Pueblo, Nora Naranjo-Morse gives herself over to clay, letting new forms emerge from the fluid relationship between matter and hand. This deep immersion in material properties and processes also informs her work in such diverse mediums as video, poetry, and, here, bronze. In *The Way She Leans into Him*, Naranjo-Morse accentuated the cool, hard properties of bronze while softening them with a slight curve – a subtle, tender gesture that sets in motion a relationship between the sculpted figures.

Naranjo-Morse employed a pared-down language of color, geometry, and proportion to communicate the gender of her forms. The duality of the gently curving female and stiff, upright male is equally legible to mainstream American society and the Tewa worldview to which Naranjo-Morse is connected. Importantly, however, the core of the action and interest of this piece lies with the female form. Her softness is not the subservient pliability of the sculpted Venuses that abound in European art history. Instead, her movement conveys a kind of generosity, and perhaps a curiosity absent in her stoic male counterpart.

Tewa women actively shape their world, not only through molding clay but by occupying respected positions in a traditionally matrilineal society.[1] Here, Naranjo-Morse engaged a European tradition of bronze-casting to express relational forms drawn from the cultural foundations of Pueblo pottery. – JLH

Notes
1. Naranjo-Morse, in e-mail to Madeleine M. Kropa, June 5, 2010.

References
Abbott 1994.

Changing

Voicing

Knowing

Locating

Voicing Individuality, Creativity, Repetition, and Change

Janet Catherine Berlo

In 1987, in California, Puyoukitchum (Luiseño) artist James Luna, wearing only a loincloth, performed *The Artifact Piece* in the San Diego Museum of Man (plate 77). Lying motionless in a museum display case, he presented himself as an object open to the spectator's gaze, just as his ancestors and the works of their hands had been for so many generations. Also in 1987, in Ontario, Anishinaabe artist Rebecca Belmore, wearing a Surrealist version of a Victorian velvet ball gown, performed *Rising to the Occasion* to coincide with and respond to Prince Andrew's and Lady Sarah Ferguson's visit to Thunder Bay (where, predictably, they visited a fort and rode in a birchbark canoe). With porcelain tea saucer bodice ornaments, fringed buckskin peplum, and a bustle fashioned of a thicket of sticks, Belmore burlesqued the absurdities so often found in colonial encounters, both historic and contemporary (figure 1).

Both artists were wielding humor like a scalpel to slice through centuries of congealed stereotypes regarding Native art and identity and the resultant scar tissue that has accumulated on the collective Native body politic. Since enacting these trenchant post-modern responses

to the noble savage and the Indian princess, the artists have continued to make eloquent and critically acclaimed work and consistently employed self-representation to give voice to Native concerns about history, modernity, and intercultural politics. For example, Belmore presented *Fringe* (2008) (plate 74), another memorable body image, on a twenty-four-foot-long billboard atop a Montreal building. In this color photo of a reclining Native odalisque seen from the back, a long gash extending diagonally from shoulder to hip has been neatly sutured with large stitches, giving the appearance of two pieces of animal hide lashed together with sinew. What look like long drips of blood, on closer inspection, are revealed as strands of vermilion trade beads. Belmore has transformed the female body into an elegant but grisly version of Native women's art of sinew-sewn beadwork, the beads affixed not to deer hide but to her own skin. This is shapeshifting at its most painfully provocative.

Native individuals have been making art that critically responds to their changing times since the first cross-cultural encounters half a millennium ago. Many objects – both historic and contemporary – reflect a highly

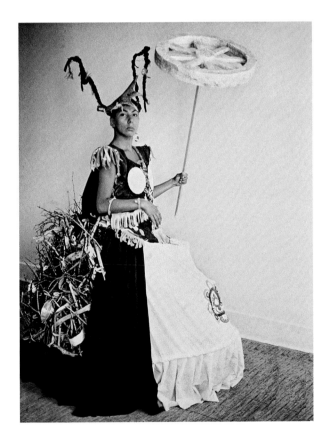

Figure 1. Rebecca Belmore (born 1960), Anishinaabe. *Rising to the Occasion*, 1987. Mixed media. Art Gallery of Ontario, Toronto, Gift from the Junior Volunteer Committee, 1995. Image of performance courtesy of the artist, photograph by Michael Beynon.

personal voice and response to changing historical conditions. The dynamic concepts articulated in this book – *Changing, Knowing, Locating,* and *Voicing,* signal a state of being on the move. In his groundbreaking *Language and Art in the Navajo Universe*, Gary Witherspoon observed that the verb "to be" is relatively unimportant in Navajo, while "to go" has more than three hundred thousand conjugations. He asserted that "the great emphasis upon repetitions, continuations, and revolutions found in the Navajo language" is foundational for understanding Navajo life and art.[1] This principle finds apt application in Native art across many centuries and many traditions. An investigation of conceptual areas such as Abstracting, Mapping, Laughing, and Embodying, reveals that individuals have found numerous ways to voice their unique artistic visions while still participating in the long historic dance of repetition and change that informs Native creativity.

Abstracting: Methods of Meaning and Marking

Abstraction requires an elegant simplification of imagery as well as a distillation of meaning. It is an ancient artistic principle in Native North America, for example, in

Woodland art, both large and small. Tiny abstract birds and hands in copper and mica were placed in the graves of high-ranking individuals (plates 28 and 29). The giant avian and serpentine images that altered the landscapes at ancient Hopewell sites in the Midwest were apparently made to please the supernaturals, for these cosmic abstractions could be viewed only from an aerial perspective.[2]

An early eighteenth-century Inoka robe from what is today Illinois depicts ancient abstract representations of feathers, presumably those of the supernatural Thunderbird, whose flapping wings cause wind and thunder and whose blinking eyes are lightning (plate 70). The smaller red circles inscribed on the hide would then represent the hail that accompanies the potent summer storms on the Midwestern prairies.[3] Abstract symbols are often multivalent, which may be the case here, for the stretched hide, which still retains the shape of the animal, with its head to the left, is also painted with a boxy black enclosure that seems to mimic the shape of the deer, including its two front legs. This makes the splayed elongated triangles evoke the animal's ribs, with the five small squares indicating the spinal cord.

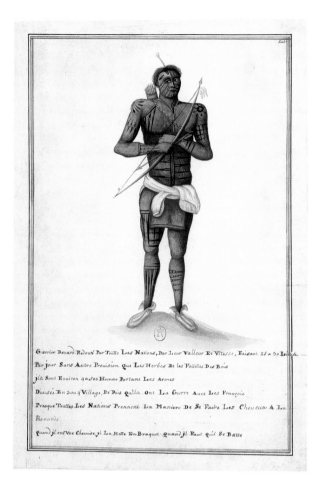

Figure 2. European artist. Fox Warrior ("Guerrier Renard"), 1731. Watercolor on paper. Bibliothèque nationale de France.

People tattooed similar abstract designs on their own bodies as well. A watercolor from 1730 depicts a Fox or Mesquakie warrior from the same general region as the Inoka (figure 2). He wears a red trade cloth breechclout and a white cloth tied around his waist. His entire body is tattooed in abstract designs. On his face, arms, and legs, the designs are asymmetrical; notably, the same elongated triangles as on the Inoka robe indelibly mark his abdomen. Such designs would have provided biographical and spiritual information to his comrades, including how many enemies he had killed in battle and who his spiritual protectors were.

Native women have long excelled in abstraction using porcupine and bird quills; feathers; moose, mountain goat, and caribou hair; and plant fibers (plates 14, 22, 27, and 31). After hundreds of years of development, Native North American abstraction reached its apex of sophistication in the formlines and ovoids of Tlingit and Haida art (plate 47).[4] These painters, carvers, and weavers sought to distill the features of totemic animals into calligraphically elegant designs so complex that sometimes they could be interpreted only by other artists familiar with the formal conventions of Northwest Coast art.

By the twentieth century, many Native artists were participating in international, cosmopolitan versions of abstraction. These range from Awa Tsireh (plate 7), who in the 1920s experimented with imagery that merged traditional Pueblo designs with Art Deco ones, to contemporary painter Kay WalkingStick (plate 73), a participant in the global abstract painting movement that she first studied as a student in the 1960s at Pratt Institute in New York. Just as abstraction of form has long been central to Native art, so has abstraction of meaning. Abstracting and wearing iconographic elements of potent beings help to map one's interactions with the human world and with the forces of the universe.

Mapping: Chronicles of Multiple Worlds

While almost no art objects have survived from the first generations after the European invasion, surely indigenous American artists immediately began to map the new realities of encounter. Beyond its narrow cartographic sense, mapping includes a conceptual charting of both ancient epistemologies as well as new world orders – chronicling changes wrought by the colonial encounter. Throughout history and across cultures, artists have always used their work to record and make sense of transition. Moreover, during times of cultural upheaval, their art may reflect that intensity and take on a sense of urgency.

Two nineteenth-century artists working fifty years apart chronicled their changing worlds by means of complex visual narratives. Dennis Cusick (Tuscarora, ca. 1800–1824) and Bear's Heart (Southern Tsistsistas [Cheyenne], 1851–1882) were each subject to a proselytizing endeavor to reshape Native people in the image of industrious Euro-American Christians. To some extent, both seem to have been willing participants. Their art endures as examples of excellence, creativity, adaptability, and curiosity about new realms.

Cusick was part of a prominent Tuscarora family: his father, Nicholas, was an interpreter and a chief; one brother was an artist and tribal historian, another a Baptist minister.[5] Missionary schoolteacher James Young described Dennis Cusick as "honest, temperate, and industrious, and a member of the Church," going on to say that he had received no artistic training, except by copying (a widespread mode of art instruction at the time).[6] At the Seneca Mission at Buffalo Creek, New York, Cusick painted scenes of Native life on paper that were affixed to a box sent East to receive "mission money" to support Christian proselytizing efforts (plate 63). The object reveals not only Cusick's artistic and calligraphic skill but also illuminates the intercultural complexities of Haudenosaunee life.[7]

On the right side of the box, some four dozen children stand and pray with their teacher in their classroom. Above is the bible verse: *"You shall keep my Sabbaths. I am the Lord."* The scene would have reassured Christians that the conversion of the Indian was well underway. Yet, the children's clothing, particularly the young men's *gustoweh* headdresses, would have signified to a Native audience that this young generation remained Iroquois even as it accepted literacy and Christianity. On the left side, Cusick rendered an exclusively female world, for the processing of flax and sheep's wool was women's knowledge in colonial and early Federal America (figure 3). His meticulous delineation is a veritable primer, showing spinning wheels, baskets overflowing with wool roving, and girls carding wool for spinning. Tall standing figures of Mrs. Young and a Native woman frame the scene. On the desk to the left are two bibles, whose pages justify the women's labors. Verses from the Book of Proverbs emblazoned high on the schoolroom wall include: *"She seeketh wool and flax and worketh willingly with her hands. XXXI, 13."* At the bottom is written: *"Seneca Mission House, Nov. 15, 1821; Dennis Cusick, son*

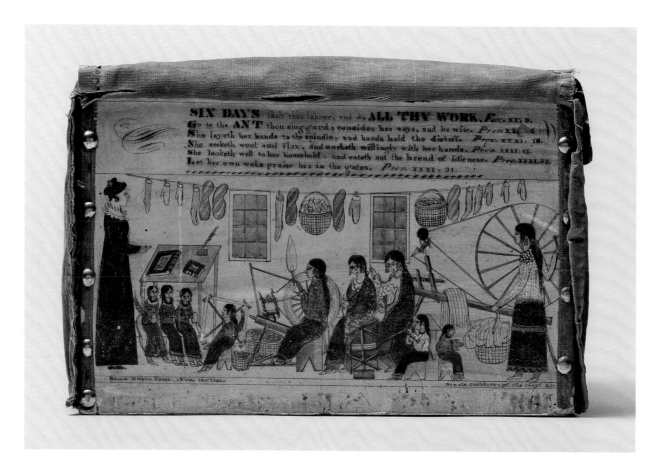

Figure 3. Dennis Cusick (ca. 1800–1824), Tuscarora. Church collection box, weaving scene, 1821–22. Watercolor on paper affixed to wood. Andover Newton Theological School, Newton Centre, Massachusetts. Image © 2012 Peabody Essex Museum, photograph by Walter Silver.

of the chief, fecit" [Latin for "he made it"]. The miniature masterpiece truly captures a nineteenth-century ideal of feminine domestic industry.

The lid of the box maps a complex web of Christian connections that stretches from London to Lake Erie to the Sandwich Islands and beyond. Because Cusick came from an elite cosmopolitan Tuscarora family that had for generations been involved with non-Natives, and because he was already Christian and literate, it is tempting to interpret his work as intentionally allying himself with the mission schoolteacher in reaching out to less fortunate Seneca schoolchildren. His work is a

fascinating glimpse into the intercultural complexities of life in America two centuries ago.

Some five decades later, the Southern Cheyenne artist Bear's Heart, also in his early twenties, made drawings in very different circumstances: while incarcerated in a military prison in St. Augustine, Florida, hundreds of miles from his homeland on the Southern Plains. The story of the Cheyenne and Kiowa warrior-artists who made hundreds of drawings while imprisoned at Fort Marion in 1875–78 is well known in Native American art history.[8] Their jailer, Army officer Richard Pratt, sought to eradicate Native ethnicity while insisting on the humanity of his prisoners, famously stating: "In order to save the man,

Detail of plate 76

we must kill the Indian."[9] He insisted that his inmates cut off their long braids, wear military-issued clothing, and learn to read and write, yet he also allowed them greater latitude than occurred anywhere else in nineteenth-century penal history. He took them on camping trips, encouraged them to make drawings to sell to tourists, and even allowed the men to keep their earnings. Reformers and activists such as novelist and abolitionist Harriet Beecher Stowe and the Episcopal Bishop of Minnesota Henry Whipple eagerly visited Pratt's experimental penal colony.[10]

Bear's Heart's four known drawing books illustrate traditional life on the Southern Plains, but he was most interested in chronicling the long train ride East, mapping the alien vistas of coastal Florida and depicting the experiences of warriors transformed into "schoolboys" at Fort Marion. One of his most ambitious drawings is an aerial view of St. Augustine's harbor (figure 4). At the lower left are the massive walls of the seventeenth-century Spanish-built fortress that was his temporary home. To the right, orderly rows of houses flank the tree-lined walking park. One ship with sails lowered rests at dock, while another sails out of the harbor. In the center of the image is the forested Anastasia Island with its two lighthouses, where Pratt sometimes took the men camping and fishing. Another island at the upper left forms a third landmark. Here, Bear's Heart literally mapped his new world, which surely never lost its strangeness to a man from the landlocked Southern Plains.

In more than one of his drawing books, Bear's Heart recorded Bishop Henry Whipple delivering a sermon (figure 5). Bear's Heart painstakingly drew sixty-nine Native men in Army garb, sitting in two long rows of benches. At the upper right are five female teachers and in the center is the bishop flanked by the interpreter George Fox and Captain Pratt in his military dress. Bishop Whipple corroborated the orderly audience of Cheyenne and Kiowa: "I have never had a more attentive congregation."[11] Yet, it is hard not to read into the bland monotony of the Army-issued clothing a sense of melancholy for the loss not only of individual autonomy but of a more vivid and colorful day (see plate 37).

Bear's Heart had unusual experiences for a nineteenth-century warrior from the Southern Plains. Not only did he make a perilous journey that most of the prisoners thought would result in their deaths, but he then attended the Hampton Institute in Virginia, where in 1878 a small number of Natives joined the ranks of African-American pupils. He did summer work on a farm in the Berkshire mountains of western Massachusetts, went sight-seeing in Boston, and marched in President James Garfield's inaugural parade in 1881.[12] Educated, Christianized, and "rehabilitated" from his former ways, he served as a public example of the good works of the Indian reformers. He and others gave lectures on Indian "progress" and sang hymns for missionaries and other Christian congregations in Connecticut and New York.

In the present post-colonial era, resistance to acculturation is more appealing than acquiescence. Yet, American and Native American history is not a one-dimensional narrative. The philosopher Kwame Anthony Appiah has coined the term "ennobling lies" for the inspirational "historical" tales that we tell ourselves in order to provide a sense of heritage, identity, dignity, and power based on what our ancestors did.[13] Such impulses are popular in any culture searching for roots, but too often they render the past unrecognizable. Native people had to grapple with the messy realities of accommodation to the dominant culture, which included an accommodation to Christianity.

Figures 4 and 5. Bear's Heart (1851–1882), Southern Tsistsistas (Cheyenne). Drawing book, view of St. Augustine Harbor and sermon by Bishop Whipple, ca. 1876. Pencil, ink, and crayon on paper. Minneapolis Institute of Arts, The William Hood Dunwoody Fund and Gift of Jill Collins and John H. Thillmann, 98.151.1.

Of course, Native art history provides narratives and intercultural collaborations that better satisfy a longing for cultural persistence than images of Christian conversions. Hosteen Klah (which translates roughly as "Mr. Left-handed") was an influential twentieth-century Navajo *hataałii* (medicine man and ceremonial singer) and artist who sought to keep alive the tremendously complex and arcane Navajo systems of knowledge. For twenty-five years, he was apprenticed to a succession of ritual experts who performed the complex songs, made the painstaking images in sand of Navajo supernatural figures, and mastered the herbal medicine that together form the *hataałii's* spiritual tool kit. Even as a child, Klah demonstrated great aptitude for memorizing the overwhelming number of visual and aural details of multi-night ceremonies.[14] Growing up in a family of weavers, he also learned the spinning, carding, and weaving more commonly practiced by girls. By building his looms much larger than most weavers, he could create the ten-foot-square textiles for which he is celebrated, such as *The Skies (from the Shootingway Chant)*, which maps the four directions and the four sacred mountains of the Navajo world (plate 26).[15]

Though some ritual experts felt it was dangerous to weave the ephemeral imagery of the sandpainting ritual into permanent form, no harm befell Klah, and eventually he taught his nieces Gladys and Irene Manuelito to weave them as well. Furthermore, Klah was concerned with giving voice to Navajo beliefs in more public contexts. He collaborated with two remarkable women, Franc Johnson Newcomb and Mary Cabot Wheelwright, to convey Navajo knowledge to a larger world. The first apprenticed herself to him, replicated many sandpaintings, and eventually wrote a book about Klah.[16] The second worked with him to publish the chants he believed would otherwise have died out, and built a museum in his honor that is known today as the Wheelwright Museum of the American Indian in Santa Fe.[17]

By charting what has been called the "cultural biographies"[18] of works such as *The Skies*, today's scholars shed light on changing interests in and interpretations of Native art objects, by Native people and outsiders alike. Cusick's box, when it served as a receptacle for donations to support Christian missions, was seen as nothing more than a curiosity that illustrated the remarkable results that followed conversion. Today, it is viewed as a distinguished artistic ancestor in a genealogy of Iroquois art. The Fort Marion drawing books were sometimes used as similar demonstrations, which is how Bear's Heart's books came into the hands of Bishop Whipple and even the implacable Indian fighter William Tecumseh Sherman (see plate 58). More often, they were purchased as souvenirs by Northern tourists who traveled to St. Augustine in the winters of 1876 and 1877.[19]

Klah's works, in contrast, have always been recognized as masterpieces. After his death, the last few inches of *The Skies* was finished by the nieces who had worked so closely with him. They gave it to his beloved friend Franc Newcomb in thanks for her having provided the money for two funerals for their uncle – one traditional Navajo and one Anglo. After her death, Newcomb's daughters sold it to Edwin Kennedy, who formed the largest collection of Navajo sandpainting textiles in existence.[20]

The maker of a tapestry featuring trains (plate 60) was another innovative artist. We do not know her name, only the tall tales told about her by the man who collected her work. George Wharton James preferred fiction to fact. In his influential *Indian Blankets and Their Makers* of 1914, he waxed eloquent about the "chatty" weaver near Gallup, New Mexico, from whom he bought it. She allegedly told him about the numerous trains that passed near her hogan as she wove: a passenger train, a cattle train, a sleeping car. Oddly, he went on to say: "When she was

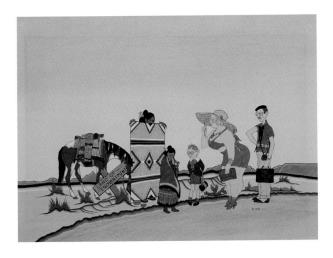

Figure 6. Woody (Woodrow Wilson) Crumbo (1912–1989), Potawatomi. *Land of Enchantment*, ca. 1946. Watercolor on board. Philbrook Museum of Art, Tulsa, Oklahoma, Gift of Clark Field, 1946.45.4. Image © 2012 Philbrook Museum of Art, Inc., Tulsa, Oklahoma.

Laughing: A Sacred Medicine

Native people often remark that "Indian humor" – a certain self-deprecating spin on life – is both widespread in home communities and fundamental to life. In fact, if there were a Native version of the saying "laughter is the best medicine," it would probably be "laughter is a sacred medicine." In Pueblo culture, performance by ritual clowns teaches through bad example and buffoonery, and has done so for at least a millennium (see plate 35). While it may be hard to discern humor in historical Native art, the Haida portrait of a red-haired Euro-American, perhaps a sea captain, with his inlaid glass freckles surely was meant to evoke amusement when it was carved some 160 years ago on what was then called by outsiders the Queen Charlotte Islands (today, Haida Gwaii) (plate 62).

ready to weave more and no train appeared, she wove six birds and five women."[21] As former San Diego Museum of Man curator Kathy Whitaker wrote, this is "a story spun and woven by James even more fanciful than the weaver's own creation."[22] Her research indicates that James actually purchased this rug from a dealer in Oakland, California.

While many Navajo weavers, including Hosteen Klah, mapped a traditional universe, others wove into their textiles images of late nineteenth-century modernity, using imported dyes and fibers.[23] Starting in 1882, railroad lines traversed New Mexico, bringing tourists and goods, including the four-ply Germantown yarn from Pennsylvania in bright aniline-dyed colors that ushered in a new phase of weaving. While many weavers continued to shear their own sheep and spin and dye their own wool, others (especially those associated with some of the larger trading posts) were supplied this fine new yarn. Thus, the tapestry was actually an ultra-modern work that reflected the marriage of ancient technological knowledge with modern materials and imagery.

Humor is widespread in Native artwork of the last half-century. The sly wit of Potawatomi artist Woody Crumbo's infamous *Land of Enchantment* (ca. 1946) (figure 6) broke through the market-driven picturesque images often found in Native paintings of the 1920s through the 1950s. The title refers to the state motto of New Mexico, a tourist destination since the end of the nineteenth century. A Navajo woman, her daughter in the foreground, proffers a rug for the inspection of a white tourist family who are presented as outlandish caricatures. They examine the rug while the weaver peeks shyly from behind her textile and her daughter looks down sadly. The wooden sign, "Land of Enchantment," is battered and askew. From the Native perspective, the days of enchantment are long gone. Crumbo's accessible style draws in the viewer, but the subject matter lacerates, as it illustrates the discomforting dimensions of intercultural exchange: the asymmetry of power between the Native maker and the white consumer. The critique of Native/white relations so common in Indian art in the last decades of the twentieth century is prefigured here. Works such as this signaled that America's static vision

of the Indian could no longer be maintained. As artist Judith Lowry (Mountain Maidu/Hamawi Pit River/Washo) has dryly observed, humor allows Native artists "the opportunity to give expression to the 'lighter' side of colonialism."[24]

The black humor of *After Two or Three Hundred Years You Will Not Notice* by Dwayne Wilcox (Oglala Lakota) grows out of the relationship between Plains Indians and George Armstrong Custer (plate 72). In Native stories, the erstwhile military hero is the absurd "Yellow Hair" who ignored the advice of his Crow scouts and led his soldiers into annihilation at the 1876 Battle of Little Big Horn. In Wilcox's drawing on ledger paper, Custer offers a souvenir American flag to a seated Plains warrior in a feathered bonnet, who points to the ball and chain painted with the Stars and Stripes that immobilizes his right foot. Wilcox was taken with images by the prolific Amos Bad Heart Bull (1869–1913), a Lakota artist who made more than four hundred drawings of Lakota history at the beginning of the twentieth century.[25] Such images on ledger paper and in drawing books were an intercultural art form a century or more ago.

In addition to Custer, other common figures of ridicule in Native life are the photographer Edward S. Curtis (1868–1952) and TV character The Lone Ranger.[26] Curtis's iconic, static, and ubiquitous sepia-toned images of noble and vanishing Indians seem oppressive to many Native people today. The Lone Ranger, with his stalwart Indian sidekick, Tonto, haunted all mid-twentieth-century childhoods. Tlingit photographer Larry McNeil put Tonto, The Lone Ranger, Curtis, and even Bear's Heart's jailer, Richard Pratt, into play in a digital print titled *Tonto's TV Script Revision* (2006) (figure 7). With McNeil in charge, the tables are turned: Tonto dunks Pratt's head in a washbasin and The Lone Ranger aims his pistol at Curtis. The work is also a sly self-portrait: at

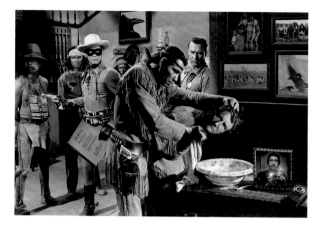

Figure 7. Larry McNeil (born 1955), Tlingit. *Tonto's TV Script Revision*, 2006. Digital print. Courtesy of the artist.

the lower right, McNeil takes aim at the viewer with his camera.[27] The tools of his trade are his weapons for addressing and redressing the injustices of Native history.

In his earlier *Sacred Power Pole* (1998) (plate 71), McNeil quietly poked fun at the national hunger for the sacred wisdom of Native America, and the proclivity of curators to organize exhibitions of Native art around the sacred. Thus, he imbued a beaten-up telephone pole with a sacred aura because he – an authentic Native expert – deems it so! In the Tlingit world, southern Alaska, tourists come in search of totem poles, seeking something essentially Native and quintessentially sacred.[28] So, McNeil proposed, any pole there must be sacred. As he assures us with great practicality on his website, the sacred is not for sale – "but might be rented at reasonable rates."[29]

Paul Chaat Smith (Comanche) wrote in *Indian Humor* that irony (or, as he personified it, Irony) has always been part of Native response to life: "He was there when Sitting Bull and Black Hawk signed up with Buffalo Bill and toured Europe, when Montezuma looked at Cortez and concluded the Spanish explorer was a deity, when Cher recorded 'Half Breed,' and when the first Mohawks built the first

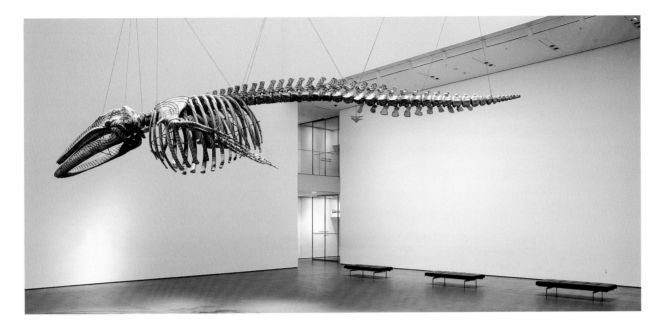

Figure 8. Gabriel Orozco (born 1962). *Mobile Matrix*, 2006. Graphite on whale skeleton. Installation view of the exhibition *Gabriel Orozco* (December 13, 2009 through March 1, 2010, The Museum of Modern Art, New York). Biblioteca Vasconcelos, Mexico City. © Gabriel Orozco, image © The Museum of Modern Art/Licensed by SCALA/Art Resource, New York, photograph by Jonathan Muzikar.

skyscraper."[30] British Columbian artist Brian Jungen's elegant and clever *Cetology* (2002) (plate 2) is deeply ironic on numerous levels. The public for Native American art expects a relationship between Native art of the Northwest Coast and giant sea creatures (for example, the abstract killer whale in plate 47). But, Jungen is Dunne-Za Nation, from the interior, not the coast. He purposely played with these expectations and deflected them by making his diving whale out of plastic garden chairs – materials as "inauthentic" as he deems himself to be. Like Larry McNeil, Jungen also took a poke at the dominant culture's hunger for spirituality and its ineradicable stereotype of indigenous peoples' alleged closeness to nature. Neither totem nor celebration of natural forces, Jungen's sea creature is an indictment of our age of global warming, depletion of the oceans, and excessive consumption of petrochemicals to make the plastics of our lives.

In this regard, *Cetology* makes a provocative contrast to Gabriel Orozco's far better known *Mobile Matrix* (2006), an actual whale skeleton covered with numerous graphite arcs and circles that was the centerpiece of the Mexican artist's 2009 retrospective at New York's Museum of Modern Art (figure 8). Orozco's site-specific piece conceived for Mexico's National Library could be seen as reinscribing a deeply romantic nineteenth-century relationship to natural history.[31] *Cetology*, on the other hand, prompts questions about our "romance" with nature, the future of endangered species, and the ubiquity of human-made detritus. At the same time, the large-scale bricolage is playful and inspires delight.

Embodying: Corporeal Knowledge

Native people have long appreciated that knowledge resides in bodily as well as cerebral experience. In ceremonies, humans may both embody and honor the supernaturals; prayers may be danced as well as recited.[32] A Descartian mind-body dualism was never the way that indigenous peoples of the Americas ordered their universe.

In a Navajo healing ceremony, a ceremonial landscape is constructed out of ephemeral materials. Ritual specialists manipulate potent plant and mineral substances and chant powerful, repetitive songs to engender in the patient a transitory experience of embodying the ancestral Holy People who formed the universe. Through this, *hózho* (beauty, peace, harmony) is created. Imitating, replicating, and finally embodying deep cultural values are pathways toward making sense of the mysteries of the universe. It is said that Hosteen Klah, as a *nádleehí* – embodying both male and female – was thereby able to excel at the most specialized work of men – being a ritual healer – as well as that of women – being an extraordinary weaver.[33] In his sandpainting textiles, Klah took the ephemeral and male art of replicating the world of the Holy People using pollen and crushed mineral pigments and gave it new form through the female art of weaving long-lasting images using wool and plant dyes (plate 26).

In Native art, embodying takes multiple forms. There is the idea of taking on the power of the bison, the eagle, and the horse by appropriating abstracted portions of these animals, perhaps to tattoo one's own body (figure 2). Ritual performers at Cahokia and other ancient cities embodied the spirits of land animals and birds (plate 36). Such performances continue today, for example, in the sacred dances at Hopi, Zuni, and other pueblos, where men mask their identities and dance as animals or spirit figures.

Three of the most important Native artists of the last few decades – James Luna, Jaune Quick-To-See Smith, and Rebecca Belmore – tackle large conceptual issues of embodiment. The photographic representation of Luna's *The Artifact Piece* (plate 77) is only a pale documentation of his audacious and powerful performance in the San Diego Museum of Man, where he bravely grappled with a long

history of Native people embodied in museum representations. Using his own body to identify with all of those Native ancestors – and force his audience to identify with them – Luna ensured that "Indian artifacts" could never again be experienced uncritically.

During days of reflection in his vitrine, surely Luna thought about specific Native people whose bodies and artifacts had been held captive in museums. In 1897, seven-year-old Minik (1890–1918), a Greenlandic Eskimo, was taken with his father and four others to reside at the American Museum of Natural History in New York. Four died of pneumonia within eight months; their bodies were autopsied, the flesh stripped from their bones, and their skeletons stored at the museum where just weeks earlier these visitors had displayed their tools and provided information on Greenlandic customs and language.[34] And, as an indigenous Californian, Luna certainly thought about Ishi (ca. 1860–1916), the often described "last of his tribe" of Yahi, who in August 1911 emerged from the hills near Oroville, California, malnourished and dressed in rags. Taken into custody and given over to anthropologist Alfred Kroeber at the University of California at Berkeley, Ishi worked as a janitor and lived the last few years of his life in the university museum. Visitors flocked to see him demonstrate how to knap obsidian arrowheads.[35] Luna's *The Artifact Piece* was both restitution and homage for such museum histories. He understands performance as a creative mode that bridges past to present and "offers an opportunity like no other for Indian people to express themselves without compromise…."[36]

In a different sort of embodiment, in the Columbus Quincentennial year 1992, Jaune Quick-To-See Smith (Salish/Kootenai) boldly took on five centuries of a Eurocentric masculine tradition when she lay down on two canvases she had collaged and directed her studio assistant to outline the shape of her body. Over this,

Figure 9. Leonardo da Vinci (1452–1519). *The Vitruvian Man*, ca. 1492. Pen and ink with wash over metal point on paper. Accademia, Venice. Image © SCALA/Art Resource, New York.

she painted a red quartered circle. Titling her work *The Red Mean: Self-Portrait* (plate 76), Quick-To-See Smith was referencing Leonardo da Vinci's famous *The Vitruvian Man* (figure 9). Leonardo in turn was illustrating an observation by the ancient Roman architect Vitruvius: "If a man is imagined lying back with outstretched arms and feet within a circle whose center is at the navel, the fingers and toes will trace the circumference of this circle."[37] Quick-To-See Smith's circle does not contain her body; her outline extends beyond it. While some have called Quick-To-See Smith's circle a medicine wheel, it also can be read as a target, its central X crossing over the lower abdomen of the female figure.[38]

In this work, Quick-To-See Smith did not address the European male artist exclusively. As an ambitious artist determined to make a living in the art world, she was coming to national critical attention in 1980 even as she was just finishing her master's degree in Studio Art. At that time, Quick-To-See Smith voiced her intention to make a place for women in the small but decidedly masculinist world of contemporary Native art, too, proclaiming: "Move over Fritz Scholder [plate 3]; out of my way, Momaday," naming the foremost Native painter and the foremost Native writer of the 1960s and 1970s.[39] Notably, Quick-To-See Smith was concerned with making a place for all Native women artists, not just herself. From her role as the self-proclaimed "Mother Superior" at the Gray Canyon Artists Collective in Albuquerque in the late 1970s to her curatorial work on *Women of Sweetgrass, Cedar and Sage* in 1985 and beyond, Quick-To-See Smith has blazed a trail for women artists in subsequent generations.[40]

Turning Around on Purpose

For Quick-To-See Smith, Luna, and Belmore, the power and authority of their work accumulates, in each case, from community-based knowledge, and from a deep study of the complexity of Native histories and indigenous life today. But none of these artists is limited by ethnicity or resorts to what cultural critic Kobena Mercer called "ethnic absolutism."[41] Rather, they are part of a global art world conversation in which gender, race, nationality, class, the problematics of the nation-state, and a host of other issues are addressed. Simplistic identities are dismantled, and complex ones take their place.

The work of Luna and Belmore is located between the long history of indigenous performance and twentieth-century international contemporary performance art. Both artists have performed at the Venice Biennale. Through their art school training and subsequent

international travels, they have been influenced by performance artists of the 1960s and 1970s, as well as by their contemporaries. Feminist artist Eleanor Antin (born 1935) and Dutch conceptual artist Bas Jan Ader (1942–1975) influenced Luna.[42] Belmore's work contains adumbrations of a number of female performance artists who preceded her: the Japanese artists Yayoi Kusama (born 1929) and Yoko Ono (born 1933), as well as Americans Hannah Wilke (1940–1993) and Carolee Schneeman (born 1939), Yugoslavian Marina Abramovic (born 1946), Cuban Ana Mendiata (1948–1985), and Canadian Lisa Steele (born 1947). All of these women used their own bodies in wrenchingly memorable performances, some as early as the 1950s.[43] But Belmore's work is not merely in conversation with that of other women and other Native artists. *Fringe* explores the integrity of the human body in a way similar to the Los Angeles – based conceptual artist Daniel Martinez (born 1957), who in digital self-portraits from 1999 to 2001 depicted his body appearing to be sliced open and sewn back up.[44] In much recent art, including Native art, the body is the site for playing out many complex issues of our time. In her own work, Belmore has said with regard to the Aboriginal body in particular: "It's the politicized body, it's the historical body, it's the body that didn't disappear."[45]

Writing in 1992, on the occasion of the Columbian quincentennial, when many were considering the history and legacy of Native art, Jean Fisher remarked of two of the most influential Native artists of the era:

James Luna and Jimmie Durham express "traditional" aesthetics through what the latter calls "turning around on purpose; acts and perceptions of combining, of making constant connections on many levels." Tradition, then, lies not in the object itself but in organizing principles of thought: the dynamics of circulation and return, continuity and change by which Native systems of knowledge synthesize the paradoxes and heterogeneity of life experience.[46]

This observation provides an insightful characterization of Native art in general: ever dynamic, circulating, and heterogeneous – a tradition of vitality and change. In the nineteenth century, Cusick and Bear's Heart exemplified the tradition of vitality and change, as Smith, Belmore, and Luna do today. In the twenty-first century, too, Native artists are continuing to make art that dynamically gives voice to changing lives and circumstances, "turning around on purpose" to illuminate the past as well as the future.

Notes
1. Witherspoon 1977, p. 21.
2. See Townsend 2004B.
3. For figural depictions of this supernatural by a nineteenth-century Lakota artist, complete with hail spots, see Berlo 2000, pls. 1 and 2.
4. See Carlson 1982, for early manifestations of this design system.
5. Brydon 1995, p. 60; also Cusick 1848.
6. Brydon 1995, p. 85 n. 9.
7. In addition to the Seneca and Tuscarora, the Haudenosaunee (or Iroquois, also known as The People of the Longhouse) consist of the Mohawk, Oneida, Onondaga, and Cayuga, whose communities can be found in Montreal, Quebec, Pennsylvania, New York, and Ohio.
8. See Petersen 1971; Berlo 1996; Szabo 2007.
9. Pratt 1973, p. 260.
10. Pratt 1964; Lookingbill 2006.
11. Bishop H. B. Whipple, "Mercy to Indians," *The New York Daily Tribune*, Saturday April 1, 1876, as quoted in Pratt 1964, pp. 163–64.
12. These details on Bear Heart's life are drawn from Karen Daniels Petersen's pioneering work on the Fort Marion artists, which remains unsurpassed in terms of its biographical narratives. See Petersen 1971, pp. 97–109. She characterized Bear's Heart as "among the most prolific and technically advanced of the artists" (p. 104).
13. Appiah 1992.
14. Newcomb 1964, pp. 84–85.
15. McGreevy 1982. Its plates are unnumbered, but show many of his finest works, as well as those of his nieces.
16. Lange 2010; Newcomb 1964.
17. Mary Cabot Wheelwright wrote of her friend Klah: "I grew to respect and love him for his real goodness, generosity – and holiness, for there is no other word for it. He never had married, having spent twenty-five years studying not only the ceremonies he gave, but all the medicine lore of the tribe…. After I had recorded his great ceremonies and myths, I went on to other Medicine Men and always found that when I told them of Klah and the idea of the Museum to keep the records safe for their

people and mine, and of the ceremonies I had already seen, they were willing to tell me their myths and show me what I needed to know…. Mrs. Newcomb and I were very lucky to have come in touch first with one of the great men of the tribe, who was not only that but a real student of his religion. Our civilization and miracles he took simply without much wonder, as his mind was occupied with his religion and helping his people." Wheelwright 1942, pp. 11–13. I am grateful to Leatrice Armstrong at the Wheelwright Museum for bringing this text to my attention, and for corresponding with me in 2005 about Mary Cabot Wheelwright.

18. Kopytoff 1986.

19. Szabo 2001.

20. I am grateful to Jennifer McLerran, former Curator of Collections, Kennedy Museum of Art, for telling me this anecdote. Personal communication, December 29, 2010. See also McLerran 2002. Kennedy's collection was published in Dockstader 1987.

21. James 1914, pp. 124–25.

22. Whitaker 1978, typescript p. 4.

23. See Campbell, J. Kopp, and K. Kopp 1991 for pictorial textiles of trains and other images of modernity. On new materials, see Hedlund 1987.

24. Lowry, quoted in Bates, Rickard, and Chaat Smith 1995, p. 67.

25. See Blish 1967.

26. See Sweet and Berry 2001. For further exploration of humor in Native art, see Ryan 1999.

27. See McNeil 2009.

28. For a critique of the totem pole in North American culture, see Jonaitis and Glass 2010.

29. LarryMcNeil.com.

30. Chaat Smith 1995, p. 14. Since the early twentieth century, Mohawk ironworkers from both Canada and New York have worked in the "high steel" construction industry.

31. See Temkin 2009. This real whale skeleton was excavated from a sand dune in Baja, California, with permission and help from the Mexican government, specifically for use as an installation in a government building.

32. See, for example, Basso 1996; Feld and Basso 1996; Weiss and Haber 1999; Csordas 1990.

33. A *nádleehí,* or *nadle* as it is sometimes spelled, is usually understood to be a hermaphrodite, though some scholars find this a reductive definition. See Epple 1998. In Navajo culture, a *nádleehí* was considered to be powerful. For more on Klah, see Roscoe 1988; Newcomb 1964, p. 97; W. W. Hill 1935.

34. Harper 2000.

35. See Starn 2004.

36. Haas, Chaat Smith, and Lowe 2005, p. 16.

37. Vitruvius 1999, p. 47.

38. For a discussion of *The Red Mean* in relation to Quick-To-See Smith's other works of the 1990s, see Valentino 1997, pp. 25–37.

39. Quick-To-See Smith 1979. Fritz Scholder (1937–2005) achieved international recognition as an expressionist painter. See *Two American Painters: Fritz Scholder and T. C. Cannon* 1972; Sims 2008. N. Scott Momaday (born 1934) is the Pulitzer Prize-winning author of *House Made of Dawn* (1968), *The Way to Rainy Mountain* (1969) and many other works.

40. Quick-To-See Smith discussed her role in the Gray Canyon Group in Quick-To-See Smith 1979. See also Hammond and Quick-To-See Smith 1985.

41. Mercer 1990, p. 68.

42. González 2008, p. 37.

43. Jones 1998. See also Kalbfleisch 2010; Biesenbach 2010.

44. See Fusco and Wallis 2003, unnumbered plate on p. 326; Hanor 2006, pp. 84–85.

45. Augaitis and Ritter 2008, p. 55.

46. Fisher 1992, p. 50.

57 Kevin Lee Burton (born 1979), Swampy Cree. *Nikamowin (song)*, 2007. Digital video. Dimensions variable. Courtesy of the artist and Vtape.

With indigenous languages facing a steady decline, their survival depends on efforts by Native nations to revitalize and maintain their cultural importance. The oral tradition contains key knowledge encoded and recounted through storytelling, performance, and song. Swampy Cree filmmaker Kevin Lee Burton created the extraordinary experimental film *Nikamowin* by merging aural and visual art forms to confront the critical urgency of losing a language and being lost without one. The film captures the unique worldview of the Cree led by a conversation morphed into a soundtrack of sampled patterns and snippets of dialogue together with electronic organic beats streamed against a collage of panoramic scenes of wilderness, rural landscapes, and cityscapes in motion.

Nikamowin is Burton's personal journey, yet a relevant one for many Native people who consider their language to be vital to understanding who they are, where they come from, and how it connects them to their environment. By creating a contemporary song with his film, Burton challenged the idea of tradition being stagnant and conventional. He explained: "I do this to explore the many unanswered questions around how the notion of how 'traditional' is not only something of the past, but is current and ever fluid."[1] – RR

Notes
1. Farrell 2009.

References
Farrell 2009; National Museum of the American Indian, Smithsonian Institution 2010; Beat Nation 2010A

58 Bear's Heart (1851–1882), Southern Tsistsistas (Cheyenne). Drawing book, tipi with dragonflies, ca. 1876. Pencil, ink, and crayon on paper. 8 5/8 × 11 1/4 inches (21.9 × 28.6 cm). Minneapolis Institute of Arts, The William Hood Dunwoody Fund and Gift of Jill Collins and John H. Thillmann, 98.151.1.

In 1875, some six dozen warriors from the Southern Plains were incarcerated at a military fort in St. Augustine, Florida, where one of the most unusual experiments in American penal reform took place. The Kiowa and Southern Cheyenne prisoners, who have come to be known as the Fort Marion artists, were taught to read and write; many made drawings for sale to tourists. Their drawing books provide insight into Plains Indian life during an era when every force of the United States – military, legislative, and social – was marshaled against Native people. They, in turn, marshaled all their forces to resist this onslaught. Artistic creativity was one such force. Bear's Heart was among the most accomplished of the Fort Marion artists, as evidenced in this book and three others.[1] In them, he signed his name and recorded his memories of the eventful trip from Oklahoma Territory to Florida by horse cart, train, and ship, as well as scenes of his Florida life.[2] The page illustrated here depicts a tipi painted with dragonflies. In Cheyenne cosmology, dragonflies, butterflies, eagles, and hawks are mediators between humans and Maheo, the Great Spirit.

Bear's Heart was a twenty-four-year-old warrior when he was incarcerated at Fort Marion. Upon their release in 1878, some men went home while others stayed in the East for further schooling. Bear's Heart spent three years at the Hampton Institute in Virginia (originally a school for ex-slaves), returning to the Cheyenne-Arapaho Agency in Oklahoma in 1881. He died of tuberculosis just a few months later. – JCB

Plate 57, detail

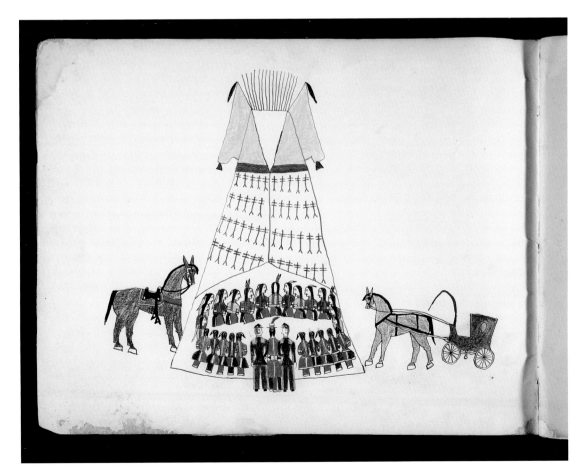

Plate 58

58

Notes

1. A drawing book presented to General William Tecumseh Sherman when he toured the fort in 1876 is now in the National Museum of the American Indian. See Supree 1977. Eleven folios from a drawing book previously thought to be by Etahdleuh Doanmoe (Kiowa) are now recognized as by Bear's Heart. See Earenfight 2007. The Silberman collection contains many individual drawings that apparently make up another book. See Szabo 2007.

2. The book in The Minneapolis Institute of Arts was donated by Karen Daniels Petersen, the first scholar of Fort Marion art. It had been passed down in her family from Jared Daniels, MD, an Indian Agent among the Sioux in the late nineteenth century. See Petersen 1971, pp. 97–108, and Berlo 1996, pp. 115–77.

References

Petersen 1971; Supree 1977; Berlo 1996; Earenfight, 2007; Szabo 2007.

59

Diego Romero (born 1964), Cochiti Pueblo. *Iwo Jima Pot* **(from "Never Forget" series), 2001.** Ceramic and paint. 21 1/2 × 11 inches (diam.) (54.6 × 27.9 cm). Peabody Essex Museum, Salem, Massachusetts, Museum Purchase with partial funds from Merry Glosband, 2001, E301811.

Ceramist Diego Romero was born in 1964 to a Cochiti Pueblo father and Euro-American mother. Raised in Berkeley, California, Romero considers himself half city-raised kid and half Cochiti Indian.[1] His eclectic artistic style reflects this notion, as he seeks to synthesize the multifaceted identities of contemporary Native Americans. Romero blends his Cochiti ancestors' method of coiling Native clay with inspiration from ancient Southwestern pottery, Greek amphoras, and popular culture. The unromanticized vignettes he paints on the surfaces are sometimes amusing explorations of daily life but also boldly confront difficult issues surrounding Native politics, history, war, and alcoholism.

During World War II, more than forty-four thousand Native Americans fought for the United States. Among them was Ira Hayes, from the Akimel O'odham (Pima) tribe. The marine was immortalized as one of the six soldiers in Joe Rosenthal's iconic photograph of the flag-raising on Iwo Jima's Mount Suribachi on February 23, 1945. Never comfortable with his participation in this event[2] and the fervor with which he was identified as a hero, Hayes suffered from post-traumatic stress disorder and alcoholism. He died in 1954 at age thirty-three. Hayes was a favorite subject of Diego Romero's father, the renowned traditional Cochiti watercolorist Santiago Romero, who fought in Korea and considered Hayes a brother in arms.[3] In this complex work, Diego paid tribute to the fallen soldier, exalting him as a Native warrior atop a gilded trophy that honors Hayes's legacy. A lifelong fan of comic books, Romero depicted Hayes in the panel of a comic illustration with the unfaltering adoration afforded to childhood heroes. By separating Hayes from the key elements – the flag, the photo, and the personal disaster – that defined him following Rosenthal's photograph, Romero poignantly restored Hayes's identity and voice. Unmistakably Cochiti in its construction and conceptualization, this trophy situates Hayes within Native American social consciousness, memorializing his accomplishments with the dramatic admonition "never forget" called out in a splash balloon. – MMK

Notes

1. Romero 2008.
2. Two flag raisings occurred on Suribachi the morning of February 23, 1945. Hayes participated in the raising of the second flag, an event which is often debated as having been "staged" by Rosenthal in order to capture the photograph that made him famous.
3. Romero 2008.

References

Weston 2002; Fairbrother 2003; *Unlimited Boundaries: Dichotomy of Place in Contemporary Native American Art* 2007; Romero 2008; Romero 2010; Spirit Voices 2010; *Wikipedia* 2010B.

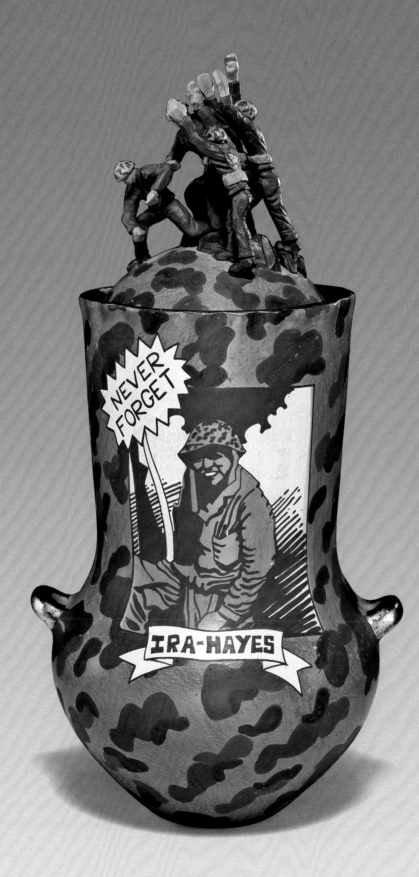

Plate 59

60 **Diné (Navajo) artist. Tapestry, 1885–95.** Germantown yarn and aniline dye. 47 1/2 × 27 inches (120.7 × 68.6 cm). San Diego Museum of Man, San Diego, 1959.030.0004.

This tapestry is testimony to the transformative power of art. On the surface, there appears to be nothing Navajo about the piece as Native art is usually defined. The factory-made yarns are chemically dyed and locomotives and trains are not commonly part of a Native landscape. Nonetheless, the artist has taken foreign products and made them part of the Native Navajo world. Filled with imagination, humor, vitality, and artistic vision, this textile demonstrates that the continuity and vitality of Native art is reliant on new ideas and materials.

The weaver was clearly insightful, a keen observer, and inventive. Train wheels morph into rows of diamonds that echo the decorative multicolored rows of serrated diamonds found throughout the piece; the realistic railroad track profile alternatively divides the tapestry into balanced blocks of color and design and moves the locomotive beyond the frame of the weaving itself.

Pictorial weavings were transitional creations, falling between blankets made for community use to floor rugs made for non-Navajo homes. Traders encouraged an earth-tone palette for the rugs, although the bright-colored commercial wools sparked a period of irrepressible creativity for weavers by engendering more dynamic and increasingly complicated designs.

The weaving's provenance provides further commentary regarding sentimental ideas of Native art. Although he actually purchased the tapestry from Smith Bros. Booksellers in Oakland, California, Indian historian and art dealer George Wharton James published it in his *Navajo Blankets* (1914) with an elaborate story of how he sat with the Navajo family over several days, each passing train inspiring a horizontal band of design, along with the fiction of the weaver traveling to Gallup, New Mexico, to tour sleeping cars in preparation for weaving the masterpiece. The fanciful description does more to reveal the romanticism James attached to Indians than anything set in reality. – BB

References
James 1914; Cherney 1976; Kent 1985; Campbell, J. Kopp, and K. Kopp 1991; McGreevy 1994.

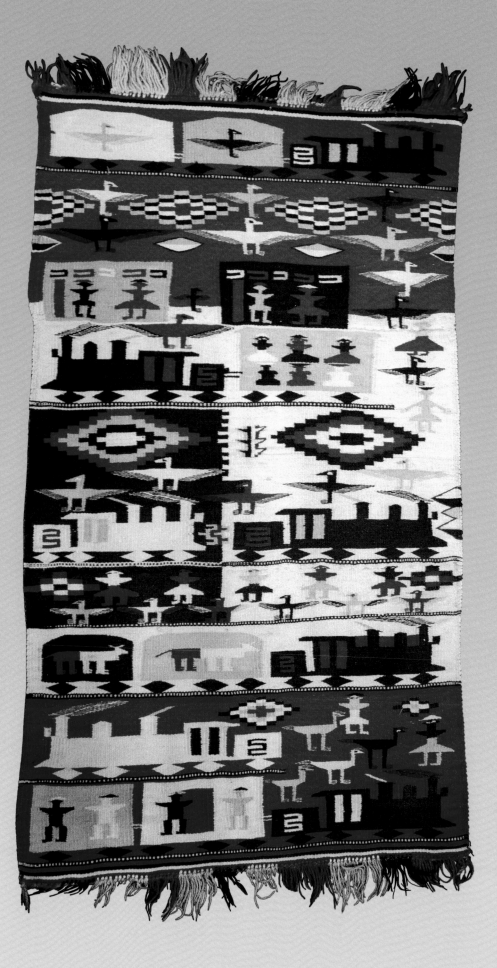

Plate 60

61 **Marie Watt (born 1967), Seneca.** *Column (Blanket Stories)*, **2003.** Wool blankets and cedar. 144 × 20 × 20 inches (365.8 × 50.8 × 50.8 cm). Collection of Deborah Green.

Marie Watt's towering column of fabric evokes many literal and figurative associations. Twelve feet tall, it recalls the conifers of Watt's childhood in Washington state, but also references her Native Seneca (one of six Haudenosaunee nations of the Iroquois confederacy, land based in what is today the northeastern United States) heritage and the Seneca's vertical spatial orientation of sky to ground, and heaven to earth. Totem poles, ladders, and architectural pillars also quickly come to mind. Yet, this structure created with more than seventy-five wool blankets collectively reveals the complex history, intercultural exchange, and trade economy associated with blankets, as well as the many personal, familial, and communal stories held within their cherished fibers.

Wool blankets first came to Native peoples through trade with the French and the English during the 1600s. The history's dark side includes the distribution of smallpox-infected blankets by Euro-Americans as a vehicle of annihilation. Smallpox, with other diseases from European contact, caused the death of 40–60% of Native populations. Today, however, blankets are associated with beauty, honor, and respect, and are indispensable to Native events and celebrations. These prized items weave together an intergenerational continuum and are gifted at births, comings-of-age, graduations, marriages, namings, and honorings. It is as great a privilege to give as to receive a blanket.

In her art, Watt politicizes recycled blankets, strategically referring to them as "reclaimed wool" and considering them symbolic of Native struggles to reclaim land and sovereign rights. Simultaneously, they represent the interconnectedness of all human experiences – providers of warmth and comfort from birth to life's end. To further unveil their embedded humanity, Watt documents the stories of the families who originally owned the blankets, tagging each blanket with a note indicating where it came from and, when known, its significance. The blankets also pay homage to the additional stories (about love, marriage, raising children, and so forth) that were shared with each stitch taken during the sewing circles Watt holds to create her sculptures. Her work is in part a feminist statement about the relationship between women's craft and fine art. – KE

References
Watt 2004; Berlo 2005; Archuleta 2005; Everett in Everett and Zorn 2008, pp. 233–36; Trautmann 2010; Watt Studio 2010.

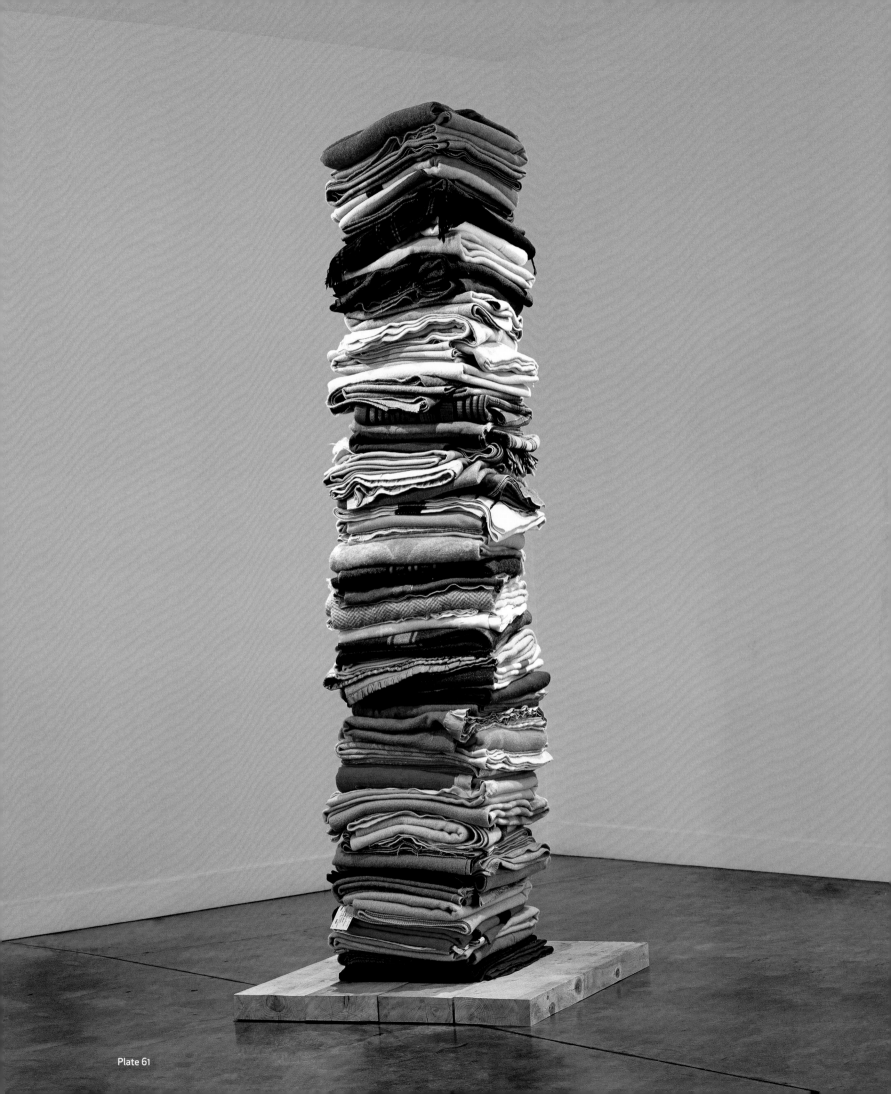

Plate 61

Plate 62

Plate 63

62 **Haida artist. Mask, 1850.** Wood, glass, and paint. 10 1/2 × 9 × 6 inches (26.8 × 22.9 × 15.2 cm). Joslyn Art Museum, Omaha, Nebraska, Museum Purchase, 1959.532.

The Haida live off the coast of northern British Columbia on Haida Gwaii, once called the Queen Charlotte Islands. Their location, which offers safe harbors in the sometimes rough seas, proved attractive to the late eighteenth-century ships that first explored the Northwest Coast. The traders purchased sea otter pelts to sell for large sums in China, and the wealth that poured into Haida Gwaii led to a tremendous flourishing of art, from monumental totem poles to delicate horn spoons. By the first decades of the nineteenth century, the otters had been hunted nearly to extinction, but the entrepreneurial Haida soon developed new items to market.

Because the foreigners wanted souvenirs, the Haida began producing artistic commodities for sale. Starting in the 1820s, travelers could purchase carvings of wood or argillite, a locally quarried carbonaceous shale. These first "tourist arts" created on the Northwest

Coast exhibit the same craftsmanship and high quality so apparent in Haida art created for use within their communities. The Haida seem to have been fascinated with the dress and behavior of the foreigners. Some early argillite works, which doubtless had considerable market appeal, depict Euro-Americans as well as their ships, furniture, and animals. The Haida also on occasion made images of visitors in wood, such as this mask that possibly depicts a sea captain.

Haida ceremonial masks could be strikingly naturalistic and so were some masks made for sale. This red-headed man has a chin-curtain beard and a generous sprinkling of what appear to be glass freckles on his cheeks. Seemingly pensive, he gazes downward with a slight grin. It is possible that this portraitlike mask was commissioned or made with the hope of selling it to the individual portrayed. – AJ

References
J. C. H. King 1979; Vaughan and Holm 1982; Malloy 2000; Wright 2001.

63 **Dennis Cusick (ca. 1800–1824), Tuscarora. Church collection box, 1821–22.** Watercolor on paper affixed to wood. 5 1/4 × 8 1/2 × 8 1/2 inches (13.3 × 21.6 × 21.6 cm). Andover Newton Theological School, Newton Centre, Massachusetts.

In 1820, schoolteacher James Young arrived at the Seneca Mission at Buffalo Creek, on Lake Erie in western New York. He was soon working with Tuscarora artist Dennis Cusick on the making of pictures and texts to decorate a box to be sent back East to raise money. Such church collection boxes supported the American Bible Society, which by 1821 was issuing fifty thousand

bibles a year, many to "foreign" missions, including Native American ones.

Though Cusick has been called a student at the Seneca Mission School, this is unlikely because his works reveal him to have already been fully literate. The existence of two other nearly identical drawings suggests that Young and Cusick may have devised a modest business enter-prise making such boxes to illustrate the success of the missionary endeavor.[1]

The box presents a miniature schoolhouse. The back depicts the exterior of the building. The left side, with

63 its imagery of women's arts of spinning and weaving, suggests the domestic skills taught therein six days of the week. The right side depicts Sabbath prayers taking place within the schoolroom. Thus, both secular and sacred instruction are illustrated in one economical image. The top – where coins are deposited – is a metaphoric diagram of the cultural relationships behind the missionary endeavor. Among the names written are Hans Egede (Norwegian and the first Lutheran missionary to Greenlandic Inuit), John Eyre and John Jefferson (British missionaries to Tahiti), and Harriet and Samuel Newell

(the first American missionaries to Bombay). The object deliberately blurs the distinction between the monolingual Seneca that Young and his colleagues were trying to educate and convert, and the cosmopolitan bilingual individuals, such as Cusick, who had existed in small numbers across the Iroquois communities for a century. – JCB

Notes
1. For Cusick's other drawings, see Brydon 1995, figs. 11 and 12.

References
Fenton 1956; Brydon 1995.

64 **Jessie Oonark (1906–1985), Baker Lake. *Untitled*, ca. 1972.** Stroud, felt, embroidery floss, and thread. 83 1/2 × 56 3/4 inches (212 × 144 cm). Art Gallery of Ontario, Toronto, purchased with assistance from Wintarlo, 1977, 76-229.

One of Canada's most celebrated artists of the twentieth century, Jessie Oonark was born on the tundra in the Barren Lands of what was then called the Northwest Territories. She was a widow in her fifties when, in 1958, her starving family was brought into Baker Lake, on the west side of Hudson Bay. For the next twenty years, she drew and sewed nonstop. Making wall-hangings took the sewing skills of a traditional Inuit woman in a new direction. Instead of fashioning family garments from somber caribou hide, women at Baker Lake sew bright figures of wool cloth from the Hudson's Bay Company store. For more than forty years, these have provided both creative expression and a valuable source of income.

Oonark's subject matter combines her first five decades as part of a group of nomadic subsistence hunters with the changes brought by community living. Her

figures wear the characteristic parka styles of the Barren Lands region – a woman's parka has a long flap in the back for extra insulation while sitting on ice, a smaller flap in front, and a roomy hood and shoulder area for carrying a baby. Oonark was baptized in the Anglican Church in 1944, and in this wall-hanging she depicted four kneeling figures within an arched enclosure, two of whom wear priestly vestments. Her bold graphic style is unmistakable, favoring strong colors and simplified forms. She used embroidery thread like a drawing tool to create facial features and the seam lines of clothing. Here, figures of white, blue, yellow, tan, and red stand like paper-doll cutouts against a dark blue background. They mirror each other in dynamic symmetry, as exemplified in the figures seated in front of igloos at the lower left and right. – JCB

References
Blodgett and Bouchard 1986.

Plate 64

65 **Donald Varnell (born 1973), Haida.** *Immaculate Conception,* **2008–11.** Red cedar and paint. 27 × 24 × 1 3/4 inches (68.6 × 61 × 4.5 cm). Courtesy of the artist. Not in exhibition.

Donald Varnell is an innovative Haida artist who takes inspiration from his ancestors to express a personal perspective of his cultural background and the world around him. Like James Schoppert (plate 4) and some other contemporary Northwest Coast artists, after acquiring classical skills and knowledge Varnell became eager to explore a wider aesthetic vocabulary. Over the years, he has taken Northwest Coast "formline" style in entirely new directions, and, as in *Immaculate Conception,* almost beyond the domain of recognizable Northwest Coast art. The ovoids, u-forms, and the narrowing and swelling bands of the formline clearly reveal Varnell's Haida heritage, but his work is intentionally original.

Varnell, who has given many carving demonstrations at museums in Alaska, objects to assumptions that if visitors learned what an image depicted, they would understand the artwork. In response to what he believes is a disregard for the complexity behind Northwest Coast art, he creates images that are not immediately or sometimes ever recognizable. Varnell also feels that the artist need not explain his work, and, as a corollary, he objects to permanent titles and often renames his works. At the time of this writing, this carving bore the title *Immaculate Conception.* Varnell finds strange the

concept of a supreme deity impregnating a woman and ironic that missionaries told the Haida their beliefs were wrong when those of Christianity were equally unexplainable. In this relief, amorphous, amoebalike forms merge with languid sensuality. Indeed, the ironically titled *Immaculate Conception* is almost erotic in its swellings and soft projections. Varnell has shared various descriptive words that came to mind as he was making this piece, including "vulnerable, erotic, disturbing, disfigured, incomplete, complete, longing, on display, curiosity, birth defect, stumps, physically handicapped, pet, frantic, anxiety." – AJ

References
Fair and Worl 2000; McFadden and Taubman 2005; Jonaitis 2008.

66

Simeon Stilthda (ca. 1799–1889), Haida. Sphinx, ca. 1875. Pine and plaster. 28 1/4 × 13 1/2 × 14 3/4 inches (71.8 × 34.3 × 37.5 cm). The British Museum, London, Am1896,-.1202.

Until the 1880s, the Haida made beautifully crafted art both for use in their own communities and as souvenirs for Euro-Americans. Factors, including a smallpox epidemic that in the 1860s killed almost 90% of the population, the increased presence of missionaries in their land, and an apparently sincere desire to modernize, led most Haida to abandon totem pole carving, production of crest regalia, and lavish potlatches – which a 1884 Canadian law made illegal. Nonetheless, they continued making art, now almost exclusively for sale. Perhaps freed from the formal constraints of their artistic traditions, they made some of their most remarkable and innovative works late in the century. Anthropologists, museum collectors, and others named some artists from whom they purchased works. Because certain others had distinctive hands, even anonymous works can now be confidently attributed to individual masters.

Happily, this unusual sculpture was identified as the work of Simeon Stilthda when it was purchased for the British Museum. Unlike the more typical model houses and totem poles, masks, and figures made by artists of his generation, this carving represents a sphinx, an Egyptian mythic being. According to collection records, the Reverend William Collison showed Stilthda an illustrated bible that portrayed the sphinx, which Stilthda copied. Art historian Robin K. Wright found such an image in the reverend's bible at the Duncan Cottage in Metlakatla, Alaska (figure 1). Interestingly, Stilthda showed only the head and forelegs, not its lion body, and instead of a proper nemes scarf that covers the head and shoulders, he split the cloth in two to reveal, from the back, the sphinx's hairdo. It is curious that he would

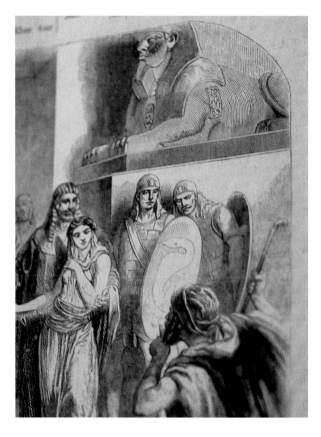

Figure 1. Illustration from the Reverend Collison's bible featuring a sphinx (detail), ca. 1850. Duncan Cottage Museum, Metlakatla, Alaska. Image courtesy of Robin K. Wright.

have omitted the sphinx's body; perhaps he was interested only in its frontal image. And, since the drawing cuts off the top of the sphinx's headdress, it is understandable that Stilthda would have imagined that it was split in the middle and the back.[1]– AJ

Notes
1. Wright 2001, p. 289.

References
Swanton 1905; Holm 1981; Wright 1998; Wright 2001; Augaitis 2006.

Plate 66

Plate 67

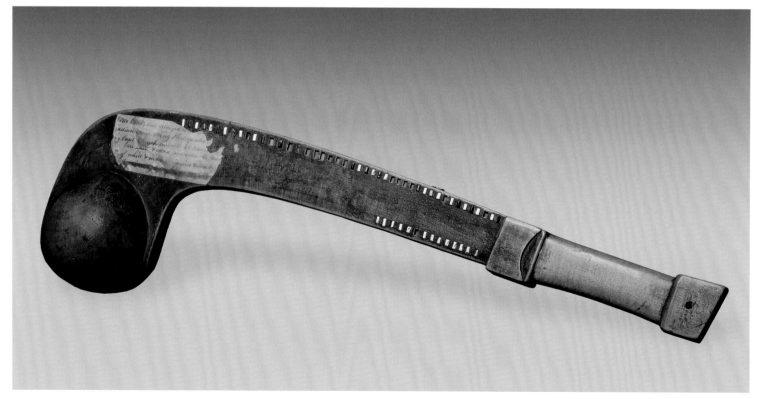

Plate 68

67 **Penobscot artist. Powder horn, before 1815.** Horn, wood, brass, and cordage. 5 1/4 × 14 1/4 × 4 inches (13.3 × 36.2 × 10.2 cm). Peabody Essex Museum, Salem, Massachusetts, Gift of C. W. Hardy, 1947, E27326.

In spite of early restrictions against supplying firearms to Native Americans, by 1670 the Penobscot had acquired guns and ammunition, primarily through trade for furs, and were as familiar with them as their English neighbors. Accessories, such as this engraved powder horn, became an integrated part of Penobscot vocabulary.[1]

At their most basic level, powder horns, typically made from cow horns, were used to carry gunpowder and keep it dry. The horn was boiled, then scraped smooth and plugged with wood at the open end; the tip was formed into a spout from which the charge was measured. Engraved with symbols, designs, maps, or words, the utilitarian objects became important vehicles of personal expression.[2]

This powder horn's bold iconography relates to many Native cultures of the Northeast Woodlands, including the Penobscot.[3] Delicate, double-curved motifs, geometric figures, triangles, and diamonds fill the visual plane of the curved surface and imbue the horn with the owner's worldview. In particular, the double-curve, an ongoing symbol of Penobscot cosmology and ideology, has many associations, such as the desire for balance in one's life and community and the desire for peace.[4] This tool of war, transformed by a Penobscot artist, became a revealing and deeply personal account of an individual's voice, his expression of peace, and continued agency in the face of change. – MMK

Notes
1. Grimes 2002D, p. 94. Engraved powder horns were not specific to Native cultures; the artistic tradition was widespread in this period.
2. Dresslar 1996, pp. xi–xii.
3. Double-curved motifs are common among the Wabanaki, a term referring to Algonquian-speaking communities of the Abenaki, Maliseet, Mi'kmaq, Passamaquoddy, and Penobscot.
4. Speck 1940, p. 160.

References
Speck 1940; Dresslar 1996; Grimes 2002D; Zea 2009.

68 **Possibly Pokanoket Wampanoag artist. Ball-headed war club, ca. 1675.** Maple, whelk, quahog, and horn. 6 × 22 1/2 × 4 1/2 inches (15.2 × 57.2 × 11.4 cm). Fruitlands Museum, Harvard, Massachusetts, I.0095.002.

The decorations on seventeenth- and eighteenth-century Woodland Native American war clubs formed part of a visual vocabulary understood by indigenous foes as well as allies. Their makers recorded warriors' visages, spirit guides gained in vision quests, military campaigns, and counts of felled enemies and prisoners in the finely etched lines and inlaid pieces of shell, horn, or bone along the shafts of clubs. When carried to battle, such clubs corroborated the physical and spiritual power of their owners; when left at the side of dead opponents, they functioned as ominous "calling cards."[1]

This club allegedly belonged to Metacom (King Philip), a war chief of the Wampanoag group who lived in present-day Massachusetts and northern Rhode Island. In 1675, Metacom led his people in a campaign against encroaching English colonists. The carnage of what is known as

68

King Philip's War was tremendous. An estimated six hundred English and three thousand Native people died, including Metacom himself. While his ownership of the club cannot be corroborated, oral stories testify that the Native man who shot Metacom gave it to the Reverend John Checkley in the same year and in the region of his death. Those stories, like the club itself, were passed down through Checkley's family. It is carved from the root ball of a maple tree and inlaid with double rows of white and purple wampum shell and triangular

pieces of horn, likely recounting a high number of enemies killed or captured in battle.[2] – JLH

Notes
1. Meachum 2007, pp. 67–69.
2. Fruitlands Museum 2011.

References
Meachum 2007; Fruitlands Museum 2011.

69

Bob Haozous (born 1943), Chiricahua Apache. *Wheel of Fortune*, 2005. Steel and paint. 96 inches (diam.) (243.8 cm). Courtesy of the artist.

With *Wheel of Fortune*, Bob Haozous confronted the viewer with an uncomfortable commentary on Native identity and cultural cowardice anchored by the face of Geronimo, his gaze riveted and unwavering, painted on a steel wheel. Although Haozous used his image – a popular icon of Indian identity – this work is not about Geronimo, but instead demonstrates how Indian identity has been manipulated by Native people today. Around Geronimo's face are a series of descriptive, often contradictory words about Native men in particular, both positive and negative, such as "brave" and "unmanly." The wheel, as in the television game show of the same name, spins around like some ancient Celtic game of fate, randomly determining who the Indian will be today. Outlined images of chickens, a widespread symbol of cowardice, cover the surface of the disk as well; they also spin in circles with no stopping point, just as chickens might wander aimlessly around a farmyard, oblivious to their confinement.

It is a harsh critique, though Haozous's purpose, as it has been throughout his artistic career, was to unseat Native self-doubt and force the confrontation of real issues instead of hiding behind stereotypes. Geronimo – whose image in this work was taken from the infamous 1880s portrait attributed to photographer Ben Wittick, who captured his reputation as a rebel, outlaw, and fierce warrior – wears an expression of deep concern or anger. By choosing this image, oversized and inexorable, Haozous issued a challenge to Native people to stop playing games and being "afraid of our own reality."[1] – KA-M

Notes
1. Haozous, interview with the author, January 24, 2011.

References
McFadden and Taubman 2002; Institute of American Indian Arts Museum 2005; BobHaozous.com.

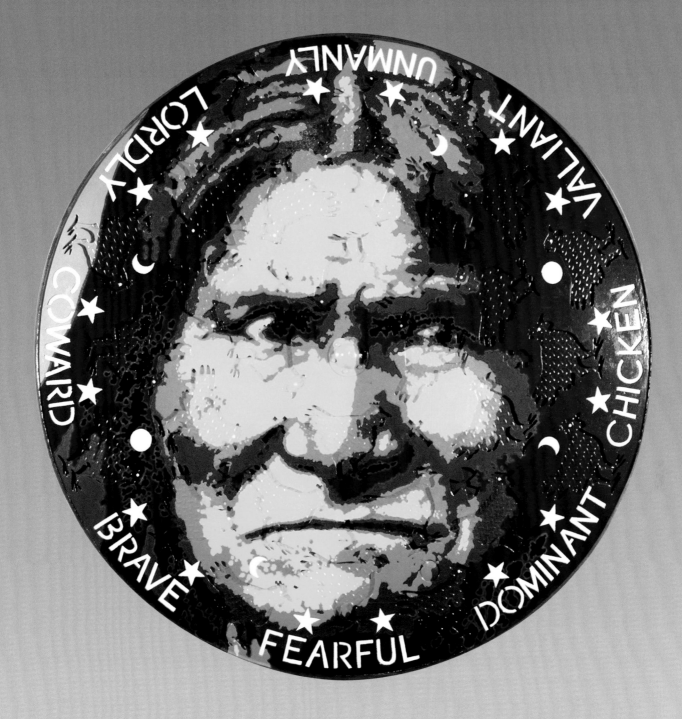

Plate 69

70

Inoka artist. Robe, ca. 1700–50. Bison or stag hide and pigment. 49 1/4 × 57 inches (125 × 145 cm). Musée du quai Branly, Paris, 71.1878.32.132. Not in exhibition.

A small number of early, rare, painted hide robes made by Inoka (Illinois) villagers of the mid-Mississippi River Valley have been preserved in France since the late seventeenth or early eighteenth century. The first Europeans to visit and write about these communities in what is today the southern part of the state of Illinois and around St. Louis, Missouri, were the Jesuit Jacques Marquette and the young explorer Pierre Joliet in the summer of 1673. Marquette remarked their skill at hunting buffalo and other game, noting that "they use the hides for making fine robes which they paint in various colors," but also describing them as being "clad in cloth."[1] The cloth often came through trade with the French. As early as the late 1600s, the tradition of painting hides to use as robes was on the wane.

Among Sioux people farther west and a century later, such abstract designs would most likely have been painted and worn by women, but it is impossible to know if this was the case for the Algonquian-speaking Inoka. An eighteenth-century French painting portrays a Mesquakie man of this region with his body painted in similar designs (see Voicing, page 166 and figure 2). The elongated triangles on this and other robes of the early eighteenth century probably symbolize the Thunderbird – the great spirit of the sky so important to the belief systems of many peoples of the Great Lakes and prairies.[2] Just as the Thunderbird was the powerful leader in the sky realm, the men who donned such robes surely were the leaders in the human community. – JCB

Notes
1. Gold Thwaites 1896–1901, p. 117.
2. Brasser 1999, p. 51.

References
Gold Thwaites 1896–1901, p. 113; Vidart and G. P. Horse Capture 1993; Brasser 1999.

71

Larry McNeil (born 1955), Tlingit. *Sacred Power Pole (from "Sacred Arts" series)*, **1998.** Digital print. 24 × 40 inches (61 × 101.6 cm). Courtesy of the artist.

Are the curators happy? The text that accompanies Larry McNeil's image of a "sacred" telephone pole suggests that they will be. If audiences come seeking spirituality in every work of Native American art, McNeil is happy to oblige. Never mind his sarcasm. This is McNeil as Trickster, using humor to raise important questions and deliver sometimes uncomfortable messages. Edward S. Curtis, Hollywood Indians, "New Agers," and postmodern theorists have all come under McNeil's scrutiny as he uses his art to open a dialogue about stereotypes and realities of Native experience. "My tactic from the beginning was to use humor," he says, "because that is what all humans have in common; we can all laugh at the absurdities we encounter."[1]

Art historian Jo Ortel has likened McNeil's images to a *Far Side* sketch, or a single-frame cartoon. But his digital photographs are hardly one-liners; their meanings are complex, and they usually come in series.[2] Included in the "Sacred Arts" series are four more images documenting McNeil's tongue-in-cheek "spirit quest" – a flash of "chrome" on a stretch of highway near Santa Fe; a sign

Plate 70

Over the years I've been cordially invited to participate in a number of exhibitions, many with titles such as Spirit Capture, Praising the Spirit, Spirit of Native America, and so on.

I must be a spiritual expert, so I set out on a quest to gather spiritual power.

On my sacred journey, I found this sacred power pole. The curators will be happy.

Plate 71

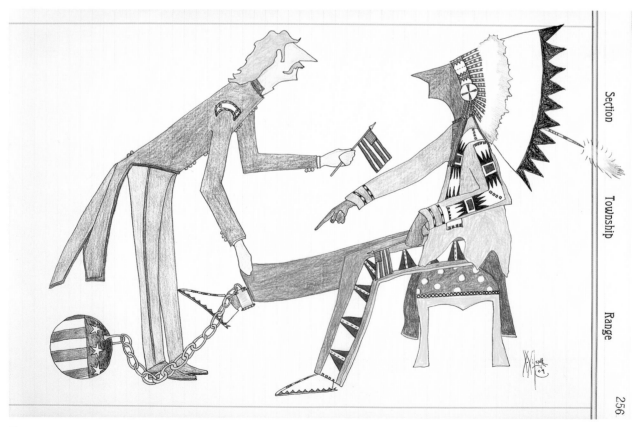

Section

Township

Range

256

Plate 72

71

that announces, "Yes, this is the place they sent you to see!"; and two more montages of road signs riddled with bullet holes. Ortel stated that each deceptively simple frame contains "a far wider constellation of narrative forms and structures, texts and subtexts" than what we perceive on the surface.[3] In this case, the accompanying text provides further insight, asserting that spirituality is not a commodity to be bartered, bought, or sold. Finally, the seemingly casual inclusion of a pair of industrial smoke stacks in the background of *Sacred Power Pole* portends McNeil's future work: a series of photographs

of smoke belching from coal power plants that he calls "Global Climate Crisis Photography." – KM

Notes
1. McNeil, quoted in Askren 2007, p. 87.
2. The "Sacred Arts" series comprises five works; see the artist's website, LarryMcNeil.com.
3. Ortel 2006, p. 50.

References
Allison 1998; Ortel 2006; Askren 2007.

72

Dwayne Wilcox (born 1957), Oglala Lakota. *After Two or Three Hundred Years You Will Not Notice*, 2009. Colored pencil on antique ledger paper. 11 × 17 1/4 inches (27.9 × 43.8 cm). Dr. J. W. Wiggins Collection, Sequoyah National Research Center, UALR, Little Rock, Arkansas.

Drawing has a long history as a means of communication to express narratives representative of time and culture. The transitional genre of Plains-style ledger art encompasses the transitional period when contact with Euro-Americans introduced new material culture to Plains Indians. During the nineteenth century, the indigenous people developed new interpretations and renderings of a genre that has become an aesthetic that is uniquely Native.

Dwayne Wilcox is inspired by and utilizes the innovative tradition of ledger drawings to chronicle contemporary indigenous perspectives. *After Two Hundred Years You Will Not Notice* is a biting critique of the brutal impact

of colonization. Wilcox graphically illustrated the imposition of the United States government's power over Native Americans through a metaphorical and literal physical restraint characterized by a Stars-and-Stripes – decorated ball and chain. The divisive imprisoning device represents the consequences of the conquest of America, the concept of Manifest Destiny, and burdensome policies such as the Indian Removal Act. Wilcox acknowledged in his drawing the speciousness of the notion of Native "sovereignty" in view of the historic and contemporary restrictions and confinements placed on Indians across the land. – RR

References
DogHatStudio.com; K. Miller 2010–2011.

73 **Kay WalkingStick (born 1935), Cherokee.** *La Primavera*, **2005.** Oil and gold leaf on wood. 32 × 64 inches (81.3 × 162.6 cm). Courtesy of June Kelly Gallery.

La Primavera – springtime – shows two figures locked in a joyful embrace in a landscape carpeted in lavender and lush green. As in Sandro Botticelli's painting of the same title (1482), Kay WalkingStick's *La Primavera* celebrates renewal and fertility in a multifaceted reawakening. For thirty years, WalkingStick has employed the diptych (two-panel) format to convey raw emotions such as grief and joy, without actually picturing the human figure. Instead, she pairs landscape images with symbolic or geometric elements, finding in those pairings a kind of resonance that enables her to speak of things that are "visual, immediate, and particular," as well as "spiritual, long-term, and nonspecific."[1]

In the mid-1990s and again in 2000 and 2003, WalkingStick spent long periods in Italy; her study of medieval and Renaissance art had a profound effect on her work. Slowly, the human figures that she had left behind in the 1970s reemerged, first as ghostly outlines in the landscape, then as dark, fragmented silhouettes, and finally fleshed in gold leaf. WalkingStick wrote: "The move to figures seemed inevitable although I hadn't depicted humans in my paintings for many years. In fact, their absence had seemed crucial to the significance of the work. It had been the uninhabited landscape I had sought in relation to the eternal."[2] Even as the figure returned, WalkingStick has continued her quest to express both the immediate and the spiritual in her diptychs. The relationship between the figures and what WalkingStick calls the "life-giving earth" is an intimate one, and the use of gold leaf invokes the sacred as it has since the Middle Ages. – KM

Notes
1. WalkingStick 1992, p. 16.
2. WalkingStick 2010.

References
WalkingStick 1992; Valentino 1994; Morris 2001; Archuleta 2003; Morris 2007; WalkingStick 2010.

74 **Rebecca Belmore (born 1960), Anishinaabe.** *Fringe*, **2008.** Inkjet print on paper. 21 × 63 inches (53.3 × 160 cm). Collection of Catherine Sullivan-Kropa and William Kropa.

A deep gash, roughly sewn together, winds down the back of an elegant reclining figure in this powerful photograph by Rebecca Belmore. Belmore has often used the female body, her own or a model's, as the focus of her critique on Native issues such as abuse and dispossession (see Voicing, page 164). In *Fringe*, the body of this anonymous Native woman at first appears gracefully posed, like a classic nude, but closer examination reveals a gauntness to her form. She lies in a white environment and is loosely covered by a sheet, as if she has just turned over in bed, or is perhaps lying in a clinical environment such as on an operating table. The deep wound confronts us with its rawness and violence. This mutilation can be read as representing both the violence perpetrated against Native women and the land. Sewn together and adorned with a fringe of red beadwork, it becomes a stigmata of suffering, but also shows an effort at healing. – KA-M

References
Townsend-Gault and Luna 2002; *Rebecca Belmore: Fountain* 2005; Augaitis and Ritter 2008; RebeccaBelmore.com.

Plate 73

Plate 74

Plate 75

75 **Judith Lowry (born 1948), Mountain Maidu/Hamawi Pit River/Washo. *My Aunt Viola*, 1996.** Acrylic on canvas. 60 × 40 inches (152.4 × 101.6 cm). Peabody Essex Museum, Salem, Massachusetts, Gift of Mr. and Mrs. James N. Krebs, E303666.

Renowned for her clever humor, vivid color, and large-scale figures that seem to pop off the canvas, Judith Lowry continues in visual form her family's tradition of storytelling. She explained: "I celebrate the triumphs and woes of a family and a culture with as much honesty and compassion as I can."[1] In addition, Lowry's body of work explores multiculturalism in Native America and cultural stereotyping of Native people.

This painting is based on Lowry's favorite photograph of her Aunt Viola, taken at a county fair in California during the 1940s (figure 1). She and others from the Native community often took temporary jobs at the fair, dressing and parading as "Indians." At this time, thanks primarily to Hollywood films, feather headdresses became a generic symbol and stereotype for all Native American cultures. In reality, however, most Native Americans in this period wore regular streetclothes, and even for special ceremonial occasions, Native California Indians never wore Plains-style headdresses or Southwestern-style textiles wrapped around their shoulders as depicted here.

Lowry's painting addresses notions of authenticity and objectification of Native identity. Indeed, the ominous storm gathering behind her flattened, sun-splashed figure seems symbolic of this.[2] Nonetheless, the painting celebrates the beauty and character of her aunt

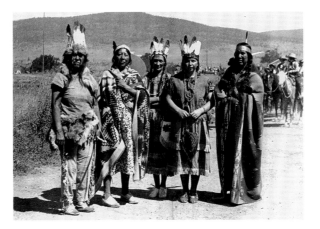

Figure 1. Judith Lowry's Aunt Viola (center) at the fair, 1940s. Photograph. Courtesy of Judith Lowry.

on a personal level that is removed from any pan-Indian stereotypes. When Lowry asked, "Auntie, why did you let them stick a headdress on you and put you in a blanket like that?," Viola answered, "Free tickets to the fair, are you kidding?"[3] – KKR

Notes
1. Peabody Essex Museum 2008, p. 4.
2. Lowry 2006.
3. Lowry 2000, p. 48.

References
Lippard 1999; Lowry 2000; Lowry 2006; Peabody Essex Museum 2008; English 2009.

76 **Jaune Quick-To-See Smith (born 1940), Salish/ Kootenai.** *The Red Mean: Self-Portrait*, **1992.** Acrylic, newspaper, shellac, and mixed media on canvas. 90 × 60 inches (228.6 × 152.4 cm). Smith College Museum of Art, Northampton, Massachusetts, Partial Gift from Janet Wright Ketcham, Class of 1953, and Partial Purchase from the Janet Wright Ketcham, Class of 1953, Acquisition Fund, SC 1993: 10a,b.

Jaune Quick-To-See Smith considers herself a conduit, a carrier of overtly political messages. For forty years, she has made art that addresses issues important to Native people, especially regarding the environment, cultural preservation, racism, and the stereotyping of Indian identity. Her political activism intensified in 1992, when the occasion of the Columbian Quincentennial inspired her to confront the legacies of colonialism in a series of works entitled "The Quincentenary Non-Celebration."[1] In these works, Quick-To-See Smith employed a strong contour outline of a figure: a horse in *Go West Young Man*, a canoe in *Trade: Gifts for Trading Land with White People*, and a buffalo in the painting with the same name. *The Red Mean: Self-Portrait* is marked by the outline of Quick-To-See Smith's own body, traced directly onto a layering of pages from the Flathead Nation's weekly newspaper.

Quick-To-See Smith's pose, actually a double portrait of superimposed outlines, is a direct quotation of Leonardo da Vinci's *The Vitruvian Man* (ca. 1492) (Voicing, figure 9), based on the Classical formula for ideal human proportions.[2] In the place of the "ideal"

body – European and male in the original– Quick-To-See Smith substituted her own, subverting the notion that all things are to be measured by the standards of Europe. Her version even translates geometry into indigenous terms, replacing the circle and square with the medicine wheel and symbol of the four directions. The motif also involves a form of cancellation, reflecting Quick-To-See Smith's concern that Native perspectives and identities are negated by the colonialist order and the Western "mean." *The Red Mean* resists this cancellation, as Quick-To-See Smith's own bodily presence asserts: "I am here. We survived." – KM

Notes
1. Quick-To-See Smith's works were included in many "Quincentennial Response" shows in 1991–93 and she organized and curated two group shows: *Submuloc Show/Columbus Wohs*, and *We The Human Beings*.
2. Quick-To-See Smith may be alluding to the broadest aspect of the quincentennial as a celebration of all things Renaissance, including scientific rationalism. Leonardo sketched *The Vitruvian Man* around 1492, shortly before Columbus set sail from Europe.

References
Abbott 1994; *Subversions/Affirmations* 1996; Valentino 1997; Muehlig 1999; Morris 2009.

Plate 76

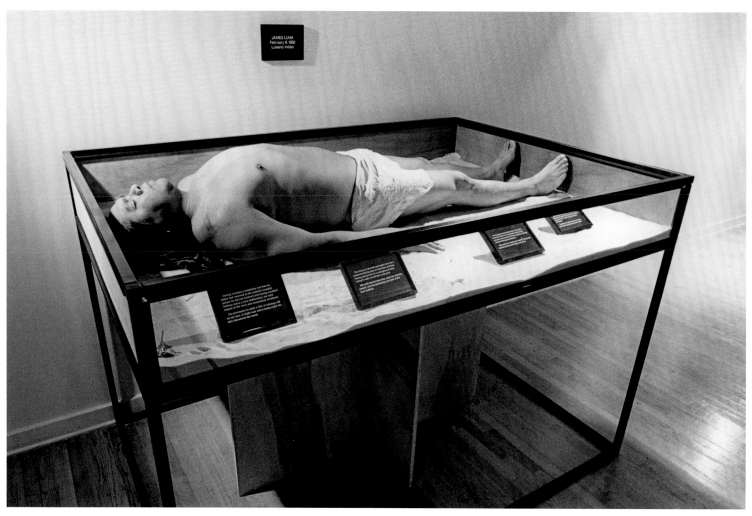

Plate 77

77 James Luna (born 1950), Puyoukitchum (Luiseño). *The Artifact Piece*, **1987.** Photograph of performance. 48 × 60 inches (121.9 × 152.4 cm). Courtesy of the artist.

This photograph records the day in February 1987 when the installation and performance artist James Luna first lay down on a bed of sand in an exhibition case he had prepared in the San Diego Museum of Man. Declaring his own body an artifact, he reclined, motionless, in solidarity with all those aboriginal bodies that had been appropriated by museums for over a century. "It was my turn to bite back," he announced. "I thought about all our relatives, lying in some museum, on some shelf, in someone's closet, in a box."[1] This was a bold and non-negotiable signal that representation of the aboriginal body would henceforth be in the control of aboriginal people themselves. Luna wore a loincloth; in front of his body, messages mimicking conventional museum labels pointed out scars and attributed them to "excessive drinking," thus addressing stereotypes about Native men.

Luna, who studied with artist James Turrell in the 1970s at the University of California-Irvine, was among the first Native artists of the last quarter of the twentieth century to seize upon performance art as a transformative tool for articulating troubling intercultural histories. In *The Artifact Piece*, not only was Luna's own body the work of art, but he also sought to engage viewers in forging new understandings of Native subjects and objects in a museum context. In the twenty-five years since this vitally important work, Luna has achieved international renown and prompted Native and non-Native audiences to rethink their ideas about politics, identity, and other crucial issues of our time. – JCB

Notes
1. Luna 2004, p. 151. Luna also performed *The Artifact Piece* at the New Museum of Contemporary Art in New York in 1990 in *The Decade Show: Frameworks of Identity in the 1980s*, an internationally important exhibition of contemporary artists. See Peraza, Tucker, and Conwil 1990, pp. 171–72, pl. IL.

References
Peraza, Tucker, and Conwil 1990; Luna 2004; Haas, Chaat Smith, and Lowe 2005; González 2008; Gladstone and Berlo 2011.

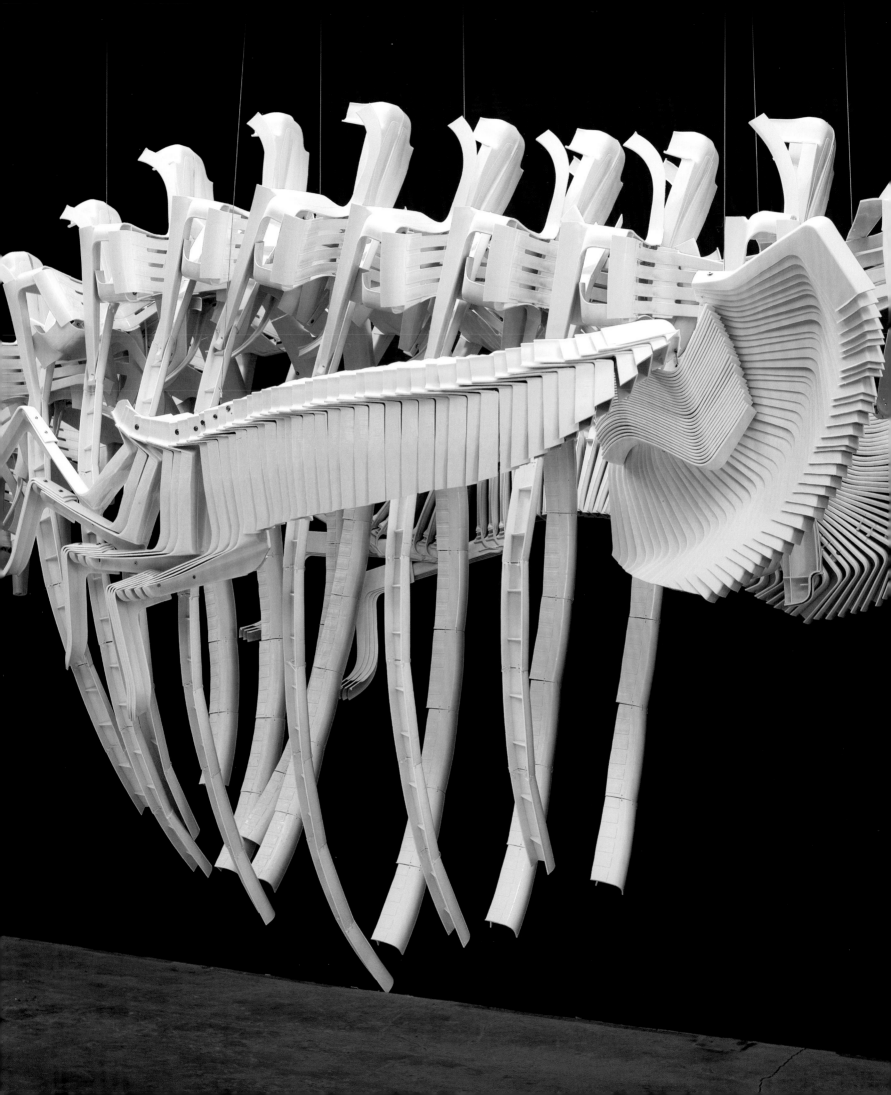

Famous Long Ago

Paul Chaat Smith (Comanche)

Dateline February 2011: For three weeks, I've been glued to Al Jazeera, which has been glued to Cairo, reason being that Cairo is exploding. When I'm at my office, I watch via the streaming Internet, and at home in DC, thanks to Comcast, it's right there on channel 275. (People think I'm crazy, but I like Comcast. Yes, it's not cheap, but look at all you get!) When I am not watching Al Jazeera, I'm watching *SportsCenter* or reading about Egypt. A journalist remembers covering that country for a few years in the 1990s. When he was assigned to another continent, he tried to keep up with the latest developments, and noticed there didn't seem to be any. Or, as he looked more closely, it was the same stories, over and over: mass arrests, crackdowns, corruption, fake elections. Same story, different decade. The journalist realized that Egypt was a country where "news" no longer happened, which is why newspapers hardly ever wrote about the place.

I am thinking that it's possible that Indians are like Egypt, and not only because we both used to build pyramids.

We are possibly like Egypt because we hardly ever make the news.

Here is the latest news about Indians: erasure, money, feathers. Erasure, because we were almost erased. People without a history and so forth. Money, because we don't have any, except a few tribes who run casinos near big cities. People without money are losers. Feathers – now, this is what we have in lieu of money, the feathers that made us world famous, which is quite a trick for losers without history. The Indian paradox: nearly erased, almost invisible, yet almost everyone in the world knows something about us. This is a fact: give Ms. Almost Anyone Anywhere a picture of a head-dressed Indian, and she'll nod and say, "Indian." If you consider how few headdress-wearing, horseback-riding Plains Indians there ever were (a few hundred thousand?), and how briefly they existed (a hundred years?), it's pretty amazing (figure 1).

You might say we are the supermodels of ethnicities. Has this ever done us any good? No. Can we turn the feathers and fame thing into something positive? Probably not.

Detail of plate 2

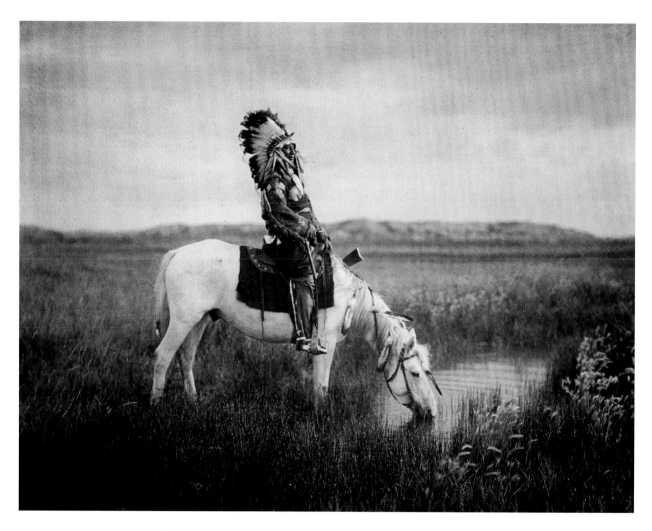

Figure 1. Edward S. Curtis (1868–1952). *An Oasis in the Bad Lands*, 1905. Platinum print. Peabody Essex Museum, Salem, Massachusetts, Gift of Dr. Charles Goddard Weld, 1906, PH76.86. Image © 2012 Peabody Essex Museum, photograph by Mark Sexton.

Yet, we keep trying! I think because we have lots of time on our hands, and you can't watch Al Jazeera twenty-four hours a day.

So, what do I see as the biggest difference between Egyptians and Indians? Although both are famous for their past, the world knows full well that Egyptians and the nation state of Egypt exist today. And the world doesn't regard an Alexandria cab driver as inauthentic if he can't translate hieroglyphics on demand. However, Indians have been so conflated with that supermodel that we are seen as unreal if we are not just like her.

For American Indians, art is more important than politics. Politics is expensive. We hope to be able to afford politics some day, and there are rumors that Indians in California "own the Democratic Party," or so I was told recently, but that is certainly the exception. Art, however, is cheap, and part of our brand. I'm never sure if we're actually good at it, or maybe it's just because we're not allowed to try anything else, but for whatever reason, art is our ticket. Also, on a practical level, we have tons of artists, which isn't to say they're expendable, but at the same time it's not like there's going to be a shortage anytime soon.

Artists are deeply respected in the Native world. We ask of them just two things: 1) make fabulous art, and 2) lead the revolution.

People say God is a lousy novelist. They are right, these people. It makes us appreciate all the more those rare moments when life unfolds exactly the way it should. For example, how cool would it be if the next chapter of Indian art began right on time, in the first year of the twenty-first century? On opposite sides of Turtle Island? And featured two guys most people never heard of? You would say, very cool.

The first guy is Brian Jungen.

Doesn't it seem like *Cetology* (2002) (plate 2) has always been with us? Everything about that pile of fake bones is perfect; the series has only gotten better with time.

Even the creation story for the first whale, *Shapeshifter*, in 2000, is perfect. Jungen (Dunne-Za Nation) constructed it in secret during an uncharacteristically hot summer in Vancouver, British Columbia, mostly at night, which is probably the way they made the first stealth fighters in the desert outside Los Angeles. A test pilot, remembering the first time he laid eyes on the advanced jet he had known just as a rumor, could compare his new ride only to fictional spaceships he knew from Buck Rogers.

Shapeshifter was precisely this kind of leap – the kind that makes you use words whose meaning you're not exactly sure of, like "quantum." Yeah, we knew of this dude from BC and his series of fetching, clever Michael Jordan masks made from expensive shoes that he called *Prototypes for New Understanding* (figure 2). Brilliant? Possibly. Somebody to keep an eye on, that's for sure. We watched from afar, cautiously. Life tells us that probably this Jungen would be just a

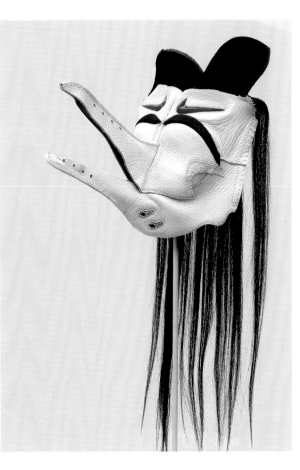

Figure 2. Brian Jungen (born 1970), Dunne-Za Nation. *Prototype for New Understanding, #2*, 1998. Nike Air Jordans and hair. Vancouver Art Gallery, purchased with the financial support of the Canada Council for the Arts Acquisition Assistance Program and the Vancouver Art Gallery Acquisition Fund, VAG99.20.1. Image courtesy of Brian Jungen and Catriona Jeffries Gallery, photograph by Trevor Mills, Vancouver Art Gallery.

one hit wonder, and perhaps start turning cowboy hats into feathered headdresses.

Then *Shapeshifter* was revealed, and man, did those questions disappear fast. It was everything we loved about *Prototypes for New Understanding* but bigger, smarter, deeper, and even more awesome. The shoes were very fast, NBA fast. *Shapeshifter* was positively supersonic. We could relax, nervously. This guy was really, really good. And he was going to be around for a while.

Shapeshifter, now with a Canadian passport, toured the world, leaving sonic booms and adoring crowds in its wake. A brother and a sister arrived in 2002 and 2003, named *Cetology* and *Vienna*, and nobody would have been displeased if the pod were joined by a dozen or two more. Sadly, that was not to be. By 2003, white mono-block plastic furniture had nothing more to teach Jungen, so that was that. No more whales, ever.

Lots of people think that Jungen's whales are actually dinosaurs. Maybe even most. Not surprising: how many of us have ever seen a whale skeleton? The whales we know are fully clothed: brooding in the deep, trium-phantly rising into the sky, or taking aim at Captain Ahab. This confusion is interesting. We are told whales may soon be extinct; some varieties already are.

With *Prototypes*, Jungen performed three tricks with brutal and elegant efficiency. First, he showed how easily an athletic shoe could become something like a tribal mask. (Of course, it wasn't easy, it just looked easy – that was part of the trick.) Second, by using a celebrity shoe and staging the works in expensive vitrines, it collapsed the obsessive world of pop culture collectors with the obsessive world of museums and private collectors of historic indig-enous material. Third, the *Prototypes* themselves actually *became* valuable artifacts, not just an ironic comment on valuable artifacts, and soon were eagerly sought by collectors and museums.

With the whales, Jungen must have decided that was all a bit too busy, with too many steps, so the viewer is confronted with a thing so amazing it can't be ignored, familiar and strange at the same time. It is possible, though unwise, to walk right past a *Prototype*, but nobody ignores *Cetology*. Stop. Then, you see it's made of patio chairs.

Figure 3. Film still from *Alien*, 1979. Image © 1979 Twentieth Century Fox. All rights reserved.

Figure 4. "Skeleton Bar," H. R. Giger Museum, Gruyère, Switzerland. Designed by H. R. Giger, set designer of *Alien* film. Photograph by Annie Bertram.

Unmissable and Unforgettable.

Cetology evokes a range of emotions. People laugh easily when they see Jungen's sculptures, and for good reason. Using familiar materials is deeply empowering for viewers. We relax, maybe even feel a slight buzz, as if we're holding a vodka tonic instead of a museum brochure. We forget we're in a contemporary art museum (so serious! so quiet!) and then it's just us and the plastic whale, regarding each other.

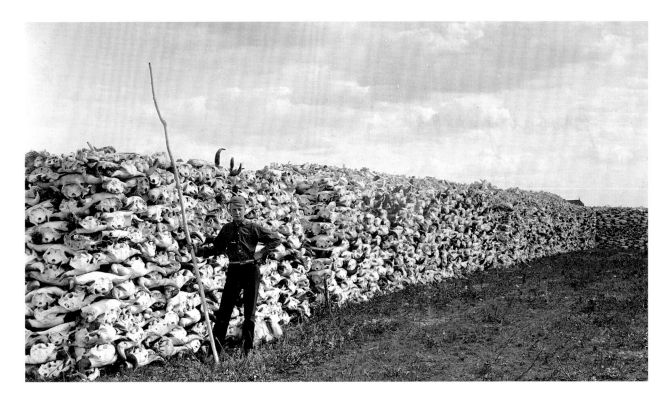

Figure 5. Piles of bison skulls awaiting shipment at Saskatoon, ca. 1890. Saskatchewan Archives Board, R-B677-2.

I've always found *Shapeshifter*, *Cetology*, and *Vienna* more menacing than amusing. And deeply sad. I think of the *Alien* movies, especially those scenes from inside the monster (figures 3 and 4). And I think of Regina, Saskatchewan, a town whose original name was Pile of Bones. The bones belonged to buffalos, and the piles of the bones stretched across the prairie, stacked higher than a man could reach (figure 5). By the end of the brutal erasure campaign against the Buffalo Nation, vast numbers were killed just for their tongues.

Sometimes God dabbles in science fiction, like when She thought it would be a hoot to make an African-American community organizer from Chicago President of the United States. And even more fun if his name was Barack Hussein Obama, Junior. Funnier still if he ran for president of a country whose greatest enemies were actually named Hussein and Osama. Also, let's make him really smart, and not just a politician, but a cultural critic with opinions on everything.

For example, consider this report from the *Washington Post*, September 25, 2008 – forty days before the election.[1]

Obama Answers Critical Question – About Music
By Shailagh Murray

Sen. Barack Obama stopped by his Senate office before heading over to the White House this afternoon for the big bipartisan meeting on the financial meltdown.

Met at the door by a few reporters, he answered a key question – at least for his generation.

Beatles or Stones? asked a Congressional Quarterly *reporter.*

"Stones," Obama replied.

Figure 6. Mark Rothko (1903–1970). *No. 17 [or] No. 15*, 1949. Oil on canvas. National Gallery of Art, Washington, DC, Gift of The Mark Rothko Foundation, Inc., 1986.43.142. Image courtesy of the National Gallery of Art, Washington, DC.

Figure 7. Glenn Ligon (born 1960). *Black Like Me #2*, 1992. Paint stick and acrylic gesso on canvas. Hirshhorn Museum and Sculpture Garden, Smithsonian Institution, Washington, DC, Museum Purchase, 1993, 93.3. Photograph by Lee Stalsworth.

Figure 8. George Catlin (1796–1872). *K'nisteneux Indians Attacking Two Grizzly Bears*, 1861–69. Oil on card mounted on paperboard. National Gallery of Art, Washington, DC, Paul Mellon Collection, 1965.16.181. Image courtesy of the National Gallery of Art, Washington, DC.

Fast forward a year, and the senator and freelance rock critic was now president. In addition to fighting two wars and preventing a Second Great Depression, he and Michelle found time to select art for the Obama White House. With everything else going on, this was not a big story, except to the hundreds (just kidding!) of people who avidly follow contemporary American art. And to them, and to us, the dozens who avidly follow Native American art, this was very big news.

The Obamas made some predictable, rather tame choices, and also selected some fine work by Mark Rothko and Jasper Johns. So far, so good. Nice job, Obamas! They also chose a painting by Glenn Ligon, and this was nothing less than astonishing. Ligon, an African-American conceptual artist whose work is anything but tame and predictable, in the White House! (figures 6 and 7).

The Obamas also chose some stellar Pueblo pots, and twelve George Catlin paintings of Indians. What are we to make of this? I see it as an accurate snapshot of how Native people are regarded in the twenty-first-century

American imagination. We are regarded, even by those with the exceptional taste and education of Michelle and Barack Obama, as subjects for others to paint. In 2011, we are still in the nineteenth century, sitting for George Catlin and Edward S. Curtis (figure 8).

I left out something about money. It's not just that we don't have it, it's also that wealth from the Americas five centuries ago made Spain a superpower, Europe rich, and eventually helped make the United States the richest country in the world. Yes, life is unfair. Nobody wants to hear about vast transfers of wealth so long ago, and I don't blame them. I mean, it was a long time ago, the fifteenth century! Bad things happen to everybody sooner or later.

Naturally, we think we're special in all kinds of ways. But, if we ask what is really unique about American Indians, I would answer: two things, maybe three. One: we survived the greatest biological catastrophe in human history. After contact with Europe, disease from which we had no immunity killed perhaps 90% of us. Millions upon millions, we'll never know how many. Second: we are the most destitute segment of the population in just about every country in the Americas. Three: we can never really live in the present. Modernism just flew right over us, the way fashion flies over Washington, DC. Not in the real world, because we actually liked new and shiny things, like horses and guns and so forth, but the accepted idea of Indians meant we could never get with the program and be part of the world. We wanted to be part of the world, but never made it past the velvet ropes. Edward S. Curtis was modernism's bouncer, famously removing an alarm clock from his iconic picture of Old Indian Guy. The rules said: if we're not like Old Indian Guy, we're nobody. Indians must live in the timeless past.

So, if the goal is to defeat the reactionary ideas about Indians that hold us back, making us moody and

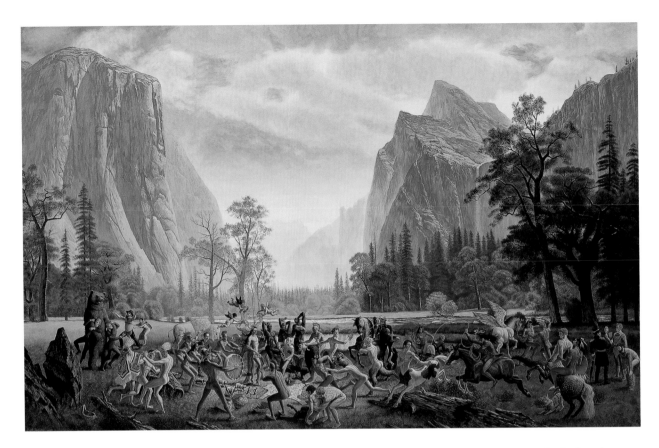

Figure 9. Kent Monkman (born 1965), Cree. *The Triumph of Mischief*, 2007. Acrylic on canvas. National Gallery of Canada, Ottawa, 42217. Courtesy of Kent Monkman and Bruce Bailey Art Projects, image © National Gallery of Canada.

depressed, and by us I mean not just red people but everyone who wants to know how the world came to be the way it is, and how we came to be the way we are, it is necessary to change the way we think about the past in order to shape the future.

Back to the next chapter in Native American Art. The second guy is Kent Monkman. Like Barack Obama, he's a polymath.

In 2000, when Jungen was making his first supersonic whale in Vancouver, Kent Monkman (Cree) was in Ontario, repainting the past with stunning canvases that blew a wormhole into art history (figure 9). The

shocking thing about those paintings isn't that they show cowboys and Indian men having sex, although that certainly gets our attention. What's shocking is that they reveal how much Monkman loves and respects the originals. It could never work otherwise. Even with Monkman's tremendous technical skill, a cynical approach would reveal itself, and the paintings would fail to be transcendent.

Théâtre de Cristal (2007) (plate 1), like *Cetology*, is a work from the future about a people who aren't supposed to have one. Monkman's paintings and films interrogate the past from a position of respect, even reverence, both for the formal aspects of the works he is interrogating and also for their ambition, beauty, and success in building imaginary worlds. Monkman's work never quite feels ironic – too much is at stake. (This is a new strategy, one that other Native artists and critics could learn from.)

Figure 10. Kent Monkman (born 1965), Cree. Film still from *Group of Seven Inches*, 2005. Super-8 film (7:34 minutes). The Glenbow Museum, Alberta, Canada, purchased with funds from Historic Resource Fund, 2008, 2008.099.011. Courtesy of Kent Monkman and Bruce Bailey Art Projects.

He respects the Hudson River School, he respects George Catlin, and when he rides a horse for his films, you can tell he respects the horse (figure 10). When he wears feathers and becomes Miss Chief, those feathers are no joke. Monkman inhabits the imaginary worlds of noble Indians on horseback not to refute them, but to complicate them. He's intrigued by the sublime canvases of Catlin and Paul Kane, noting: "For many, these Romantic visions of the New World and its Aboriginal people were assumed to be literal depictions, a kind of reportage photography of the wild landscape and the 'romantic savage.' Of course these painters brought their own values and expectations to their work.... They took significant license in their paintings. I'm re-imaging their world and I'm bringing my own perspective, my own values and prejudices, to it."[2]

Can this re-imagining be effective? "Once an idea has taken hold of the brain, it's almost impossible to eradicate," said Dom Cobb, played by Leonardo DiCaprio in Christopher Nolan's 2009 *Inception*.

Kent Monkman respects these images and appreciates their enduring power. His decision to mess with them on such a personal level, in a way that requires so much investment in time and emotion, is an acknowledgment that these images are still more powerful than anything we have yet created. This is a sobering realization. We wish to be through with Catlin and Curtis once and for all, but available evidence says we are nowhere close to being done.

Brian Jungen's work takes viewers into the twenty-first-century world they see every day, and makes an airtight case that Native people are part of that world, without ever having to say it out loud. We are simply here, like everybody else, like golf bags and white plastic chairs. Kent Monkman's time-traveling takes us into the nineteenth-century world that falsely defined us, and offers a guided tour of pasts that might have been and futures yet to be determined.

Notes
1. Murray 2008.
2. Monkman 2007.

Bibliography

Madeleine M. Kropa

The following list includes short titles for all works referenced.

Abbott 1994. Abbott, Lawrence, ed. *I Stand in the Center of the Good: Interviews with Contemporary Native American Artists.* Lincoln: University of Nebraska Press, 1994.

AbsoluteArts.com 2009. AbsoluteArts.com. "Brian Jungen: Cetology." Accessed September 29, 2009. http://www.absolutearts.com/ artsnews/2003/01/24/30686.html.

Adair 1944. Adair, John. *The Navajo and Pueblo Silversmiths.* Norman: University of Oklahoma Press, 1944.

Adams 1975. Adams, Clinton. *Fritz Scholder Lithographs.* Boston: New York Graphic Society, 1975.

Alexie 2010. Alexie, Sherman. Lecture, The Lensic, Santa Fe, August 2010.

Allison 1998. Allison, Jane, ed. *Native Nations: Journeys in American Photography.* London: Barbican Art Gallery, 1998.

Anderson 1999. Anderson, Duane, ed. *Legacy: Southwest Indian Art at the School of American Research.* Santa Fe: School of American Research Press, 1999.

Antoine and Bates 1991. Antoine, Janeen, and Sara Bates. *Portfolio III: Ten Native American Artists.* Seattle: Marquand Books, for American Indian Contemporary Arts, 1991.

Anthes 2006. Anthes, Bill. *Native Moderns: American Indian Painting, 1940–1960.* Durham, North Carolina: Duke University Press, 2006.

Apache Skateboards 2011. Apache Skateboards. "The "8" Artists of "INDIAN INK II"/Say HELLO To My Little FRIEND!(s)." *Facebook.* Tuesday, March 1, 2011. http://www.facebook.com/#!/note.php?note_id=1015009 7990612024&id=837872489 (site discontinued).

Appiah 1992. Appiah, Kwame Anthony. *In My Father's House: Africa in the Philosophy of Culture.* New York: Oxford University Press, 1992.

Archuleta 2003. Archuleta, Margaret. "Kay WalkingStick." In *Path Breakers: The Eiteljorg Fellowship for Native American Fine Art, 2003.* Indianapolis: Eiteljorg Museum of American Indians and Western Art, 2003, pp. 11–31.

Archuleta 2005. Archuleta, Margaret. "From Ordinary to Extraordinary…." In "Marie Watt, Blanket Stories: ladder." Unpublished handout, Institute of American Indian Arts Museum, Santa Fe, 2005.

Ash-Milby 2007A. Ash-Milby, Kathleen, ed. *Off the Map: Landscape in the Native Imagination.* Washington, DC: National Museum of the American Indian, Smithsonian Institution, 2007.

Ash-Milby 2007B. Ash-Milby, Kathleen. "The Imaginary Landscape." In Ash-Milby, Kathleen, ed. *Off the Map: Landscape in the Native Imagination.* Washington, DC: National Museum of the American Indian, Smithsonian Institution, 2007, pp. 17–45.

Askren 2007. Askren, Mique'l Icesis. "Larry Tee Harbor Jackson McNeil: Visual Myth Maker." In *Diversity and Dialogue: The Eiteljorg Fellowship for Native American Fine Art, 2007.* Indianapolis: Eiteljorg Museum of American Indians and Western Art, 2007, pp. 77–93.

Augaitis 2006. Augaitis, Daina. *Raven Traveling: Two Centuries of Haida Art.* Vancouver: Vancouver Art Gallery, Douglas and McIntyre, and University of Washington Press, 2006.

Augaitis and Ritter 2008. Augaitis, Daina, and Kathleen Ritter, eds. *Rebecca Belmore: Rising to the Occasion*. Vancouver: Vancouver Art Gallery, 2008.

Babcock 1984. Babcock, Barbara. "Arrange Me into Disorder: Fragments and Reflections on Ritual Clowning." In *Rite, Drama, Festival, Spectacle: Rehearsals Toward a Theory of Cultural Performance*. Ed. John J. MacAloon. Philadelphia: The Institute for the Study of Human Issues, 1984, pp. 102–28.

Bahti 2008. Bahti, Mark. *Silver + Stone: Profiles of American Indian Jewelers*. Tucson, Arizona: Rio Nuevo Press, 2008, pp. 176–77.

Bailey and Swan 2004. Bailey, Garrick, and Daniel C. Swan. *Art of the Osage*. St. Louis: Saint Louis Art Museum, in association with University of Washington Press, 2004.

Baizerman 1989. Baizerman, Suzanne. *Ramona Sakiestewa: Patterned Dreams*. Santa Fe: Wheelwright Museum of the American Indian, 1989.

Barbeau 1929. Barbeau, Marius. *Totem Poles of the Gitksan: Upper Skeena River*. Ottawa: National Museums of Canada, 1929.

Bartow 1989. Bartow, Rick. "Carving Masks." Froelick Gallery. Unpublished statement, 1989. Microsoft Word file.

Bartow 1996. Bartow, Rick. "Artist Statement." Froelick Gallery. Unpublished statement, 1996. Microsoft Word file.

Bartow 1998. Bartow, Rick. "Carving Cedar." Froelick Gallery. Unpublished statement, 1998. Microsoft Word file.

Bartow 2010. Bartow, Rick. "Rick Bartow: Yurok." *A Time of Vision: Interviews by Larry Abbott*. Last modified September 28, 2010. http://www.britesites.com/native_artist_interviews/rbartow.htm.

Bartow 2011. Bartow, Rick. "From Nothing Coyote Creates Himself, 2004." Froelick Gallery. Accessed March 18, 2011. http://www.froelickgallery.com/Artwork-Detail.

Basso 1996. Basso, Keith. *Wisdom Sits in Places: Landscape and Language among the Western Apache*. Albuquerque: University of New Mexico Press, 1996.

Bates, Rickard, and Chaat Smith. Bates, Sara, Jolene Rickard, and Paul Chaat Smith. *Indian Humor*. San Francisco: American Indian Contemporary Arts, 1995.

Batkin 1987. Batkin, Jonathan. *Pottery of the Pueblos of New Mexico*. Colorado Springs: Taylor Museum of the Colorado Springs Fine Arts Center, 1987.

Batkin 1999. Batkin, Jonathan. *Clay People: Pueblo Indian Figurative Traditions*. Santa Fe: The Wheelwright Museum, 1999, pp. 24–31.

Beat Nation 2010A. Beat Nation. "Kevin Lee Burton." Last modified August 20, 2010. http://www.beatnation.org/kevin-lee-burton.html.

Beat Nation 2010B. Beat Nation. "Nicholas Galanin." Last modified August 20, 2010. http://beatnation.org/nicholas-galanin.html.

D. Y. Begay 1996. Begay, D. Y. *"Shi' Sha' Hane'* (My Story)." In Bonar, Eulalie H., ed. *Woven by the Grandmothers: Nineteenth Century Navajo Textiles from the National Museum of the American Indian*. Washington, DC: Smithsonian Institution Press, 1996, pp. 13–27.

S. Begay et al. 2002. Begay, Shonto, Walter Hopps, Lee Kogan, Greg LaChapelle, and John and Stephanie Smither. *Collective Willeto: The Visionary Carvings of a Navajo Artist*. Santa Fe: Museum of New Mexico Press, 2002.

Belmore 2011. Belmore, Michael. "Artist's Statement: *Placid*," 2011.

Berlo 1996. Berlo, Janet Catherine, ed. *Plains Indian Drawings, 1865–1935: Pages from a Visual History*. New York: Harry N. Abrams and the American Federation of Arts, 1996.

Berlo 2000. Berlo, Janet Catherine. *Spirit Beings and Sun Dancers: Black Hawk's Vision of a Lakota World*. New York: George Braziller, 2000.

Berlo 2005. Berlo, Janet Catherine. "Back to the Blanket: Marie Watt and the Visual Language of Intercultural Encounter." In *Into the Fray, The Eiteljorg Fellowship for Native American Fine Art, 2005*. Ed. James H. Nottage. Indianapolis: Eiteljorg Museum of American Indians and Western Art, in association with University of Washington Press, 2005, pp. 111–21.

Berlo 2006. Berlo, Janet Catherine. "'It's Up to You–': Individuality, Community and Cosmopolitanism in Navajo Weaving." Athens, Ohio: Kennedy Museum of Art, Ohio University, 2006, pp. 34–47.

Berlo 2010. Berlo, Janet Catherine. "Understanding the Thaw Collection: Native American Art in the 21st Century *Art of the American Indians: the Thaw Collection*." In *Art of the American Indians: the Thaw Collection*. Ed. Eva Fognell. Cooperstown, New York: Fenimore Art Museum, 2010, pp. 13–25.

Berlo 2011. Berlo, Janet Catherine. "Navajo Cosmoscapes: Up, Down, Within." *Smithsonian Journal of American Art* 25, 1 (Spring 2011), pp. 10–13.

Bernstein 1994. Bernstein, Bruce. "Potters and Patrons: The Creation of Pueblo Art Pottery." *American Indian Art Magazine* 20, 1 (Winter 1994), pp. 70–79.

Bernstein 1998. Bernstein, Bruce. "Julian and Maria Martinez." In *St. James Guide to Native North American Artists*. Ed. Roger Matuz. Detroit: St. James Press, 1998, pp. 358–62.

Bernstein 2003. Bernstein, Bruce. *The Language of Native American Baskets: From the Weavers' View*. Washington, DC: National Museum of the American Indian, Smithsonian Institution, 2003.

Bernstein and Gomez 2010. Bernstein, Bruce, and Gabe Gomez. "My Favorite Tools Are My Hands: Feral Metal in a Tame Land." *SofaWEST: Santa Fe 2010*. Chicago: The Art Fair Company Inc., 2010, pp. 24–27.

Bernstein and Lowe 2006. Bernstein, Bruce, and Truman Lowe. "New Horizons." In NMAI Editions. *Essays on Native Modernism: Complexity and Contradiction in American Indian Art*. Washington, DC: National Museum of the American Indian, Smithsonian Institution, 2006, pp. 13–29.

Biesenbach 2010. Biesenbach, Klaus, ed. *Marina Abramović: The Artist Is Present*. New York: The Museum of Modern Art, 2010.

Black 1991. Black, Lydia T. *Glory Remembered: Wooden Headgear of Alaska Sea Hunters*. Juneau: Alaska State Museum, and Friends of the Alaska State Museum, 1991.

Black and Liapunova 1988. Black, Lydia T., and R. G. Liapunova. "Aleut: Islanders of the North Pacific." In *Crossroads of Continents: Cultures of Siberia and Alaska*. Eds. William W. Fitzhugh and Aron Crowell. Washington, DC: Smithsonian Institution Press, 1988, pp. 52–57.

Blair and Blair 1999. Blair, Mary Ellen, and Laurence R. Blair. *The Legacy of a Master Potter: Nampeyo and Her Descendants*. Tucson, Arizona: Treasure Chest Books, 1999.

Blish 1967. Blish, Helen. *A Pictographic History of the Oglala Sioux*. Lincoln: University of Nebraska Press, 1967.

Blodgett and Bouchard 1986. Blodgett, Jean, and Marie Bouchard. *Jessie Oonark: A Retrospective*. Winnepeg, Manitoba: Winnepeg Art Gallery, 1986.

Boas 1916. Boas, Franz. "Tsimshian Mythology: Based on Texts Recorded by Henry W. Tate." *31st Annual Report of the Bureau of American Ethnology for the Years 1909–1910*, 1916.

Bolgiano 1995. Bolgiano, Chris. *Mountain Lion: An Unnatural History of Pumas and People*. Mechanicsburg, Pennsylvania: Stackpole Books, 1995.

Bonar 1996. Bonar, Eulalie H., ed. *Woven by the Grandmothers: Nineteenth Century Navajo Textiles from the National Museum of the American Indian*. Washington, DC: National Museum of the American Indian, Smithsonian Institution, 1996.

Bragdon 1996. Bragdon, Kathleen J. *Native People of Southern New England, 1500–1650*. Norman: University of Oklahoma Press, 1996.

Brasser 1999. Brasser, Ted. "Notes on a Recently Discovered Indian Shirt from New France." *American Indian Art Magazine* 24, 2 (Spring 1999), pp. 47–55.

Breunig and Younger 1986. Breunig, Robert, and Erin Younger. "The Second Biennial Native American Fine Arts Invitational." *American Indian Art Magazine* 11, 2 (Spring 1986), pp. 60–65.

The British Museum 2010. The British Museum. "Hunting Helmet." Accessed December 20, 2010. http://www.britishmuseum.org/explore/highlights/highlight_objects/aoa/h/hunting_helmet.aspx (site discontinued).

Brody 1977. Brody, J. J. *Mimbres Painted Pottery*. Albuquerque: University of New Mexico Press, 1977.

Brody 1997. Brody, J. J. *Pueblo Indian Painting: Tradition and Modernism in New Mexico, 1900–1930*. Santa Fe: School of American Research, 1997.

B. Brown 2010. Brown, Bill. "Objects, Others, and Us (The Refabrication of Things)." *Critical Inquiry* 36, 2 (Winter 2010), pp. 183–207.

J. A. Brown 2007. Brown, James A. "On the Identity of the Birdman within Mississippian Period Art and Iconography." In *Ancient Objects and Sacred Realms: Interpretations of Mississippian Iconography*. Eds. F. Kent Reilly III and James F. Garber. Austin: University of Texas Press, 2007, pp. 56–106.

S. Brown 1997. Brown, Steve. "Formlines Changing Form: Northwest Coast Art as an Evolving Tradition." *American Indian Art Magazine* 22, 2 (Spring 1997), pp. 62–73, 81, 83.

Brydon 1995. Brydon, Sherry. "Ingenuity in Art: the Early 19th Century Works of David and Dennis Cusick." *American Indian Art Magazine* 20, 2 (Spring 1995), pp. 60–69.

Bunzel 1972. Bunzel, Ruth L. *The Pueblo Potter: A Study of Creative Imagination in Primitive Art*. New York: Dover Publications, 1972.

Burke 2009. Burke, Christina E. "Jewelry and Silverwork in the Eugene B. Adkins Collection." *American Indian Art Magazine* 34, 4 (Autumn 2009), pp. 40–49.

Campbell 2005. Campbell, Tyrone. "Weaving Is Believing: Navajo Sandpainting Tapestries." *HALI* 141 (July/August 2005), pp. 52–57.

Campbell, J. Kopp, and K. Kopp 1991. Campbell, Tyrone, Joel Kopp, and Kate Kopp. *Navajo Pictorial Weaving 1880–1950*. New York: Dutton Studio Books, 1991.

Carlson 1982. Carlson, Roy. *Indian Art Traditions of the Northwest Coast*. Burnaby, British Columbia: Archaeology Press, 1982.

Catlin 1841. Catlin, George. *Letters and Notes on the Manners, Customs, and Conditions of the North American Indian*. Vol. 2. London, 1841.

Catlin, Heyman, Gurney, and Dippie 2002. Catlin, George, Therese Thau Heyman, George Gurney, and Brian W. Dippie. *George Catlin and His Indian Gallery*. Washington, DC: Smithsonian American Art Museum, and W. W. Norton, 2002.

Chaat Smith 1995. Chaat Smith, Paul. "A Place Called Irony." In Bates, Sara, Jolene Rickard, and Paul Chaat Smith. *Indian Humor*. San Francisco: American Indian Contemporary Arts, 1995, pp. 13–17.

Chaat Smith 2009A. Chaat Smith, Paul. *Everything You Know About Indians Is Wrong*. Minneapolis: University of Minnesota Press, 2009.

Chaat Smith 2009B. Chaat Smith, Paul. "Art Quantum Tribe." Keynote address for the Eiteljorg Fellowship for Native American Fine Art Symposium. Eiteljorg Museum of American Indian and Western Art, November 14, 2009. http://fellowship.eiteljorg.org/#mainGallery::Main Gallery|symposium::Webcast.

Chavez Lamar, Racette, and Evans 2010. Chavez Lamar, Cynthia, Sherry Farrell Racette, and Lara Evans, eds. *Art in Our Lives: Native Women Artists in Dialogue*. Santa Fe: School of Advanced Research, 2010.

Cherney 1976. Cherney, Charlene. "Navajo Pictorial Weaving." *American Indian Art Magazine* 2, 1 (Winter 1976), pp. 46–51.

Cirillo 1992. Cirillo, Dexter. *Southwestern Indian Jewelry*. New York: Abbeville Press, 1992.

Clifford 1988. Clifford, James. *The Predicament of Culture*. Cambridge, Massachusetts: Harvard University Press, 1988.

Coe 1977. Coe, Ralph T. *Sacred Circles: Two Thousand Years of North American Indian Art*. London: Arts Council of Great Britain, 1977.

Cohodas 1992. Cohodas, Marvin. "Louisa Keyser and the Cohns: Mythmaking and Basketmaking in the American West." In *The Early Years of Native American Art History: The Politics of Scholarship and Collecting*. Ed. Janet Catherine Berlo. Seattle: University of Washington Press, 1992, pp. 88–133.

Cooper 2006. Cooper, Thomas Joshua. "Thomas Joshua Cooper." Interview by Robert Ayers. *ArtInfo.com*. December 27, 2006. www.artinfo.com/news/story/24114/thomas-joshua-cooper.

Cooper and Yau 2006. Cooper, Thomas Joshua, and John Yau. *Ojo de Agua: Thomas Joshua Cooper*. New York: Pace Wildenstein, 2006.

Csordas 1990. Csordas, Thomas. "Embodiment as a Paradigm for Anthropology." *Ethos* 18 (1990), pp. 5–47.

Cusick 1848. Cusick, David. *David Cusick's Sketches of the Ancient History of the Six Nations*. Lockport, New York: Turner and McCollum, 1848.

Dawson and Deetz 1965. Dawson, Lawrence E., and James Deetz. "A Corpus of Chumash Basketry." *UCLA Archaeological Survey Annual Report*. Los Angeles: Department of Anthropology, University of California, Los Angeles, 1965, pp. 193–275.

De Laguna 1990. De Laguna, Frederica. "Tlingit." In *Northwest Coast*. Vol. 7. Ed. Wayne Suttles. *Handbook of North American Indians*. General editor, William C. Sturtevant. Washington, DC: Smithsonian Institution, 1990, pp. 203–28.

Deadman 2007. Deadman, Patricia. *Terra Incognita: Mary Anne Barkhouse and Michael Belmore*. Guelph, Ontario: Macdonald Stewart Art Centre, 2007.

Decker 1999. Decker, Julie. *Icebreakers: Alaska's Most Innovative Artists*. Anchorage: Decker Art Services, 1999.

Decker 2002. Decker, Julie. *John Hoover: Art and Life*. Seattle: University of Washington Press, 2002.

Deloria 1995. Deloria, Vine Jr. *Red Earth, White Lies. Native Americans and the Myth of Scientific Fact*. New York: Scribner, 1995.

DesignTAXI.com 2009. DesignTAXI.com. "Art Institute of Chicago Presents '500 Ways of Looking at Modern.'" Last modified September 3, 2009. http://www.designtaxi.com/news.php?id=28504.

Diaz-Granados 2004. Diaz-Granados, Carol. In Townsend, Richard F., ed. "Marking Stone, Land, Body, and Spirit." In *Hero, Hawk, and Open Hand: American Indian Art of the Ancient Midwest and South*. Chicago: The Art Institute of Chicago, in association with Yale University Press, 2004, pp. 139–49.

Dillingham 1992. Dillingham, Rick. *Acoma and Laguna Pottery*. Santa Fe: School of American Research Press, 1992.

Dobkins 2002. Dobkins, Rebecca. *Rick Bartow: My Eye*. Salem, Oregon: Hallie Ford Museum of Art, Willamette University, in association with University of Washington Press, 2002.

Dockstader 1987. Dockstader, Frederick. *The Song of the Loom: New Traditions in Navajo Weaving*. New York: Hudson Hills Press, 1987.

Dodge 1949. Dodge, Ernest S. "A Seventeenth-Century Pennacook Quilled Pouch." Salem, Massachusetts: Peabody Museum, 1959. Reprinted from *Publications of the Colonial Society of Massachusetts* (Boston) 38 (1949).

Douglas and D'Harnoncourt 1941. Douglas, Frederic H., and René D'Harnoncourt. *Indian Art of the United States*. New York: The Museum of Modern Art, 1941.

Dresslar 1996. Dresslar, Jim. *Folk Art of Early America: The Engraved Powder Horn*. Bargersville, Indiana: Dresslar Publishing, 1996.

Dubin 2004. Dubin, Lois S. "Charles Loloma." In *Totems to Turquoise: Native North American Jewelry Arts of the Northwest and Southwest*. Ed. Kari Chalker. New York: Harry N. Abrams, in association with American Museum of Natural History, 2004, p. 162.

Duff 1967. Duff, Wilson. "Gallery 6. Charles Edenshaw: Master Artist." In *Arts of the Raven: Masterworks by the Northwest Coast Indian*. Vancouver: Vancouver Art Gallery, 1967.

Dunn 1968. Dunn, Dorothy. *American Indian Painting of the Southwest and Plains Areas*. Albuquerque: University of New Mexico Press, 1968, pp. 198–207.

Durham 2009. Durham, Jimmie. "Jeffrey Gibson: Our Miles Davis." In *Art Quantum: The Eiteljorg Fellowship for Native American Fine Art 2009*. Ed. James H. Nottage. Seattle: University of Washington Press, 2009, pp. 57–69.

Dye 2004. Dye, David H. "Art, Ritual, and Chiefly Warfare in the Mississippian World." In Townsend, Richard F., ed. *Hero, Hawk, and Open Hand: American Indian Art of the Ancient Midwest and South*. Chicago: The Art Institute of Chicago, in association with Yale University Press, 2004, pp. 191–205.

Dye 2007. Dye, David H. "Ritual, Medicine, and the War Trophy Iconographic Theme in the Mississippian Southeast." In *Ancient Objects and Sacred Realms: Interpretations of Mississippian Iconography*. Eds. F. Kent Reilly III and James F. Garber. Austin: University of Texas Press, 2007, pp. 152–73.

Earenfight 2007. Earenfight, Phillip. "Reconstructing *A Kiowa's Odyssey*: Etahdleuh, Bear's Heart, and the Yale-Dickinson Drawings from Fort Marion." In *A Kiowa's Odyssey*. Ed. Phillip Earenfight. Seattle: University of Washington Press, 2007, pp. 57–96.

Emmons 1991. Emmons, George Thorton. *The Tlingit Indians*. Ed. Frederica De Laguna. Vancouver: Douglas and McIntyre, and American Museum of Natural History, 1991, pp. 224–33.

Emmons 1993. Emmons, George Thorton. *The Basketry of the Tlingit and the Chilkat Blanket*. Sitka, Alaska: Friends of the Sheldon Jackson Museum, 1993.

English 2009. English, Karah. "Reinventing the Gaze: Judith Lowry's Artistic Expressions Contextualized." MA thesis. University of California Davis, 2009.

Epple 1998. Epple, Carolyn. "Coming to Terms with Navajo '*Nádleehí*': A Critique of 'Berdache,' 'Gay,' 'Alternative Gender,' and 'Two-Spirit.'" *American Ethnologist* 25, 2 (May 1998), pp. 267–90.

Everett and Zorn 2008. Everett, Deborah, and Elayne Zorn, eds. *Encyclopedia of Native American Artists: Artists of the American Mosaic*. Westport, Connecticut: Greenwood Press, 2008.

Ewers 1968. Ewers, John C. *Indian Life on the Upper Missouri*. Norman: University of Oklahoma Press, 1968.

Ewers 1982. Ewers, John C. "The Awesome Bear in Plains Indian Art." *American Indian Art Magazine* 7, 3 (Summer 1982), pp. 36–45.

Ewing 1982. Ewing, Douglas. *Pleasing the Spirits*. New York: Ghylen Press, 1982.

Fair 2006. Fair, Susan W. *Alaska Native Art: Tradition, Innovation, Continuity*. Ed. Jean Blodgett. Fairbanks: University of Alaska Press, 2006.

Fair and Worl 2000. Fair, Susan W., and Rosita Worl, eds. *Celebration 2000*. Juneau: Sealaska Heritage Foundation, 2000.

Fairbrother 2003. Fairbrother, Trevor. *Family Ties: A Contemporary Perspective*. Salem, Massachusetts: Peabody Essex Museum, in association with Marquand Books, 2003.

Farrell 2009. Farrell, Amanda. "VFF: Leaping Forward." *MondayMag.com*. January 28, 2009. http://mondaymag.com/articles/entry/leaping-forward/.

Feest 1983. Feest, Christian. "Powhatan's Mantle." In MacGregor, Arthur, ed. *Tradescant's Rarities: Essays on the Foundation of the Ashmolean Museum, 1638*. Oxford: Clarendon Press, 1983, pp. 132–34.

Feest and Kasprycki 1999. Feest, Christian F., and Sylvia S. Kasprycki. *People of the Twilight: European Views of Native Minnesota, 1823 to 1862*. Afton, Minnesota: Afton Historical Society Press, 1999.

Feld and Basso 1996. Feld, Steven, and Keith Basso, eds. *Senses of Place*. Santa Fe: School of American Research Press, 1996.

Fenton 1956. Fenton, William. "Toward the Gradual Civilization of the Indian Natives: The Missionary and Linguistic Work of Asher Wright (1803–1875) among the Senecas of Western New York." *Proceedings of the American Philosophical Society* 100, 6 (1956), pp. 567–81.

Fienup-Riordan 1996. Fienup-Riordan, Ann. *The Living Tradition of Yup'ik Masks*. Seattle: University of Washington Press, 1996.

Fienup-Riordan 2007. Fienup-Riordan, Ann. *Yuungnaqpiallerpt/The Way We Genuinely Live: Masterworks of Yup'ik Science and Survival*. Seattle: University of Washington Press, in association with Anchorage Museum Association, and Calista Elders Council, 2007.

Fisher 1992. Fisher, Jean. "In Search of the 'Inauthentic': Disturbing Signs in Contemporary Native American Art." *Art Journal* 51, 3 (Fall 1992), pp. 44–50.

Flower 2005. Flower, Grace Medicine. "Art: Traditionally Contemporary." In *Indigenous Motivations: Recent Acquisitions from the National Museum of the American Indian*. National Museum of the American Indian, Smithsonian Institution. Last modified August 1, 2006. http://www.nmai.si.edu/exhibitions/indigenous_motivations/flash8/index.html.

Fonseca 2010. Fonseca, Harry. "Harry Fonseca: Maidu." *A Time of Vision: Interviews by Larry Abbott*. Last modified September 28, 2010. http://www.britesites.com/native_artist_interviews/hfonseca.htm.

Fragnito 2002. Fragnito, Skawennati Tricia. "Five Suggestions for Better Living." In *On Aboriginal Representation in the Gallery*. Ed. Lynda Jessup with Shannon Bagg. Hull: Canadian Museum of Civilization, 2002, pp. 229–37.

Frederick 1995. Frederick, Joan. *T. C. Cannon: He Stood in the Sun*. Flagstaff, Arizona: Northland Publishing, 1995.

Fruitlands Museum 2011. Fruitlands Museum. "King Philip's Club." Accessed January 7, 2011. http://www.fruitlands.org/fruitlands_features/kingphilipsclub.

Fusco 1994. Fusco, Coco. "The Other History of Intercultural Performance." *The Drama Review* 38, 1 (Spring 1994), pp. 143–67.

Fusco and Wallis 2003. Fusco, Coco, and Brian Wallis. *Only Skin Deep: Changing Visions of the American Self*. New York: International Center for Photography, 2003.

Galanin 2004. Galanin, Nicholas. "Nick Galanin." In *Totems to Turquoise: Native North American Jewelry Arts of the Northwest and Southwest*. Ed. Kari Chalker. New York: Harry N. Abrams, in association with American Museum of Natural History, 2004, p. 102.

Galanin 2010A. Galanin, Nicholas. "Artist Statement." *Beat Nation*. Last modified August 20, 2010. http://www.beatnation.org/nicholas-galanin.html.

Galanin 2010B. Galanin, Nicholas. "Nicholas Galanin – Tlingit/Aleut." Interview by Ronald Egger. *Contemporary North American Indigenous Artists*. March 28, 2010. http://contemporarynativeartists.tumblr.com/post/479617639/nicholas-galanin-tlingit-aleut.

Gallivan 2007. Gallivan, Martin D. "Powhatan's Werowocomoco: Constructing Place, Polity, and Personhood in the Chesapeake, C.E. 1200–C.E. 1609." *American Anthropologist* 109, 1 (March 2007), pp. 85–100.

Garfield and Wingert 1951. Garfield, Viola, and Paul Wingert. *The Tsimshian: Their Arts and Music*. New York: American Ethnology Society, 1951.

Gilliland 1989. Gilliland, Marion Spjut. *Key Marco's Buried Treasure: Archaeology and Adventure in the Nineteenth Century*. Gainesville: University of Florida Press, and The Florida Museum of Natural History, 1989.

Gladstone and Berlo 2011. Gladstone, Mara, and Janet Catherine Berlo. "The Body in the White Box: Corporeal Ethics and Museum Representation." In *Routledge Companion to Museum Ethics: Redefining Ethics for the Twenty-First Century Museum*. Ed. Janet Marstine. New York: Routledge Press, 2011, n.p. (forthcoming).

Gold Thwaites 1896–1901. Gold Thwaites, Reuben. "Of the First Voyage Made by Father Marquette Toward New Mexico, and How the Idea Thereof Was Conceived." *The Jesuit Relations and Allied Documents*. Vol. 59. Cleveland: The Burrows Company, 1896–1901.

González 2008. González, Jennifer A. "James Luna: Artifacts and Fictions." In González, Jennifer A. *Subject to Display: Reframing Race in Contemporary Installation Art*. Cambridge, Massachusetts: MIT Press, 2008, pp. 22–62.

Gopnik 2009. Gopnik, Blake. "Native Intelligence." *The Washington Post*, October 20, 2009. http://www.washingtonpost.com/wp-dyn/content/article/2009/10/19/AR2009101903331.html.

Greene, Richard, and Thompson 2007. Greene, Candace S., Bonnie Richard, and Kirsten Thompson. "Treaty Councils and Indian Delegations: The War Department Museum Collection." *American Indian Art Magazine* 33, 1 (Winter 2007), pp. 66–80.

Griffin-Pierce 1992. Griffin-Pierce, Trudy. *Earth Is My Mother, Sky Is My Father: Space, Time and Astronomy in Navajo Sandpaintings*. Albuquerque: University of New Mexico Press, 1992.

Grimes 2002A. Grimes, John R. "Baby Carrier." In Grimes, John R., Christian F. Feest, and Mary Lou Curran. *Uncommon Legacies: Native American Art from the Peabody Essex Museum*. New York: American Federation of Arts, in association with University of Washington Press, 2002, p. 202.

Grimes 2002B. Grimes, John R. "Burl Cup." In Grimes, John R., Christian F. Feest, and Mary Lou Curran. *Uncommon Legacies: Native American Art from the Peabody Essex Museum*. New York: American Federation of Arts, in association with University of Washington Press, 2002, p. 96.

Grimes 2002C. Grimes, John R. "Overcoat." In Grimes, John R., Christian F. Feest, and Mary Lou Curran. *Uncommon Legacies: Native American Art from the Peabody Essex Museum*. New York: American Federation of Arts, in association with University of Washington Press, 2002, p. 166.

Grimes 2002D. Grimes, John R. "Powder Horn." In Grimes, John R., Christian F. Feest, and Mary Lou Curran. *Uncommon Legacies: Native American Art from the Peabody Essex Museum*. New York: American Federation of Arts, in association with University of Washington Press, 2002, p. 94.

Grimes and K. Kramer 2002. Grimes, John R., and Karen Kramer. "Hat." In Grimes, John R., Christian F. Feest, and Mary Lou Curran. *Uncommon Legacies: Native American Art from the Peabody Essex Museum*. New York: American Federation of Arts, in association with University of Washington Press, 2002, p. 152.

Grinnell 1923. Grinnell, George Bird. *The Cheyenne Indians: Their History and Ways of Life*. Vol. 1. Lincoln: University of Nebraska Press, 1923.

Haas, Chaat Smith, and Lowe 2005. Haas, Lisbeth, Paul Chaat Smith, and Truman Lowe. *James Luna: Emendatio*. Washington, DC: National Museum of the American Indian, Smithsonian Institution, 2005.

Hackworth and Macmillan 2004. Hackworth, Nick, and Duncan Macmillan. *Point of No Return: Thomas Joshua Cooper*. London: Haunch of Venison Gallery, 2004.

Haga (Third Son): Truman Lowe 1994. *Haga (Third Son): Truman Lowe*. Indianapolis: Eiteljorg Museum of American Indians and Western Art, 1994.

Hail 2000A. Hail, Barbara A., ed. *Gifts of Pride and Love: Kiowa and Comanche Cradles*. Providence, Rhode Island: Haffenreffer Museum of Anthropology, Brown University, 2000.

Hail 2000B. Hail, Barbara A. "A House for the Beginning of Life." In Hail, Barbara A., ed. *Gifts of Pride and Love: Kiowa and Comanche Cradles*. Providence, Rhode Island: Haffenreffer Museum of Anthropology, Brown University, 2000, pp. 17–39.

Halpin 1981. Halpin, Marjorie. *Totem Poles: An Illustrated Guide*. Vancouver: University of British Columbia Press, 1981.

Halpin 1984. Halpin, Marjorie. "'Seeing' in Stone: Tsimshian Masking and the Twin Stone Masks." In *The Tsimshian: Images of the Past: Views for the Present*. Ed. Margaret Seguin. Vancouver: University of British Columbia Press, 1984, pp. 281–308.

Hammond and Quick-To-See Smith 1985. Hammond, Harmony, and Jaune Quick-To-See Smith. *Women of Sweetgrass, Cedar, and Sage*. New York: American Indian Community House, 1985.

Hanor 2006. Hanor, Stephanie. *Transactions: Contemporary Latin American and Latino Art*. San Diego: Museum of Contemporary Art, 2006.

Hansen 2007. Hansen, Emma I. *Memory and Vision: Arts, Cultures, and Lives of Plains Indian People*. Cody, Wyoming: Buffalo Bill Historical Center, in association with University of Washington Press, 2007.

Harlow 1990. Harlow, Francis. *Two Hundred Years of Historic Pueblo Pottery: The Gallegos Collection*. Santa Fe: Morning Star Gallery, 1990.

Harp 1998. Harp, Maureen Anna. "Faith, Conflict, and Conversion: Slovene Catholic Missions in the Upper Great Lakes, 1830s–1850s." *U.S. Catholic Historian* (Native-American Catholics) 16, 2 (Spring, 1998), pp. 20–40.

Harper 2000. Harper, Kenn. *Give Me My Father's Body: The Life of Minik, the New York Eskimo*. South Royalton, Vermont: Steerforth Press, 2000.

J. Hart 2004. Hart, Jim. "Charles Edenshaw." In *Totems to Turquoise: Native North American Jewelry Arts of the Northwest and Southwest*. Ed. Kari Chalker. New York: Harry N. Abrams, in association with American Museum of Natural History, 2004, pp. 72–73.

M. A. Hart 2010. Hart, Michael Anthony. "Indigenous Worldviews, Knowledge, and Research: The Development of an Indigenous Research Paradigm." *Journal of Indigenous Voices in Social Work* 1, 1 (February 2010), pp. 1–16.

Haworth 2007. Haworth, John. "Introduction: On the Map." In Ash-Milby, Kathleen, ed. *Off the Map: Landscape in the Native Imagination*. Washington, DC: National Museum of the American Indian, Smithsonian Institution, 2007, pp. 11–14.

Hedlund 1987. Hedlund, Ann Lane. "Commercial Materials in Modern Navajo Rugs." *The Textile Museum Journal* 25 (1987), pp. 83–94.

Henderson 1925. Henderson, Alice Corbin. "A Boy Painter among the Pueblo Indians." *The New York Times*, September 6, 1925, p. SM18.

Hickman 1987. Hickman, Pat. *Innerskins Outerskins: Gut and Fishskin*. San Francisco: San Francisco Craft and Folk Art Museum, 1987.

Highwater 1976. Highwater, Jamake. *Song from the Earth: American Indian Painting*. Boston: New York Graphic Society, 1976.

R. Hill 1994. Hill, Richard. "The Old and the New: Different Forms of the Same Message." *Native American Expressive Culture, Akwe:kon Journal* (New York: NMAI and Akwe:kon Press, Cornell University) 11, 3 and 4 (Fall/Winter 1994), pp. 75–83.

W. W. Hill 1935. Hill, W. W. "The Status of the Hermaphrodite or Transvestite in Navajo Culture." *American Anthropologist* 37, 2 (1935), pp. 273–79.

Holm 1981. Holm, Bill. "Will the Real Charles Edenshaw Please Stand Up?" In *The World Is as Sharp as a Knife: An Anthology in Honour of Wilson Duff*. Ed. Donald Abbott. Victoria: British Columbia Provincial Museum, 1981, pp. 175–200.

Holm 1982. Holm, Bill. "Shaman's Mask." In Vaughan, Thomas, and Bill Holm. *Soft Gold: The Fur Trade and Cultural Exchange on the Northwest Coast of America*. Portland, Oregon: Historical Society, 1982, p. 92.

Holubizky 2009. Holubizky, Ihor. "Michael Belmore: Shorelines, Flux, Origins, and Dark Water – The Slowness of Things." In *HIDE: Skin as Material and Metaphor*. Ed. Kathleen Ash-Milby. Washington, DC: National Museum of the American Indian, Smithsonian Institution, 2009, pp. 67–77.

Hoover 1995. Hoover, Alan L. "Charles Edenshaw: His Art and Audience." In *American Indian Art Magazine* 20, 3 (Summer 1995), pp. 44–53.

Hoover 2009. Hoover, Alan L., ed. *Nuu-chah-nulth Voices: Histories, Objects and Journeys*. Victoria: Royal British Columbia Museum, 2000.

G. P. Horse Capture and Her Many Horses 2006. Horse Capture, George P., and Emil Her Many Horses, eds. *A Song for the Horse Nation: Horses in Native American Cultures*. Washington, DC: National Museum of the American Indian, Smithsonian Institution, in association with Fulcrum Publishing, 2006.

J. D. Horse Capture and G. P. Horse Capture 2001. Horse Capture, Joe D., and George P. Horse Capture. *Beauty, Honor, and Tradition: The Legacy of Plains Indian Shirts*. Washington, DC: National Museum of the American Indian, Smithsonian Institution, and Minneapolis Institute of Arts, 2001.

Houze 1989. Houze, Herbert. *Sumptuous Flaske: European and American Decorated Powder Flasks of the Sixteenth to Nineteenth Centuries*. Cody, Wyoming: Buffalo Bill Historical Center, and Andrew Mowbry, Inc., 1989.

Howard 1951. Howard, James H. "Notes on the Dakota Grass Dance." *Southwestern Journal of Anthropology* (University of New Mexico) 7, 1 (Spring 1951), pp. 82–85.

Howard 1960. Howard, James H. "When They Worship the Underwater Panther: A Prairie Bundle Ceremony." *Southwestern Journal of Anthropology* (University of New Mexico) 16, 2 (Summer 1960), pp. 217–24.

Hudson and Blackburn 1983. Hudson, Travis, and Thomas C. Blackburn. *The Material Culture of the Chumash Interaction Sphere, Volume II: Food Preparation and Shelter*. Menlo Park, California: Ballena Press, and Santa Barbara Museum of Natural History, 1983.

Indyke 2006. Indyke, Dottie. "A Lakota Artist Specializing in Buffalo-Horn Jewelry Brings New Attention to the Medium." *Southwest Art Magazine*, November 6, 2006. www.southwestart.com/articles-interviews/featured-artists/kevin_pourier.

Institute of American Indian Arts Museum 2005. Institute of American Indian Arts Museum. *Bob Haozous: Indigenous Dialogue*. Santa Fe: Institute of American Indian Arts Museum, 2005.

Jackinsky 2008. Jackinsky, Nadia. "Four Exhibits of Alaska Native Art: Women Artists Breaking Boundaries." *Paradoxa: International Feminist Art Journal* 22 (2008), pp. 90–93.

James 1914. James, George Wharton. *Indian Blankets and Their Makers*. Chicago: A. C. McClurg and Co., 1914. Reprint, New York: Dover, 1974.

Jensen 2004. Jensen, Vickie. *Totem Pole Carving: Bringing a Log to Life*. Vancouver: Douglas and McIntyre, and University of Washington Press, 2004.

John Simon Guggenheim Memorial Foundation 2009. John Simon Guggenheim Memorial Foundation. "Thomas Joshua Cooper: 2009–US and Canada Competition Creative Arts–Photography." Accessed January 10, 2010. www.gf.org/fellows/16515-thomas-joshua-cooper.

Jonaitis 2008. Jonaitis, Aldona. "A Generation of Innovators in Southeast Alaska: Nicholas Galanin, Stephen Jackson, Da-ka-xeen Mehner and Donald Varnell." *American Indian Art Magazine* 33, 4 (Autumn 2008), pp. 56–67.

Jonaitis and Glass 2010. Jonaitis, Aldona, and Aaron Glass. *The Totem Pole: An Intercultural History*. Vancouver: Douglas and McIntyre, and University of Washington Press, 2010.

Jones 1997. Jones, Amelia. "'Presence' in Absentia: Experiencing Performance as Documentation." *Art Journal* 56, 4 (Winter 1997), pp. 11–18.

Jones 1998. Jones, Amelia. *Body Art: Performing the Subject*. Minneapolis: University of Minnesota Press, 1998.

Jopling 1989. Jopling, Carol F. "The Coppers of the Northwest Coast Indians: Their Origin, Development, and Possible Antecedents." New Series, *Transactions of the American Philosophical Society* 79, 1 (1989), pp. i–xii, 1–164.

Jungen and Augaitis 2005. Jungen, Brian, and Daina Augaitis. *Brian Jungen*. Vancouver: Vancouver Art Gallery, and Douglas and McIntyre, 2005.

Kalbfleisch 2010. Kalbfleisch, Elizabeth. "Bordering on Feminism: Space, Solidarity, and Transnationalism in Rebecca Belmore's *Vigil*." In *Indigenous Women and Feminism: Politics, Activism, Culture*. Eds. Cheryl Suzack, Shari Hunsdorf, Jeanne Perreault, and Jean Barman. Vancouver: University of British Columbia Press, 2010, pp. 278–97.

Karp and Levine 1991. Karp, Ivan, and Steven D. Levine, eds. *Exhibiting Cultures: The Poetics and Politics of Museum Display*. Washington, DC: Smithsonian Institution Press, 1991.

Kasprycki 1997. Kasprycki, Sylvia S. "Quilled Drawstring Pouches of the Northeastern Woodlands." *American Indian Art Magazine* 22, 3 (Summer 1997), pp. 64–75.

Kent 1985. Kent, Kate Peck. *Navajo Weaving: Three Centuries of Change*. Santa Fe: School of American Research Press, 1985.

A. King 2002. King, Adam. "Mississippian Period: Overview." *New Georgia Encyclopedia*, October 2002. http://www.georgiaencyclopedia.org/nge/Article.jsp?id=h-707.

J. C. H. King 1979. King, J. C. H. *Portrait Masks from the Northwest Coast of America*. London: The British Museum, 1979.

J. C. H. King 1999. King, J. C. H. *First Peoples, First Contacts: Native Peoples in North America*. Cambridge, Massachusetts: Harvard University Press, 1999.

J. C. H. King and Feest 2007. King, J. C. H., and Christian F. Feest, eds. *Three Centuries of Woodlands Indian Art*. Altenstadt, Hesse, Germany: ZKF Publishers, 2007.

Kopytoff 1986. Kopytoff, Igor. "The Cultural Biography of Things." In *The Social Life of Things*. Ed. Arjun Appadurai. Cambridge: Cambridge University Press, 1986, pp. 64–91.

Kouwenhoven 2010. Kouwenhoven, Bill. "Capturing the Void." *British Journal of Photography* 157 (April 2010), pp. 42–49.

B. Kramer 1996. Kramer, Barbara. *Nampeyo and Her Pottery*. Albuquerque: University of New Mexico Press, 1996.

K. Kramer 2007. Kramer, Karen. "Intersections: Native American Art in a New Light." *American Indian Art Magazine* 32, 4 (Autumn 2007), pp. 74–83.

Krauss 1984. Krauss, Rosalind. *The Originality of the Avant-Garde and Other Modernist Myths*. Cambridge, Massachusetts: M.I.T. Press, 1984.

Kulber 1962. Kubler, George. *The Shape of Time: Remarks on the History of Things*. New Haven: Yale University Press, 1962.

LaChapelle 2002. LaChappelle, Greg. "Charlie Willeto, 1897–1964: A Recollection." In Begay, Shonto, et al. *Collective Willeto: The Visionary Carvings of a Navajo Artist*. Santa Fe: Museum of New Mexico Press, 2002, pp. 5–9.

LaFarge and Sloan 1931. LaFarge, Oliver, and John Sloan. *Introduction to American Indian Art*. New York: The Exposition of Indian Tribal Arts, 1931.

Lange 2010. Lange, Patricia Fogelman. "The Spiritual World of Franc Newcomb." *Navajo Sand Painting – Franc Johnson Newcomb*. Accessed December 29, 2010. http://www.francnewcomb.org/.

Lanmon 2005. Lanmon, Dwight. "Pueblo Man-Woman Potters and the Pottery Made by the Laguna Man-Woman, Arroh-a-och." *American Indian Art Magazine* 31, 1 (Winter 2005), pp. 72–85.

La Salle 2008. La Salle, Marina J. *Beyond Lip Service: An Analysis of Labrets and Their Social Context on the Pacific Northwest Coast of British Columbia*. MA thesis. Vancouver: University of British Columbia, August 2008.

Lessard 1990. Lessard, Rosemary. "Lakota Cradles." *American Indian Art Magazine* 16, 1 (Winter 1990), pp. 44–53, 105.

Lesser 1996. Lesser, Alexander. *The Pawnee Ghost Dance Hand Game: Ghost Dance Revival and Ethnic Identity*. Lincoln: University of Nebraska Press, 1996.

LewAllen Galleries 2007. LewAllen Galleries. "Ramona Sakiestewa: Nebula–The Reflection Series." *Artnet*. 2007. http://www.artnet.com/Galleries/Exhibitions.asp?gid=662&cid=121786.

Lippard 1985. Lippard, Lucy R. "Double Vision." In Hammond, Harmony, and Jaune Quick-To-See Smith. *Women of Sweetgrass, Cedar and Sage*. New York: Gallery of the American Indian Community House, 1985, pp. 1–7.

Lippard 1999. Lippard, Lucy R. "Judith Lowry: Aiming for the Heart." In Lowry, Judith, Lucy R. Lippard, and Theresa Harlan. *Illuminations, Paintings by Judith Lowry*. Santa Fe: Wheelwright Museum of the American Indian, 1999, pp. 7–15, 33–37.

Lippard 2000. Lippard, Lucy R. *Mixed Blessings: New Art in a Multicultural America*. New York: The New Press, 2000, p. 216.

Longfish 1995. Longfish, George. "Artist Statement." In Bates, Sara, Jolene Rickard, and Paul Chaat Smith. *Indian Humor*. San Francisco: American Indian Contemporary Arts, 1995, p. 62.

Longtoe 2006. Longtoe, Vera. "The Double Curve Motif." *Elnu Abenaki Tribe*, 2006. http://www.elnuabenakitribe.org/DoubleCurves.html.

Lookingbill 2006. Lookingbill, Brad D. *War Dance at Fort Marion: Plains Indian War Prisoners*. Norman: University of Oklahoma Press, 2006, p. 58.

Lord 2011. Lord, Erica. "Binary Selves." Accessed January 7, 2011. http://ericalord.com/section/23760_Binary_Selves.html.

Lowe 2004. Lowe, Truman, ed. *Native Modernism: The Art of George Morrison and Allan Houser*. Washington, DC: National Museum of the American Indian, Smithsonian Institution, in association with University of Washington Press, 2004.

Lowry 2000. Lowry, Judith. "I Just Paint from My Heart." *Museum Anthropology* 24, 2/3 (September 2000), pp. 44–49.

Lowry 2006. Lowry, Judith. "Artist Statement." Unpublished statement, 2006. Microsoft Word file.

Luna 2004. Luna, James. "Sun and Moon Blues." In *Obsession, Compulsion, Collection: On Objects, Display Culture, and Interpretation*. Ed. A. Kiendl. Toronto: Banff Centre Press, 2004, pp. 150–57.

Lussier and Sealey 1978. Lussier, Antoine S., and D. Bruce Sealey, eds. *The Other Natives: The Métis*. 3 vols. Winnipeg: Manitoba Métis Federation Press, 1978.

MacGregor 1983. MacGregor, Arthur, ed. *Tradescant's Rarities: Essays on the Foundation of the Ashmolean Museum, 1638*. Oxford: Clarendon Press, 1983.

Macmillan 2004. Macmillan, Duncan. "At the Still Point of the Turning World." In Hackworth, Nick, and Duncan Macmillan. *Point of No Return: Thomas Joshua Cooper*. London: Haunch of Venison Gallery, 2004, p. 45.

Macnair 1998. Macnair, Peter L. "Power of the Shining Heavens: The Human Face Divine." In Macnair, Peter L., Robert Joseph Peter, and Bruce Grenville. *Down from the Shimmering Sky: Masks of the Northwest Coast*. Vancouver: Douglas and McIntyre, in association with University of Washington Press, and Vancouver Art Gallery, 1998, pp. 60–94.

Macnair, Hoover, and Neary 1984. Macnair, Peter L., Alan Hoover, and Kevin Neary. *The Legacy: Tradition and Innovation in Northwest Coast Art*. Seattle: University of Washington Press, 1984.

Macnair, Joseph, and Grenville 1998. Macnair, Peter L., Robert Joseph, and Bruce Grenville. *Down from the Shimmering Sky: Masks of the Northwest Coast*. Vancouver: Douglas and McIntyre, in association with University of Washington Press, 1998.

Macnair and Stewart 2002A. Macnair, Peter L., and Jay Stewart. "Chilkat Blanket." In Grimes, John R., Christian F. Feest, and Mary Lou Curran. *Uncommon Legacies: Native American Art from the Peabody Essex Museum*. New York: American Federation of Arts, in association with University of Washington Press, 2002, p. 162.

Macnair and Stewart 2002B. Macnair, Peter L., and Jay Stewart. "Human Face Mask." In Grimes, John R., Christian F. Feest, and Mary Lou Curran. *Uncommon Legacies: Native American Art from the Peabody Essex Museum*. New York: American Federation of Arts, in association with University of Washington Press, 2002, p. 150.

Madill 2007. Madill, Shirley J. "Intelligent Mischief: The Paintings of Kent Monkman." In Liss, David, and Shirley Madill. *Kent Monkman: The Triumph of Mischief*. Hamilton, Ontario: Art Gallery of Hamilton, 2007, pp. 25–30.

Malloy 2000. Malloy, Mary. *Souvenirs of the Fur Trade: Northwest Coast Indian Art and Artifacts Collected by American Mariners, 1788–1844*. Cambridge, Massachusetts: Peabody Museum of Archaeology and Ethnology, Harvard University, 2000.

Marriott 1948. Marriott, Alice Lee. *Mariá the Potter of San Ildefonso*. Norman: University of Oklahoma Press, 1948.

Masco 2006. Masco, Joseph. *The Nuclear Borderlands: The Manhattan Project in Post–Cold War New Mexico*. Princeton: Princeton University Press, 2006.

Maurer 1992. Maurer, Evan A. *Visions of the People: A Pictorial History of Plains Indian Life*. Minneapolis: The Minneapolis Institute of Arts, 1992.

McChesney 2007. McChesney, Lea S. "The Power of Pottery: Hopi Women Shaping the World." *Women's Studies Quarterly* (The Feminist Press at the City University of New York) 35, 3/4, Activisms (Fall-Winter 2007), pp. 230–47.

McFadden and Taubman 2002. McFadden, David Revere, and Ellen Napiura Taubman, eds. *Changing Hands: Art without Reservation 1: Contemporary Native American Art from the Southwest*. London: Merrell Publishers, in association with American Craft Museum, 2002.

McFadden and Taubman 2005. McFadden, David Revere, and Ellen Napiura Taubman, eds. *Changing Hands: Art without Reservation 2: Contemporary Native North American Art from the West, Northwest and Pacific*. New York: Museum of Arts and Design, 2005.

McGreevy 1982. McGreevy, Susan Brown, ed. *Woven Holy People: Navajo Sandpainting Textiles*. Santa Fe: The Wheelwright Museum, 1982.

McGreevy 1994. McGreevy, Susan Brown. "The Image Weavers: Contemporary Navajo Pictorial Textiles." *American Indian Art Magazine* 19, 4 (Autumn 1994), pp. 48–57.

McGreevy 2010. McGreevy, Susan Brown. "The World According to Charlie Willeto." *American Indian Art Magazine* 35, 2 (Spring 2010), pp. 62–70.

McIntosh 2007. McIntosh, David. "Miss Chief Eagle Testickle, Postindian Diva Warrior, in the Shadowy Hall of Mirrors." In Liss, David, and Shirley Madill. *Kent Monkman: The Triumph of Mischief*. Hamilton, Ontario: Art Gallery of Hamilton, 2007, pp. 31–46.

McLerran 2002. McLerran, Jennifer. "Woven Chantways: The Red Rock Revival." *American Indian Art Magazine* 28, 1 (Winter 2002), pp. 64–73.

McLerran 2006A. McLerran, Jennifer. *Weaving Is Life: Navajo Weavings from the Edwin L. and Ruth E. Kennedy Southwest Native American Collection*. Athens, Ohio: Kennedy Museum of Art, Ohio University, 2006.

McLerran 2006B. McLerran, Jennifer. "Textile as Cultural Text: Contemporary Navajo Weaving as Autoethnographic Practice." *Weaving Is Life: Navajo Weavings from the Edwin L. and Ruth E. Kennedy Southwest Native American Collection*. Athens, Ohio: Kennedy Museum of Art, Ohio University, 2006, pp. 8–33.

McNeil 2009. McNeil, Larry. "American Myths and Indigenous Photography." In *Visual Currencies: Reflections in Native Photography*. Eds. Henrietta Lidchi and Hulleah Tsinhnahjinnie. Edinburgh: National Museums of Scotland, 2009, pp. 108–23.

Meachum 2007. Meachum, Scott. "'Markes upon Their Clubhamers': Interpreting Pictography on Eastern War Clubs." In King, J. C. H., and Christian F. Feest, eds. *Three Centuries of Woodlands Indian Art*. Altenstadt, Hesse, Germany: ZKF Publishers, 2007, pp. 67–74.

Mercer 1990. Mercer, Kobena. "Black Art and the Burden of Representation." *Third Text* 10 (Spring 1990), pp. 61–78.

A. L. Miller et al. 2008. Miller, Angela L., Janet Catherine Berlo, Bryan Jay Wolf, and Jennifer L. Roberts. *American Encounters: Art, History and Cultural Identity*. Upper Saddle River, New Jersey: Prentice Hall, 2008.

J. Miller 1997. Miller, Jay. *Tsimshian Culture: A Light Through the Ages*. Lincoln: University of Nebraska Press, 1997.

K. Miller 2010–2011. Miller, Karen. "Contemporary Native American Ledger Art: Drawing on Tradition; August 14, 2010–January 16, 2011." 25th Anniversary Issue, *Hood Museum of Art Quarterly* (Autumn/Winter 2010–2011), p. 7.

Mint Museum 2010. Mint Museum. "Passionate Journey: The Grice Collection of Native American Art." Accessed December 23, 2010. http://www.themintmuseums.org/.

Momaday 2005. Momaday, N. Scott. "A Tribute to Fritz Scholder." *Native Peoples Magazine* 18, 3 (May/June 2005), p. 34.

Monkman 2007. Monkman, Kent. "Kent Monkman: Re-imaging History." Interview by Kelvin Browne. *ROM* (Toronto: Royal Ontario Museum), Winter 2007, p. 56. http://www.kentmonkman.com/images/press/rom-w07.pdf.

Morand, K. Smith, Swan, and Erwin 2003. Morand, Anne, Kevin Smith, Daniel C. Swan, and Sarah Erwin. *Treasures of Gilcrease: Selections from the Permanent Collection*. Tulsa, Oklahoma: Gilcrease Museum, 2003.

Morgan 2010. Morgan, Susan. "USA Fellows Stories: Virgil Ortiz." *United States Artists*. Accessed December 23, 2010. www.unitedstatesartists.org/news/usa/usa_fellows_stories_virgil_ortiz.

Morris 2001. Morris, Kate. "Picturing Sovereignty: Landscape in Contemporary Native American Art." In *Painters, Patrons, and Identity: Essays in Native American Art to Honor J. J. Brody*. Ed. Joyce M. Szabo. Albuquerque: University of New Mexico Press, 2001, pp. 187–209.

Morris 2007. Morris, Kate. "Places of Emergence: Painting Genesis." In Ash-Milby, Kathleen, ed. *Off the Map: Landscape in the Native Imagination*. Washington, DC: National Museum of the American Indian, Smithsonian Institution, 2007, pp. 47–63.

Morris 2009. Morris, Kate. "Reading between the Lines: Text and Image in Contemporary Native American Art." *American Indian Art Magazine* 34, 2 (Spring 2009), pp. 52–59.

Morrison and Galt 1998. Morrison, George, with Margot Fortunato Galt. *Turning the Feather Around: My Life in Art*. St. Paul: Minnesota Historical Society Press, 1998.

Muehlig 1999. Muehlig, Linda, ed. *Masterworks of American Paintings and Sculpture from the Smith College Museum of Art*. New York: Hudson Hills Press, 1999.

Murray 2008. Murray, Shailagh. "Obama Answers Critical Question – About Music." *The Washington Post*, September 25, 2008. http://voices.washingtonpost.com/the-trail/2008/09/25/obama_answers_critical_questio.html.

Nemiroff 1992. Nemiroff, Diana. "Truman Lowe." In Nemiroff, Diana, Robert Houle, and Charlotte Townsend-Gault. *Land, Spirit, Power: First Nations at the National Gallery of Canada*. Ottawa: National Gallery of Canada, 1992, pp. 182–89.

New 1975. New, Lloyd Kiva. "Foreword." In Monthan, Guy, and Doris Born Monthan. *Art and Indian Individualists: The Art of Seventeen Contemporary Southwestern Artists and Craftsmen*. Flagstaff, Arizona: Northland Press, 1975.

Newcomb 1964. Newcomb, Franc. *Hosteen Klah: Navaho Medicine Man and Sand Painter*. Norman: University of Oklahoma Press, 1964.

Nichols 1997. Nichols, David, ed. *Instrument of Change: James Schoppert Retrospective*. Anchorage, Alaska: Anchorage Museum of History and Art, 1997.

Nicolson 1998. Nicolson, Marianne. "Marianne Nicolson Speaks…." In *Reservation X: The Power of Place in Aboriginal Contemporary Art*. Ed. Gerald McMaster. Seattle: University of Washington Press and Canadian Museum of Civilization, 1998, pp. 99–101.

Nottage 2007. Nottage, James H. "Larry Tee Harbor Jackson McNeil (Tlingit/Nisgaa) Visual Myth Maker." In *Diversity and Dialogue: The Eiteljorg Fellowship for Native American Fine Art 2007*. Ed. James H. Nottage. Seattle: University of Washington Press, 2007, pp. 77–87.

Ortel 2003. Ortel, Jo. *Woodland Reflections: The Art of Truman Lowe*. Madison: The University of Wisconsin Press, 2003.

Ortel 2006. Ortel, Jo. "Multiple Migrations: (E)merging Imagery." In *Migrations: New Directions in Native American Art*. Ed. Marjorie Devon. Albuquerque: University of New Mexico Press, 2006, pp. 39–62.

Ortiz 1947. Ortiz, Fernando Ortiz. *Cuban Counterpoint: Tobacco and Sugar*. New York: Alfred A. Knopf, 1947.

Ostrowitz 1999. Ostrowitz, Judith. *Privileging the Past: Historicism in the Art of the Northwest Coast*. Seattle: University of Washington Press, 1999.

Papadaki 2006. Papadaki, Eirini. "Through Social Images: Postcards as Souvenirs of Memorable Instances and Places." In Milnes, Kate. *Narrative, Memory and Knowledge: Representations, Aesthetics, Contexts*. Huddersfield, United Kingdom: University of Huddersfield, 2006, pp. 55–62.

Pardue 2007. Pardue, Diana F. *Contemporary Southwestern Jewelry*. Salt Lake City: Gibbs Smith Publisher, 2007.

Pasco 1994. Pasco, Katie. "The Critical Chilkat: Understanding and Appreciating Chilkat Weaving." *American Indian Art Magazine* 19, 3 (Summer 1994), pp. 58–67, 104.

Peabody Essex Museum 2008. Peabody Essex Museum. "Full Disclosure: Autobiographical Paintings Continue a Storytelling Tradition." *PEM Connections*, November/December 2008, pp. 4–5.

Pearlman 1992. Pearlman, Barbara. *Allan Houser (Haozous)*. Santa Fe: Glenn Green Galleries, and distributed by Smithsonian Institution Press, 1992.

Penney 1991. Penney, David W. "Floral Decoration and Culture Change: An Historical Interpretation of Motivation." *American Indian Culture and Research Journal* 15, 1 (1991), pp. 53–77.

Penney 1999. Penney, David W. "George Morrison." In *Contemporary Masters: The Eiteljorg Fellowship for Native American Fine Art 1999.* Indianapolis: Eiteljorg Museum of American Indians and Western Art, 1999, pp. 16–22.

Peraza, Tucker, and Conwil 1990. Peraza, Nilda, Marcia Tucker, and Kinshasha Conwil, eds. *The Decade Show: Frameworks of Identity in the 1980s.* New York: The New Museum, 1990.

Petersen 1971. Petersen, Karen Daniels. *Plains Indian Art from Fort Marion.* Norman: University of Oklahoma Press, 1971.

Peterson 1997. Peterson, Susan. *Pottery by American Indian Women: The Legacy of Generations.* New York: Abbeville Press, and the National Museum of Women in the Arts, 1997.

P. Phillips and J. A. Brown 1978. Phillips, Philip, and James A. Brown. *Pre-Columbian Shell Engravings from the Craig Mound at Spiro, Oklahoma.* Cambridge, Massachusetts: Peabody Museum of Harvard University, 1978.

R. B. Phillips 1984. Phillips, Ruth B. *Patterns of Power: The Jasper Grant Collection and Great Lakes Indian Art of the Early Nineteenth Century.* Kleinburg, Ontario: The McMichael Canadian Collection, 1984.

R. B. Phillips 1991. Phillips, Ruth B. "Glimpses of Eden: Iconographic Themes in Huron Pictorial Tourist Art." *European Review of Native American Studies* 5, 2 (1991), pp. 19–28.

R. B. Phillips 1998. Phillips, Ruth B. *Trading Identities: The Souvenir in Native North American Art from the Northeast, 1700–1900.* Seattle: University of Washington Press, 1998.

R. B. Phillips 2001. Phillips, Ruth B. "Quilled Bark from the Central Great Lakes: A Transcultural History." *Studies in American Indian Art: A Memorial Tribute to Norman Feder.* Seattle: University of Washington Press, 2001, pp. 118–79.

R. B. Phillips and Steiner 1999. Phillips, Ruth B., and Christopher Burghard Steiner. *Unpacking Culture: Art and Commodity in Colonial and Postcolonial Worlds.* Berkeley: University of California Press, 1999.

Pourier 2008. Pourier, Kevin. "Buffalo Horn Carver Kevin Pourier." *YouTube.* Posted October 22, 2008. http://www.youtube.com/watch?v=Cs22cIX6DDg.

Pourier 2010. Pourier, Kevin. "Artist Interview: Kevin Pourier." By Chandler Sampson. *Vimeo.* April 19, 2010. http://vimeo.com/11052817.

Pratt 1964. Pratt, Richard H. *Battlefield and Classroom: Four Decades with the American Indian, 1867–1904.* New Haven: Yale University Press, 1964.

Pratt 1973. Pratt, Richard H. "The Advantages of Mingling Indians with Whites." In *Americanizing the American Indians: Writings by the "Friends of the Indian" 1880–1900.* Ed. Francis Paul Prucha. Cambridge, Massachusetts: Harvard University Press, 1973, pp. 260–71.

Priddy 2004. Priddy, Sumpter T. *American Fancy: Exuberance in the Arts.* Milwaukee: Chipstone Foundation, 2004.

Quick-To-See Smith 1979. Quick-To-See Smith, Jaune. Interview by Laurel Reuter. Grand Forks: University of North Dakota, 1979.

Rebecca Belmore: Fountain 2005. *Rebecca Belmore: Fountain.* Published in conjunction with the 51st Biennale di Venezia, curated by Jann L. M. Bailey et al., with essays by Jessica Bradley and Jolene Rickard. Vancouver: Morris and Helen Belkin Art Gallery, and University of British Columbia, 2005.

Rhoades 2000. Rhoades, Everett R. "The Rowell Family Cradles." In Hail, Barbara, A., ed. *Gifts of Pride and Love: Kiowa and Comanche Cradles.* Providence, Rhode Island: Haffenreffer Museum of Anthropology, Brown University, 2000, pp. 41–51.

Ringlero 2005. Ringlero, Aleta. "Harry Fonseca: In Your Face, In His Element." In *Into the Fray: The Eiteljorg Fellowship for Native American Fine Art 2005.* Ed. James H. Nottage. Seattle: University of Washington Press, 2005, pp. 59–69.

Ringlero 2008. Ringlero, Aleta. "Man of Steel." *National Museum of the American Indian Magazine* 9, 2 (Summer 2008), pp. 18–21.

Rodenbeck 1996. Rodenbeck, J. F. "Yayoi Kusama: Surface, Stitch, Skin." In *Inside the Visible.* Ed. Catherine de Zegher. Boston: The Institute of Contemporary Art, 1996, pp. 149–56.

Romero 2008. Romero, Diego. "Diego Romero of Cochiti Pueblo Talks about His Work in His Own Neo-Mimbres Style." Lecture, Museum of Indian Arts and Culture, Santa Fe, August 22, 2008.

Romero 2010. Romero, Diego. "Diego Romero: Cochiti." *A Time of Visions: Interviews with Larry Abbott.* Last modified September 28, 2010. http://www.britesites.com/native_artist_interviews/dromero.htm.

Roscoe 1988. Roscoe, Will. "We'wha and Klah: The American Indian Berdache as Artist." *American Indian Quarterly* 12, 2 (Spring 1988), pp. 127–50.

Roscoe 1991. Roscoe, Will. *The Zuni Man-Woman.* Albuquerque: University of New Mexico Press, 1991.

C. Rosenak and J. Rosenak 1994. Rosenak, Chuck, and Jan Rosenak. *The People Speak: Navajo Folk Art.* Flagstaff, Arizona: Northland Publishing, 1994.

Rushing 1991. Rushing, W. Jackson. "Authenticity and Subjectivity in Post-War Painting: Concerning Herrera, Scholder, and Cannon." In *Shared Visions: Native American Painters and Sculptors in the Twentieth Century.* Eds. Margaret Archuleta and Rennard Strickland. New York: The New Press, 1991, pp. 12–21.

Rushing 1992. Rushing, W. Jackson. "Street Chiefs and Native Hosts: Richard Ray (Whitman) and Hachivi Edgar Heap of Birds Defend the Homeland." In *Green Acres: Neo-Colonialism in the U.S.* Ed. Christopher Scoates. St. Louis: Washington University Press, 1992, pp. 23–36.

Rushing 1995. Rushing, W. Jackson. *Native American Art and the New York Avant-Garde: A History of Cultural Primitivism.* Austin: University of Texas Press, 1995.

Rushing 2004. Rushing, W. Jackson. *Allan Houser: An American Master (Chiricahua Apache, 1914–1994).* New York: Harry N. Abrams, 2004.

Ryan 1999. Ryan, Allan. *The Trickster Shift: Humour and Irony in Contemporary Native Art.* Vancouver: University of British Columbia Press, and University of Washington Press, 1999.

Salm 2010. Salm, Betsy Krieg. *Women's Painted Furniture 1790–1830: American Schoolgirl Art.* Lebanon, New Hampshire: University Press of New England, 2010.

Samuel 1982. Samuel, Cheryl. *The Chilkat Dancing Blanket.* Seattle: Pacific Search Press, 1982.

Samuel 1990. Samuel, Cheryl. *The Chilkat Dancing Blanket.* Norman: University of Oklahoma Press, 1990.

Sanchez 2010. Sanchez, Casey. "Culture Shock Value." Pasatiempo. *The Santa Fe New Mexican,* July 26–August 5, 2010, pp. 26–27.

Scholder 2008. Scholder, Fritz. "An Interview with Fritz Scholder." By Brian Daffron. *American Indian Art Magazine* 34, 1 (Winter 2008), pp. 56–65.

Scholder 2011. Scholder, Fritz. "Fritz Scholder: Indian/Not Indian." Podcast audio presented by National Museum of the American Indian. Accessed January 17, 2011. http://www.nmai.si.edu/mp3/fs/fritzscholder_001.mp3.

Schoppert 1987. Schoppert, James. Interview by Jan Steinbright. *Journal of Alaska Native Arts.* March–April 1987, pp. 3–5.

Schrader 1983. Schrader, Robert Fay. *The Indian Arts and Crafts Board: An Aspect of New Deal Indian Policy.* Albuquerque: University of New Mexico Press, 1983.

Seeman 2004. Seeman, Mark F. "Hopewell Art in Hopewell Places." In Townsend, Richard F., ed. *Hero, Hawk, and Open Hand: American Indian Art of the Ancient Midwest and South.* Chicago: The Art Institute of Chicago, in association with Yale University Press, 2004, pp. 57–72.

Sims 2008. Sims, Lowery Stokes, ed. *Fritz Scholder: Indian/Not Indian.* Washington, DC: National Museum of the American Indian, Smithsonian Institution, 2008.

L. Smith 1982. Smith, Lillian. "Three Inscribed Chumash Baskets with Designs From Spanish Colonial Coins." *American Indian Art Magazine* 7, 3 (Summer 1982), pp. 62–68.

T. Smith 2005. Smith, Trevor. "Collapsing Utopias: Brian Jungen's Minimalist Tactics." In Jungen, Brian, and Daina Augaitis. *Brian Jungen.* Vancouver: Douglas and McIntyre, and Vancouver Art Gallery, 2005, pp. 81–89.

National Museum of the American Indian, Smithsonian Institution 2009. National Museum of the American Indian, Smithsonian Institution. "Introduction." *Fritz Scholder: Indian/Not Indian.* Last modified February 10, 2009. http://www.nmai.si.edu/exhibitions/scholder/introduction.html.

National Museum of the American Indian, Smithsonian Institution 2010. National Museum of the American Indian, Smithsonian Institution. "Kevin Lee Burton." *Native Networks.* Accessed December 30, 2010. http://www.nativenetworks.si.edu/eng/rose/burton_k.htm.

Speck 1935. Speck, Frank G. *Naskapi: The Savage Hunters of the Labrador Peninsula.* Norman: University of Oklahoma Press, 1935.

Speck 1940. Speck, Frank G. *Penobscot Man: The Life History of a Forest Tribe in Maine.* Philadelphia: University of Pennsylvania Press, 1940.

Spirit Voices 2010. Spirit Voices. "Ira Hayes: Pima Tribe." Accessed December 20, 2010. http://thegoldweb.com/voices/irahayes.htm.

Spivey 2003. Spivey, Richard L. *The Legacy of Maria Poveka Martinez.* Santa Fe: Museum of New Mexico Press, 2003.

Starn 2004. Starn, Orin. *Ishi's Brain: In Search of America's Last "Wild" Indian.* New York: W. W. Norton, 2004.

Steponaitis and Knight 2004. Steponaitis, Vincas P., and Vernon James Knight Jr. "Moundville Art in Historical and Social Context." In Townsend, Richard F., ed. *Hero, Hawk, and Open Hand: American Indian Art of the Ancient Midwest and South.* Chicago: The Art Institute of Chicago, in association with Yale University Press, 2004, pp. 167–81.

Stewart 1993. Stewart, Hilary. *Looking at Totem Poles.* Vancouver: Douglas and McIntyre, and University of Washington Press, 1993.

Struever 2005. Struever, Martha Hopkins. *Loloma: Beauty Is His Name.* Santa Fe: Wheelwright Museum of the American Indian, 2005.

Subversions/Affirmation 1996. *Subversions/Affirmations: Jaune Quick-To-See Smith, A Survey.* In conjunction with an exhibition organized by the Jersey City Museum. Jersey City, New Jersey: Jersey City Museum, 1996.

Supree 1977. Supree, Burton. *Bear's Heart.* Philadelphia: J.B. Lippencott Co., 1977.

Swanton 1905. Swanton, John. *Contributions to the Ethnology of the Haida.* Leiden, The Netherlands: E. J. Brill, 1905.

Swanton and Enrico 1995. Swanton, John R., and John Enrico. *Skidegate Haida Myths and Histories.* Skidegate, British Columbia: Queen Charlotte Islands Museum Press, 1995.

Sweet and Berry 2001. Sweet, Jill, and Ian Berry. *Staging the Indian: The Politics of Representation*. Saratoga Springs, New York: Tang Teaching Museum, Skidmore College, 2001.

Szabo 2001. Szabo, Joyce M. "From General Souvenir to Personal Memento: Fort Marion Drawings and the Significance of Books." In *Painters, Patrons, and Identity: Essays in Native American Art to Honor J. J. Brody*. Ed. Joyce M. Szabo. Albuquerque: University of New Mexico Press, 2001, pp. 49–70.

Szabo 2007. Szabo, Joyce M. *Art from Fort Marion: The Silberman Collection*. Norman: University of Oklahoma Press, 2007.

Taylor 2006. Taylor, Drew Hayden. *Me Funny*. Vancouver: Douglas and McIntyre, 2006.

Temkin 2009. Temkin, Ann. *Gabriel Orozco*. New York: The Museum of Modern Art, 2009.

Thomas 1996. Thomas, Wesley. "Chil Yool T'ool: Personification in Weaving." Washington, DC: National Museum of the American Indian, Smithsonian Institution, 1996, p. 33.

Timbrook 2010. Timbrook, Jan. "Basket Made by Juana Basilia Sitmelelene (Chumash, 1782–1838)." In *Infinity of Nations: Art and Nation in the Collections of the National Museum of the American Indian*. Last modified October 22, 2010. http://www.nmai.si.edu/exhibitions/infinityofnations/california-greatbasin/230132.html.

Touchette 2001. Touchette, Charleen. "George Morrison (1919–2000) Standing on the 'Edge of the World.'" *American Indian Art Magazine* 27, 1 (Winter 2001), pp. 72–83.

Touchette 2003. Touchette, Charleen. *ndn art: Contemporary Native American Art*. Albuquerque: Fresco Fine Art Publications, 2003.

Townsend 2004A. Townsend, Richard F., ed. *Hero, Hawk and Open Hand: American Indian Art of the Ancient Midwest and South*. Chicago: The Art Institute of Chicago, in association with Yale University Press, 2004.

Townsend 2004B. Townsend, Richard F. "American Landscapes, Seen and Unseen." In Townsend, Richard F., ed. *Hero, Hawk and Open Hand: American Indian Art of the Ancient Midwest and South*. Chicago: The Art Institute of Chicago, in association with Yale University Press, 2004, pp. 15–35.

Townsend-Gault and Luna 2002. Townsend-Gault, Charlotte, and James Luna. *The Named and the Unnamed*. Vancouver: The Morris and Helen Belkin Art Gallery, 2002.

Trautmann 2010. Trautmann, Rebecca Head. "Personal Memory and Identity." *The Contemporary Native Art Collection Vantage Point*. Washington, DC: National Museum of the American Indian, Smithsonian Institution, 2010.

Tsabetsaye 2011. Tsabetsaye, Roger. *Myspace page*. Accessed February 10, 2011. http://www.myspace.com/rogertsabetsaye.

Two American Painters 1972. *Two American Painters: Fritz Scholder and T. C. Cannon*. Washington, DC: The Smithsonian Institution Press, 1972.

Ubelaker and Viola 1982. Ubelaker, Douglas H., and Herman J. Viola, eds. *Plains Indian Studies: A Collection of Essays in Honor of John C. Ewers and Waldo R. Wedel*. Washington, DC: The Smithsonian Institution Press, 1982.

Unlimited Boundaries 2007. *Unlimited Boundaries: Dichotomy of Place in Contemporary Native American Art*. Albuquerque: Albuquerque Museum and Indian Pueblo Cultural Center, 2007.

Valentino 1994. Valentino, Erin. "'Mistaken Identity': Between Death and Pleasure in the Art of Kay WalkingStick." *Third Text* 8, 26 (Spring 1994), pp. 61–73.

Valentino 1997. Valentino, Erin. "Coyote's Ransom: Jaune Quick-to-See Smith and the Language of Appropriation." *Third Text* 11, 38 (Spring 1997), pp. 25–37.

Valiskakis 2005. Valiskakis, Gail Guthrie. *Indian Country: Essays on Contemporary Native Culture*. Waterloo, Ontario: Sir Wilfred Laurier University Press, 2005.

Van Bussel 2001. Van Bussel, Gerard W. "The Collection of the North and Central American Department of the Museum für Völkerkunde, Vienna." In *Art and the Native American: Perceptions, Reality, and Influences*. Eds. Mary Louise Krumrine and Susan Clare Scott. University Park: Pennsylvania State University, 2001, pp. 303–313.

Varjola 1990. Varjola, Pirjo, with contributions by Julia P. Averkieva, and Roza G. Liapunova. *The Etholén Collection: The Ethnographic Alaskan Collection of Adolph Etholén and His Contemporaries in the National Museum of Finland*. Helsinki: National Board of Antiquities [of Finland], 1990.

Vaughan and Holm 1982. Vaughan, Thomas, and Bill Holm. *Soft Gold: The Fur Trade and Cultural Exchange on the Northwest Coast of America*. Portland, Oregon: Historical Society, 1982.

Vennun 1982. Vennun, Thomas. *The Ojibwe Dance Drum: Its History and Construction*. Washington, DC: The Smithsonian Institution Press, 1982.

Vidart and G. P. Horse Capture 1993. Vidart, Anne, and George P. Horse Capture. *Parures d'histoire: Peaux de bisons peintes des Indiens d'Amerique du Nord*. Paris: Musée de l'homme, 1993.

Vitruvius 1999. Vitruvius. *Ten Books on Architecture*. Eds. Ingrid D. Rowland and Thomas Noble Howe. Cambridge: Cambridge University Press, 1999.

Waldman 1985. Waldman, Carl, with illustrations by Molly Brown. *Encyclopedia of Native American Tribes*. New York: Facts on File, 1985.

WalkingStick 1992. WalkingStick, Kay. "Native American Art in the Postmodern Era." *Art Journal* 51, 3 (Fall 1992), p. 16.

WalkingStick 2010. WalkingStick, Kay. "Artist Statement." *KayWalkingStick.com.* Last modified January 29, 2010. http://www.kaywalkingstick.com/statement/index_new.htm.

Wallen 1990. Wallen, Lynn Ager. *Face of Dance: Yup'ik Eskimo Masks from Alaska.* Calgary, Alberta: The Glenbow Museum, 1990.

Wallo and Pickard 1990. Wallo, William, and John Pickard. *T. C. Cannon – Native American: A New View of the West.* Oklahoma City: National Cowboy Hall of Fame and Western Heritage Center, 1990.

Warhus 1997. Warhus, Mark. *Another America: Native American Maps and the History of Our Land.* New York: St. Martin's Press, 1997.

Waselkov, Wood, and Hatley 2006. Waselkov, Gregory A., Peter H. Wood, and Tom Hatley, eds. *Powhatan's Mantle: Indians in the Colonial Southeast.* Lincoln: University of Nebraska Press, 2006.

Wasserman 1987. Wasserman, Abby. "Coyote and the Mythmaker." *Museum of California Magazine* 11, 2 (1987).

Watt 2004. Watt, Marie. "Artist Statement." *PDX contemporary art,* 2004. http://pdxcontemporaryart.com/blanket-stories.

Watt Studio 2010. Marie Watt Studio. "Blanket Stories: Objects." Accessed October 15, 2010. http://mkwatt.com/index.php/content/work_detail/category/blanket_stories_objects/.

Weaving Is Life 2006. *Weaving Is Life: Navajo Weavings from the Edwin L. and Ruth E. Kennedy Southwest Native American Collection.* Athens, Ohio: Kennedy Museum of Art, Ohio University, 2006.

Weber 1978. Weber, Msgr. Francis J. "Chumash Indian Basketry at San Buenaventura." *The Ventura County Historical Society Quarterly* 24, 1 (Fall 1978), pp. 17–25.

Weiss and Haber 1999. Weiss, Gail, and Honi Fern Haber. *Perspectives on Embodiment: The Intersections of Nature and Culture.* London: Routledge, 1999.

West 1998. West, Richard W. Jr. "The Centrality of Place." In *Reservation X: The Power of Place in Aboriginal Contemporary Art.* Ed. Gerald McMaster. Seattle: University of Washington Press, and Canadian Museum of Civilization, 1998, p. 11.

Weston 2002. Weston, Wendy. "It Is Art: Contemporary Native Creations; The American Craft Museum." *Native Peoples Magazine* 15, 4 (May/June 2002), p. 64.

Wheelwright 1942. Wheelwright, Mary Cabot. *Navajo Creation Myth, the Story of Emergence by Hosteen Klah.* Santa Fe: Museum of Navajo Ceremonial Art, 1942.

Whipple 1876. Whipple, Bishop H. B. "Mercy to Indians." *The New York Daily Tribune,* April 1, 1876. In Pratt, Richard H. *Battlefield and Classroom: Four Decades with the American Indian, 1867–1904.* New Haven: Yale University Press, 1964, pp. 163–64.

Whitaker 1978. Whitaker, Kathleen. "George Wharton James's Railroad Textile." Unpublished manuscript, 1978, in the object files at the San Diego Museum of Man. Typescript, p. 4.

Whitman 1990. Whitman, Richard Ray. "Artist's Statement." In *Reimaging America: the Arts of Social Change.* Eds. Mark O'Brien and Craig Little. Philadelphia: New Society Publishers, 1990, p. 78.

Whitman 2011. Whitman, Richard Ray. "Richard Ray Whitman: Yuchi." *A Time of Visions: Interviews by Larry Abbott.* Last modified September 28, 2010. http://www.britesites.com/native_artist_interviews/rwhitman.htm.

Wikipedia 2010A. *Wikipedia.* "Indian Country." Last modified November 28, 2010. http://en.wikipedia.org/wiki/Indian_Country.

Wikipedia 2010B. *Wikipedia.* "Raising the Flag on Iwo Jima." Last modified December 19, 2010. http://en.wikipedia.org/wiki/Raising_the_Flag_on_Iwo_Jima.

Wilbur 1995. Wilbur, C. Keith. *The Woodland Indians: An Illustrated Account of the Lifestyles of America's First Inhabitants.* Old Saybrook, Connecticut: The Globe Pequot Press, 1995.

Wilson 1985. Wilson, Lee Anne. "Southern Cult Images of Composite Human and Animal Figures." *American Indian Art Magazine* 11, 1 (Winter 1985), pp. 46–57.

Winter 2002. Winter, Mark. *Dances with Wool: Celebrating One Hundred Years of Woven Images from Southwestern Mythology.* Toadlena, New Mexico: Toadlena Trading Post, 2002.

Wissler 1912. Wissler, Clark. "Societies and Ceremonial Associations in the Oglala Division of the Teton-Dakota." In *Anthropological Papers of the American Museum of Natural History* (New York: Trustees of the American Museum of Natural History) 11, part 1 (1912).

Wissler 1975. Wissler, Clark. *Societies of the Plains Indians.* New York: AMS Press, 1975. Reprint, *Anthropological Papers of the American Museum of Natural History* 11 (1916).

Witherspoon 1977. Witherspoon, Gary. *Language and Art in the Navajo Universe.* Ann Arbor: University of Michigan Press, 1977.

Wlaskeno 2009. Wlasenko, Olexander. *Michael Belmore: Embankment.* Whitby, Ontario: Station Gallery, 2009.

Wooley and J. D. Horse Capture 1993. Wooley, David L., and Joe D. Horse Capture. "Joseph No Two Horns, He Nupa Wanica." *American Indian Art Magazine* 18, 3 (Summer 1993), pp. 32–33.

Wooley and Waters 1988. Wooley, David, and William T. Waters. "Waw-no-she's Dance." *American Indian Art Magazine* 14, 1 (Winter 1988), pp. 36–45.

Wright 1986. Wright, Robin K. "The Depiction of Women in Nineteenth Century Haida Argillite Carving." *American Indian Art Magazine* 11, 1 (Autumn 1986), pp. 36–45.

Wright 1998. Wright, Robin K. "Two Haida Artists from Yan: Will John Gwaytihl and Simeon Stilthda Please Step Apart?" *American Indian Art Magazine*, 23, 3 (Summer 1998), pp. 42–57, 106–107.

Wright 2000. Wright, Robin K. "Edenshaw, Charles." In *Dictionary of Canadian Biography Online*, 1911–1920, vol. 14. University of Toronto, 2000. http://www.biographi.ca/009004-119.01-e.php?&id_nbr=7354.

Wright 2001. Wright, Robin K. *Northern Haida Master Carvers*. Vancouver: Douglas and McIntyre, and University of Washington Press, 2001.

Wyckoff 1996. Wyckoff, Lydia. *Visions and Voices: Native American Painting from the Philbrook Museum of Art*. Tulsa, Oklahoma: The Philbrook Museum, and the University of New Mexico Press, 1996.

Yau 2006. Yau, John. "At the Southern Edges of the New World." In Cooper, Thomas Joshua, and John Yau. *Ojo de Agua: Thomas Joshua Cooper*. New York: Pace Wildenstein, 2006, p. 51.

Young Man 2006. Young Man, Alfred. "Segregation of Native Art by Ethnicity: Is It Self-imposed or Superimposed?" In *[Re]Inventing the Wheel: Advancing the Dialogue on Contemporary American Indian Art*. Ed. Nancy Blomberg. Denver: Denver Art Museum, 2006, pp. 79–103.

Zea 2008. Zea, Philip. *Keeping Their Powder Dry: Powder Horns of the French and Indian War: The William H. Guthman Collection at Historic Deerfield*. Last modified September 11, 2009. http://www.antiquesjournal.com/pages09/monthlypages/aug09/powderhorn.html. An earlier version of this article appeared in *Historic Deerfield*, Summer 2008, pp. 20–27.

Index

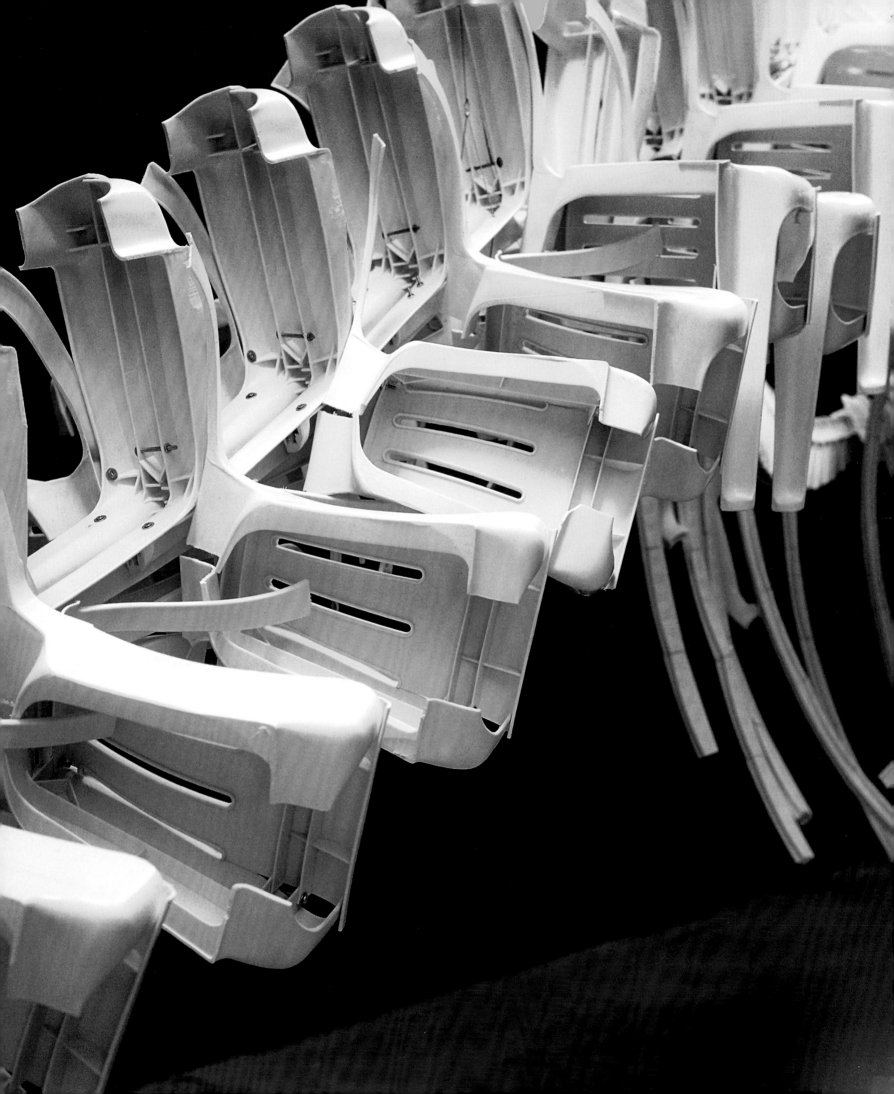

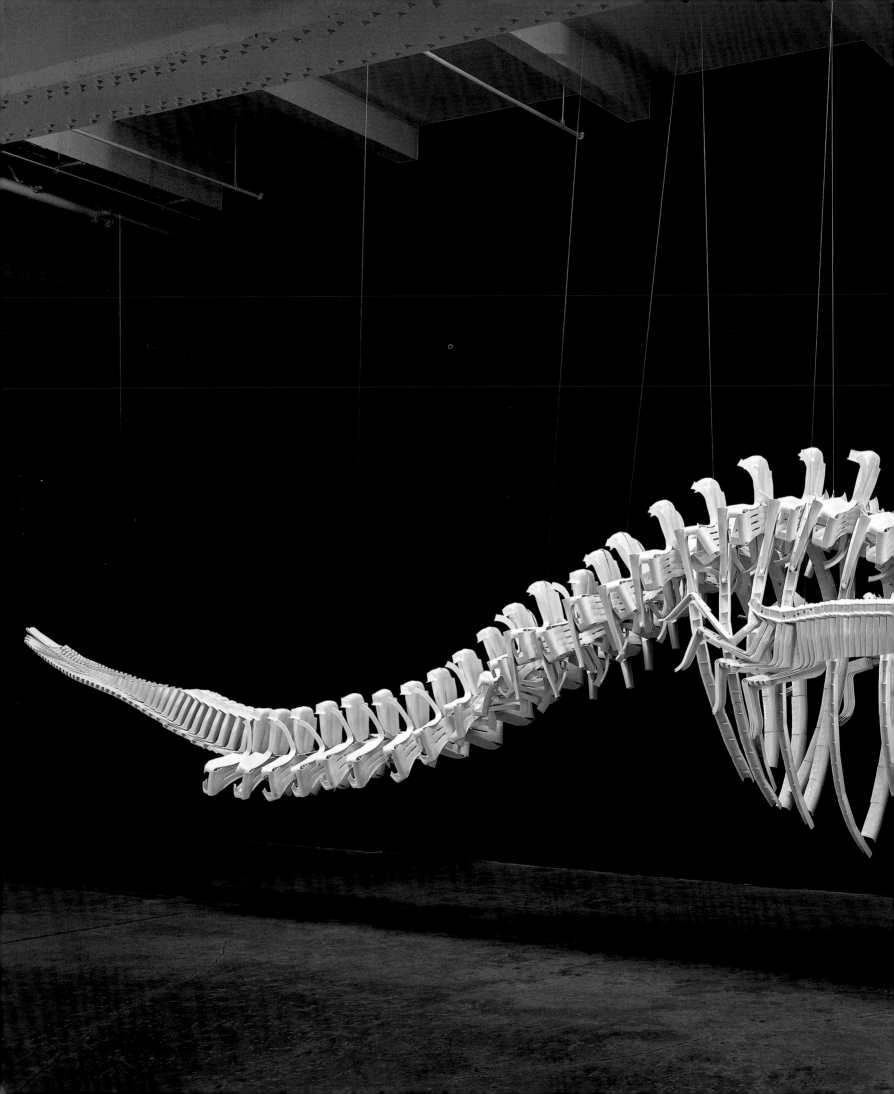

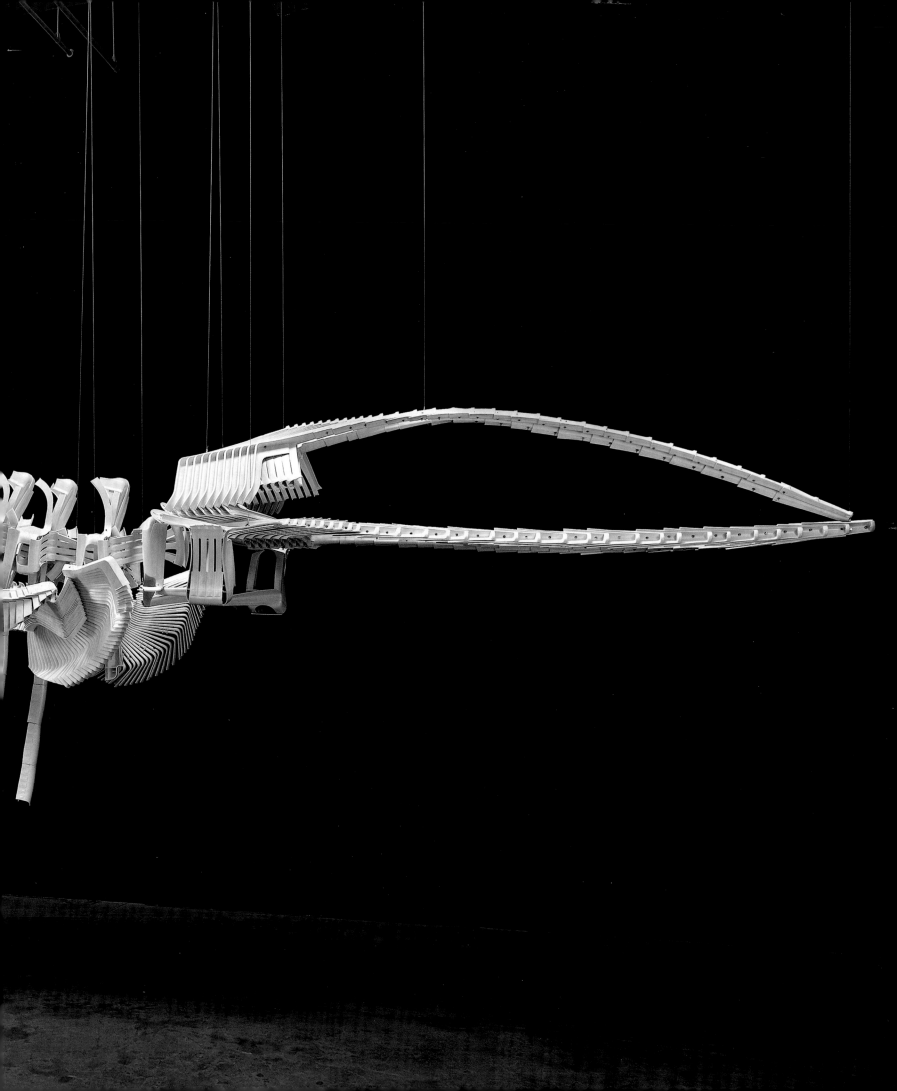